Famous Works of Art—
And How They Got
That Way

Famous Works of Art— And How They Got That Way

John B. Nici

ROWMAN & LITTLEFIELD
Lanham · Boulder · New York · London

Published by Rowman & Littlefield
A wholly owned subsidiary of The Rowman & Littlefield Publishing Group, Inc.
4501 Forbes Boulevard, Suite 200, Lanham, Maryland 20706
www.rowman.com

Unit A, Whitacre Mews, 26-34 Stannary Street, London SE11 4AB

British Library Cataloguing in Publication Information Available

Library of Congress Cataloging-in-Publication Data

Nici, John B.
 Famous works of art—and how they got that way / John Nici.
 pages cm
 Includes bibliographical references and index.
 ISBN 978-1-4422-4954-7 (hardback : alk. paper) — ISBN 978-1-4422-4955-4 (ebook)
 1. Masterpiece, Artistic—Public opinion. 2. Art and society. I. Title.
 N72.5.N53 2015
 701'.03—dc23

 2015008192

∞™ The paper used in this publication meets the minimum requirements of American National Standard for Information Sciences—Permanence of Paper for Printed Library Materials, ANSI/NISO Z39.48-1992.

Printed in the United States of America

To Carol Lewine and Bill Clark,
extraordinary scholars, masterful teachers

Contents

Foreword

WHAT PRICE FAME?

"*It's* a masterpiece," "A signature work," "A classic!" With ever greater frequency, "masterpieces" seem to come down to us fully validated as such, but who determines their rarified status? And, more important, how is it determined? What, in fact, does the designation of a work of art as a masterpiece actually mean? In contemporary usage, the definition trends toward a work of exceptional quality, or the most virtuosic example, a magnum opus, by a particular artist—a great artist, to be more exact.[1] By implication, a masterpiece—be it visual, literary, dramatic, musical—awes its audience with its sheer genius, originality, and expressive power. In its modern conception, the designation in effect becomes largely aesthetic, presupposing a lofty cultural achievement. Yet it was hardly always thus.

The original meaning of "masterpiece" in a visual context was derived from medieval artistic practice and, more specifically, the obligatory requirements of guild membership. Having finished his or her training, a young or immigrant artist could only gain entry into the artists' guild by finishing and submitting a test piece, a demonstration work that attested to its maker's mastery of his or her chosen craft. In a rather unusual demand of rigor, one especially protectionist guild of painters and sculptors in late fifteenth-century Cracow is documented as having required as many as three exemplars, posing different representational challenges and thus testifying to the artist's ability to conquer a wide range of technical problems. Upon the work's acceptance, the applicant's status as a journeyman or apprentice ended and that of full-fledged master began. The proof was thus in the skill: the most critical requirement separating a successful craft-masterpiece from a failing effort. On occasion, this very same precondition of supreme quality and skill was exploited by the guilds not only to elevate the socioeconomic status of a practitioner from artisan to artist or to protect the consumer from flawed, inferior products but to use it as an exclusionary tactic, foreclosing unwanted competition from foreigners within the local artistic community by means of arbitrary or prohibitively strict assessment. Local councils and individual patrons at times felt the stifling effects in their own right, protesting that guild protectionism ran the risk of compromising trade and even artistic innovation. By the mid-sixteenth century in Florence and the mid-seventeenth century in Paris, guild control was sharply on the wane; in its

place arose the government-sanctioned academy. The requirement of a qualifying masterpiece or "diploma work" for entry still persisted into the age of academies, though in an increasingly more relaxed and pedagogical spirit.

To return to the present day, what one might call the "masterpiece effect" is inextricably tied to currency, in both senses of the word: hard currency and the currency of fame. This, too, was not always thus. Do we know the identity of the makers of the Great Sphinx? Was the *Mona Lisa* ever delivered to its patron, Francesco del Giocondo and his wife Lisa Gherardini—in fact, was Lisa's likeness even finished? (The answer on both counts is no.) And how many masters now universally lauded for the masterpieces contained within the present book's covers were rejected during their own lifetimes? Many now-revered names headline this otherwise surprising list, wearing, in their afterlife, their former repudiation as a badge of honor. In the last two centuries alone, one need only to recall the names of William Blake, Vincent van Gogh, Édouard Manet, and Amedeo Modigliani in this regard.

Of the twenty highest known prices ever paid for paintings, all but two of them (both late canvases by Van Gogh) sold post-1990 at auction or, more commonly, in private sale, each and every one belongs to the usual late nineteenth- to twentieth-century artistic suspects. Headlining the list are four Van Goghs, four Picassos, two Warhols, two Klimts. All twenty works in question are now valued at an inflation-adjusted price of $100 million or above. Claiming the top perch is Paul Cézanne's *Card Players* of 1892–1893, purchased by the small, oil-rich state of Qatar in 2011 and valued at over a staggering $250 million. The painting is the most starkly spare of five known versions of the same subject, the other four housed in distinguished museum collections. More recently, in 2013, Jeff Koons's jumbo-sized, stainless steel *Balloon Dog* from the artist's *Celebration* series, perhaps the best known of Koons's playful yet heavily marketed creations, sold at auction for over $58 million, the record for any living artist. The clothing line H&M, which sponsored Koons's recent show at the Whitney Museum, soon launched a handbag emblazoned with the *Balloon Dog*, priced at $49.50. Giant images of the glossy canine immediately graced the façade of the newly opened flagship H&M on Fifth Avenue and Forty-Eighth Street.

Johannes Vermeer was one old master who may have stood to use some Koonsian commercial savvy. Held in the highest regard in his lifetime, as he is today, the great Sphinx of Delft dwelt in relative obscurity until his rediscovery in the late nineteenth century. Nor was his end a happy one. A year and a half after Vermeer's sudden death at the age of forty-three in the winter of 1675, Catharina Bolnes, his widow and mother of their eleven children (ten of them still minors at the time), petitioned for bankruptcy. She claimed that her husband was not only unable to sell any of his own paintings during the "ruinous and protracted war"—a reference to the French invasion of the Dutch Republic in 1672—but that the painter-dealer was also "left sitting with the paintings of other masters" for which he had failed to find buyers. Ultimately, Vermeer plunged into a state of "such decay and decadence," according to Catharina's sad account, and had taken his money troubles "so to heart," that "he had fallen into a frenzy, [and] in a day and a half he had gone from being healthy to being dead."[2]

Bankruptcy likewise haunted Rembrandt's final years. Despite the Amsterdam master's financial success not only as an artist but also teacher and art dealer (like

Vermeer to follow), his penchant for lavish living forced him to declare bankruptcy in 1656. Even Rembrandt's earnings from a subsequent auction—his remarkable collection of art and antiquities boasting objects ranging from ancient sculpture to Far Eastern art and arms and armor—and the sale of his house proved insufficient to pay off his mounting debts. Despite his dire financial troubles, it was in his late period that Rembrandt produced some of his most profoundly moving works, including *Bathsheba* (Louvre, Paris, 1654); *Jacob Blessing the Sons of Joseph* (Staatliche Gemäldegalerie, Kassel, 1656); a Lear-like self-portrait (Frick Collection, New York, 1658); and *The Jewish Bride* (Rijksmuseum, Amsterdam, 1665–1669).

Certainly, artists and their publics rarely, if ever, ignored matters of finance altogether—to think so would be naive. Still, in the case of art's makers, the exceptions are often still more revealing than the rule.

According to the Latin writer Pliny the Elder (AD 23–79) in his *Natural History*, the legendary painter Zeuxis of Heracleia, upon reaching the height of his wealth and fame, freely gave away some of his works as he deemed them to be beyond any price. One such example was a scene of the *Infant Hercules Strangling the Serpent*, an image of the most pleasurable terror, which he presented to the people of Agrigentum. Alas, not a single one of his paintings now survives, living on only in their ancient written descriptions and praise. Two millennia after Zeuxis, the genial fifteenth-century Florentine sculptor Donatello was said by the artist-biographer Giorgio Vasari to have been so unconcerned with the trappings of fame that he returned to Cosimo de' Medici the powerful banker-patron's lavish gift of a scarlet cloak, cap, and doublet, having worn them but once . . . in great discomfort, at that. The same Donatello is said (perhaps apocryphally) to have kept a basket filled with money suspended from the ceiling of his studio, in case his young assistants were in need of some petty cash. Little wonder that Vasari constantly referred to the sculptor informally as "Donato," the corresponding verb "donato" meaning "that which is freely given" (from *donare*, "to give"). Unlike his great hero Donatello, Michelangelo was nothing if not concerned with fame, honor, and wealth. The "Divine One" rarely gave his drawings away, but when he did, he gifted them to admired friends and platonic beloveds. Other sheets he gave away to struggling pupils, thus generously sharing with them technical secrets of the trade—or at times, one suspects, providing them with a ready source of income. In his own words, these meticulously finished presentation drawings were made "for love rather than duty." The alleged chestfulls of drawings that remained in Michelangelo's possession at the close of his long life, the master requested to be burned upon his death, so as to hide from prying eyes the labor behind the final tour de force pictorial solutions—solutions beyond all but the most elevated understanding and, one might imagine Michelangelo claiming, above all price.

How then did pre- and early modern artists, in particular, not only survive, but profit from their labors? Why did some works fetch princely sums while others, of the same scale and subject matter, bring only modest pay? And who decided the value of an artist's efforts? Who determines the value today, both in critical legacy and in price? It certainly bears noting that fame long eluded a number of artists now widely feted, the subject of numerous publications and exhibitions and the headliners of lucrative auction sales. Lest one forget, the likes of Piero della Francesca, Sandro Botticelli,

Caravaggio, and Gianlorenzo Bernini all fell into relative obscurity until well into the nineteenth century, when their reputations at last were revived. The latter pair of baroque masters was excoriated in the Age of Enlightenment for what their critics perceived as their excess and figural deformities, as the exponents of a new classically inspired aesthetic sought to purge art of playful exuberance, illusionistic devices, high emotion, and licentious freedom by returning to a simple, noble style of restraint, rooted in the lessons of antiquity. Darkness also long engulfed El Greco, by and large until his rediscovery by the French and English romantics (Théophile Gautier, chief among them) and, most telling, fellow painters ranging from Delacroix and Cézanne to Picasso and Pollock in the late nineteenth to twentieth centuries. Chardin, too, had a long time to wait for his return to favor—like the other guiding lights mentioned here, never underrated in his own time, just forgotten. All of this to say, taste, critical reception, and fame are, and have always been, a very fickle thing.

The vagaries of fame (and the art market) have long been subjected to commentary and criticism, often by artists themselves, as captured by John Baldessari's *Tips for Artists Who Want to Sell* of 1966–1968, a sardonic send-up of subject matter that "sells." Portraits often do well on the market, especially those of women. As it happens, no better example of the capriciousness of fame comes to mind than Leonardo's *Mona Lisa*, a work treasured by Leonardo and never relinquished from his own possession throughout his final, peripatetic years but a work that remained largely unknown to the public for approximately two hundred years after its production. After the French Revolution, the painting was kept by Napoleon in his bedroom. Afterward, it found a permanent and public place in the new Louvre Museum. Yet, it was left out or given no higher status there than the hundred or so other works exhibited in the Louvre's splendid Salon Carré. That is, until the panel was stolen on August 21, 1911, by an Italian housepainter named Vincenzo Peruggia, who had briefly worked at the Louvre. It took twenty-eight hours for museum officials even to realize that the painting had been stolen and not temporarily removed for photography or study. (Two of the first suspects to be questioned were Picasso, who had bought two stolen Iberian sculptures originally in the Louvre, and his friend, the poet Guillaume Apollinaire!) American titans of collecting, like J. P. Morgan and Henry Clay Frick, were initially suspected by some as potentially masterminding an elaborately planned heist. After the painting's theft, the Louvre left the now vacant spot on the wall blank—and crowds flocked to pay the void their respects. The portrait was recovered two years later, when Peruggia, who had kept the panel in the false bottom of a wooden trunk filled with tools, clothes, and a mandolin, attempted to sell the hot work, ultimately claiming that he had stolen it not for profit but for reasons of nationalist pride, seeking to repatriate Lisa to her native soil in Italy. And so, only upon its disappearance did the *Mona Lisa* get her first big round of worldwide headlines. At long last, she entered the annals of pop culture. A blessing or a curse, one might be prompted to ask?

When fame is indeed granted, it often comes with its own price. The *Mona Lisa* has been attacked no fewer than four times—with acid, a rock, with red paint, and, most recently, with a teacup. The said projectile was purchased at the Louvre gift shop—and then hurled at the painting by a Russian woman, angry that she had been denied French citizenship. Nor, as John Nici will describe, was Leonardo's most celebrated rival Michelangelo immune from the modern public's fits of obsession—and madness.

TIPS FOR ARTISTS
WHO WANT TO SELL

- GENERALLY SPEAKING, PAINT-
INGS WITH LIGHT COLORS SELL
MORE QUICKLY THAN PAINTINGS
WITH DARK COLORS.

- SUBJECTS THAT SELL WELL:
MADONNA AND CHILD, LANDSCAPES,
FLOWER PAINTINGS, STILL LIFES
(FREE OF MORBID PROPS ___
DEAD BIRDS, ETC.), NUDES, MARINE
PICTURES, ABSTRACTS AND SUR-
REALISM.

- SUBJECT MATTER IS IMPOR -
TANT: IT HAS BEEN SAID THAT PA-
INTINGS WITH COWS AND HENS
IN THEM COLLECT DUST
___ WHILE THE SAME PAINTINGS
WITH BULLS AND ROOSTERS SELL.

John Baldessari, *Tips for Artists Who Want to Sell*, 1966–1968, acrylic on canvas, 68 × 56.5 inches. *Courtesy of the artist and Marian Goodman Gallery*

Arguably the most thought-provoking example of artistic iconoclasm in the West persists in the form of Diego Velázquez's *Toilet of Venus* (ca. 1647–1651), better known as the *Rokeby Venus*, so named after its earlier provenance in the Morritt Collection at Rokeby Park in County Durhamin in Northern England. Now displayed as something of a marvel of conservation in the National Gallery, London, the canvas survives as the first known female nude in Spanish painting, quite a rare distinction considering the religious and moral prohibitions of the Spanish church at the time of its production. Sharing the sensuality and grace of Titian's earlier reclining *Venus of*

Urbino yet here radically transforming the viewer's experience by means of reflecting the latter's voyeuristic gaze via a mirror, the great Spanish master's work was first recorded in 1651 in the posthumous inventory of Domingo Guerra Colonel, an artist about whom we know very little and who had no obvious link with Velázquez. Soon after, it entered the collection of Don Gaspar Méndez de Haro, the seventh Marqués del Carpio and son of the first minister of Spain. It was presumably displayed privately in the marqués's living quarters, thus avoiding the reprimand (or worse) of the Spanish Inquisition. Throughout its later history, the work was adored—even fetishized. It was, precisely for its fame as an object of exquisite beauty, that, on March 10, 1914, Mary Richardson slashed the canvas on the walls of the National Gallery with seven swings of a meat cleaver.[3] Why commit such a violent act of destruction on a revered, near-iconic national treasure? The public was soon to learn that she inflicted the gaping wounds on the canvas so as to draw attention to the unjust treatment of a flesh and blood woman, one Emmeline Pankhurst, a fiercely militant British champion of women's suffrage, who was imprisoned six times between 1908 and 1912 alone. Richardson explained her militant act of protest thus:

> I have tried to destroy the picture of the most beautiful woman in mythological history as a protest against the government for destroying Mrs. Pankhurst, who is the most beautiful character in modern history. . . . If there is an outcry against my deed, let everyone remember that such an outcry is a hypocrisy so long as they allow the destruction of Mrs. Pankhurst and other beautiful living women, and that until the public cease to countenance human destruction the stones cast against me for the destruction of this picture are each an evidence against them of artistic as well as moral and political humbug and hypocrisy.[4]

On July 2, 1928, just three weeks after Pankhurst's death of illness, a law was passed allowing all women over the age of twenty-one to vote.

And so, why this book? And why now? In light of our age of commodification and increasingly celebrity-driven culture, the need for a fresh perspective on the peculiar—and often inexplicable—resonance of certain images, but not others, with the public only continues to grow in importance. To be sure, the same should be said for the swings and swells of the art market and new trends in collecting. Cutting to the quick is a disarmingly simple yet essential question: How is the greatness of a work of art different than its fame? Further on this point, what of artists well regarded and cherished by scholars but long forgotten by the masses? Here, in the United States, many are familiar with Norman Rockwell and Andrew Wyeth. But what about the likes of Louise Nevelson, Lee Krasner, Joan Mitchell, or Eva Hesse? What of all great women artists—and their still-muted presence in textbooks, in exhibitions, in the canon at large? Whose canon is it, anyway?

These are but some of the most probing questions that John Nici addresses in his series of illuminating case studies. They are most certainly questions in urgent need of asking.

—Dennis Geronimus
Associate Professor of Renaissance Art and Department Chair
Department of Art History, New York University

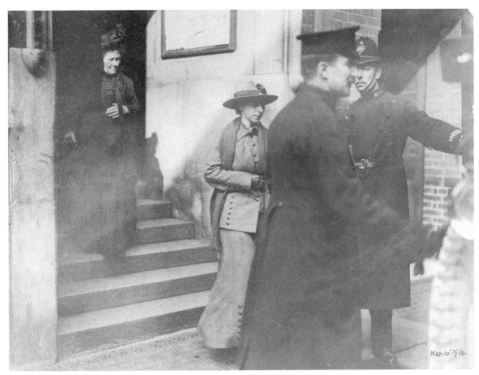

The suffragette "Slasher" Mary Richardson (center), who attacked the *Rokeby Venus* by Diego Ve-
lázquez, leaving for court, 1914. Across England a number of draconian museum measures, aimed
at women, soon followed. *HIP / Art Resource, NY*

Acknowledgments

Throughout this project, and in many other ways, I have repeatedly benefited from the expertise, ready enthusiasm, and generosity of spirit of Jack Jarzavek and Bill Levin, two esteemed colleagues in the field of art history. I am especially fortunate in having taught a number of exceptional students who have remained in contact with me long after graduation, and who have contributed to this book: Svetlana Katz, who introduced me to Janklow and the world of literary agents, and who first believed in this project; Jared Kornblatt, an insightful literary editor who helped to shape the introduction; and Dennis Geronimus, whose ability to combine scholarship and pedagogy is second to none. His foreword is both a contribution to this book and an act of long-standing friendship. Words cannot express my gratitude to my agent, Michael Steger, for his professional advice on publishing this manuscript, and his assistance in polishing the text. Also thanks is extended to Rowman & Littlefield, and Stephen Ryan in particular, for having faith in this manuscript and considering it worthy for publication. For innumerable kindnesses and unstinting support throughout this project I am particularly indebted to my wife, Judy Nici.

Introduction

FRAMED BY FAME

*T*he Metropolitan Museum in New York City is steamy and hot, filled with directionless tourists wandering among the galleries secretly taking pictures of this sculpture and that painting. Through it all, I am leading a group of chatty high school seniors, victims of my Advanced Placement Art History class, around the museum, looking at what I consider, in my wisdom, to be the choice masterpieces.

After euphorically waxing over Rembrandt's *Aristotle Contemplating a Bust of Homer*, I lead the group to a rendezvous with a former student of mine, Dennis Geronimus, who is now a PhD in art history working out of NYU, and one of the foremost authorities on Italian Renaissance art. Dennis is kindhearted, to say the least, to do me the favor of talking to my class during his off-hours. His job on this occasion is to discuss two paintings of interest, the Metropolitan's recent blockbuster purchase of the only remaining Duccio in private hands, a small panel simply called *Madonna and Child*, and the masterly *Portrait of a Young Man* by one of the greatest mannerist painters, Agnolo Bronzino.

Dennis is superb, mesmerizing even. He covers every angle: the iconography, the context, the medium, the technique, the style, the costuming, and the composition. He is detailed, scholarly, and most important to his audience, entertaining. The students are extremely appreciative, and express their thanks by giving him a round of applause.

Later on the way home in a chartered yellow school bus that kids refer to as a "cheese bus," one student asks, in all innocence, "So what is so famous about that Duccio painting? I mean it's nice and all, but it seems like all the paintings in the same room were just as nice."

The question is more profound than it seems. The Duccio had just become famous because the Metropolitan purchased it in 2004 for an undisclosed sum, reported to be $45 million. Can I tell my student that the reason the painting has become famous is because of the price tag and not because of its quality? After all, it *does* look very much like all the paintings in that gallery.

And what of that Bronzino? I wanted my students to see that painting because it is on the cover of our textbook, the iconic *Gardner's Art through the Ages*. This is not perhaps the best motivation for discussing a work of art, but it does show how

works can become noteworthy, even if briefly, by their prominent placement on the cover of a best seller.

People have largely forgotten about the big splash the Duccio made in the press in 2004, and *Gardner* has gone through so many editions that the Bronzino is no longer lionized on its cover. However, other paintings have been catapulted to fame and remained there, often for reasons that have nothing to do with quality. In fact, many quality works are known only to specialists in the field, and others of minimal artistic worth have become well known for various and sometimes strange reasons. It is rare that quality and celebrity are matched, but it does happen with the most famous of them all: the *Mona Lisa*.

In a world filled with great museums and great paintings, Lisa Gherardini, better known as the Mona Lisa, is the reigning queen. Her portrait rules over a carefully designed salon, one that was made especially for her in a museum that may, sometimes, seem to visitors today intended for no other purpose than to showcase her virtues—Louvre curators say that 90 percent of all visitors come specifically to see her. When the museum opens in the morning, a wave of people charge up the stairs to the Salle des Etats to gaze in wonder.

She is defended by two museum guards at any given time, and plainclothes security officers haunt the space looking for potential troublemakers, like pickpockets, who have seized upon her popularity for their own exploits. Lisa's fame has caused a spate of vandalisms: a 1956 attacker threw acid at the painting while on display in a museum in Montauban, France; later that same year, a Bolivian anarchist pitched a rock at her and damaged her left elbow.[1] In 2009 a deranged visitor hurled a teacup at her, which bounced off the bulletproof glass and shattered on the floor.[2]

Such attacks represent only one aspect of her increasingly complex history—a history that includes a "borrowing" of the painting by Napoleon so it could hang in his bedroom for four years, and a theft by a museum employee in 1911 (it was recovered two years later). A trip to the United States in 1962–1963, and a voyage to Japan in 1974, stirred enormous interest worldwide. While journeying across the Atlantic to New York, the *Mona Lisa* was accompanied by a flotilla of protective ships, and

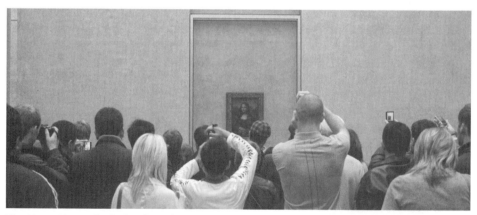

The Mona Lisa smiles before her adoring fans who come bearing cameras to record her presence.
Andrei Iancu / Dreamstime

was greeted by an awaiting throng of half a million people at the National Gallery in Washington. President Kennedy himself opened the exhibition in January 1963. Reporters were euphoric, busily taking newsreel images of throngs walking silently before her. At least a million more people gathered at the Metropolitan Museum in New York to gaze admiringly at the famous painting.

The *Mona Lisa* probably will never leave the Louvre again—and hasn't in nearly five decades. There is a morbid fear among the Louvre's management that they would have to deal with thousands of irate tourists in Paris disappointed about not being able to see her. The salon in which the painting hangs is meant to handle 1,500 visitors an hour, a fact that is certainly believable given the crush of onlookers. One might imagine that the smile on her face reflects her amusement over these modern realities.

The visitor who wishes to see the other paintings in the salon in which she holds court should beware that the general public has not come to contemplate Titian, Veronese, or Giorgione. They have only come to see *her*. And pity the poor scholar who actually needs to see the painting for research; he cannot get within teacup-throwing distance.

What has made this portrait so famous? Miles and miles of museum corridors house thousands of objects of great value and considerable beauty, but of little fame. The *Mona Lisa* has risen above all else, all others, and all rivals, and has commanded the kind of popular adoration and respect, even reverence, that few other man-made objects have ever been given. The secrets to her popularity are complex, but the results are plain to see.

Few would doubt that the artist in question, Leonardo da Vinci, has been the source of some of the fame. His vast genius and his mercurial personality have resonated throughout the ages, generating an awed and adoring fan base. Biographies of all sorts have been written about him: from commercial ventures of pop culture, to deep psychological portraits, to artistic assessments. He is even the subject of wild fictional tales, such as *The Da Vinci Code*, which shamelessly reinterpreted his paintings to suit the dramatic ends of a popular novel. How much more fascinating does the *Mona Lisa* become when placed against this backdrop?

Many writers and tourists stand before the works of Leonardo stupefied; their stunned reactions are best characterized as jaw-dropping reverence to works like his *Last Supper*. Mary Shelley, author of *Frankenstein* and wife of poet Percy Bysshe Shelley, offered this assessment:

> First we visited the fading inimitable fresco of Leonardo da Vinci. How vain are copies! Not in one, nor in any print, did I ever see the slightest approach to the expression in our Saviour's face, such as in the original. Majesty and love—these are the words that would describe it—joined to an absence of all guile that expresses the divine nature more visibly than I ever saw it in any other picture.[3]

There have been countervoices, however; not everyone has been so enamored of Leonardo's masterwork. When Mark Twain visited Milan and cataloged his 1869 adventures in *Innocents Abroad* he immediately took note of Leonardo's vast *Last Supper* and commented:

The world seems to have become settled in the belief, long ago, that it is not possible for human genius to outdo this creation of da Vinci's. I suppose painters will go on copying it as long as any of the original is left visible to the eye. There were a dozen easels in the room, and as many artists transferring the great picture to their canvases. Fifty proofs of steel engravings and lithographs were scattered around, too. And as usual, I could not help noticing how superior the copies were to the original, that is, to my inexperienced eye. Wherever you find a Raphael, a Rubens, a Michelangelo, a Carracci, or a da Vinci (and we see them every day), you find artists copying them, and the copies are always the handsomest. Maybe the originals were handsome when they were new, but they are not now.[4]

Twain's unflattering eulogy over the dead Leonardo painting tells us, among other things, that even in its half-life, great works of art are sought after and critically analyzed by everyone from wisecracking Americans to professional tourists. Guidebooks from the early twentieth century echo Twain's thoughts, and are contrary to Shelley's:

I cannot honestly advise you to spend a very long time in the Refectory, as there is so little to be seen of Leonardo's work, that beyond an impression of emotion and beauty you have little to gain.[5]

It is in part through the words of great writers like Twain and Shelley that works we today call masterpieces have achieved their renown, even if some writers have been so unimpressed by these works that they have tried to verbally tip them from their pedestals.

Some of the earliest writings that have come down to us are by authors who have journeyed great distances to marvel at human accomplishments. The ancient Greeks went to see the Pyramids; the Romans admired the Parthenon; medieval Christians visited holy shrines. Those so committed devoted a large portion of their limited life spans to travel vast distances in the hope of seeing or touching a revered object of outstanding human creativity (e.g., many a sacred relic has been fashioned inside an elaborate reliquary and displayed in some vast cathedral complex commanding the pilgrimages of religious devotees). Take for instance the life-size sculpture of Saint Peter by Arnolfo di Cambio in the main aisle of Saint Peter's Basilica in Rome, dated around 1300. So many adoring pilgrims have touched, even caressed, its feet that they have all but been worn away. Even in the modern secular world, visitors are still amazed by these marvels: the Pyramids still evoke wonder, Greek sculptures still symbolize classical beauty, and medieval cathedrals still inspire religious awe.

The Greek historian Plutarch was among the first to write vivid accounts of artistic monuments. Plutarch understood that a great work of art speaks not only about the people and the society that create it, but also about the messages that society communicates through such works—not only to viewers of the time, but also to future unknown audiences.

Plutarch's account of the Parthenon in Athens, placed amid a glowing biography of Pericles, discusses why it has become a standard of excellence.

These buildings were of immense size, and unequalled in beauty and grace, as the workmen endeavoured to make the execution surpass the design in beauty; but what was most remarkable was the speed with which they were built. All these edifices, each of which one would have thought, it would have taken many generations to complete, were all finished during the most brilliant period of one man's administration. . . . And this makes Pericles's work all the more wonderful, because it was built in a short time, and yet has lasted for ages. In beauty each of them at once appeared venerable as soon as it was built; but even at the present day the work looks as fresh as ever, for they bloom with an eternal freshness which defies time, and seems to make the work instinct with an unfading spirit of youth.

The overseer and manager of the whole was Pheidias, although there were other excellent architects and workmen, such as Kallikrates and Iktinus, who built the Parthenon on the site of the old Hekatompedon, which had been destroyed by the Persians.[6]

By the time Plutarch wrote this passage the Parthenon was five hundred years old, which means that its reputation had already withstood the test of time. Today no one doubts that the ruins on the Acropolis, including the Elgin Marbles, the sculptures once held within the Parthenon, are some of the great achievements in human history. Armies of tourists have ascended to the Acropolis complex in Athens and have visited the Elgin Marbles in the British Museum in London, seeing for themselves some of the most noble vestiges of Greek classical society.

Because the excellence of the Parthenon has been universally recognized, the Greeks in the modern era have been campaigning to get the Elgin Marbles back from the British government. Conversely, the Greeks have not been fighting to get back thousands of miscellaneous, little-known sculptures cast about in collections around the world.

There certainly has been no fight over a large, possibly ancient, seven-foot sculpture of a young man in the J. Paul Getty Museum in Malibu, California, called the *Getty Kouros* (*kouros* being the ancient Greek word for a male youth). If real, it would be only one of seven complete kouros statues in the world. The authenticity of the work has been called seriously into question, however, and the museum label on the statue's base now reads "Greek, about 530 B.C., or modern forgery." The Greeks are not fighting for the return of this dubiously authentic sculpture; perhaps they would not even be interested in a voluntary return.

The authenticity battle among Greek experts has raised the profile of the *Getty Kouros*, but ultimately fame will elude a work whose genuineness has been tarnished by doubt. Once a work is labeled a fake, or a possible fake, or even a workshop copy, the luster diminishes so greatly that most museums, except apparently the Getty, remove them from view to avoid shame.

Genuineness and originality are keys to a work's success and fame. In a digital age in which the computer has brought images instantly to our iPaded and Kindled fingertips, the aura of standing before the actual work of art still mesmerizes. One American tourist loudly proclaimed in the Louvre, "Now I can say I've been to Paris. I have seen the *Mona Lisa*." Clearly no virtual image will do, even if seeing the original is hampered by the modern realities of bulletproof glass and armies of camera-toting paparazzi.

~

Sometimes an artist's biography adds another layer of fascination onto the painting's fortunes. Everything by Vincent van Gogh will stimulate interest, and will sell for premium prices, in part because of his intriguing life story. Works by equally fine, but lesser known, artists may suffer from lack of name recognition because these artists led more pedestrian lives.

Colorful biographies lead writers, who always enjoy a good story, to spin seductive true-life histories into a larger-than-life novels. Irving Stone's biography of Michelangelo, *The Agony and the Ecstasy*, and the subsequent movie based on the book, turned the artist's life into a vague series of historical patches stitched together to make an embroidery that can only be described as creative writing. Almost everything about the movie is untrue, especially the scenes in which Michelangelo has a near love affair with the daughter of a Medici prince, which is wrong on many levels. Michelangelo was most likely a homosexual, was extremely awkward socially both with friends and patrons, and would never have considered any relationship with the Medicis. Add this to the casting of Rex Harrison as Pope Julius II, and you have all the makings of campy classic, if it weren't also so boring.

Van Gogh's treatment at the hands of the same author in *Lust for Life* has created another popular fiction around an artist; we now choose to see him as tormented and obsessed, a self-mutilating manic depressive, fascinating as much for the psychological content of his works as for the very painterly virtues that should command at least equal attention. His paintings have been placed on the psychoanalyst's couch no less than on the walls of museums and private collections. We live in an age in which the public likes to uncover the secret details of a person's life, even when that person has been dead for more than a century—or, for that matter, many centuries. *The Starry Night* at times seems more like an exercise in psychoanalysis than a brilliant landscape of the French countryside. The public has an undying fascination with Van Gogh's seemingly ever-evolving biography.

Van Gogh has been treated as something of a hometown hero in the various places he has lived: Arles, St. Remy, and most especially Amsterdam, which built a museum in his honor down the street from the hallowed Rijksmuseum—the building that contains the cream of Dutch baroque painting. This is not unusual. Cities have often taken great pride in local artists who have lived there, even if not by choice. Michelangelo was virtually imprisoned in Florence for a time while working on the Medici tombs. None of this has stopped Florence from celebrating his work at every turn. Santa Fe, New Mexico, did nothing to build its reputation as the home of Georgia O'Keeffe until well after her death when they belatedly set about gathering a small collection of paintings in a four-room museum just for the tourist trade.

Not every city has been so dispassionate about famous artists. Today, municipalities have pursued artists like Christo to produce a mass public attraction so that tourists will travel to see it. Christo's reputation for creating enormous works in spectacular open settings makes him the unofficial artistic representative for chambers of commerce worldwide.

In the medieval town of Modena, Italy, a twelfth-century sculptor named Wiligelmo must have achieved enormous success in his own time. He carved a series of relief sculptures on the façade of the cathedral, and below one of them it is proudly inscribed, "Among sculptors, your work shines forth, Wiligelmo. How greatly you are worthy of honors." Ironically, today Wiligelmo is known only to medieval art historians; the general public has not seen his works "shine forth" "among sculptors."

Like Wiligelmo, many artists and single works of art have fallen from favor in this way, or sometimes just become the bailiwick of experts. The *Apollo Belvedere* has suffered the greatest fall from grace any work of art has ever endured. Once thought to be the very paradigm of Greco-Roman sculptural excellence, by no less than Michelangelo, Raphael, and Dürer, it now knows little more than neglect. What do we think we know that the artistic giants of the past did not?

In England, the most widely read travel writer of the nineteenth century was Bayard Taylor, the peripatetic guidebook author of the 1846 best seller *Views A-Foot: Europe Seen with a Knapsack and Staff*. He recorded his sincere, if overly zealous, observations about works of art for the traveling public. His account of the *Apollo Belvedere* is beyond enthusiasm:

> I absolutely trembled on approaching the cabinet of the Apollo, I had built up in fancy a glorious ideal, drawn from all that bards have sung or artists have rhapsodized about its divine beauty. I feared disappointment—I dreaded to have my ideal displaced and my faith in the power of human genius overthrown by a form less than perfect. However, with a feeling of desperate excitement, I entered and looked upon it.
>
> Now what shall I say of it? How make you comprehend its immortal beauty? To what shall I liken its glorious perfection of form, or the fire that imbues the cold marble with the soul of a god? Not with sculpture, for it stands alone and above all other works of art—nor with men, for it has a majesty more than human. I gazed on it, lost in wonder and joy—joy that I could, at last, take into my mind a faultless ideal of godlike, exalted manhood. The figure appears actually to possess a spirit, and I looked on it, not as on a piece of marble, but a being of loftier mould, and half expected to see him step forward when the arrow had reached its mark. I would give worlds to feel one moment the sculptor's mental triumph when his work was completed; that one exulting thrill must have repaid him for every ill he might have suffered on earth! With what divine inspiration has he wrought its faultless lines! There is a spirit in every limb which mere toil could not have given. It must have been caught in those lofty moments.[7]

You could almost see a Victorian audience being swept away by Bayard's rhapsodic prose, perhaps even being stimulated to pack for a journey to Rome to see the crowning cultural treasure of a lifetime. Today, guides at the Vatican pass by the work en route to the Sistine Chapel without so much as a passing glance, if that.

On the other hand, the fickle flame of fame can sometimes burn hotly only after first being snuffed out; the artistic reputations of artists like Sandro Botticelli and El Greco, both famous in their own lifetimes, had their fame sink instantly when they died. For over two hundred years after their respective deaths, their

neglect might have made Wiligelmo look world famous; eighteenth-century guide-books make no mention of either artist. Botticelli, now seen as a premier exponent of Renaissance linear form, had his work consigned to the oblivion as the painter of identified portraits, and his Sistine Chapel fresco had been overshadowed by the effulgence of Michelangelo. El Greco, disdained in his own time for flouting the baroque tradition then at its heyday, was found too eccentric, nigh contemptible, for his age, with his bizarre and complex iconography deemed incomprehensible throughout his lifetime and for centuries after. Nevertheless, in the nineteenth century both their reputations slowly revived, and their major works, like Botticelli's *The Birth of Venus* and El Greco's *The Burial of Count Orgaz*, now have been given their proper place in the pantheon of masterpieces.

Occasionally, a work becomes famous almost immediately upon its unveiling because of its superior artistic qualities, overruling in the eyes of its appreciators all that has come before. A good example is Michelangelo's *David*, which was commented on by the sixteenth-century biographer and artist Giorgio Vasari:

> The work fully completed, Michelangnolo [*sic*] gave it to view, and truly may we affirm that this Statue surpasses all others whether ancient or modern, Greek or Latin; neither the Marforio at Rome, the Tiber and the Nile in the Belvedere, nor the Giants of Monte Cavallo, can be compared with it, to such perfection of beauty and excellence did our artist bring his work. The outline of the lower limbs is most beautiful. The connexion of each limb with the trunk is faultless, and the spirit of the whole form is divine: never since has there been produced so fine an attitude, so perfect a grace, such beauty of head, feet and hands' every part is replete with excellence; nor is so much harmony and admirable art to be found in any other work.[8]

Vasari's assessment of Michelangelo was as correct as Plutarch's about the Parthenon. Like the *David*, some works of art have become instant hits, like Edvard Munch's *The Scream* or Grant Wood's *American Gothic*. In the case of *American Gothic* fame has come with a mixed critical reception, and so the painting has established a popular reputation without the blessings of the art history establishment. Nowadays, neither painting could have a more iconic status in American culture. Indeed, these two works have been parodied endlessly, shuffled and altered and injected into every media form and outlet. Such is true recognition—the parody implies you must *at least* know the source for it to work. To quote the nineteenth-century Englishman Charles Caleb Colton, "Imitation is the sincerest [form of] flattery."

Both *The Scream* and *American Gothic* gathered attention at their unveiling in part because the artists were presenting something new, even if they relied for inspiration on sources in the past. There has been no shortage of screamers in art history, nor double portraits of a man and a woman; it is the artists' unusual take on the familiar that has created great interest.

The list of avant-garde works that have been inspired by episodes from the past is long—even longer if one includes the Bible as both religion and history.

In a conventional sense, paintings such as *Washington Crossing the Delaware* and *Guernica* were used not only to capture a great historical moment, adding a certain gravitas to the scene, but also to express a political point of view. In such paintings,

the artist may be declaring allegiance to Washington and the colonists; or as in *Guernica*, to the Spanish Republic. However, once reproductions of *Washington Crossing the Delaware* and *Guernica* were disseminated, the images gradually took on different meanings as they were enshrined in grammar-school classrooms, government offices, and private homes.

Nevertheless, not every historical moment has spawned a great work of art. There has been nothing of any significance spun off from the moon landings or from the battlefields of Iraq or Afghanistan—at least, not yet. *Washington Crossing the Delaware* was created seventy-five years after the event by people who could never have been there, but it gives the illusion of putting the viewer on the scene. Perhaps it is not too much to believe that in seventy-five years a great work could do the same thing for a moon landing.

Talented artists use their imagination to re-create a scene, and if that won't do, they find a location in which their works cannot be ignored. Dramatic locations can propel an artistically less significant object to stardom. The enormous 1931 art deco statue of *Christ the Redeemer* sits atop Mount Corcovado in Rio de Janeiro, Brazil, and is visible from nearly every corner of that city. Its dramatic location and awesome presence has made it the very symbol of Brazil.

Similarly, the Statue of Liberty commands respect not just for its symbolism or its artistic merit, but also due to its placement in New York Harbor. Even the *Little Mermaid*, a Danish sculpture just offshore in Copenhagen harbor, has become a symbol of the city because of her location. This is a work that would have been ignored in a city street; in the harbor it becomes a photo opportunity.

The Great Sphinx sits in the Giza Plateau of Egypt, among the prism-like Pyramids, calling for our attention. This great human face on a lion's body adds a touch of humanity to the geometric pile of ruins behind it. Conversely, the *Nike of Samothrace*'s original setting amid now miscellaneous ruins on a Greek island is just a shell today, but the impressive staging of the work above a stately and centralized flight of stairs at the Louvre has helped seal the sculpture's reputation as a great work of art.

Even the Vietnam Veterans Memorial in Washington, D.C., hunkering down into a deep hollow in the ground, relies on its fame in part because it sits squarely on the tourist road map between the Washington Monument and the Lincoln Memorial.

Sometimes hidden locations are the key to a work's attraction. Few sciences have the romance archaeology possesses. Spectacular finds enhance our interest in what gold or gems could be lying below. In 2009 an amateur treasure hunter with a metal detector discovered the largest hoard of Anglo-Saxon gold and silverwork in a field in Staffordshire, England. It was the greatest archaeological discovery in that country's history. One English newspaper reported, "A harvest of Anglo-Saxon gold and silver so beautiful it brought tears to the eyes of one expert, has poured out of a Staffordshire field—the largest hoard of gold from the period ever found."[9] Such recent discoveries make archaeologists eager to pursue their work, knowing there must still be vast untapped resources beneath the ground or under the sea.

The number of archaeological discoveries has been dramatic even if only the twentieth century is considered. In 1974 local farmers discovered the massive tomb of Emperor Shi Huangdi in China, which ultimately revealed a series of chambers

so vast that they contained eight thousand life-size male figures in combat poses—the Terracotta Army.

The prehistoric Chauvet Cave in France, filled with exciting depictions of horses and reindeer made thousands of years before those of Lascaux, was discovered in 1994 by spelunking enthusiasts, who had no idea what was before them. The cave and its contents have now become the focus of the famed documentarian Werner Herzog, whose *Cave of Forgotten Dreams* examines the cave paintings as quintessential expressions of humanity at its earliest stages of consciousness.

No archaeological discovery, however, can match the majesty of the Tutankhamun find in 1922. Every archaeologist thereafter has yearned to have Howard Carter's luck, as well as his diligence and resources, to claim the biggest prize in archaeology. And no country has exported its archaeology more triumphantly than has Egypt, making sure its relics are seen in the largest venues in the world. More than most, Egypt has lured tourists to see attractions that are thousands of years old—and almost nothing else besides.

Carter wrote a best-selling book explaining how he unearthed Tutankhamun—not that he needed to do this in order to secure his place in the archaeological firmament. However, this book does illustrate a common trend: almost all famous people eventually publish a book giving a personal account of their version of things—just think of American presidents and their memoirs (even if they prove readable today only by their political bases).

Leonardo da Vinci did not detail his life in an autobiography—perhaps fortunately. Imagine a chapter entitled "How I Met and Painted Mona Lisa," and what that would do to Leonardo scholarship. He let his notebook papers do the talking for him—thousands of pages of notations, sketches, and scientific theories—all telling his biography in a less conventional, but no less real, way.

Other writers have stepped in to fill the void left by Leonardo, waxing poetic about the *Mona Lisa*. Walter Pater, one of the greatest of Victorian writers, wrote this landmark assessment of the *Mona Lisa* in 1873:

> The presence that rose thus so strangely beside the waters, is expressive of what in the ways of a thousand years men had come to desire. Hers is the head upon which all "the ends of the world are come," and the eyelids are a little weary. It is a beauty wrought out from within upon the flesh, the deposit, little cell by cell, of strange thoughts and fantastic reveries and exquisite passions.[10]

Of course the *Mona Lisa* didn't need Walter Pater's vivid analogies to become famous, but his evocative descriptions do add the blessings of a renowned art historian to what the ordinary visitor already feels.

Such is also the case with the *Sistine Madonna* by Raphael, which probably enjoys as strong a literary heritage as any other painting in history, having received notable mention in works by George Eliot, Leo Tolstoy, and Fyodor Dostoyevsky, to name just a few. As with the *Mona Lisa*, writers and artists have been drawn to Raphael's *Madonna* because of the intensity of her gaze, as she looks out seemingly with a mixture of inquiry, uncertainty, and maternal protection that has perplexed viewers for centuries.

Early travel guides to Germany describe the painting in incredibly glowing terms:

The radiant magnificence of *Raphael's* Sistine Madonna, in which the most tender beauty is coupled with the charm of the mysterious vision, will forcibly strike every susceptible beholder, and the longer he gazes, the more enthusiastic will be his delight.[11]

Bayard Taylor was even more enthusiastic:

I have just taken a last look at the gallery this morning, and left it with real regret; for, during the two visits, Raphael's heavenly picture of the Madonna and child had so grown into my love and admiration, that it was painful to think I should never see it again. . . . I can see the inspired eye and god-like brow of the Jesus-child, as if I were still standing before the picture, and the sweet, holy countenance of the Madonna still looks upon me. . . . The figure of the virgin seemed to soar in the air, and it was difficult to think the clouds were not in motion. An aerial lightness clothes her form, and it is perfectly natural for such a figure to stand among the clouds. Two divine cherubs look up from below, and in her arms sits the sacred child. Those two faces beam from the picture like those of angels. The wild, prophetic eye and lofty brow of the young Jesus chains one like a spell. There is something more than mortal in its expression—something in the infant face which indicates a power mightier than the proudest manhood. There is no glory around the head; but the spirit which shines from those features, marks his divinity. In the sweet face of the mother there speaks a sorrowful foreboding mixed with its tenderness, as if she knew the world into which the Saviour was born, and foresaw the path in which he was to tread. It is a picture which one can scarce look upon without tears.[12]

Perhaps crying before a work of art may seem bathetic today; we live in an age in which, if people do cry over paintings, they certainly do not write about it anywhere. This was not always the case. In the Oscar Wilde 1891 classic *The Picture of Dorian Gray*, Dorian is confronted with his portrait for the first time:

As he thought of it, a sharp pang of pain struck through him like a knife and made each delicate fibre of his nature quiver. His eyes deepened into amethyst, and across them came a mist of tears. He felt as if a hand of ice had been laid upon his heart.

"Don't you like it?" cried Hallward at last, stung a little by the lad's silence, not understanding what it meant.

"Of course he likes it," said Lord Henry. "Who wouldn't like it? It is one of the greatest things in modern art."[13]

Some patrons or buyers have perhaps not cried over a work of art, but over its price. Auctions can reduce potential buyers to tears; perhaps they cannot afford that important work that defines the soul but not the wallet. Paintings have become famous because of circumstances surrounding their sale. The public perhaps snickers in disbelief when the price of a painting reaches historic highs. Nevertheless, the painting becomes more famous because of the price, and the price encourages the idea that we are now looking at a masterpiece: Why else would it be worth so much?

Rarity has something to do with it. For example, the world's most expensive postage stamp, a Swedish misprint from 1855 printed on the wrong color paper, went for sale in 1996 for $2.3 million and was resold for at least that much in 2010. There is only one such stamp like this in the world, and that has everything to do with the wild price paid for it.

Few people would put a postage stamp in the same league as a Rembrandt, and therefore there was not much publicity surrounding the sale of this Swedish anomaly. How much more interest would there be in the sale of the "million-dollar Rembrandt" in 1961, namely, his *Aristotle Contemplating a Bust of Homer?* When the auctioneer began the bidding at one million dollars, the painting had already broken records and instantly leapt to fame. Today, millions are simply the starting point for great works of art—and stamps for that matter, but in the 1960s they were incredible sums thought wisely spent on the few great masterpieces left to buy.

When patrons have the money, but not a specific artist in mind, they hold a contest to find the best product. Artistic contests are more common than the general public thinks. The most famous contest in art history took place in 1401 in Florence, Italy. Two finalists, Lorenzo Ghiberti and Filippo Brunelleschi, competed for the right to carve a set of doors on Florence Cathedral Baptistery. Both contestants did the same scene from the Bible, the sacrifice of Isaac, and showed the results in the city square for all to see. It took months for the jury to decide, and finally they gave Ghiberti the commission. This was no small commission. Work on these bronze doors was to take twenty years—that's twenty years of full employment to an artist. In part, that's why the competition was so fierce. Brunelleschi, the loser, swore he would never sculpt again, and turned his attention to architecture. Ghiberti was not only successful, but he was commissioned immediately thereafter to do another set of doors, also in bronze, for the same building. These were so rapturously greeted that a generation later Michelangelo said they were fit to stand at the gates of paradise, and that name has stuck ever since.

Many architectural monuments have been the products of frenzied international contests, like the Chicago Tribune Building and the Sydney Opera House. Even buildings as famous as London's Houses of Parliament were chosen as a result of a contest with many entrants.

In the United States there have been many artistic contests, the most heated being over the building of a memorial to America's involvement in Vietnam. Part of the controversy lay with the war itself, an enormous point of contention within the American consciousness. Any effort to memorialize such a deeply divisive moment in history was undoubtedly going to bring about acrimony. However, the earnestness of the rejection of the monument in some quarters made the memorial instantly a hit, and caused many to maintain an interest in what would otherwise have been just another stone monument in a city filled with such monuments.

Contests produce winners who go on to make their fortune, at least temporarily, but contests also produce losers, who can become famous—sometimes eventually supplanting the winner in reputation. *American Gothic* did not win first prize when first unveiled, but the winner has been unceremoniously packaged off onto a dusty curatorial shelf in the back of a museum someplace.

Sometimes a whole work becomes overshadowed by an excerpt. For example, most people have heard the line "All the world's a stage and all the men and women are merely players," and most people can tell you its author is Shakespeare, but what play is it from? The line has become more recognizable than the source, as is true with many excerpts. It turns out that *As You Like It* is a charming Shakespearean comedy that is performed occasionally, but does not receive the kind of recognition his major works receive.

Actress Bette Davis made many lines famous in her movies. In one movie, walking down a flight of stairs and looking into her living room, she murmured, "What a dump!" That line was later picked up as the opening line in Edward Albee's *Who's Afraid of Virginia Woolf?* Indeed, everyone knows the line, but what movie *is* it from? So famous a line, one suspects, should come from a famous source; but actually, it is from a little-known picture called *Beyond the Forest.* You will have to search far and wide to find a copy of that movie today, and you would be unrewarded for your efforts should you actually watch it.

In the art world the excerpt sometimes reigns supreme. Michelangelo's *Moses* is surrounded by the tomb of Pope Julius II, but for all anyone who actually visits the monument is concerned, the sculpture might as well be sitting by itself.

The beautiful cherubs at the base of the *Sistine Madonna* have overtaken the entire painting in its popularity, and are now available as calendar art, refrigerator magnets, and throw pillows.

Rodin's *Thinker* has been excerpted from the original *Gates of Hell*, but in this case it is the artist who did the excerpting, perhaps sensing that *The Thinker* did not need its surroundings to be completely understood. Rodin's excerpt, however, was placed in a square before the Pantheon in Paris and soon became a rallying point for extremists who felt they were great thinkers in their own right. The work was eventually moved to a less accessible inner courtyard of the Rodin Museum, far from the frenzy that characterizes French politics, for nothing succeeds like notoriety, or preferably a good scandal.

Modern artists depend on the occasional shock value to achieve recognition in the face of severe competition. Think Jackson Pollock, Pablo Picasso, or any of the fauve painters from the early twentieth century who relished the idea that they were labeled "wild beasts." Even in the past, artists like Caravaggio relied on both the enlightened patron and the horrified public for publicity. Caravaggio shocked his patrons in the Church of San Luigi dei Francesi with his erotic portrait of *Saint Matthew and the Angel.* Rejected, the painting was taken down and replaced by a much tamer version of the same subject. The rejected painting began a curious career of being a hot property and therefore traded with great enthusiasm around Europe. It ended up in a museum in Germany and during World War II it disappeared, presumably destroyed in an air raid attack.

Édouard Manet, for all intents and purposes a respectable middle-class Frenchman, was propelled into the spotlight when his painting *Luncheon on the Grass* was not only rejected from the all-powerful official Salon, but placed in a separate setting called the Salon of the Rejected, and then ridiculed by the press. Manet not only recovered, but he became a hero for all avant-garde artists since, and played up the rejection for all it was worth.

Manet was not alone in benefiting from the power to shock. Most famously, Igor Stravinsky later reinterpreted the opening night riot at his 1913 Ballets Russes production of *The Rite of Spring* as a bourgeois condemnation of his cutting-edge music. Recent scholarly research has revealed that the disturbances were more about the choreography and social issues of the time than any of the music Stravinsky wrote, much of which was unheard at the concert anyway.[14] Stravinsky, however, formulated an enduring myth of the misunderstood genius, living far ahead of his time, and then reaped the benefits of the riotous opening.

Both he and Manet achieved what George Bernard Shaw called in 1896 a "*succès de scandale.*" Looking at the Manet or listening to the Stravinsky today, one wonders what the fuss was all about. Creating a stir may be an avenue to fame, and in some cases the public consciousness parks itself permanently before the object and never stops admiring it. In other cases, the fame that seems so eternal flickers only momentarily and then passes from view, as the public moves on to the next thing.

The aim of this book is not to choose *the* most famous works of art and explain how they got that way, but to analyze different paths to (and from) fame for each. Each of the works highlighted here has become famous in a different way, sometimes for a number of reasons. Each has a fascinating pedigree that calls us to different explorations of the fickle nature of fame, and its impact on the general consciousness. Why do certain works of art sustain or lose their fame? Become chucked or embraced? Be heralded for eternity, or flagged for immediate dismissal, only to float in the trash heap of the misbegotten forgotten, but then resurface to plaudits and near-universal acclaim? These are the central questions and preoccupations of this book.

The Great Sphinx

Beyond Human Understanding

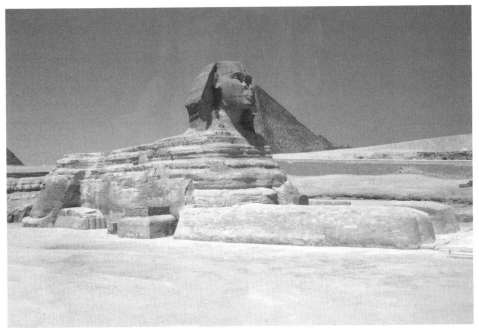

The Great Sphinx. *Pavle Marjanovic / Dreamstime*

The Sphinx is drowsy
Her wings are furled:
Her ear is heavy,
She broods on the world.

—Ralph Waldo Emerson, "The Sphinx"

*N*apoleon never wasted an opportunity, especially one that was to bring him glory. When he invaded Egypt in 1798, his prize was not just Egypt as a pivotal strategic center of the Middle East. He was also after the Egypt of the pharaohs, the Egypt conquered by Greek and Roman emperors before him, and his prize was to bask in the reflected glory that the Pyramids and the Sphinx represented.

Napoleon amassed no ordinary invasion. True, there were grenadiers, infantry, and cavalry, but there was also a flotilla of artists and architects, zoologists and botanists, archaeologists and mathematicians, astronomers and engineers: 167 specialists in all. Why would Napoleon carry this regiment of scholars to battle in the desert? What could be gained from such an invasion of French academics into this embattled region?

Napoleon was not interested in discovering the hidden scientific and artistic achievements of an antique land, he was interested in what these discoveries could do for him. Therefore, he ordered all kinds of scholarly activity to take place. Naturalist Geoffroy Saint-Hilaire was told to collect fish from the Nile—boatloads full—and have them sent back to France for analysis. Chemist Jacques Conte was ordered to find a mineral useful as a writing material, and invented a mixture of graphite and clay, which we today call pencil lead.

Artist and writer Dominique Vivant was sent to Giza to sketch the monuments of ancient Egypt, sometimes under gunfire. He published in 1802 the *Journey to Upper and Lower Egypt*, the book that made the Egyptian monuments known to European readers.

Vivant left behind the definitive account of the Great Sphinx that summed up the current penchant for proportion and balance:

> I had only time to view the Sphinx, which deserves to be drawn with a more scrupulous attention that has ever yet been bestowed upon it. Though its proportions are colossal, the outline is pure and graceful: the expression of the head is mild, gracious, and tranquil; the character is African; but the mouth, the lips of which are thick, has a softness and delicacy of execution truly admirable; it seems real life and flesh. Art must have been at a high pitch when this monument was executed; for, if the head wants what is called *style* that is to say, the straight and bold lines which give expression to the figures under which the Greeks have disguised their deities, yet sufficient justice has been rendered to the fine simplicity and character of nature which is displayed in this figure.[1]

Not every large sculpture can elicit this response; in fact, many a huge monument goes completely unnoticed: the Pilgrim Monument in Plymouth, Massachusetts, the one-hundred-foot statue of the Duke of Sutherland in the Scottish Highlands, and a myriad of gigantic Buddha sculptures in Asia. Size isn't everything.

The Great Sphinx has more than just size; it mesmerizes the viewer with its direct stare and self-absorbed nature. There was no indication, however, that Napoleon was interested in the least in the seemingly eternal questions that the Sphinx raises, or in any of the achievements that the scholars in his expedition carried out. What would one expect from a leader who labeled a pivotal moment in the conflict "The Battle of the Pyramids," even though the Pyramids were nine miles away, and had nothing to do with the battle?

Napoleon may have been unmoved by the Sphinx's mysteries, but others have spent lifetimes trying to unravel its secrets. There are still heated debates over the meaning behind its expression, the rationale for placing the sculpture where it is, and whose face it depicts.

The Sphinx is both puzzling and startling in part because it is the oldest monumental sculpture anywhere in the world; there is nothing anywhere near its size done before it. Indeed, there were no colossal sculptures like this for another five hundred years anywhere around the world, let alone Egypt. Few sculptures have rivaled it in size and beauty; none can rival its age.

Resting on a high plateau at the end of a long causeway in Giza, the Great Sphinx is near the entrance to a series of pyramids, the three most famous such Pyramids in Egypt, indeed, the very buildings that symbolize the country in the popular imagination. Given that we know that the Pyramids were gigantic tombs used to house the bodies of dead pharaohs, it is natural to believe that the Sphinx must have been a funerary monument, too.

Originally the Sphinx probably had a dual function. It represents the dead pharaoh, most likely Khafre who reigned in the middle of the third millennium BC and who commissioned the construction of one of the three Pyramids at Giza. However, the dead pharaoh was considered by the Egyptians to be immortal, persisting beyond the time and space of his mortal life. In a sense, Khafre is still alive, or, at least, his memory lives on in the Sphinx, a monumental reminder of the pharaoh's everlasting nature. As one scholar put it, the Sphinx is "a living symbol of the birth of the pharaoh and his time on earth."[2]

The Sphinx was carved around 2500 BC during a period of Egyptian history called the Old Kingdom. This makes the Sphinx very old, even for Egyptian works. It was made over a thousand years before the Tomb of Tutankhamun, and over 2,500 years before Queen Cleopatra reigned. Even to Tutankhamun and Cleopatra, then, the Pyramids and the Sphinx were ancient.

One of the many enigmas surrounding the Sphinx is the question of how it was carved. The Egyptians possessed bronze tools that were soft and easily damaged when used against a hard limestone surface such as that of the Sphinx. Copper chisels last about five strokes against limestone before they bend and have to be replaced.

Nature, however, probably gave the Egyptians some help. Someone, perhaps an unrecorded foreman, must have noticed that this outcropping of limestone resembled a lion.[3] After all, people throughout history have often seen faces in geological

features, like the now collapsed Old Man in the Mountain in New Hampshire. This natural formation was then transformed into a sphinx partly by carving and partly by clearing around the base to expose more of the rock. The debris removed from the base was used to fill the interior of a nearby pyramid under construction.

The end product of this carving is a huge 240-foot-long sculpture of a recumbent figure, part man, part lion, towering sixty-six feet above its base. Its tail curves around its right hind leg in a manner that cat owners today would never see. Its front paws symmetrically frame the head as its eyes stare not straight ahead so much as above the viewer. Its face, once painted bright red with perhaps gazelle's blood[4] stands out from the desert wastes below, and must have worked its magic on all believing Egyptians. It still cultivates a romantic image in our own modern imagination as well.

Egyptian sphinxes come in a number of variations, but all stress the connection between pharaoh and lion. For example, some Egyptian sphinxes have lion heads, some lion manes, some feminine bodies, but no lion faces. Lions were no rarities in ancient Egypt—in fact, they were so numerous that they were pests. They were respected as beasts, but they also menaced livestock and attacked people. The Egyptians were the first, and certainly not the last, civilization to utilize the lion as a symbol in the pantheon of their gods. Some Egyptian gods, like Sekhmet, had a lion's head on the body of a woman. She is depicted as a warrior, the fiercest of all hunting gods, and the protector of the pharaoh in battle. Fifteen centuries after the building of the Sphinx, the lion symbolism endures; they were still being hunted in royal expeditions both in Egypt and in the ancient Near East.

It is not often realized that among all the sphinxes Egypt has produced, this sphinx, the Great Sphinx, is by far the largest and the first, perhaps the largest royal portrait ever made.[5] Many are struck by the long line of sphinx images that have spun off the original.

The ultimate compliment to the Great Sphinx was created in the New Kingdom: The complex of temples between Karnak and Luxor were "guarded" by no fewer than one thousand sphinxes, called the Avenue of the Sphinxes. Each sphinx is ten feet long and four feet high, and is spaced thirteen feet apart. Long and low they stretch miles into the distance, studying the scene before them, even today, with their vacant countenances.

Under Queen Hatshepsut the sphinxes had a more feminine appearance with slightly rounded breasts and sleeker forms. Under Amenemhet III the Sphinx appears more leonine with heavier manes and greater claws. At times sphinxes were grouped in pairs; alternatively, they lined royal avenues. Later when stronger contacts were established with the Near East, Egyptian sphinxes took on a more Mesopotamian look, the bodies combining other animal forms like bulls or horses.

There is a fanciful tale, which may have had a basis in fact, that the Sphinx was visited around 1400 BC by an Egyptian prince name Thutmose. Thutmose, it is said, fell asleep between the paws of the Sphinx and dreamed that the giant face spoke to him. The Sphinx complained wearily of the suffocating desert sands and its weather-battered body. If only some hero could deliver it from this state, the rewards would be everything a young prince could imagine. According to legend, the Sphinx implored Thutmose in words engraved on a pink granite stele placed before the Sphinx:

I shall give you the kingship on earth, in front of all the living ones. You shall wear the White and the Red Crowns [i.e., the crowns of upper and lower Egypt] upon the throne of Geb, the hereditary prince. The earth shall be yours in its length and width, (everything) that the Eye of the Lord-of-All illuminates. The food of the Two Lands shall be yours, (as well as) the great tributes of every foreign land, (your) lifetime will be a time, great in years. My face is yours, my heart is yours as you are a protector to me, for my (current) condition is like one that is in need, all my limbs (as if they were) dismembered as the sands of the desert upon which I lie have reached me. So run to me, to have that done which I desire, knowing that you are my son and my protector. Come forth, and I shall be with you, I shall be your leader.[6]

Thutmose apparently heard the cry of the Sphinx. As pharaoh, Thutmose made Sphinx worship a state-approved cult in New Kingdom Egypt, and commissioned a stele to be erected on the site where he experienced his dream vision. He also undertook the first known restoration of the sculpture.

Did Thutmose really have this dream? Or was this a cynical attempt to bestow kingship on a person who seized power and needed a historical construct to legitimize his authority? Many Egyptologists maintain that Thutmose was not, in fact, the crown prince, but someone who overwhelmed his brother, the legitimate heir to the throne. Nonetheless, other Egyptologists maintain that Thutmose was the legitimate occupant of the throne, and that this stele commemorates a genuine episode in the king's life.[7]

This so-called Dream Stele is still in situ, perched dramatically between the paws of the feet of the lion. The relief sculpture on the façade features the king making offerings to the Great Sphinx, with explanatory hieroglyphic writings below. It is here that the sculpture is referred to by name for the first time. He is Horemakhet, or Horus-on-the-Horizon,[8] not the Sphinx. Horus was the royal god of the sky, and the horizon was the Giza Plateau. From the earliest Egyptian writings, Horus is thought of as being at one with the pharaoh, and therefore he is divinely descendant. All this makes the connection between the Sphinx and the pharaoh more convincing.

The Sphinx's autocratic and aloof visage worked its magic on the young Thutmose the way it still holds a fascination for us centuries later. Vivid descriptions about the head have come down to us through the ages. The medieval historian and perhaps the first Egyptologist, Abdul Latif, writing in the late twelfth century, wondered in awe at the Sphinx's head:

The nicety of proportion in the nose, for example, the eyes, and the ears, the same proportion is remarked as is observed by nature in her works. Thus, the nose of a child is suitable to its stature, and proportioned to the rest of its frame, while if it belonged to the face of a full-grown man it would be reckoned a deformity. The nose of a grown man on the visage of a child would equally be a disfigurement . . . and where these proportions are not observed, the face is spoiled. Hence the wonder that in a face of such colossal size the sculpture should have been able to reserve the

exact proportion of every part, seeing that nature presented him with no model of a similar colossus or any at all comparable.[9]

Indeed, the head is unnervingly placed at close range. While no doubt tall, its body rests in a cavity that was dug into the earth. Therefore the Sphinx rises only about twenty-six feet above the desert floor, leaving only the head and neck above ground level. Perhaps for this reason, many have seen the monument as a direct threat. The Sufi iconoclast Saim-ed-Dahr defaced the monument in the eighth century. In 1380 Muslim zealots further vandalized the visage in a fit of religious fervor. Much later, probably in the eighteenth century, it was used as target practice by the Mamluks. Arab writers tell us that the Sphinx had fallen prey to iconoclasts who may have thought they were doing God's work by destroying the face.[10] The exact nature of each attack on the Sphinx is not known, but the end result is plain to see. Because of the mutilation, pieces of the Sphinx today are to be found in museums around the world: a fragment of the beard is in the British Museum, and miscellaneous ruins are in the Egyptian Museum in Cairo. The nose has never been found.

Of considerable interest are two flanking sculptures now in the Louvre that were discovered in 1816. In both scenes Ramses II is adoring a carved image of an enthroned sphinx on its pedestal. In both the king faces the Great Sphinx. On one relief the pharaoh holds a censer used to anoint the sphinx, and on the other he holds another censer but also raises an empty hand in adoration. The king wears the *nemes* headdress and the royal beard the same as the Sphinx himself, clearly equating the pharaoh with the sculpture. They were once attached to a small temple erected between the paws of the Sphinx and placed at right angles to the Dream Stele.

Legends, of course, circulate around the Sphinx. The earliest derivation of the word "sphinx" comes from the Greeks, whose culture flourished some fifteen hundred years after the Sphinx was made. The ancient Greek verb *sphingein* means "to squeeze." The connection between the word and the monument is pure speculation, if there ever really was a connection between the two. The Greeks had colorful names for a number of Egyptian monuments. Pyramid, for example, is a Greek word that derives from fire, "pyro," as used in "pyrotechnics" and "pyromania." Perhaps the word originally referred to the shape of campfire, or of a stack of grain or wheat, presumably arranged in a pyramid-like shape.[11] Obelisk is derived from the Greek οβελίσκος, meaning a "small spit" or "nail."[12]

It is not surprising, then, that the Greek derivation for the word is at variance with how we view the Sphinx today. The Greeks may have called composite ("squeezed together") winged figures from ancient Near Eastern art, "sphinxes," and then conflated these mythical creatures with their Egyptian counterpart. Greeks enjoyed composite creations and introduced the world to their own inventions like centaurs, Minotaur, and Pegasus.

In any case, the Greeks busily embraced the Sphinx persona, adding stories and powers to the figure. The Sphinx of legend terrorizes Thebes, holding the entire pop-

ulation in its grasp, and demanding a response to its riddle: "What has one voice, but has four feet in the morning, two in the afternoon and three in the evening?" Everyone who valiantly tried to respond to the Sphinx but failed was gobbled up.

Unlike its Egyptian counterpart, this Greek Sphinx created havoc; it was a sinister monster, and systematically devoured human victims. It also was portrayed with feminine characteristics, including pronounced breasts and a tiara. When Oedipus responded correctly to the riddle—man crawls on all fours in the morning of his life, rises and walks erect in the afternoon, and uses a cane in old age—the Sphinx reacted by killing herself. Thebes is thereby liberated from the terror. However, the reputation of the Sphinx, its characteristic inscrutability, mystery, and wisdom was only enhanced by the Greek legend.

There is evidence that in later times, when travelers wandered to Egypt hoping to see the Sphinx, they carried with them the Greek legends, and grafted the stories onto this monument. Few Egyptologists today, however, accept the theory that there is anything about the Sphinx that is inherently mysterious, secret, or omniscient, and it was probably never meant to be that way.[13]

Was the Sphinx always famous? If fame is measured by the number of tourists and writers who have waxed poetic before a work of art, then fame was late in coming.

The Greeks, it seems, had much to say about sphinxes, but almost nothing to say about this Sphinx. The Greek historian Herodotus, writing in the fifth century BC, discusses the Pyramids in great detail but does not even make passing mention of the Sphinx. It is not until the Roman author Pliny, writing in the first century AD, that some reference to the Sphinx is made:

> In Egypt too are the pyramids, which must be mentioned, if only cursorily. They rank as a superfluous and foolish display of wealth on the part of the kings, since it is generally recorded that their motive for building them was to avoid providing funds for their successors or for rivals who wished to plot against them, or else to keep the common folk occupied. . . .
>
> In front of them is the Sphinx, which deserves to be described even more than they, and yet the Egyptians have passed it over in silence. The inhabitants of the region regard it as a deity. They are of the opinion that a King Harmais is buried inside it and try to make out that it was brought to the spot: it is in fact carefully fashioned from the native rock. The face of the monstrous creature is painted with ruddle[14] as a sign of reverence.[15]

This is the first real appreciation of the Sphinx ever written, especially notable since it disparages the Pyramids. Pliny's appreciation tells us that the Sphinx had emerged from the relentless sands of the Sahara. His research could find no earlier written commentary, perhaps causing him to remark "the Egyptians have passed it over in silence." Perhaps that is the reason the Greeks also refrained from commentary.[16]

The desert has been cruel to the Sphinx, with sandstorms covering it up sometimes so forcefully that just the head surfaces above the deluge. In the Middle Ages the

site was alternately swallowed up or unmasked by shifting sands. Medieval chroniclers oftentimes mention the Sphinx, but only in the context of the Pyramids and only as a passing reference. Its lonely head has inspired Muslims to call the Sphinx "Abu'l Hol" or "father of terror."

International attention to the monument only grew when Napoleon invaded Egypt in 1798. The archaeologists who accompanied Napoleon's army not only did preliminary work investigating the site, but also helped themselves to more than a few of the artistic treasures that were scattered about, sending them home to fill the galleries of the Louvre.

As we have seen, Napoleon enjoyed associating himself with other great emperors, preferably dead ones from long ago. From ancient Rome he took the idea of a triumphal arch and turned it into the Arc de Triomphe—the very symbol of Paris. He tried to take Trajan's Column in Rome, but his experts told him that touching it would destroy it, so he built a modern version in Paris called the Vendôme Column. His court painter Jacques-Louis David copied Roman laurel wreaths and put them on some of his portraits.

In Giza in the summer of 1798, Napoleon stood before the monumental works of the Old Kingdom and reveled in the immortality they represented. He exhorted his troops: "Soldiers! From the height of these pyramids, forty centuries look down upon you!"[17] While the Sphinx was too big to bring home, its imagery could easily be rendered everywhere, both as an exotic ornament and as a reminder of Napoleon's expedition. Egyptian monumentality had its uses as well, and nothing that was useful was left untouched. One scholar pointed out that for Napoleon "there is nothing he ever wasted, except human lives."[18]

While in Egypt, Napoleon took time out to see the Pyramids and the Sphinx, the only ancient monuments he visited. He marveled at their grandeur, and it is reported that he stood mesmerized in the inner chambers of the Pyramids themselves. The French treated the ancient monuments with awe. His scholars brought back fascinating tales and objects from Egypt, most prominently the Rosetta Stone. In fact, Egyptology began as a serious study with this expedition. Napoleon's team of scholars wrote a twenty-two-volume work, the *Descriptions de L'Egypte*.

The native Egyptian population, naturally enough, was not happy. They invented all sorts of tales about Napoleon's occupation, including the lie that he ordered his soldiers to shoot the Sphinx's nose off. This story may have been a way for the defeated to disparage the conqueror, but—at least in this case—the legend of Napoleon's rapacity is unfounded. The record shows that the nose was already gone by the time Napoleon arrived in Egypt, in fact by hundreds of years. Even so, as recently as 1995, people like Louis Farrakhan, head of the Nation of Islam, proclaimed during the Million Man March held in Washington, D.C., that year: "White supremacy caused Napoleon to blow the nose off the Sphinx because it reminded [him] too much of the black man's majesty."[19]

Suddenly upon Napoleon's return from Egypt, the world became sphinx-happy. In the rich and influential salons of France, sphinx heads, sphinx wings, and sphinx tails became fashionable accessories on everything from armoires to wallpaper, and

became a feature of what became known as the "empire style." No longer an object of suspicion and terror, the Great Sphinx has been domesticated and transformed into an ornamental feature suitable for table legs and armrests.

Its decorative character did not limit the power of the Sphinx to generate mystery and a devoted following. The first modern tourists began to come to Egypt expecting to be mesmerized by the face, which was all that was visible.

The Greek tale of the riddle of the Sphinx was overlaid onto the much older Egyptian work, as if there had only ever been one sphinx, and this riddle then began to belong as much to Egypt as to Greece. Even in nineteenth-century America, when relatively few people traveled to Egypt or Greece, the myth and the monument held an irresistible attraction.

Ralph Waldo Emerson, the transcendentalist American essayist and poet, said that in the riddle of the Sphinx, "the perception of identity unites all things and explains one by another."[20] For the characteristically optimistic Emerson, the Sphinx, once understood, would bring harmony and meaning to the universe.

Novelist and poet Herman Melville, who had little patience for Emerson's "stuff," saw the Sphinx decidedly differently. In chapter 70 entitled "The Sphynx" of *Moby Dick*, Captain Ahab remarks that the head of the sperm whale "was a black and hooded head; and hanging there in the midst of so intense a calm, it seemed the Sphynx's in the desert."[21] All is foreboding and tense. Melville's Sphinx seeks no understanding, but is an adversary no human can hope to fathom. It taunts mortals with their feeble attempts to understand the deepest secrets of the universe.

In George Bernard Shaw's 1898 play *Caesar and Cleopatra*, Cleopatra's nurse, named Ftatateeta, exhorts:

> Listen to me, ye young men without understanding. Cleopatra fears me; but she fears the Romans more. There is but one power greater in her eyes than the wrath of the Queen's nurse and the cruelty of Caesar; and that is the power of the Sphinx that sits in the desert watching the way to the sea. What she would have it know, she tells into the ears of the sacred cats; and on her birthday she sacrifices to it and decks it with poppies. Go ye therefore into the desert and seek Cleopatra in the shadow of the Sphinx; and on your heads see to it that no harm comes to her.[22]

Whatever its original intention, the sculpture by this point had absorbed all the myths that had come after it, and has become one with its subsequent legends.

Even the word "sphinx" has taken on connotations associated with objects or questions of an inscrutable nature. In works as early as Ben Jonson's 1605 play *Sejanus: His Fall*, the character Lucius Arruntius says about a puzzling situation, "By Jove, I am not Oedipus enough to understand this Sphinx."[23] John Speed, England's great early cartographer, remarked about a perplexing situation, "The Sphinx who is said to be the Author of this ambiguous Riddle . . . was Adam de Torleton."[24]

Charles Kingsley, the English historian and novelist of works such as *Westward, Ho!*, summed up the usage of the word "sphinx" for modern readers, in his description of a character in his novel *Two Years Ago*. Kingsley captures the contradictions with which a sphinx can describe a character:

He held fully the opinion of his superiors, that there was no saying what an Englishman might not, could not, and would not do. He was a sphinx . . . who took unintelligible delight in getting wet, and dirty, and tired, and starved, and all but lolled; and called the same "taking exercise": who would see everything that nobody ever cared to see, and who knew mysteriously everything about everywhere.[25]

Mystifying all, the Sphinx is an appropriate metaphor for the nature of love, as Shakespeare himself proclaimed:

> Subtle as Sphinx; as sweet and musical
> As bright Apollo's lute, strung with his hair:
> And when Love speaks, the voice of all the gods
> Makes heaven drowsy with the harmony.[26]

Even though the Sphinx drew interest because of its baffling nature, travelers in the nineteenth century had little respect for the actual monument. It would be unthinkable today for anyone to be allowed to touch a work that appears even as sturdy as this, but nineteenth-century visitors did not hesitate to walk all over it, in effect having the Sphinx stand beneath their feet. Alexandre Dumas, the author of *The Three Musketeers* and *The Count of Monte Cristo*, wrote of his 1830 journey to see the Sphinx with this irreverent account:

> We left these chambers . . . to salute her highness, the Sphinx. It is nearer to the Nile than the Pyramid is by a few hundred yards; and may be called the gigantic dog that watches its granite flock. With the assistance of my Arabs, I succeeded in mounting its back, and from its back to its head, which was no easy job. . . . I then slipped down to the shoulders of the Colossus, and from there to the ground, and began to sketch.[27]

Europeans did not see this as being disrespectful. On the contrary, they were in awe of its image, mutilated and vandalized as it is. Harriet Martineau, a nineteenth-century English social theorist, who visited the Sphinx in 1846, said that she was "half afraid to it. . . . So life-like,—so huge,—so monstrous,—it is really a fearful spectacle."[28]

~

Archaeological excavations, if one could call them that, began in 1817 when the Genoese captain Giovanni Battista Caviglia led 160 men in the first modern attempt to unearth the Sphinx. Caviglia's men could not hold back the sand around their dig, which poured into their excavation pits nearly as fast they could dig it out.[29] These excavations were important because they discovered a piece of the cobra that was once attached to the head of the monument. Egyptian pharaohs often wore a headdress that was composed of a cobra and a falcon, symbolizing the unity of lower and upper Egypt.

In 1902, more systematic excavations began around the Sphinx, trying to free it from its sandy nest. Large concessions were issued to Americans, Austrians, Germans, Italians, and Egyptians to do archaeological work, much of it continuing throughout

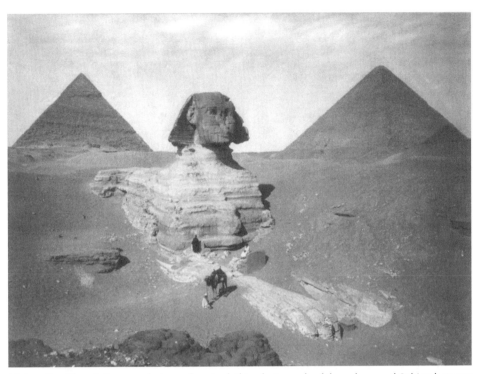

Maison Bonfils, a Lebanese photographer, took this photograph of the submerged Sphinx between 1867 and 1899. In historic photographs the Sphinx takes on the look of a drowning man, hoping that the tide will cast him ashore. *Library of Congress*

World War II, when the Sphinx was near, but not damaged by, the heated battles of El-Alamein. Repairs were made to the sculpture at this time, probably saving it from further erosion, which has haunted the weaker areas in the stonework for millennia.

In 1980, a German geologist, Tom Aigner, theorized that the limestone used to make the Sphinx probably had fossils of plankton-like creatures that could be mapped and traced in other monuments. He discovered that the wall around the temple of the Pyramid came from the stones in the ditch around the Sphinx. Apparently, as the Sphinx was being carved out of the ground, the stones were being reused elsewhere on the site. If Aigner's findings are correct, then the Sphinx would be contemporary with Khafre's temples and the Pyramid.[30]

In the twentieth century nearly everything about the Sphinx has been called into question: its age, its function, and even the ethnicity it represents. In the highly contentious world of art history scholarship, the Sphinx has become a key player in modern criticism. Take, for example, the recent theory propounded by a few scientists that considers the possibility that the Sphinx is between three to five thousand years older than previously thought.

Dr. Robert M. Schoch of Boston University conducted a number of experiments on the weathering of limestone and the climate of the Giza Plateau. His findings, unveiled at the Geological Society of America in 1992 and reported widely in the American press, indicate that the Sphinx could not have been built around 2500 BC

as previously thought, but perhaps around 5000 or 7000 BC, thousands of years before any of its sister pyramids were built and thousands of years prior to the very existence of ancient Egypt. This finding has not gone over well with Egyptologists like Dr. Mark Lehner from the University of Chicago, who denounced the results saying, "You don't overthrow Egyptian history based on one phenomenon like a weathering profile."[31]

Such thinking as Dr. Schoch's leads to other riddles in the Sphinx's identity. If it is much older than previously thought, who built it? And why? And where are the other traces of this civilization? And doesn't it look like a pharaoh anyway?

Dr. Schoch has contended that the Sphinx's current appearance stems from re-modeling by Pharaoh Khafre to conform to the standards of the Egyptian Old Kingdom. Needless to say this theory has been hotly contested, proving that even at the end of the second millennium AD the Sphinx had the power to confound and perplex.

Another controversy about the Sphinx is its ethnic identity. Are the features those of an African? This may sound like a new question, raised amid current accusations of racial profiling and multiculturalism, but in fact it actually goes back to the eighteenth century.

Prominent modern thinkers like W. E. B. Du Bois, a proponent of civil rights and one of the founders of the NAACP, maintained in his 1939 book *Black Folk: Then and Now*:

> In Egyptian sculpture and painting, the Negro appears as a slave and captive, as a tribute-bearer and also as ruler and official. The great Sphinx at Giza, so familiar to all the world; the Sphinxes at Tanis, the statue from Fayum; the statue of the Esquiline at Rome; and the Colossi of Bubastis, all represent Negroid types. They are described by Petrie as "having high cheek bones, flat cheeks, both in one plane, a massive nose, firm projecting lips, and thick hair, with an austere and almost savage expression of power."[32]

All sorts of experts have had their say—each applying his or her definitive judgments to this work. One orthodontist, Sheldon Peck of Newton, Massachusetts, wrote in a 1992 op-ed piece in the *New York Times*, using language that can be characterized as dental-speak, that "from the right lateral tracing of the statue's worn profile a pattern of bimaxillary prognathism is clearly detectable. This is an anatomical condition of forward development on both jaws, more frequently found in people of African ancestry than in those from Asian or Indo-European stock."[33] Dr. Peck, however, noted that these dental features are not found in sculptures of Khafre himself. Accordingly, Peck argued that the Sphinx does not represent Khafre, but has a separate identity.

In 1990, an American tourist was horseback riding in the desert, about half a mile from the Sphinx, when her horse stumbled through the roof of an Egyptian ruin. It turned out to be a cemetery from the Old Kingdom, containing the remains of six hundred bodies, all of whom were workers on the Pyramid complex. Nearby, another find revealed the ruins of a minicity of barracks containing food and lodging for thousands of workmen, all of whom had worked in the service of the pharaoh and his vision.[34]

These finds contribute to our knowledge of the workmen who labored on the Sphinx. We now know that these skilled workmen certainly weren't slaves, that they

worked in huge teams, and they were fed on beef from cattle slaughtered on the site. Ordinary Egyptians also contributed to the labor, perhaps as part of their national service or in fulfillment of some kind of a feudal obligation in times when they were not needed in the field.[35]

Compared to the Pyramids, the Sphinx has received modest critical attention from the professional world of art historians and archaeologists. Few books have been dedicated just to it, and fewer critical analyses have been conducted. Wander the aisles of a university library and you will see shelves of books detailing the Pyramids, and perhaps one—maybe one—to the Sphinx.

This dearth of critical attention has been supplanted by persistent folk beliefs and common misconceptions. Nature, they say, hates a vacuum. Words such as "guardian" and "protector" are often applied to the image without much foundation, especially since sphinxes, in most contexts, rarely guard anything, but instead serve as figures who make offerings.

What we do know is that the Sphinx is wearing a *nemes*, a headdress that was reserved for Egyptian royalty. The narrow false beard, sported by most pharaohs, including Khafre, is missing—perhaps it has fallen off. It may have rested on the protuberance above the center of his legs.

The Sphinx is also a lion, a royal symbol in Egypt, allegorically representing the strengthening power of the pharaoh. All this royal imagery, and the fact that the Sphinx has been placed alongside an avenue leading to the Pyramid of Khafre has led many to conclude that it is a guardian figure. But what could the Sphinx of Khafre be guarding? Itself? Perhaps one should better view this monument as a symbolic representation of the king placed before his tomb. Certainly a figure of the deceased placed before his or her tomb is not something unfamiliar in art history. No one suggests that these figures guard their tombs.

However situated, groomed, or festooned, everyone knows the Great Sphinx at a glance. It is a fitting tribute to this monumental image that tourists seek it out in order to be amazed, and stand transfixed speculating at its power. Now, as it sits in a ruined state eroded by time and dust, it commands our attention so vividly that it has grown to become the veritable artistic symbol of a country. A work of art rarely becomes popular through its mystery. The Sphinx has achieved fame, like the *Mona Lisa*, in no small part due to its power to perplex, a power that has remained steadfast for forty-five centuries and counting.

• *2* •

The Tomb of Tutankhamun

Politics, Ethnic Pride, Hornets, a Dead Canary, and a Curse

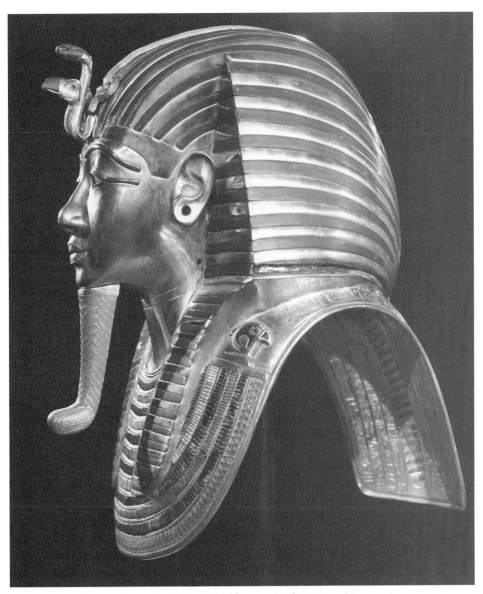

The golden mask of King Tutankhamun. *Neil Harrison / Dreamstime*

He gave his life for tourism.

—Steve Martin, "King Tut"

\mathcal{B}y all accounts George Herbert, fifth Earl of Carnarvon, was a fascinating man. He came from money, inherited even more money, and then married a Rothschild. He indulged his interests with a zeal that only his money could buy.

At first, horses were his great passion; he bred and raced them throughout his life. Next it was automobiles. He drove recklessly when cars had few safeguards; he enjoyed the thrill of leaving petrified pedestrians in the dust—at twenty miles per hour. His impulsive behavior behind the wheel led to a 1901 car accident in Bad Schwalbach, Germany, which left him permanently handicapped. Not that this slowed him down.

He then took up photography, a pursuit he became both technically and artistically proficient at. It is said he took over six hundred photographs in one season of excavations in Egypt.[1]

By 1903 he began a series of trips to the Mediterranean to get away from the damp English climate that was incompatible with his delicate health. In 1907 he turned his attention to Egyptology and studied the subject so thoroughly that he became a connoisseur of considerable standing with a discerning eye for small precious objects. Carnarvon went on to sponsor a series of excavations at Deir el-Bahari in Egypt, and enlisted the help of a number of Englishmen working on the site, including the up-and-coming archaeologist Howard Carter. In 1914 they began exploring the Valley of the Kings, and by 1922 they had uncovered the Tomb of Tutankhamun, the greatest discovery of artistic treasures in history.

Carter was already an experienced excavator when he opened Tutankhamun's tomb. His fieldwork dates as far back as 1891, when he joined the Archaeological Survey of Egypt as an artist; he was then only seventeen. He trained in various venues, and eventually was made chief inspector of antiquities of upper Egypt in 1899. However, Carter came into his own when he met the fifth Earl of Carnarvon. This symbiotic relationship began with Carter's digging in the Valley of the Kings in 1917 and continued, through World War I, until Carter had found Tutankhamun's tomb.

Carter had believed all along that Tutankhamun's tomb had to be somewhere in the Valley of the Kings—the trouble was finding it under an ocean of sand. The only way to ensure a successful dig was to excavate down to the bedrock, no small achievement in the shifting sand and blazing heat of the Egyptian desert. Carter concluded from the evidence of a faience cup and a piece of gold foil, both having Tutankhamun's name on it, that his tomb had to be someplace in the vicinity. Five winter seasons of meticulous searching produced almost nothing, and Lord Carnarvon was about to cancel the project altogether when Carter convinced him that just one more season was needed.

Carter was right. On the fourth day of the new season, workers had uncovered a rock-cut step that led downhill. More work gradually unveiled a flight of stairs, and then within a day, the entrance to the tomb was unearthed. Carter couldn't believe his good luck, but he remained restrained. So many incomplete or vandalized tombs had been discovered, that the buzz about this new tomb made the archaeologist and

his associates hold back enthusiasm for fear that this would be one in just a long line of disappointments.

There were reasons to be encouraged, however. The outer doors were sealed, a sign that they were not despoiled in the past. The inner doors had the original ties used by the Egyptians, another good sign:

> It was a thrilling moment for the excavator. Alone, save for my native workmen, I found myself, after years of comparatively unproductive labour, on the threshold of what might prove to be a magnificent discovery. Anything, literally anything, might lie beyond that passage, and it needed all my self-control to keep from breaking down the doorway, and investigating then and there.[2]

News was going to leak out quickly. Carter thought it wise to let Carnarvon know that they were on the heels of a great discovery. Carnarvon dropped everything and came to Egypt, arriving in Luxor by November 23, great speed in 1922 considering Carter's first encounter with the tomb was on November 4. Egyptian officials were already gathering around the tomb like gadflies: irritating, inspecting, supervising, and offering unwanted help.

On November 26, all was set for the opening of the tomb; tension was unbearable. Lord Carnarvon and his daughter Lady Evelyn accompanied Carter into the deep and steep entranceway, candles in hand. When the side of the door was jimmied open, hot gases escaped, and the candle flickered. Carter thrust the candle into the

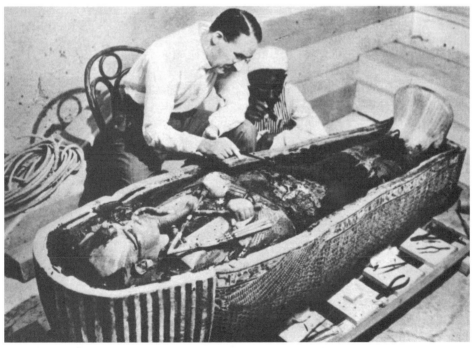

Howard Carter and an Egyptian worker examine the sarcophagus of King Tutankhamun. © *François Guenet / Art Resource, NY*

room. "Can you see anything?" Lord Carnarvon stuttered. "Yes, wonderful things," was all Carter could manage in the moment.[3]

In no time, a great cache of ancient goods began to emerge, including the imperial throne of Tutankhamun and four chariots encrusted with semiprecious stones and gold ornament. Alabaster vases were followed by royal robes, ebony and ivory boxes, royal wigs, and gilt musical instruments. The depth of the find was incredible; everyone was mesmerized.

Popularity was ensured by the sheer magnificence of the discovery. By December 1 every newspaper in the world was carrying the story of Tutankhamun, a ruler hitherto completely unknown except to experts in the field. Now he was a household name. A front-page headline in the *New York Times* read:

GEM-STUDDED RELICS

IN EGYPTIAN TOMB

AMAZE EXPLORERS[4]

With fame came problems. How could such a tomb be secured so that proper care could be taken for the effects? Wild rumors began to seize the local population: three aeroplanes had landed to whisk away the treasure! Impoverished natives began seeing Tutankhamun as a path to survival in an increasingly tourist-hungry world. If the treasure should disappear . . .

Carter, who by this time was on top of a crowded pyramid of Egyptologists, orchestrated what he thought would be a balanced effort at managing the news by re-creating an official opening of the tomb, welcoming the press, in particular the *London Times*, and asking everyone to inspect the tomb alongside him. If he thought this was going to calm things down, he was seriously mistaken. Hysterical press releases, daily from the field, sensationalized a find that not only did not need sensationalizing, but created a powerful urge for tourists to come and see for themselves.

Already cruise ships were thinking of ways to capitalize on this new discovery. By the end of 1922 the White Star liner *Adriatic*, the Cunard liner *Mauretania*, the Holland America *Rotterdam*, and the Canadian Pacific liner *Empress of Scotland* announced plans to set sail to Alexandria in January 1923, with land excursions available to Luxor. Some of these trips were privately charted. In total 3,500 new tourists could be arriving in just one month.[5]

Daily reports in the press were fiery. Rare was the paragraph that did not have words like "priceless," "magnificent," "greatest," "glorious," and "magnitude." *The Atlanta Constitution* proclaimed rather inaccurately:

TUTANKHAMUN THE MAGNIFICENT, LAST PHARAOH OF GOLDEN AGE[6]

By December 6 members of the Egyptian Antiquities Bureau had given permission for American tourists to visit the site.

On December 13 a steel gate was installed, and before the year was out bureaucrats began to wander down to the tomb by Carter's side to begin the parade of public officials. "Notables Are 'Stupefied' by Beauty, Finesse and Magnificence of the

Treasures,"[7] said a *New York Times* subheadline. Egyptian government functionaries all wanted a look for themselves, as did the foreign diplomatic corps in Cairo.

Egyptian officials, who had allowed so much to leave the country in the nineteenth century to fill the museums in London, Paris, Turin, and New York, began to sense that Tutankhamun might go the same way. The visitors' mobbing of the tomb also gave authorities reason to act. On December 22 more representatives of the press were invited, along with some Egyptian officials. This was understood by many of the local population to include themselves, and hence hundreds gathered outside the comparatively small tomb. A maximum of four could fit into the space at any one time, and many angry visitors were turned away. Lord Carnarvon returned to England in part to escape the media circus that had developed around the tomb.

The world wanted news, however, and daily reports from the field were demanded by editors of newspapers who didn't send their reporters to Egypt for nothing. Visitors hampered progress at every turn: arriving on entourages of donkeys, setting up camp, taking photos, bothering the archaeologists for a peek. Dignitaries came in caravans. Carter was handed a daily batch of letters of introduction, friends of friends, scholars of indisputable reputation, all eager to see for themselves. One intrepid person posed as a telegraph boy trying to make a delivery, and wormed his way into the tomb. Carter tells us of his various efforts to cope with the rising tide of popularity:

> The embarrassing side of it was soon brought home to us in no uncertain manner. Telegrams poured in from every quarter of the globe. Within a week or two letters began to follow them, a deluge of correspondence that has persisted ever since. Amazing literature some of it. Beginning with letters of congratulation, it went on to offers of assistance, ranging all the way from tomb-planning to personal valeting; requests for souvenirs—even a few grains of sand from above the tomb would be received thankfully; fantastic money offers, from moving-picture rights to copyright on fashions of dress; advice on the preservation of antiquities, and the best method of appeasing evil spirits and elementals; press clippings; tracts; would-be facetious communications; stern denunciations of sacrilege; claims of relationship—surely you must be the cousin who lived in Camberwell in 1893, and whom we have never heard of since. . . .[8]

Time was being lost. Important work was to be done. Even so, politicians could not understand why they would be left out of a treat that so many had already had a glimpse of. Weren't they significant enough to have a special viewing? Maybe to hold the objects and perhaps take one home to show the family?

Lord Carnarvon was thunderstruck by the find, and perhaps this is why he became less generous than he ought to have been. His contract with the Egyptian government specifically indicated that he had a right to some of the finds only if the tomb had been violated by robbers. The Tutankhamun tomb was violated in the ancient world; the contents were vandalized and the interior ransacked, but the robbers took nothing. The thieves must have been caught red handed, because the tomb was resealed with the original king's markings.

As a reaction to Carnarvon's stance, the Egyptian parliament began to consider a bill to ensure that every archaeological discovery remained in Egypt. This act, how-

ever, would stifle foreign interest, and cause widespread unemployment in the villages near the sites, bringing work to a standstill. Before parliament could act, Carnarvon brought his case to court, a case he felt sure he could win. The legal documents did indicate that Carnarvon had a right to half the treasure in the tomb, but the magnitude of the find was too enormous for Egyptian ethnic pride to let go, and his case was summarily rejected. If he had acted more graciously and was willing to accept less, perhaps the government may have seen things differently.

Back at the tomb, the treasures were being removed one by one, taken out in the open air for the tourists to ogle. After a sort of victory lap around the valley before the tourists, the archaeological prizes were spirited away for examination in a nearby laboratory. For the first time in almost four thousand years, these objects saw the light of day, before they were carried to a makeshift workshop for preservation in a nearby vacant tomb:

> This was the moment for which the crowd of watchers above the tomb were waiting. Out came the reporters' note-books, *click, click, click* went the cameras in every direction, and a lane had to be cleared for the procession to pass through. I suppose more films were wasted in the Valley last winter than in any other corresponding period of time since cameras were first invented. We in the laboratory had occasion once for a piece of old mummy cloth for experimental purposes; it was sent up to us in a stretcher, and it was photographed eight times before it got to us![9]

All of this was too much for one man. He had to deal with local bureaucrats, national figures, European experts, museum officials, and cruise ship lines. Four round-the-world voyages were stopping in Egypt and were promising another two thousand curious. The more artifacts were removed, the greater the popularity of the tomb. Tutankhamun's crosier caused an unusual exclamation of surprise, as did his royal underwear.

Tourists began to feel a sense of entitlement. Americans were particularly unnerved when they heard rumors that Carter was going to close the tomb to visitors, or that a sandstorm was keeping them from visiting the site. After all the journeying, thousands of miles over the ocean and through the desert, didn't they have a right to see the boy wonder? Whenever anyone emerged from the tomb, cameras went off, hoping to record the emergence of a spectacular find seeing the light of day after thousands of years.

Hotels were now filled to capacity, and tourists were pressing ever more dearly upon the fragile ecosystem of the Egyptian desert. Water was in short supply, as were tempers. Now that Carter had cleared out the two first rooms of the tomb, and the main room was about to be uncovered, it seemed that the rearrival of Lord Carnarvon, who had left after a month's stay, might stimulate even more hysteria.

The anticipation of even greater treasures made dignitaries from far and wide flock to Luxor. On February 17, 1923, the inner sanctuary was opened before Lord Carnarvon and his daughter Lady Evelyn, the Egyptian minister of public works, the director general of service of antiquities, curators from the Metropolitan Museum in New York, professors from various universities, and a modest assortment of minor Egyptian dignitaries, a grouping of about twenty in all.

Excitement began to grow overseas for those who could not make the journey to Egypt. The Metropolitan Museum had in its possession a gold signet ring bearing the pharaoh's throne name. Before this discovery, thousands of visitors had slipped past the display case with the curio, unaware of its association. But now, with great ceremony, the ring was placed in the "gold room," and visitors gawked at this reminder of Tutankhamun, now available in New York. The ring was purchased by the Metropolitan in December 1921 from a dealer in Cairo. Not much else is known about this tiny (1⅛" × ¾" × 1⁵⁄₁₆") artifact, or even if it ever belonged to the king himself. It was probably sold to the Metropolitan for a fraction of the price it would have been worth after the discovery of the tomb a year later.

Even royalty could not restrain themselves. The queen of the Belgians and Prince Leopold made the trip to Egypt, causing more headlines and more fanfare. The queen claimed she was "wonderstruck," and inspired other royalty to make their own pilgrimage. R. Jean Caparets, a professor in the queen's entourage, compared prior Egyptian finds to this one: "Practically all that we had up to now in the way of Egyptian industrial art was only trumpery and rubbish suitable to satisfy the vanity of people who wanted their tomb to have the appearance of royal splendor."[10]

By late February the area around the tomb was getting very hot, and the Egyptian summer, which comes early and stays late, was beginning to take its toll on the workers. Carter made the decision to cover the tomb so that it could be unearthed in the fall, when the weather would be more conducive to excavation. Still, he had not uncovered the great sarcophagus nor the mask of Tutankhamun. The world had to sit tight for a while.

However, the world wanted to do anything but sit tight. How could it with headlines in New York:

<div align="center">

SPLENDOR OF TOMB

OF TUT-ANKH-HAMEN

ASTOUNDS EXPERTS[11]

</div>

Philadelphia:

<div align="center">

FIND PRICELESS TREASURES

IN EGYPTIAN KING'S TOMB[12]

</div>

Ogden, Utah:

<div align="center">

GREATEST ART

DISCOVERY IN

WORLD, CLAIM[13]

</div>

The news blackout caused by the hiatus in digging was countered with the first "officially detailed" photographs of the objects taken from the tomb, reproduced by local newspapers week after week. Of course the photos were in black and white, but the captions could use and reuse the word "gold" to give the appropriate setting.

Even after the tomb was reburied and officially closed, and the artifacts taken to a laboratory for conservation, the curious still ventured near the off-limits site.

Everyone frantically scattered when oils used to treat the wooden objects attracted great hordes of hornets, buzzing mercilessly down on field-workers and travelers alike. Carter sped up the packing of the trophies of Tutankhamun, prompted by the angry buzzing of insects.

As if all this confusion were not enough, word came that Lord Carnarvon had died on April 5, 1923. The official cause of death was blood poisoning caused by a tropical insect bite, but this did not stop the Egyptian population from theorizing that his death was the result of the mummy's curse. Did he really die of an insect bite? Maybe he touched a poisonous object buried deep inside the tomb. Maybe he breathed in deadly air trapped underground for centuries. Was all this done thirty centuries ago to get revenge for anyone who tampered with the pharaoh's eternal rest? Who sent the hornets to the tomb anyway? It did not help that at the moment of Carnarvon's death, his dog back in England gave out a wild yelp and died on the spot.

Carter himself, it is said, lost his pet canary on the day the tomb was discovered. His servant, paralyzed with fear, told him that serpents frightened the canary to death, and that this was a sign from the dead pharaoh's tomb. "Don't open the tomb!" the servant cried as she ran from the house.

Denials of superstition did nothing, however, to quell rumors that Carnarvon had upset the ancient gods. The origin of the dead pharaoh's curse goes back to nineteenth-century London when, apparently for the entertainment of the masses, Egyptian mummies were unraveled onstage. This rather shameless exhibitionism inspired novelists to pen tales of the mummy's revenge. Even Louisa May Alcott, noted author of *Little Women*, wrote a now obscure short story called *Lost in a Pyramid; or, The Mummy Curse*, which perpetuated the myth.

Recent studies reveal that in early small Egyptian tombs, called mastabas, the walls were inscribed with "curses" meant to terrify those who would seek to desecrate a royal mortuary.[14] The curses generally threaten revenge by the gods, or death by crocodiles, scorpions, snakes, or other fearsome beasts.

Some had rationalized the deaths by theorizing that ancient germs remained dormant inside the tombs waiting for the unsuspecting archaeologist. However, attempts to confirm that sealed tombs contained pathogens that could survive for thousands of years have proven to be largely without foundation. Professor F. DeWolfe Miller, professor of epidemiology at the University of Hawaii at Manoa, has said that no known archaeologist, or single tourist, has experienced any symptoms caused by a toxic tomb. "The idea that an underground tomb, after 3,000 years, would have some kind of bizarre microorganism in it that's going to kill somebody six weeks later and make it look exactly like [blood poisoning] is very hard to believe."[15] Professor Miller then goes on to state that given the sanitation standards in Egypt in 1922, Lord Carnarvon was far safer inside the tomb than outside.

In the early twentieth century the mummy's curse gathered renewed vigor when mystery writer Sir Arthur Conan Doyle, most famous for his Sherlock Holmes stories, alleged, "I think it is possible that some occult influence caused his death. There are many legends about the powers of old Egyptians, and I know I wouldn't care to go fooling about their tombs and mummies."[16] That's all the publicity engines of the day needed to generate more fodder. Doyle then pointed suspiciously to a mummy in the

British Museum, which seemed to be haunted: "There is a mummy in the British Museum which became noted because of the series of misfortunes which befell those who had anything to do with it. The excavators, the workmen who carried it, the photographers who photographed it and others seemed to be pursued by an evil influence."[17]

Marie Corelli, now a forgotten but once extraordinarily popular novelist in her day, published her thoughts on the subject in the London and New York papers:

> I cannot but think some risks are run by breaking into the last rest of a king in Egypt whose tomb is specially and solemnly guarded, and robbing him of his possessions. According to a rare book I possess . . . entitled *The Egyptian History of the Pyramids* [an ancient Arabic text written before hieroglyphics were decoded], the most dire punishment follows any rash intruder into a sealed tomb. The book . . . names secret poisons enclosed in boxes in such wise that those who touch them shall not know how they come to suffer. That is why I ask, Was it a mosquito bite that has so seriously infected Lord Carnarvon?[18]

Carnarvon died in the Continental Savoy Hotel in Cairo, after a short illness associated with a bite from a mosquito carrying the erysipelas virus. The Countess of Carnarvon booked a passage on a steamer from Egypt to England to bring her husband's body home. This caused widespread cancellations by some passengers who feared that the boat might befall some cataclysm as a result of transporting a body carrying a mummy's curse.

Even if Carnarvon's death were caused by an insect bite, many believed that perhaps he was targeted by locals angry at the disturbing of the tomb, and the placement of the insect was purposeful. Within a few days, more bad news. Howard Carter had taken ill due to overwork; one suspects the cause involved long hours of labor under paralyzing heat. Carter recovered, but not before the imagery of the avenging dead pharaoh hovered above his reputation. He spent most of the rest of his life trying to debunk the myth of the mummy's curse. "It is rather too much to ask me to believe that some spook is keeping watch and ward over the dead Pharaoh, ready to wreak vengeance on any one who goes too near."[19]

If the mummy's curse worked, it really was not in any hurry. True, Carnarvon died quickly, but only six of the twenty-six people present at the opening of the tomb died within a decade. Carter himself did not die until 1939, apparently outliving any ill effects from being exposed to a tomb.

As the new digging season approached, it became increasingly obvious that the remaining rooms of the tomb could not be accessed without the walls being removed. Once again nerves were on edge, and Carter was pale with worry. Electric light was brought to Luxor to aid the process, and the tomb was dramatically illuminated. The inner walls were breached, and even more dazzling works were spotted, creating wider publicity. The outer sarcophagus of Tutankhamun was discovered on January 3, 1924, and it would be a few short weeks before the perfectly preserved gold coffin of the pharaoh was unveiled.

The more precious the works, the higher the stakes, and the more intense the political tension. At the moment of maximum interest, the Egyptian government began to ponder Howard Carter's motives. Perhaps officials were seriously pressured by the local population to "do something" about Carter and his team. On the one hand Carter needed quiet and concentration to uncover Tutankhamun's treasures. On the other, the quieter the team became, the more anxious authorities were that he was trying to spirit away the best pieces to England. The Egyptians must have had in mind the fate of the Elgin Marbles and the Rosetta Stone. Carter tried to allow certain visitors permission to enter in order to find a middle ground between what he wanted to do and what he should do, but no matter what action Carter tried, it was open to criticism.

Carter's trademark deportment, his unfailing kindness, and his consistent good humor did nothing to assuage the anti-British feeling that was then sweeping Egypt. The current political situation made matters worse, with the British and Egyptians arguing over trade, defense, and diplomatic issues. Egypt was unilaterally declared independent by the British on February 28, 1922, but the British maintained that their security required that only they could control the Suez Canal and take care of Egyptian military projects. So much for independence. And so much for Anglo-Egyptian cooperation in Luxor.

Troops were brought to Luxor to bar Carter from reentering the tomb. If Carter did not yield to only those people on the Egyptian government's approval list, there would be no continuance of this archaeological dig. However, for all its bluster the government was in a difficult position; there were no Egyptians at the time who were trained to continue this work. It was the English, after all, who discovered the Egyptian treasures, and deserved credit for the find.

The struggle, it seems, really was over control of the treasures. Something would have to be done to compensate the excavators for unearthing Tutankhamun—but what? Could the government remove Egypt's most important artifacts to England, the way they allowed previous works to escape to Europe? Were there agents inside the government who saw the antiquities as their own personal opportunities, and could help themselves to a few of the goodies? Who would miss a bauble or two?

The Egyptian press furiously demonized Carter and all British, while archaeologists gathered around the beleaguered explorer and papered Cairo with letters of support.

The firestorm became most heated during an exchange between government officials and Carter's lawyers, the latter claiming that the Egyptian government had forced its way into the tomb "like bandits" and caused damage to the delicately preserved artifacts. Negotiations went into a tailspin with the tomb in the middle and Egyptians claiming that once again the malevolent nature of a disturbed pharaoh's rest had cast a curse on all the proceedings.

Carter was caught in a political maelstrom from which he could not extract himself, nor could he make headway to appease the government. It took another year for the coffin of Tutankhamun to be removed from his sarcophagus, with Howard Carter again in charge.

After many days of maneuvering inside the shoebox-like tomb chamber, Carter's team eventually opened the massive lid of the sarcophagus, suspending it above the crypt so that the archaeologists could gaze within:

> A gasp of wonderment escaped our lips, so gorgeous was the sight that met our eyes: a golden effigy of the young boy king, of most magnificent workmanship, filled the whole of the interior of the sarcophagus. This was the lid of a wonderful anthropoid coffin, some 7 feet in length, resting upon a low bier in the form of a lion, and no doubt the outermost coffin of a series of coffins, nested one within the other, enclosing the mortal remains of the king.[20]

Unlike archaeologists before him, Carter finished excavating the tomb and then turned the contents over to the Egyptian government, except apparently for a few scraps of wood and some minor items that were housed at the Metropolitan Museum until 2011. No one knows how these items ended up in New York, but when the Egyptian government wanted them back, there was no argument, and they were returned with a maximum of fanfare.

The Egyptian government wanted the remains of Tutankhamun's tomb to be sent to Cairo for safekeeping. A railway line was built by specially trained engineers who labored under scorching heat to create a safe passage for these treasures. The artifacts made the five-hundred-mile journey without incident. Eventually the Tutankhamun artifacts were deposited in the Egyptian Museum in Cairo, and the world could judge the contents of the tomb for themselves. However, the story of Tutankhamun's legacy, as it turns out, was only just beginning.

The fascination with Tutankhamun was so mesmerizing that it did not take long for Hollywood to capitalize on the craze. There has been no shortage of Egypt movies even before the discovery of Tutankhamun, like the 1921 classic *The Sheik* with Rudolph Valentino. After the discovery of the tomb, all sorts of monster mummy movies came out. The 1932 version of *The Mummy* with Boris Karloff was typical of the genre, and the parallels with the Tutankhamun excavation were intentional. In the film, set in 1921, a British field expedition led by an English aristocrat, Sir Joseph Whemple, attempts to uncover the body of the Egyptian pharaoh Im-Ho-Tep. Sir Joseph mysteriously dies when he interferes with the tomb. One wonders how any audience, even then, would have thought these movies were terrifying, or even mysterious.

Hollywood also used mummies for comedy as well, and Tutankhamun was lampooned mercilessly. Most characteristically, a 1939 film by the Three Stooges called *We Want Our Mummy* features the trio journeying to Egypt in search of the remains of King Rootin-Tootin, for which a museum will pay $5,000. The Stooges rescue the mummy from assorted villains only after Curly is wound up in the mummy's bandages. At the end, Rootin-Tootin's remains reveal he was a dwarf married to Queen Hotsy Totsy; the two are triumphantly sent to the museum.

~

As long as the Tutankhamun treasures sat in the Cairo museum, they were preserved, but they could only be accessible to those who made the trek. Traveling to Egypt has always been caught in the revolving door of Middle East politics, with sometimes frosty and sometimes friendly relations determining the ebb and flow of tourist dollars.

Wars also took their toll on tourism, first World War II, then various quick wars with Israel, all dampening tourist interest. Tutankhamun was still famous, but he sat as inaccessible as ever in Cairo—for all the world could see, he might as well have remained buried.

In 1972 it was decided by Egyptian authorities that Tutankhamun would make an excellent goodwill ambassador, one who could represent Egypt today, as odd as that may sound. Many pieces in the collection were sent as an exhibition to the British Museum ostensibly to thank the British for their role in the uncovering of the tomb, and to mark the fiftieth anniversary of Howard Carter's adventures in Egypt.

Queen Elizabeth II thanked a delegation of Egyptian dignitaries, and promptly opened the exhibition to viewing, after her private encounter was over. The British Museum never saw anything like it: 1.7 million visitors saw the objects over the span of six months; the museum was open from 10:00 a.m. to 9:00 p.m. seven days a week and averaging seven thousand visitors per day. The show was a triumph—a tour de force. The seeds were planted for an even bigger event: a worldwide tour that would gather millions allegedly for antiquities preservation in Egypt.

Egyptian president Gamal Abdel Nasser already had a cozy relationship with the Soviets, mostly because they helped fund the gigantic Aswan Dam project, which was ultimately finished in 1976. Nasser had already declared Egypt a socialist state and decided that a good way to cultivate the ties between the USSR and Egypt was to send the Tutankhamun effects on a tour of five cities around the country. This may have been a cultural triumph, but the Soviet Union did not have the deep pockets to send the necessary funds back to Egypt that the Egyptian government thought would be the benefit of this tour.

When Nasser died, his successor, Anwar el-Sadat, took a more pro-Western view of politics, and was happy to respond to President Richard Nixon's invitation to send the Tutankhamun show to the United States. Thomas Hoving, the then director of the Metropolitan Museum, remembered the negotiations in his memoirs:

> But the man who pulled off "Tut" was Richard M. Nixon. On his triumphal visit to Egypt not long before he had to resign in disgrace, the president asked Sadat about getting the show for America. . . . Nixon demanded one more city than Russia and more objects. Sadat was sympathetic. A direct order from Sadat got things inching along.
>
> And Gamal Mokhtar [chairman of the Egyptian Antiquities Organization and first undersecretary of state from 1972 to 1977] decided that the Met was the only institution that could be trusted to make arrangements and guarantee the safety of the works. When Kissinger's office told us we could have the phenomenal exhibition if we agreed to guarantee its safety, we hesitated. Frankly, we shuddered at the awesome responsibility. But word came back directly from Kissinger to Douglas Dillon

[president of the Metropolitan Museum] that the show was a vital part of the Middle East peace process and all future relationships with Egypt. Unless the Met, with all its resources, became the principal organizer and the guarantor, the federal government would be "disturbed." To Dillon this meant that all federal grants might be lost forever. So, reluctantly, we agreed to take on the duty.[21]

Some fifty-three treasures from the Tomb of Tutankhamun were sent on a two-year tour of the United States. Included in the mixed bag of items was the solid gold mask placed over the pharaoh's head. The tour was arranged and financed by the Metropolitan Museum in New York, although each participating museum had to pay for its costs for transportation, insurance, and installation.

The Egyptian government seems to have had a hand in choosing the museums, ensuring widespread geographic coverage so that a maximum number of people could view the objects conveniently—and a maximum of publicity could be achieved. The tour opened in the National Gallery in Washington, creating a huge splash in the nation's capital, with intense media coverage. Politicians, like President Jimmy Carter, lined up smilingly in front of ancient artifacts—greatness by association.

From there it was on to the nation's second-biggest city, Chicago, where the exhibit was installed at the Field Museum. The South was treated to the show at the New Orleans Museum of Art, then Hollywood got its chance at the Los Angeles County Museum of Art. It was off to the Pacific Northwest by 1978 to the Seattle Art Museum, and then ultimately the Metropolitan to end the tour. A hastily arranged additional venue was added later in San Francisco's de Young Museum.

Ostensibly the appearance of Tutankhamun was to help the United States celebrate its bicentennial in 1976, although the connection between the ancient pharaoh and modern America is tenuous at best. However, Egypt was not alone in loaning national treasures for this occasion. The Irish contributed their greatest manuscripts, *The Book of Kells* and *The Book of Durrow*, for a show at the Metropolitan for just the same reason. Spain sent a small, but choice, selection of Goya paintings.

No one should underestimate the effect the Tutankhamun exhibition had on diplomacy. President Carter hosted a meeting between Sadat and Israeli prime minister Menachem Begin at Camp David, which would become the basis for the Middle East peace. When Egypt and Israel ultimately signed the accords establishing diplomatic and commercial relations, Ambassador Tutankhamun was working his magic in New York.[22]

The Tutankhamun effect on the American public was sensational. Tut fever swept the nation, as enormous crowds hungered to see the show. Museums anticipated the panic, by insisting that admission be handled through a ticket service outlet rather than through the doors of the museum itself.

Computers were in their infancy, unknown in homes. Ticket sellers like Ticketron were setting up booths in shopping malls, themselves new creations, so that they could handle theatrical shows, and sporting and concert events for those who did not want to travel downtown on the day of the performance to get the tickets they wanted. This was an ideal location to sell Tutankhamun tickets.

Little did Ticketron know what it was in for. The lines started forming the night before the tickets were available—huge lines stretching for blocks, around corners,

and down avenues. The primitive computer systems were easily overwhelmed by the huge demand. Everything was sold out in short order, so scalpers stepped in to fill the void left by the lack of availability. Tickets that cost as little as sixty cents were being scalped at $45 in Los Angeles.

Once at the exhibition, visitors slowly paced through the large spaces—there was no need to hurry, although the pressure of the great crowds was too much for some. Gift shops pulled in an average of $100,000 a week on items such as catalogs, which went for $6.95, to a replica of the golden mask for $25. Museums employed extra staffs for bathrooms, security, coat checks, and the like, hoping to make the experience a pleasant one.

Tut jewelry began appearing everywhere, along with Tut furniture, Tut clothing, Tut wallpaper, and various Tut necklaces of scarabs, golden masks, and royal insignia. The *New York Times* proclaimed, "The Tutankhamun Spirit Runs Riot in New Jewelry Everywhere."[23] Even reproductions of the ancient Egyptian board game, Senet, were manufactured. The Metropolitan Museum was particularly aggressive. In one count, it had six times the number of items for sale at the exhibit than appeared in the exhibit.[24] Some of the outdoor vendors were less serious than their museum counterparts, but more fun. Who could resist a vibrating King Tut pillow that is plugged into a wall?

Tutankhamun was memorialized in a 1978 hit song by "Steve Martin and the Toot Uncommons," who were actually members of the sixties group the Nitty Gritty Dirt Band. The song capitalized on the fame of the Tut show but also parodied America's Egyptomania.

This hysteria over Tutankhamun, that no doubt the original king would have found amusing, raises the question as to why it was so popular. Richard Morsches, senior vice president of operations of the Metropolitan Museum, pointed to the appeal of buried treasure, much of it gold, while others may have found the stories of the curse equally compelling. Still others have had childhood fascinations with mummies. No doubt the quality of the objects brought people into the doors of the museums, but aesthetically wonderful shows sometimes fall flat when it comes to attendance. In fact, 25 percent of all Tutankhamun attendees had never been in a museum before. How many would come back for more?

There was the realization that this was a once in a lifetime event. Most people do not ever get a chance to go to Egypt, and here were the masterpieces coming to them! Headlines across the country screamed about record-breaking attendance figures, museums overwhelmed with requests from prominent people to accommodate their party for a private viewing, and individual citizens trying to threaten and beg their way in to the exhibition. More than one American breathed a great sigh of relief when the treasures finally winged their way home. Eight million Americans had seen the exhibition.

Not one to allow the thunder to pass so quickly, the Egyptians hastily marketed the exhibit in other venues including France, Japan, Canada, and Germany. What was huge in the United States became an international sensation. There is no doubt, when all the dust settled, that the King Tutankhamun road show was the biggest blockbuster in the history of museums, and it was not done yet.

Back in England in 1988, the seventh Earl of Carnarvon, grandson of the sponsor of the Egyptian expedition, decided to make an inventory while cleaning out the ancestral estate in Highclere Castle. To help him with this vast task, he enlisted the aid of a seventy-five-year-old retired butler, Mr. Robert Taylor, who knew much about the house and its contents. When the earl was about to declare the work done, the butler responded that yes, they had finished listing all the contents, "except for the Egyptian stuff."

Time suddenly stood still. "What Egyptian stuff?" Taylor led the earl to two hidden cupboards in a sealed space between the drawing and smoking rooms. The earl was astonished to find them full of antiquities.[25] Then more were discovered in the document room, in the drawer used by the housekeeper, in other hidden places in this huge house.

All this material, it seems, came from the Valley of the Kings, but on the expeditions that Howard Carter conducted prior to the discovery of Tutankhamun; therefore, the collection was in England legitimately, and can be paralleled with Carter's notes on his excavations.

The sixth earl, who took over the estate after his father's sudden death in Egypt, never wanted to talk about Egypt. He felt cheated by the Egyptian government, and even forbade servants to mention the word.[26] His mother, Almina, Countess of Carnarvon, took her husband's huge collection of Egyptian antiquities, numbering over a thousand items, and in 1926 sold them to the Metropolitan Museum. That, they thought, was that.

The seventh earl now has possession of these newly discovered items, mostly from the reign of Tutankhamun's grandfather, Amenophis III, and has them on display in a purpose-built museum on-site. The Egyptian government has not made a move—yet—to get them back.

Tutankhamun's traveling treasures were allowed to rest for a generation before it was decided to mount another show. This time the show was entitled *Tutankhamun: The Golden Hereafter* and contained some fifty objects from Tutankhamun's tomb and a miscellaneous gathering of seventy other funerary objects from other Eighteenth Dynasty monarchs. The tour made the journey to Switzerland, Germany, and the United States, ending in London. It was immediately followed by *Tutankhamun and the Golden Age of the Pharaohs*, which went to Los Angeles, Fort Lauderdale, Chicago, and Philadelphia, and again to London. This show was such a success that it was reinvigorated with additional venues at the Dallas Museum of Art, the de Young Museum in San Francisco, and the Discovery Times Square Exposition in New York in 2010. The Metropolitan Museum, which has a policy of not charging for admission to extra exhibitions, let the show pass them by. A recent manifestation called *Tutankhamun and the World of the Pharaohs* opened in Vienna in March 2008 and traveled to Atlanta

before ending up at, of all places, the Indianapolis Children's Museum. Although successful, these shows paled in comparison to the climax reached in the 1970s.

The choice of venues was never accidental. Egypt has always kept a sharp eye on the revenue that the tourist business generates, and necessarily so since it is the biggest moneymaker in the country, exceeding even oil exports. The largest number of tourists is Europeans, who descend on the great monuments every year, hoping to see the treasures for themselves. In September 1997 nine people were killed aboard a German tourist bus outside the Egyptian Museum in Cairo. A month later, fifty-eight tourists, mostly Swiss, were slaughtered at Hatshepsut's Temple in Luxor. Foreign visitors suddenly found other places to visit. Tutankhamun was called in to rescue the tourist industry and exported to Germany and Switzerland.

However, the new shows now contained decidedly secondary material, some museums even quietly quipping that if the Tutankhamun name were not attached to the show, it probably would not draw much attention.

The world of traveling exhibitions has changed since the 1970s as well. Gone are the days of international cooperation and peace through art. Now there are corporate sponsorships and special tax-write-off opportunities. Museums, always needing financial resources, find it necessary to court corporations for their favors, and corporations like the association of funding fine art. In other words, Tutankhamun's trips around the world must make money. Otherwise, why would anyone bother? One critic called the recent Tutankhamun exhibits "the triumphal ascendancy of the corporate ka."[27]

Corporate sponsorship also reveals a more cautious installation of the objects surrounded by a good degree of political correctness. At the Los Angeles County Museum of Art's presentation, Tutankhamun no longer had slaves but servants. Clearly the boy king has been repackaged for modern tastes.

Los Angeles also called him the "King of Bling,"[28] and was greeted by red carpets, klieg lights, paparazzi, and celebrity interviews. This was a splashy opening for any museum, but perhaps not one for art historians or connoisseurs.[29] This road trip was in part sponsored by Anschutz Entertainment Group, a company that produces family-friendly movies, owns sports teams, and manages rock concerts for Paul McCartney, Prince, and Usher. "I'm not sure there's so much difference between Tutankhamun and Celine Dion," said Tim Leiweke, head of AEG, who joked about packaging Tut and Celine on the road. "It's about entertaining people, moving them emotionally, making them feel good about the time and money spent."[30] While museum curators may quake at the comparison, this does not mean that Leiweke is wrong.

According to Zahi Hawass, the former secretary general of Egypt's Supreme Council of Antiquities, the goal of recent shows is to raise money for Egyptian antiquities. He claims that 60 to 70 percent of the profit of this tour is going back to Egypt. "Tourism is the main destroyer of monuments," Hawass declared.[31] One wonders if that statement suggested that he preferred that tourists just simply go away. Given Hawass's ubiquitous presence on American television promoting Egyptian antiquities, one can't help but think his statement somewhat ironic.

Gone are the days of cultural exchanges as a worthy endeavor to bridge the gap between people. Hawass tersely declared that the 1970s tours failed to make money

for Egypt and this time there would be "no free meals."[32] Tutankhamun has become a pawn in a government cultural shakedown.

Just how much money Tutankhamun has earned for Egypt and the host museums has been shrouded in as much secrecy as the original tomb itself. When *Tutankhamun and the Golden Age of the Pharaohs* opened in Dallas, Hawass said that Egypt was guaranteed six million dollars, and "after that, we share the success."[33] Nice thought, but the Dallas venue fell far short of expectations—40 percent fewer visitors came to see the exhibit than projected. The museum and the organizers were left pondering additional staffing, security, insurance, transportation, and installation costs.

Just when the tours seemed to be over, yet another series has been arranged in 2011 featuring stops in the Science Museum of Minnesota, the Museum of Fine Arts in Houston, and the Pacific Science Center in Seattle. This incarnation, *TUTANKHAMUN: The Golden King and the Great Pharaohs*, features so little from the actual tomb that it has become clear Tutankhamun's name alone is being used to stimulate interest—and income. Highlights from the exhibition, as advertised on the show's website, include a sarcophagus of a "royal" (quotations original) cat, and a bed that "most likely" was used by Tutankhamun in life.[34] These objects, along with the golden toenail coverings of the boy king, indicate that art had no place in the organizing of this exhibition. Tutankhamun had sunk into the realm of a freakish curiosity.

It is only natural, then, that someone could organize an exhibition based on Tutankhamun's tomb that would feature not a single work of art. A team of dedicated entrepreneurs created an exhibition composed entirely of copies that are, according to their website, "painstakingly crafted replicas approved by renowned Egyptologists."[35] Serious Egyptologists apparently have so much time on their hands they can supervise and approve a traveling road show of fakes for an eager audience. A nine-city European tour—for example, Brussels, Cologne, Manchester, Dublin—was quickly put together with the usual hype and so the replicas went on parade, satisfying the desire to see the real and the genuine by looking at the copy. If this exhibition makes money, the organizers may well create an ersatz Sistine Chapel to be seen at a museum near you.

Beyond the exhibitions, there are the endless scientific results that come out annually on the state of the mummy, on CT scans of the corpse, on the speculation of the cause of Tutankhamun's death, and on a reconstruction of his features. Tutankhamun has passed from his own world into the heated media-conscious environment of the twenty-first century. No longer an Egyptian pharaoh, he now rests as the embodiment of ancient culture and a spokesman for the Egypt of today.

Perhaps this is the reason why he became such a target in the January 2011 Egyptian Revolution that eventually unseated longtime strongman Hosni Mubarak. Those eager to take advantage of the political instability in Cairo broke into the Egyptian Museum and began smashing glass cases and throwing antiquities to the floor. In a bizarre occurrence, two mummies were actually beheaded.[36] Insiders claimed that the brigandage was the work of grossly underpaid museum guards who knew what to take and what to leave behind. Therefore the very famous antiquities including Tutankhamun's mask and sarcophagus were left behind, but the distinctly secondary gilded

wooden statues of Tutankhamun carried by a goddess and Tutankhamun harpooning were taken. The statue of Tut harpooning has since been found.

The museum has reopened to the public with promises that a new facility is planned that will ensure that such pillaging will never happen again. The Egyptian government has a great interest in preserving Tut as an official international ambassador. It is his job to raise money for Egypt by making sure tourists keep coming—and paying—to see him, no matter where he is. Indeed, he has come down to us as the face of ancient Egypt, its most famous king, but it is a cruel irony that in the annals of Egyptian history he is a minor figure at best. He would be akin to having all the American presidents mysteriously vaporized by history, but the remains of Martin Van Buren somehow surviving and becoming the face of the American presidency for the future.

Big job for Tutankhamun, a person dead thousands of years, but that's what you get when your tomb is the sole survivor of an ancient culture, and your grave comes down intact. Ironically, the curse of Tutankhamun's tomb has been placed not so much on the archaeologists, but on the dead king himself in his afterlife, now that he has turned into a media star and a noted celebrity. Little did he realize how much unrest his eternal rest would be.

The Parthenon Sculptures

Lord Elgin and How Greece Lost Its Marbles

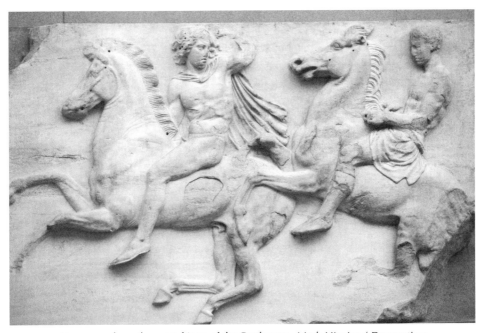

Horsemen from the west frieze of the Parthenon. *Mark Higgins / Dreamstime*

The voices of condemnation raised not only throughout the world but also in England, did not prevent the British Museum from buying them at the time for 36,000 pounds. They called them the Elgin Marbles. They must be returned, for they are an integral part of the Acropolis, which is the symbol of Greece.

—Melina Mercouri, quoted in the *New York Times*, April 18, 1982

*O*ne of the largest groupings of adobe pueblos in the American Southwest is at Mesa Verde National Park, an acropolis of Indian culture in its own right. In the late nineteenth century a Swedish scholar named Gustaf Nordenskiöld began the first systematic excavation of the site, no doubt intrigued by the power of the objects he found cast about.

The discovery of Mesa Verde had only occurred barely a few years before Nordenskiöld's expedition in 1888, and here he was digging up a virgin site with the very discoverer himself, Richard Wetherill. These findings sparked a general interest, many arriving to take some souvenirs home, others standing in awe at the pueblo's expansive majesty. Nordenskiöld was in the right place at the right time, for he happened to be passing through Durango, Colorado, on, of all things, a world tour, which he never completed.

There were no laws to prevent Nordenskiöld from not only excavating, but also taking away any items he found. So crate after crate of precious adobe ceramics, baskets, and artifacts were loaded onto boxcars for transport back home to Sweden.

Locals were at first perplexed and then apoplectic. How could we allow our American heritage to be taken out of the ground and simply shipped abroad by thieving Europeans? However, no theft had taken place. Even though Nordenskiöld was jailed and then hauled into court to account for his actions, no one could convict him of a crime because no Colorado statute existed to prevent him from taking found objects out of the state, or, for that matter, the country. The Mesa Verde incident has died down, and the artifacts, as precious as they are, are now in a museum in Finland, being cared for and preserved as any other ancient artifact should be.

An analogous situation involving the Elgin Marbles has certainly not died down; in fact, it has become more contentious and thus more famous with each passing year. The facts of the case are hard to determine, especially since they are enmeshed in partisan politics and ethnic pride. While reasonable people can disagree about hot-button topics like the return of the Elgin Marbles, all too often arguments degenerate into calling the Greeks sore losers and the British thieves. Such arguments get participants nowhere fast.

The circumstances behind the building of the Parthenon do not augur well for those who think that the ancients always preferred the high road in their behavior. Pericles, the ruler of Athens, commanded money as tribute for the protection of Greece from the Persians and considered lesser city-states not as allies but as subjects. He felt that whatever he did with their money was his business, as long as the Greeks were protected.

Unfortunately for his allies, Pericles did a lot with their money, including bribing the Spartan army to retreat for his own purposes. He also encouraged and acted as a patron for the greatest Greek dramatists of his time including Sophocles, and the greatest Greek historian of his time, Herodotus. His biggest, and by far most expensive accomplishment, was the building of the monumental Acropolis of Athens, with its shining focus, the Parthenon, in the mid-fifth century BC.

Greek city-states were horrified, but there was little they could do to prevent Pericles from spending their money as he wanted. Fortunately, Pericles was surrounded by a vast talent pool of artists and architects who could carry out his vision according to his wishes; chief among them were accomplished architects Iktinos and Kallikrates and the fabled sculptor Phidias.

Progress was speedily made, and the construction and decoration of the Acropolis dazzled those in the ancient world, who were more accustomed to measuring the construction of major buildings across generations of time.

Among the glories of the Acropolis are the magnificently carved sculptures on the Parthenon and the nearby Erechtheion, both part of an elaborately orchestrated plan that ultimately contributed to the worship of Athena, the goddess whom the temple was dedicated to. About half of these sculptures have come down to us known as the Elgin Marbles and are located in the British Museum. The other half are in Athens, and a few fragments are scattered in museums around Europe.

The incredibly high level of quality carving in Greece has been the inspiration behind the naming of the period the classical age, as if it were a standard by which all other eras in art history would have to be measured. No one could deny that from the start this was a magnificent set of works in a magnificent setting. The fact that the marbles are located in the most prominent position in the greatest city of the ancient Greek world increased their fame. It also helped that this was a true golden age; everything else about ancient Greek society has not only survived but has been enshrined as cornerstones of civilization from philosophy to drama, architecture, mathematics, and science. Even the planets are named for Greek gods, if only given in their Roman counterparts.

In 438 BC Athenians dedicated a new statue of Athena forty feet high and made of gold and ivory over a wooden frame by, one presumes, Phidias. Nothing remains of this work, lost as it is to the ravages to time. The Parthenon Marbles were completed around 440 BC, and one can safely say they never looked better.

The building reigned as a temple to Athena for a thousand years, surviving Roman domination and periodic warfare. Things changed in the fifth century AD, however, when Athens became a Christian center, and the pagan gods fell into disrepute. At this time, the Parthenon was converted into a church, with an apse carved into the east end of the building, necessitating the removal of the east frieze. There was some deliberate defacing of the sculptures, although evidence does not indicate that it was systematic. A new roof, one that had clerestory windows, added light to the interior, and a bell tower was installed to call the faithful to services.

The church was dedicated to another lady, the Virgin Mary, and became the cathedral in Athens. This indicated an interest in preserving the building for adapted use by another faith. Other ancient buildings throughout the Mediterranean were

similarly retrofitted; the famous Pantheon in Rome was converted into a church, and it remains so today. The magnificent baroque façade on the cathedral of Syracuse, Sicily, hides the Greek Doric temple behind it.

By the twelfth century wall paintings adorned the Pentelic marble walls of the Parthenon, none of which survive. The Fourth Crusade in the thirteenth century yielded the building over to Roman Catholics.

The next major change came in 1458 when the Turks took over Greece and constructed a mosque out of the remains of the Parthenon. The nearby Erechtheion housed a harem. The bell tower became a minaret, and the entire Acropolis was eventually used as a garrison for Turkish troops, the mosque acting as their local site of worship. In 1686 the adjacent temple of Athena Nike was taken down by the Turks to make way for an artillery position.

On September 26, 1687, the Parthenon suffered the worst catastrophe in its long history. The Turks, besieged by a mercenary army under the Venetian general Francesco Morosini, figured that the Parthenon was too famous to attack, and one would never damage the most immortal shrine of antiquity. The Turks filled the interior with gunpowder so that it would be in a relatively safe area. No one saw the irony that this was supposed to be a sacred site dedicated to the worship of Allah, and now was no more than an ammunition dump.

The Turks underestimated the Venetians completely. They had no problem sending rockets into the Acropolis and blowing the Parthenon to proverbial smithereens. The Turks were temporarily driven out of the city, and Morosini took possession of the hill. In his brief stint as occupier of the site, he decided that the sculptures scattered about the Parthenon, and those somehow still attached to the perilously standing west façade, could be removed and sent back to Venice as booty.

Venice enjoyed "imported" works of sculpture. The four Horses of Saint Mark's and the porphyry sculptures of the Tetrarchs were taken from Constantinople when Venetian invaders conquered the city in the Fourth Crusade. A small heel of one of the Tetrarchs has been discovered in Istanbul near the Bodrum Mosque. There has been no effort to reunite the sculptures; the heel remains on triumphant display all by its lonesome self, without context, in the Istanbul Archeological Museum.

Morosini was as clumsy as plunderers could get, smashing some of the pieces as he removed them from the west pediment, and ultimately doing as much damage as possible while coming away empty handed. However, Morosini's secretary was not about to leave Greece without a souvenir. He took a head from one of the pedimental figures back to Venice as a trophy. That head is now in the Louvre.

A Danish officer traveling with Morosini had more luck than his boss. Captain Moritz Hartmann purchased two marble heads that belonged to a metope, or square relief sculpture, from the south end of the building. They were being sold by a local street vendor in Athens. These heads, one of a Lapith and the other of a centaur, prove that extensive pillaging and souvenir hunting had already begun on the Acropolis. The works were famous enough to make a buck from; otherwise, why bother?

Today these fragments are in the Danish National Museum, and are sought after by the Greeks. Unfortunately, the museum has had troubles of its own lately, return-

ing perhaps too many things to their original owners. Icelandic *eddas*, or epic poems, have been sent back to Iceland, Inuit artifacts to Greenland, even a Maori chieftain's head has been returned to New Zealand. They are hesitating over the Greek request for fear the stampede of requests will leave them with nothing worthwhile to display.

Meanwhile the Turks, who retook Athens, considered the immense complex nothing more than a ruin—and an uninteresting ruin at that—treating the ensemble as a junk pile, dissolving some of the sculptures to make lime, and clearing away the center to build a small crude mosque.

By the mid-eighteenth century interest in the Parthenon, and its sculptures, started to reach fever pitch. The uncovering of Pompeii in southern Italy from the ravages of Mount Vesuvius revealed an undisturbed ancient world filled with previously unknown goodies, all for the taking. Maybe there were still fragments of interest left in Athens.

Western Europeans saw Greece as the foundation of civilized thought, and began pilgrimages to Athens. Germans, in particular, were very sensitive to Greek philosophy, because they viewed their Napoleonic enemies, the French, as being attached to Roman classicism. By the end of the eighteenth century tourists were arriving in great numbers, some to admire what was left, others to take home a souvenir or two.

Those with enough money to make the journey were often willing to bribe the necessary authorities to get a piece of a ruin. Bribery, after all, was one of the foundational trademarks of the Ottoman Empire. In fact, in some cases, it was not only the way to do business, but it was a time-honored tradition going back to Pericles himself. The Turks soon realized that those little bits of sculpture that were clinging to a fallen monument were worth cash, and began breaking off sections into portable pieces to produce handsome profits. Worse, others held the marbles up to horrified tourists with a chisel in one hand and a hammer in the other, threatening to deface the works unless the right price was reached. To the Turks, the sculptures were as nothing. To the Westerners, they were everything. Some Turks even cracked the marbles open because they believed that there must be gold hidden inside; otherwise, why else could these Europeans be so interested? What do they know that we don't know?[1]

One French citizen acting as an agent for the French ambassador in Constantinople bribed officials for a piece of the east frieze and a metope that were dug up in the ruins of the Acropolis. Both works are now in the Louvre in Paris. Even Robert Smirke, future architect of the British Museum, took pieces of the Erechtheion home; the pieces have never been found.

The souvenir hunters unwittingly played their part in the destruction of the marbles but may have convinced themselves that they rescued them from obscurity. A few of these ended up in public collections in Würzburg, Palermo, Padua, Rome, and Paris, but most have been lost indefinitely. One emerged by being dug up in a garden in Essex, England, in 1902—no one knows how it got there. Perhaps a few will surface in someone's attic years from now.

Fame, therefore, had no influence on the sanctity of a work of art. In fact, the fame of the Parthenon Marbles has been the source of their demise.

~

Enter Thomas Bruce, or the seventh Lord of Elgin, as he has come to be known. A career diplomat with a passionate interest in antiquity, Elgin traveled extensively on both diplomatic missions and archaeological quests. He married rich, which helped with household expenses as well as his journeys as envoy to Vienna, Brussels, and Berlin.

Elgin's interest in antiquity was sparked by Thomas Harrison, a classical architect who designed his house. Thereafter, Elgin was committed to going to Greece, and tried to get the young Joseph Turner to come as his artist in residence to sketch the ruins. Turner was willing to go, but Elgin's terms insisted that he would have complete possession of every drawing and sketch that Turner executed. In his free hours Turner was expected to give drawing lessons to Lady Elgin. Just what the fiery Turner wanted to do. Turner's demand of £400 per year was too much for Elgin, who knew he could get an artist cheaper.[2]

Ultimately, Elgin sent himself to Istanbul where he sought for artists and molders to gain access to the Parthenon. The artists were to sketch the remaining sculptures, and the molders were to make casts for British collections. By 1801 he was given permission to access the site, at a cost of five guineas a day, said to be very steep. Bribery was certainly involved at any number of steps along the way.

In the early nineteenth century Athens was about as miserable a place as anyone could imagine. It wasn't even a shadow of its ancient self; the Ottomans had so denuded the city of any of its past glory, leaving a motley collection of 1,300 shanties. Half the inhabitants did not even speak Greek.

The Turks, however, refused to allow the erection of scaffolds for the molders because the Erechtheion was still being used as a harem for Turkish women, and it would have been unseemly to have the British look at them in their private world.

Elgin obtained what is called a firman, a decree by a monarch, which enabled him to go to the Acropolis and have some access to the sculptures. The Turks were positively disposed to the English, because the French under Napoleon capitulated to the British in Ottoman-controlled Egypt, so it comes as no surprise that the English were given permission hitherto denied to French or German interests.

Here is where things get sticky. The firman is no longer in existence, and only a translation, in Italian of all languages, remains. The firman states:

1. To enter freely within the walls of the Citadel, and to draw and model with plaster the Ancient Temples there.
2. To erect scaffolding and to dig where they may wish to discover the ancient foundations.
3. Liberty to take away any sculptures or inscriptions which do not interfere with the works of the walls of the Citadel.[3]

Elgin put a Sicilian landscape painter, Giovanni Battista Lusieri, in charge of the removal of the marbles. Previously, Lusieri had been engaged by the king of Naples to paint Sicilian antiquities. Elgin offered him a salary of £200 per annum, and Lusieri, newly in need of a patron, accepted the opportunity, although he could not speak English, and Elgin could not speak Italian.

His role as company artist was only the beginning; in a short time he became company excavator, and Lusieri began removing works from the Parthenon itself. He damaged the cornice of the structure but seems to have harmed little else, although the exact nature of Lusieri's excavations is unclear. Some of the sculptures were found buried on the site; others were ripped from the building's structure. In any case, the removal took eleven years—Lusieri being hard at work from 1801 to 1811.

Lord Elgin, also eleventh Earl of Kincardine and British ambassador to the Ottoman Empire from 1799 to 1803, famously removed the Parthenon Sculptures and brought them to Britain in 1801. This image was engraved by George Perfect Harding in 1787. *Private Collection / Bridgeman Images*

It seems logical that if the Ottomans really objected to anything Lusieri or Elgin did, they would have had ample time to stop them. But so little was the Turkish interest in the Greek past, they did not even care to slow down their progress. When a ship containing seventeen crates of marbles sank in Kythera harbor, the Greek sculpture was recovered and sent on its way to Britain. Certainly they were not stolen under cover of nightfall.

The last ship to leave Greece set sail on April 22, 1811, with Lusieri and the poet Lord Byron on board. Byron was not pleased at all.

Byron's poems were read everywhere, by every literate person in early nineteenth-century England. His *Childe Harold's Pilgrimage* was published March 1, 1812, and was sold out in three days. Imagine any volume of poetry published today that would have a similar impact on the marketplace.

Childe Harold arrives in Greece sitting on a "massy stone, the marble column's yet unshaken base" and contemplates the ruins of the Parthenon:[4]

> XI.
> But who, of all the plunderers of yon fane
> On high, where Pallas[5] lingered, loth to flee
> The latest relic of her ancient reign—
> The last, the worst, dull spoiler, who was he?
> Blush, Caledonia![6] such thy son could be!
> England! I joy no child he was of thine:
> Thy free-born men should spare what once was free;
> Yet they could violate each saddening shrine,
> And bear these altars o'er the long reluctant brine.[7]

> XII.
> But most the modern Pict's[8] ignoble boast,
> To rive[9] what Goth,[10] and Turk, and Time hath spared:
> Cold as the crags upon his native coast,
> His mind as barren and his heart as hard,
> Is he whose head conceived, whose hand prepared,
> Aught to displace Athena's poor remains:
> Her sons too weak the sacred shrine to guard,
> Yet felt some portion of their mother's pains,
> And never knew, till then, the weight of Despot's chains.

Byron continues a little later:

> XV.
> Cold is the heart, fair Greece, that looks on thee,
> Nor feels as lovers o'er the dust they loved;
> Dull is the eye that will not weep to see
> Thy walls defaced, thy mouldering shrines removed
> By British hands, which it had best behoved
> To guard those relics ne'er to be restored.
> Curst be the hour when from their isle they roved,
> And once again thy hapless bosom gored,
> And snatched thy shrinking gods to northern climes abhorred!

Byron's own fame enhanced Elgin's, and moved the discussion of the marbles into another dimension, one which it would be impossible to extricate itself from. Interestingly, Byron's feelings sometimes depended on who might do the taking. When he spoke of the possibility of the French taking the marbles, he referred to this as a rescue.

Meanwhile, the marbles had to be put somewhere, even if temporarily. They were popular, but heavy and cumbersome. At first they were placed in a hastily erected shed on the grounds of Elgin's house. It is here that people asked for and were granted permission to visit. Artists flocked to the sight. Those as famous as sculptor John Flaxman (who said it was "the finest works" of art he had ever seen),[11] and painters Henry Fuseli, Benjamin West, and Thomas Lawrence came to stare and sketch. Even the most famous artist of his time, Antonio Canova, came to London just to see them. When asked if he would restore them and thus enhance their value, he responded: "It would be a sacrilege in him or any man to presume to touch them with a chisel." He also remarked, "Oh that I had but to begin again! To unlearn all that I had learned!— I now at last see what ought to form the real school of sculpture!"[12]

Canova wrote a now famous letter to Lord Elgin, thanking him for the opportunity to see the sculptures:

> I can never satisfy myself with viewing them again and again; and although my stay in this great metropolis must of necessity be extremely short, I am still anxious to dedicate every leisure moment to the contemplation of these celebrated relics of ancient art. . . . I am persuaded therefore that all artists and amateurs must gratefully acknowledge their high obligations to your Lordship, for having brought these memorable and stupendous sculptures into our neighborhood.[13]

The artistic world was mesmerized. These works, by their reputation of being on the most sacred of ancient sites, and their daring removal and arrival in London, became instantly world famous.

Not everyone was so rapturous. Richard Payne Knight, a most generous benefactor of the British Museum, said, "You have lost your labour, my Lord Elgin. Your marbles are overrated; they are not Greek; they are Roman of the time of Hadrian."[14]

Even if praise was not universal, there was no reason to misuse the sculptures. In June 1808, a prizefighter named Gregson stood naked before the Elgin Marbles for two hours in various poses so that his anatomy could be compared to the ancients.[15] Viewers paid admission to this men-only event, certainly one of the strangest things to ever take place before a work of art. Even more strangely, three boxing matches took place with the sculptures as a backdrop.

Elgin loved the idea that his marbles were garnering great publicity. He even invited Mrs. Sarah Siddons, the greatest actress of her day, and the subject of masterful portraits by Gainsborough, Reynolds, Lawrence, and Gilbert Stuart, to a private viewing. The first sight of the sculpture grouping called the Fates, Elgin tells us, "so rivetted [sic] and agitated the feelings of Mrs. Siddons, the pride of theatrical representation, as only to draw tears from her eyes."[16]

Having divorced his wealthy wife, Elgin was in deep financial stress, and now stuck with sculptures that were incomplete, ripped from their context, and haplessly

displayed in a house owned by the Duke of Devonshire. Parliament was asked to buy the marbles, and put them in a museum for all to see. However, there were questions, the kind of questions that perhaps would not be asked today:

"Do you think it of great consequence to the progress of art in Britain, that this collection should become the property of the Public?"[17]

"In what class of art do you rate them?"[18]

"As compared with the Apollo Belvidere [sic] and Laocoön, in what class should you place the Theseus and the River God?"[19]

The debate was furious. Nothing could have propelled the marbles into public view more than the fact that their worth was going to be publicly debated, and that public money was going to be used to purchase them. The final price agreed upon by the House of Commons was £35,000, a steal for certain, but nowhere near enough for Lord Elgin, who was in debt for nearly twice that much mostly from the costs incurred in Greece, the shipping to England, and the housing of these works in London. Take it or leave it, Parliament declared; but in their defense, it is inconceivable today that a modern government would spend a sum like this on an art collection.

Some Englishmen thought it was the opportunity of a lifetime, and encouraged Parliament. The young poet John Keats, age twenty-one, stood mesmerized before the sculpture and penned this sonnet in 1817:[20]

On Seeing the Elgin Marbles for the First Time

My spirit is too weak; mortality
Weighs heavily on me like unwilling sleep,
And each imagined pinnacle and steep
Of godlike hardship tells me I must die
Like a sick eagle looking at the sky.
Yet 'tis a gentle luxury to weep,
That I have not the cloudy winds to keep
Fresh for the opening of the morning's eye.
Such dim-conceived glories of the brain
Bring round the heart an indescribable feud;
So do these wonders a most dizzy pain,
That mingles Grecian grandeur with the rude
Wasting of old Time—with a billowy main,
A sun, a shadow of a magnitude.

A second sonnet heaped contempt on Payne Knight for his misjudgment of the value of the sculptures.

Britain, however, was not like continental Europe in terms of art collecting. The royal collections of the kings of France became the Louvre; the kings of Spain, the Prado; and the kings of Holland, the Rijksmuseum. No such arrangement existed in England. The royal collection today is still the royal collection, housed in the Queen's various homes scattered throughout the country.

Rich British collectors allowed savants entry to their homes by appointment to see their expansive collections—they were not open to the public. In 1753, seventy-one thousand objects were bequeathed to the new British Museum by Sir Hans Sloane

in return for a payment of £20,000, but access was limited to "all studious and curious Persons."[21] It was not until 1805 that free access to all was granted. Art collections were thought of as the province of the wealthy, not the government, hence the dickering over whether or not the British government should acquire the Elgin Marbles.

Back in Greece Lusieri continued digging, but not much of value was being sent to England, and by 1819 Elgin terminated his services, sort of, even if he did not have the heart to flatly tell him so. Lusieri remained as Elgin's employee for another two years, shipping miscellaneous objects by the hundreds to London. Unfortunately, Lusieri died a horrible death, one that made yet another sensational mark on a sensational episode. It wasn't so much that he died of a ruptured blood vessel, but that he was to bear the weight of Greek animosity against Elgin, so much so that he had to barricade himself in his house every night for fear of the avenging Greeks. He was discovered one morning, lying on the floor in a pool of blood, with a black cat seated on his chest.

Of all people to be enmeshed in the Elgin affair, Lusieri was probably the saddest. An artist of exceptional talent, he had an extraordinary gift for depicting evocative landscapes. Lord Byron referred to him as "an Italian painter of the first eminence," and then went on to explain that he "is the agent of destruction [of the Elgin marbles] . . . he has proven to be an able instrument of plunder."[22]

Despite the great acclaim Lusieri garnered, he languished in Athens. Had he been in a European center, he would have influenced the history of watercolor painting in a significant way. Shut away in a corner of Europe, he could do little more than send back reports from the field to a marginally interested British elite.

Unfortunately, Lusieri was not the only one to suffer an unlucky death; his artwork died, too. All the drawings he did of his stay in Athens, except for two, went down to the bottom of the Mediterranean when the ship that carried them sank along with that boatload full of antiquities at Kythera.

Lord Elgin, too, had a miserable end. His high-handed manner and imperious nature cost him his marriage; the marbles ruined him financially. Syphilis wracked his body, making his nose fall off.

Even Gustaf Nordenskiöld fared poorly. Constantly ill and beset by issues of plundering, he died aboard a train in Sweden in 1895. He was twenty-seven.

The site in Athens remained a collection of ruined things for the rest of the nineteenth century, perhaps more stimulating to the romantic mind who found the heaps of rocks more evocative to the soul than a finished reconstruction.

It was in this state that Mark Twain saw the Acropolis in 1869, when he published his Mediterranean journey called *Innocents Abroad*. After encountering one ancient civilization after another with one satirical grin after another, Twain stopped dead in his tracks and gazed at the sight of the Parthenon, made more alluring by its ruins:

What a world of ruined sculpture was about us! Set up in rows—stacked up in piles—scattered broadcast over the wide area of the Acropolis—were hundreds of crippled statues of all sizes and of the most exquisite workmanship; and vast fragments of marble that once belonged to the entablatures,[23] covered with bas-reliefs representing battles and sieges, ships of war with three and four tiers of oars, pageants and processions—everything one could think of. History says that the temples of the Acropolis were filled with the noblest works of Praxiteles and Phidias, and of many a great master in sculpture besides—and surely these elegant fragments attest it.

We walked out into the grass-grown, fragment-strewn court beyond the Parthenon. It startled us, every now and then, to see a stony white face stare suddenly up at us out of the grass with its dead eyes. The place seemed alive with ghosts. I half expected to see the Athenian heroes of twenty centuries ago glide out of the shadows and steal into the old temple they knew so well and regarded with such boundless pride.[24]

~

The Elgin Marbles were now their official name, and as part of the agreement with Elgin, it was their only name. They were enthroned in the newly built British Museum, whose façade looks like a modern adaptation of the Parthenon, complete with a version of pedimental sculptures. Inside this Ionic temple of the arts, the Parthenon Marbles were the center of attention, a situation that has remained unchanged for two hundred years. The display featured all the pieces Britain now owns, along with casts and photographs of the remaining pieces in Greece, so that the works can be appreciated in context.

The British, however, have not always protected the marbles as they should. Despite Canova's insistence that restoring the sculptures would be a sacrilege, nineteenth-century museum curators thought differently. Sandpaper was used to shave off pollution, and acid was used to clean the surface. The Elgin Marbles were not alone in suffering this fate. Works as famous as Michelangelo's *David* were "restored" similarly in the nineteenth century.

During World War I the marbles were hidden way in the basement for safety, and returned in 1919. However, ideas about museum displays had changed over the years, and the nineteenth-century mountings began to look old fashioned. Moreover, the sheer volume of people entering the museum made the current display inadequate. To the rescue came Joseph Duveen, who was determined to build a new gallery to properly house the Elgin Marbles.

Duveen, however, attached a series of conditions to his gift of £100,000 and intended the marbles to be displayed only in the way he saw fit. He enlisted the talents of American architect John Russell Pope to erect a wing suitable for housing and displaying the Elgin Marbles. Pope has often been called the last classical architect, since he continued building structures in the classical vein long after the Greek revival had died. His other great buildings include the Jefferson Memorial, the National Archives, and the National Gallery in Washington—it almost seems as though the architect could build nothing but columns and pediments in an age more associated with vertical American skyscrapers and artful Bauhaus designs.

Duveen took flack for hiring an American architect, as if the museum trustees had no say in the planning of the structure and the installation of the sculptures. In return for his gift, Duveen expected and got a peerage. He also sought a royal opening, which was denied. He also wanted the sculptures cleaned, to look pure white. Years of London smog and the museum's heating system had added a layer of dirt to the orange-brown patina the surface already had.[25]

Although the trustees had absolutely forbidden the restoration of the marbles, one day in September 1938 the museum director had discovered a workman cleaning one of them with copper tools and carborundum rubber, a harsh abrasive. Worse was to come, when it was discovered that some of the masons had begun removing the patina with chisels so that the surface could appear whiter. Duveen, who had already been guilty of overcleaning a number of old masters in his collection, was certainly behind this effort.[26]

When the British press found out about it, they were enraged. The museum covered its tracks with a number of statements expressing minimal damage and the sacking of those involved, but the publicity was enough to chill any opening reception this gallery would have. For these reasons, a royal unveiling was out of the question.

Opening ceremonies were announced for summer 1939, but with impending World War II air raids very likely, the sculptures were covered with iron, timber, and sandbags, and the ceremonies were largely forgotten. Later, unused London Underground stations protected the frieze.

This was lucky. In 1940 the Duveen Gallery suffered a direct hit that damaged the central core of the building, a hit so devastating that it could not reopen until 1962.

In 1943 when Greece was firmly under Nazi control, President Franklin Roosevelt approached George Vournas, the president of a Greek-American association, and asked him about the Elgin Marbles. Vournas had little information Roosevelt did not have, but Roosevelt greatly admired Greek resistance efforts in the war and wanted to repay the Greeks for their sacrifice. Roosevelt had a plan to restore "stolen" art after World War II—all stolen art, not just German stolen. This included all those objects equally taken by Napoleon, Nazi leader Hermann Goering, and Lord Elgin. Roosevelt never lived to see the end of World War II, and his plan, if there ever was one on paper, died with him.[27]

As if the marbles' checkered history were not enough to make them famous, notoriety from a new push by the Greek government to take back what they felt was illegally given away has polarized any discussion of the work and forced participants, and the public, to take very visible stands. After World War II the Greek government began to politely suggest that the British return the marbles. When they were politely rebuffed, the Greeks ratcheted up their request to demands. Both sides have their points, but no matter what angle one approaches the topic from, the central sticking point is the firman issued by the Turks—beyond that, the other reasons devolve into sentiment or bluster.

In the meantime John Henry Merryman, legal expert from Stanford University publishing in the *Michigan Law Review*, has looked at the merits of the case and has

decided that if such a situation were ever to be brought to court, the British would probably win. That is mostly likely the reason why the Greeks have never brought suit in an international court. Losing would be fatal to their cause.

Publicity, however, can only enhance their case. Who can resist the argument that the sculptures should be together in one setting, the way they were intended to be? And who can resist an international film star who can articulate the Greek position most dramatically and effectively?

In keeping with efforts to maintain maximum publicity and sympathy, the Greek government made fading film legend Melina Mercouri the official minister of culture. This was no honorary post. It meant that she would be in charge of a host of archaeological sites from Minoan civilization through the Byzantine period, and each with its corresponding pressing demands stemming from centuries of neglect, plunder, and fearful restoration. Every Greek island of any size has a ruin, or a damaged mosaic, or unearthed treasures. Even with all this to contend with, Melina Mercouri was after the big fish.

In her letter to the British Museum she eloquently expressed the Greek government's position in the form of demands: "These most precious treasures were literally snatched, and this barbarism was not committed by the Turks but by the then British Ambassador to Turkey, who, using bribes and the corruption of Turkish employees, obtained a permit to commit this vandalism."[28]

During a question and answer period with *New York Times* reporters, Ms. Mercouri was even more emphatic and more declamatory:

> They are the symbol and the blood and the soul of the Greek people. Because we have fought and died for the Parthenon and the Acropolis. Because when we are born, they talk to us about all this great history that makes Greekness. Because this is the most beautiful, the most impressive, the most monumental building in all Europe and one of the seven miracles of the world. Because the Parthenon was torn down and mutilated when we were under the Ottoman Turkish occupation. Because the marbles were taken by an aristocrat like Lord Elgin for his own pleasure. Because this is our cultural history and it belongs not to the British Museum but to this country and this temple.[29]

Ms. Mercouri was successful at maintaining a strong front-page spotlight on the marbles, aiming every possible salvo at the British Museum, the British government, and anyone else who might be standing in her way. She told the *San Francisco Chronicle* that the British and the Greeks were brothers; after all, "We have fought with you in the second world war."[30] But then she fired at the same government that the plundering of the Acropolis was worse than the Nazi pillaging of artwork in World War II.[31] Hyperbole may not be the most effective courtroom practice, but it works wonders in the court of public opinion.

Behind the British reluctance is the realization that it opens a door that calls into question every work of art that is not in its original location. If these works are to be sent back to Greece, what's to prevent the Greek government, or any government for that matter, from demanding that all the works of art originally done under their

contemporary borders be shipped back? When works of art are acquired, how is one to know what future international boundaries will look like?

Melina Mercouri died of lung cancer in 1994, but her quest is far from over. In fact, in some ways it has picked up speed. New focus has now been placed on the scattered bits of the Parthenon in other European museums, in hopes of whittling down the British. The first is a small piece only four inches long that probably shows a fragment of a man's leg that somehow, no one knows exactly how, ended up in the University of Heidelberg museum in Germany. It was not discovered as being part of the Parthenon until 1948 when a German archaeologist noted that the back has the word "Parthenon" emblazoned on it, in modern Greek. The museum was careful to aver that this was a one-time-only offer, and the transfer of this fragment was a special case and would only be accomplished by the exchange of the marble fragment for a comparable work. So in January 2006, with great ceremony, it was announced that the fragment would be returned, and installed in the newly built museum in Athens.

The Greek government reacted to the return of the Heidelberg fragment as a "highly important symbolic gesture." In other words, they were building a case for the Elgin Marbles.[32]

In November 2006 a retired Swedish gym teacher, Birgit Wiger-Angner, the descendant of a Mediterranean adventurer over a hundred years earlier, decided to return a small fragment of a marble thought to be a piece of the Erechtheion in Athens. This temple, adjacent to the Parthenon, shares the same mystical ancient significance as the Parthenon. The return was greeted jubilantly in Greece. One wonders what the reaction would have been if it was given to the English instead.

One move often inspires others. In 2008 Italian president Giorgio Napolitano declared it was time to restore artifacts "torn from their context," and declared that a fragment of the Parthenon frieze in a museum in Palermo was to be returned to Greece. This piece had been in Sicily since the early nineteenth century, when it was given to the University of Palermo by the wife of a British diplomat, and was sent on "permanent loan" to the Acropolis Museum. This permanent loan turned out to last two years—those in Palermo wanted their piece back, and they got it. In April 2010 the fragment, depicting the hem of a goddess's skirt, was sent back without ceremony.

Italy has been the most active country in the world for the repatriation of its artwork, and so seems to be acting as an example to others. In 2008, the Vatican announced that it would loan, for one year, one of its three fragments for display at the Acropolis Museum. The piece, again small at ten inches or so, depicts a man carrying a tray.

As the British Museum rightly pointed out, the Vatican move was "just a loan," but symbolically it does seem to indicate a movement toward a reunification of the work. In an effort to be conciliatory, the British Museum offered a three-month loan of all the marbles in exchange for Greece's renunciation of claims to own them. This offer was met with ridicule, and perhaps took the arguments for and against to a more fevered pitch.

The new Acropolis Museum has not been without controversy, either. It turns out that it is built on a site that houses important ruins that had to be disturbed for

construction to proceed. The very mission of the museum, to display, preserve, and protect ancient Greek works, is built on a site that destabilizes the ancient architecture below. Buildings around the museum were also targeted for demolition, not because they are harming the archaeological treasures, but because they block the view from the museum restaurant.

Piece by piece the Acropolis is being reassembled, but no amount of imagination, and no complete gathering of extant marbles can ever put Humpty Dumpty back together again. Even if the British did return the sculptures, the Greeks certainly would not place them on the Parthenon, especially in a city known for its punishing air pollution.

The Greeks themselves may want the marbles back, but studies show that after the eighth grade Greeks almost never visit these monuments, and most ancient sites are utterly neglected. Other than museum employees, almost no one speaks Greek in a Greek museum or archaeological site. These monuments are more visited, written about, and studied by foreigners than by locals. The amount of scholarly material about the Parthenon in English, German, and French vastly overwhelms those in Greek. However, even in light of all this, there is a legitimacy to the Greek claim for the sculptures.

No one can doubt the impact that the Elgin Marbles and the Parthenon have made on the modern world. There is even a replica of the Parthenon in, of all places, Nashville, Tennessee, which fancies itself as the "Athens of the South." Publicity like this has enshrined the Parthenon on the American imagination more firmly than the debate surrounding the marbles themselves.

Modern Greeks, who think of their ancient forebears as being only a generation or two removed, can claim to look back on their ancestry with pride, but in reality the connection between any people—English, Greek, or American—from any ancient society to a modern one is tenuous at best. Egyptians are especially awed by the Pyramids, but the modern Egyptian has little to do with the language, culture, laws, customs, or religion of the pharaohs. The same can be said of the Greeks, or for that matter the Americans who watched helplessly as the pueblo ruins of Mesa Verde were taken to Sweden.

When the Greeks and the English both claim that the Parthenon Marbles belong to the world they are right, but where in the world should they be displayed? As one pithy Englishman said in another context a long time ago: Ay, there's the rub.

• 4 •

Apollo Belvedere

The Rise and Fall of the *Apollo Belvedere*

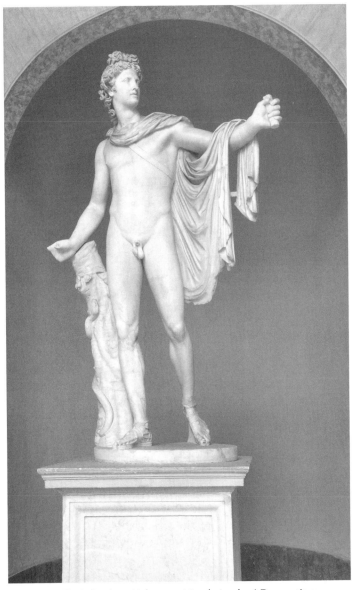

Apollo Belvedere. Valentyna Merzhyievska / Dreamstime

For four hundred years after it was discovered, the Apollo *was the most admired piece of sculpture in the world.*

—Kenneth Clark, *Civilisation*

One of the grandest celebrations in the long history of Paris took place on July 27, 1798. Napoleon, fresh from his distinguished victories in Italy, returned to Paris with an impressive array of booty, clearly demonstrating to anyone alive that this emperor could have anything he liked, and that he liked a great many things: nine paintings by Raphael, two paintings by Correggio, a collection of minerals, animals from zoos, manuscripts stolen from the Vatican, and the four bronze horses from Saint Mark's in Venice.[1] Greek and Roman statuary was similarly pillaged: *The Discus Thrower, The Dying Gaul, Laocoön,* and the *Medici Venus* were all paraded down the boulevards of Paris. Standing in the place of honor in this distinguished procession of plunder was the *Apollo Belvedere,* one of the greatest of all antique sculptures, or so the eighteenth century thought. Carefully crated in the Vatican, the *Apollo* was spirited away to Paris to be the centerpiece in the Louvre, and the centerpiece of Napoleon's cultural affections.

Why not? Didn't emperors before Napoleon remove what they wanted from conquered territories to fill the treasure-houses of their own lands? Napoleon was neatly falling into that tradition, remaking the Louvre into his own image by renaming it the Musée Napoléon.

Napoleon had a plaque placed at the base of the statue accrediting himself with bringing the sculpture to Paris. The inscription read, "The statue of the Apollo which stands on this pedestal was found in Antium at the end of the 15th century, placed in the Vatican by Julius II at the beginning of the 16th century, conquered in the fifth year of the Republic by the army of Italy under the command of General Bonaparte was fixed on the 21 Germinal Year 8, the first year of his consulate."[2]

However, it wasn't enough to own the *Apollo Belvedere* and have your name under it; in Napoleon's case he had to actually become this sculpture. In a contemporary etching Napoleon is showing off his prize sculpture to an adoring crowd of deputies, who in response notice that the poses, stances, and attitudes of Napoleon and Apollo are identical. Napoleon apparently did not consider humility a necessary virtue. In fact, decorative medals were issued in 1804 by French medal engraver Bertrand Andrieu, featuring the *Apollo Belvedere* at the center of the Salle de L'Apollon in the Musée Napoléon.

These comparisons were only just beginning. In Antoine-Jean Gros's most famous painting, *Napoleon in the Pesthouse of Jaffa,* the emperor appears in a medical sanctuary that houses his troops dying of plague. Other soldiers cover their noses from the stench, but Napoleon, *Apollo Belvedere*–like, reaches to the wound at the side of the stricken soldier as if to cure him. Apollo's association as a divine healer is paralleled with Napoleon himself, who braves the effects of the disease and boldly strides forward. The artist maintains two allusions in this painting. Napoleon can cure as Apollo does, but he is also Christlike in his abilities to make the diseased whole. Moreover, the *Apollo*'s pleasing physique flatters Napoleon's less than comely form.

Napoleon will not be the first nor the last to see himself as the *Apollo Belvedere*; indeed, it is arguably the most copied marble from the ancient world, wildly popular from the Renaissance to the end of the nineteenth century.

~

The origins of the sculpture are unknown. An early antiquarian, Ennio Quirino Visconti, has theorized that it was commissioned by the Athenians in thanksgiving to Apollo after a plague struck the city during the Peloponnesian War between 431 and 404 BC. The serpent at Apollo's side represents medicine;[3] Visconti opined that this was Apollo's gift to mankind.

Apollo was one of the greatest gods on Olympus, the son of Zeus and Leto. He is variously described as the sun god, and the god of music, poetry, and the fine arts. He is also associated with the healing arts, and is therefore the patron of medicine. Moreover, he is the god of prophecy; in this capacity he founded Delphi, where his chief temple and the oracle are located. While searching for a suitable location for his temple, he discovered a gorge in Parnassus where he killed the serpent Python with bow and arrows. The Pythian Games held in the third year of each Olympiad, beginning in 776 BC,[4] commemorate the event.

Apollo is the personification of a youthful hero: beardless, heroic, and classically ideal. It is in this guise that we see him in the *Apollo Belvedere*.

No one is really sure if the sculpture was carved as far back as 414 BC; in fact most scholars aver that what we have today is a Roman copy of a lost bronze original tentatively ascribed to the sculptor Leochares, and that the date of the original is around the late fourth century BC. The Greek geographer Pausanias said that a statue of Apollo by Leochares stood in front of the Temple of Apollo Patroos in Athens, but we have no way of knowing if this is the sculpture in question. This copy dates to perhaps the first or second century AD, and was carved in Rome, and in all likelihood was based on a number of originals, and therefore might be a pastiche, probably assembled from several sources.

Also in question is whether or not the original sculpture had the drapery hanging behind the back of the figure. The Greeks called this article of clothing a chlamys, and it was usually a seamless garment woven into a rectangle. It was worn around the upper body and attached at one shoulder by a fibula, which is an ornamental brooch or clasp. In Greek art this cloak is worn without any other garments, and as can be seen in various depictions of military figures or messengers. The chlamys provides a backdrop to the work, almost like a curtain hanging behind the figure, and limits the spectator's viewpoint to the front. No doubt this rendition of Apollo was meant to be placed in a niche or in front of a wall.

Since Antium (modern name Anzio) was the seat of Emperor Nero's summer villa, and since we are fairly certain that this *Apollo* was a Roman copy, it is likely that the sculpture was carved to adorn his seaside home—perhaps the emperor felt a connection to the god himself. If he did, he wouldn't be the first nor last emperor to possess such an imagination. Perhaps too Nero was a cultivated and discerning col-

lector of fine art, despite the fact that history tells us he was barbaric and cruel, even murdering his wife. The *Apollo*, then, can be seen as serenely ruling over this chaotic setting until the fall of Rome.

∾

Although no precise records exist, we know the *Apollo Belvedere* was found in the late fifteenth century, and quickly made its way into the collection of Cardinal Giuliano della Rovere, who later became Pope Julius II (r. 1503–1513). He was one of the single greatest patrons in the history of art, having inspired Raphael, Michelangelo, and Bramante, among many others, to achieve greatness.

It may have been first displayed in the private garden of the cardinal in his favorite church, San Pietro in Vincoli, in Rome. In 1489 a chronicle records its first presence: "In Rome this year has been found a very dignified and ancient Apollo in marble in Saint Peter in Chains."[5] Later, this church proved to be the cardinal's final resting place, with Michelangelo's *Moses* acting as his tombstone. The *Apollo* attracted only a little notice here, perhaps because its location was not conveniently located. Other scholars have indicated that the *Apollo* may have been placed in an even more remote location, in a garden adjacent to the Church of Santi Apostoli in Rome.[6]

However, artists had early access to the work, including Antico, one of the great Renaissance masters of small-scale bronze sculpture. He produced the first of what would eventually become an endless series of replicas and adaptations. An eighteen-inch bronze now in Frankfurt reproduces the easy grace and fluid motion of the original, without the supporting strut. There must have already been an eager audience for Antico's bronze in an age in which artists only worked on commission, for he created three such *Apollo*s in the 1490s, well before it was engraved. Antico was not alone. A more freely adapted twelve-inch bronze now in Budapest, perhaps by Andrea Sansovino, indicates a wider audience, since he worked primarily in Venice.

When the cardinal was elected Pope Julius II, the *Apollo* followed him to the newly constructed Belvedere Palace. Bramante designed a grand interior courtyard for the purpose of showcasing antique sculptures, of which Julius had plenty, including the *Laocoön* and the *Venus Felix*. The *Apollo Belvedere* was installed in its niche by 1511, although it had already been commented on as being in the Vatican before this, because the statue had started creating significant buzz. The exclusive location of the courtyard had the effect of conferring dignity and status on this sculpture, much the way a museum today would put a prize work in a gallery alone. After this, those who had sizable collections began to display their antique works in outdoor settings that look like the sculpture gardens of today.

Julius perhaps did not know it at the time, but the establishment of his Belvedere sculpture court was going to inspire artists for generations, even centuries. Enormous statues of the Tiber and the Nile, acting as fountains, were placed in the center. The other sculptures, including the *Apollo*, as well as the *Laocoön*, were located in niches around the surrounding walls, where they can still be seen. Julius's and Bramante's intentions show an interest in re-creating the appearance and the spirit of an ancient Roman villa, inspired by the Roman writer Pliny the Younger.[7]

The placement of the *Apollo Belvedere* in this courtyard indicates that it had a special place in the heart of Pope Julius. It was Apollo's Delphic oracle that foretold the rise of Rome out of the ashes of Troy, paralleling the reconstruction of Saint Peter's and indeed the whole city of Rome under Julius's vision.[8] By extension, Julius became a modern Apollo, even commissioning Raphael to paint a *Parnassus* for his library. At the center of the composition would be Apollo freely adapted from the *Apollo Belvedere.*

Artists began sketching the work immediately. The great German artist Albrecht Dürer must have seen one of these sketches, because he used the figure of Apollo to represent Adam in his 1504 engraving of *Adam and Eve.* It was only a short step from sketches to engravings, some from distinguished artists of the period: Francesco Francia, Baccio Bandinelli, Marcantonio Raimondi, and Agostino Veneziano. Copy after copy after copy was made, each a little different—perhaps in a slightly different pose—many containing appropriate elements of antique decay, in a work that ironically has come down to us in an excellent state of preservation.

As was the custom in the sixteenth century, the sculpture was not seen as fit for viewing unless any missing parts were crafted. To that end, Michelangelo recommended his assistant, Giovanni Angelo Montorsoli, to restore the work in 1532 by attaching sculpted hands to the lacking forearms. Montorsoli decided that Apollo should be an archer, as he can sometimes be seen in similar works; his left hand was restored with a bow, to punish those who exhibit wanton presumptuousness. His right hand held laurel branches with bandages as a sign of his healing powers. Today it is believed he may have held arrows in his left hand.

Amid the ruins of so many antique works, many of just as fine quality, what makes the *Apollo Belvedere* so noteworthy, so eye catching?

The Renaissance saw the same qualities in the *Apollo* that the first art historian, Johann Winckelmann, did in the eighteenth century. His purple prose may seem silly today, but it was taken with all sincerity by his readers:

> Among all the works of antiquity which have escaped destruction the statue of Apollo is the highest ideal of art. . . . His stature is loftier than that of man, and his attitude speaks of the greatness with which he is filled. . . . An eternal spring, as in the happy fields of Elysium, clothes with the charms of youth the graceful manliness of ripened years, and play with softness and tenderness about the proud shape of his limbs. Let thy spirit penetrate into the kingdom of incorporeal beauties, and strive to become a creator of a heavenly nature. . . . His lofty look, filled with a consciousness of power, seems to rise far above his victory, and to gaze into infinity. Scorn sits upon his lips, and his nostrils are swelling with suppressed anger, which mounts even to the proud forehead, but the peace which floats upon it in blissful calm remains undisturbed, and his eye is full of sweetness as when the Muses gathered around him seeking to embrace him.[9]

What Winckelmann and other eighteenth-century critics saw as positive attributes, the modern world now sees as not just defects but as glaring faults. Its smooth composition, effortless stride, and serene composure now smack of a glossy copy rather than a rugged classical Greek original. In fact, in all likelihood, this sculpture

was far more famous when it was found and in the centuries thereafter than it ever was in the ancient world, where it was most likely carved to fill a commission and probably forgotten about. Ancient writings about this work have not come down to us.

The eighteenth century understood the antique to possess an ideal beauty that could be measured and categorized, as if there were eternal standards artists could rely upon to achieve perfection. Sir Joshua Reynolds's widely read 1797 *Discourses on Art* outlined the masterly quality of classical Greek statuary, and how modern arts should seek to learn drawing from primarily this source. While not naming the *Apollo Belvedere*, he did stress how "all the arts achieve perfection from an ideal beauty."[10]

Even romantic artists, who would not be expected to like the *Apollo* because of their fiery temperaments, often do react with enthusiasm. Henry Fuseli, the master of haunted and ghoulish nightmare paintings, could not resist the cool lines of the *Apollo*. For him, this was the ultimate statue of the male figure. "Not the most expressive words of the most expressive language ever given to man, arranged by Homer or Milton or a power still superior to theirs," wrote Fuseli plaintively, "could produce a sensation equal to that which is instantaneously received by one glance on the face of the Venus de'Medici, or on that of the Apollo in Belvedere."[11]

It was Johann Wolfgang von Goethe, one of the greatest writers in history, and whose erudite criticism on everything—painting, architecture, literature, music, and sculpture—was taken very seriously, who set the *Apollo*'s reputation in stone, as it were. His travels to Italy, documented in a work called *Italian Journey* (1786–1788), brought him face-to-face with the great works of antiquity, and he was euphoric:

> November 9, 1786
> Sometimes I stand still for a moment and survey, as it were, the high peaks of my experiences so far. I look back with special joy to Venice, that great being who sprang from the sea like Pallas from the head of Jupiter. In Rome the Pantheon, so great within and without, has overwhelmed me with admiration. St. Peter's has made me realize that Art, like Nature, can abolish all standards of measurement. *The Apollo Belvedere* has also swept me off my feet. Just as the most accurate drawings fail to give an adequate idea of these buildings, so plaster casts, good as some I have seen are, can be no substitute for their marble originals.[12]

> December 3, 1786
> . . . the Pantheon, *The Apollo Belvedere*, one or two colossal heads and, recently, the Sistine Chapel have so obsessed me that I see almost nothing else. But how can we, petty as we are and accustomed to pettiness, ever become equal to such noble perfection?[13]

In Goethe's world everything seemed to have an idealized state inspired in some way by the ancients, even when discussing such unlikely topics as landscape architecture or women's fashions. Even in dance, vigorous and robust forms were for the lower classes; the nobility danced with an elegant series of steps that resembled dignified walking. There is something dance-like about the graceful step of the *Apollo*, and perhaps that refinement made the work palatable to eighteenth-century tastes.

Cardinal Alessandro Albani of Rome acted as connoisseur and host to American artist Benjamin West, when the young painter began his formative training by study-

ing the antique. Albani took West to see the *Apollo Belvedere*, hoping that the artist could learn perfection from the ancients. Years later, West remarked to his biographer, "My God, how like it is to a young Mohawk warrior." The Italian cardinal was stupefied, but West went on to explain that the Indians in America often stood in the same pose as the Greek god, "pursuing, with an intense eye, the arrow which they had just discharged from the bow."[14] Much of his remark was written off by the art establishment of the time as coming from the mouth of an American rustic. Nevertheless, West never forgot the sculpture. In his most famous painting, *The Death of General Wolfe*, painted in 1770, the figure of General Monckton is in the pose of the *Apollo*.

Nineteenth-century authors refer to the *Apollo Belvedere* more than any other sculpture as a standard of beauty and excellence. It is referenced in Victor Hugo's *Les Miserables* and Fyodor Dostoyevsky's *The Gambler*. Nathaniel Hawthorne's *The Marble Faun* seems to question the very nature of excellence in sculpture. Kenyon, the sculptor in the novel, feels melancholy and at a low point in his career when he gazes at the works in the Vatican:

> In the chill of his disappointment, he suspected that it was a very cold art to which he had devoted himself. He questioned, at that moment, whether sculpture really ever softens and warms the material which it handles; whether carved marble is anything but limestone, after all; and whether *The Apollo Belvedere* itself possesses any merit above its physical beauty, or is beyond criticism even in that generally acknowledged excellence. In flitting glances, heretofore, he had seemed to behold this statue, as something ethereal and godlike, but not now.[15]

Mary Shelley, author of *Frankenstein*, admired the *Apollo Belvedere*'s "divine presence" in Rome in April 1843. She remarked that "this statue is the ideal of a youthful hero."[16]

Throughout the nineteenth century the fame of the work remained steady with the public, even if experts began to demur. By the time the Canadian poet Robert Service wrote this folksy tribute in the early twentieth century, the reputation of the sculpture had already fallen:

> Say, I ain't got no culture an' I don't know any art,
> But that there statoo got me, standin' in its room apart,
> In an alcove draped wi' velvet, lookin' everlastin' bright,
> Like the vision o' a poet, full o' beauty, grace an' light;
> An' though I know them kind o' words sound sissy in the ear,
> It's jest how I was struck by that Appoller Belvydeer.[17]

Copies of the pose of the *Apollo Belvedere* are legion. Daniel Chester French's famed 1875 *Minute Man* statue in Concord, Massachusetts, is based on it. So is any number of eighteenth-century full-length English portraits by Thomas Gainsborough and Sir Joshua Reynolds. Every nobleman wanted to be more than themselves; they wanted to be posed as the great Apollo.

In 1796 the French artist Hubert Robert painted what is almost certainly the first painting depicting how an existing structure would appear when reduced to ruins, called *Imaginary View of the Gallery of the Louvre as a Ruin*. Prior to this, artists enjoyed sketching the ruins of ancient civilizations, often with a mix of awe and despair, but never

an existing building. In this futuristic work, almost nothing survives the devastation of the Louvre: the ceilings have collapsed, the walls have shattered, and everything is overgrown with vegetation. In the middle of this wreckage peasants are burning picture frames for fuel. Alone among the destroyed and mutilated stand three pillars of art: a tipped-over bust of Raphael, a knocked-over slave figure by Michelangelo, and, most prominently, the *Apollo Belvedere* still unscathed and standing tall, alone amid the devastation. Before him, an artist continues to sketch; life goes on. The greatest artworks, apparently, can survive all of man's attempts to destroy civilization.[18]

The fame of the *Apollo* was so widespread that a book dedicated to the sculpture, published in 1855, could firmly state in its opening lines: "The statue of the . . . Apollo Belvedere is one of the few works of ancient art, which everyone, even the only half-educated, will know."[19]

The drumbeats announcing the faults of Apollo began quietly in the eighteenth century, when Anton Raphael Mengs, the neoclassical painter who today is considered a dry academic, wrote that the *Apollo* was too poor in execution to be considered a Greek original.[20] This is not to say he was not influenced by it anyway. In his version of *Parnassus* for the Villa Albani in Rome in 1769, the central figure of composition is Apollo, one derived almost slavishly from the Belvedere statue. However, Mengs's comment seems to express for the first time that there is something less than perfect in this sculpture. Mengs thought that the calf and thigh were too round, and the torso inferior to the head. This suggests that he knew that smooth and rather undefined treatment of the torso smacked of a routine copy rather than a vibrant original.

Quietly critics began to murmur about the alleged virtues of the *Apollo Belvedere* when the Elgin Marbles were brought to London. These were the premier works from the high classical period of ancient Greece, indeed, works that once sat on the Parthenon itself, and were from the workshop of the great sculptor Phidias. Who could question their authenticity?

When placed side by side with a cast of the *Apollo Belvedere*, suddenly the genuine works started to look robust and muscular, the *Apollo* vapid and empty. This *Apollo*, whose echoes can be found in Christ's image in Michelangelo's *Last Judgment* in the Sistine Chapel, in Girardon's *Apollo and the Nymphs* in the grotto at Versailles, and in the foyer of the eighteenth-century Syon House by Robert Adam, found itself just an echo of an echo. Enough Greek originals were now circulating around Europe to make the Roman copies appear to be distinctly secondary.

William Hazlitt, the great British author, was among the first to be openly critical of the *Apollo Belvedere*, saying it "is positively bad, a theatrical coxcomb, and ill-made; I mean compared with the Theseus [of the Elgin Marbles]."[21] He also added, "I would not go far out of my way to see the Apollo, or the Venus, or the Laocoön. I never cared for them much; nor, till I saw the Elgin Marbles, could I tell why, except for the reason just given, which does not apply to these particular statues, but to statuary in general."[22]

This did not mean that connoisseurs were about to abandon the *Apollo* overnight. In fact, when John Flaxman, the great neoclassical sculptor, was asked about comparing the Elgin Marbles to the *Apollo Belvedere*, he readily admitted that the *Apollo* was a Roman copy, but that it was preferable to the Theseus of the Elgin Marbles, because the *Apollo* "partook of more ideal beauty."[23]

The Elgin Marbles, however, did have an effect on the *Apollo*. Visitors to the Vatican in the late nineteenth century began to see the *Apollo* in a different, and not altogether complimentary, light. George Stillman Hillard's popular *Six Months in Italy*, published in 1881, summarized the view that perhaps things were not as grand as they seemed to be:

> There is—shall I speak the word?—a little of the fine gentleman about the Apollo; and in the expression there seems to be a gleam of satisfaction reflected from the admiration which his beauty awakens. There is not enough of the serene unconsciousness of the immortal Gods. . . . The Apollo Belvedere, as compared with the Theseus in the British Museum,—perhaps the best work now left to us of the best period of Grecian art,—is like Dryden's Alexander's Feast as compared with Milton's Ode on the Nativity. The latter is the production of the greater genius, but nine readers of ten will prefer the former.[24]

John Ruskin, the great English critic of the nineteenth century, at first loved the *Apollo Belvedere* but soon began to grow weary of the sculpture. Although not a denunciation of the work, his tepid enthusiasm shows that connoisseurs were looking critically at work that others had taken for granted:

> I know not anything in the range of art more unspiritual than the Apollo Belvidere [*sic*]; the raising of the fingers of the right hand in surprise at the truth of the arrow is altogether human, and would be vulgar in a prince, much more in a deity. The sandals destroy the divinity of the foot; and the lip is curled with mortal passion.[25]

By the twentieth century, critics were ready to heap scorn on the sculpture, perhaps because they felt that they could now see what people in the past couldn't. Indeed, they were altogether bursting with self-righteousness, that history would bear out their version as the correct one.

Artists, too, have unconsciously declared the sculpture dead by not appropriating its image into modern art. The poor thing did not even seem worth quoting any longer. Faint echoes of the *Apollo* exist in the work of metaphysical painter Giorgio de Chirico, as in *Song of Love* (1914), in which a bust of Apollo is set in a surrealistic landscape, but by and large the sculpture has failed to provide consistent inspiration.

Curators at the Vatican began to react to current tastes. Off came the restorations—the fig leaf, the added hands, and the sculpted fragments meant to fill in the work. This did nothing to improve the work's reputation. The *Apollo* was featured as part of a Vatican show in the United States in 1983; some of their best works made the grand tour. Unfortunately for the *Apollo*, it was accompanied by genuine Greek pieces, which made it seem even emptier and appear like a relic of a bygone era; its

sweeping subtle shapes seemed lackluster compared to the muscular energy of works like the *Belvedere Torso.*

Kenneth Clark, one of the twentieth century's most famous art historians, said flatly about this *Apollo,* "It was Napoleon's great boast to have looted it from the Vatican. Now it is completely forgotten except by the guides of coach parties, who have become the only surviving transmitters of traditional culture."[26] Today it is looked at as a reminder of what great art *used* to look like before people apparently knew better. One writer proudly proclaimed that the "loss of esteem which the Apollo . . . [has] since suffered represents perhaps the furthest fall from grace in the history of taste."[27]

Back in Paris on November 9, 1800, everyone already thought they knew better. On the first anniversary of Napoleon's power grab, the Gallery of Antiquity opened at the Musée Napoléon, and the *Apollo Belvedere* was exhibited with as much fanfare as the emperor could muster. In a fitting display of reciprocal justice, the *Apollo Belvedere* was among the first sculptures repatriated after the fall of Napoleon, and sent packing back to Rome to once again sit in the Belvedere courtyard, where it has remained ever since.

William Hazlitt, musing on the travels the *Apollo Belvedere* has had to endure, once said, "So the French, in the Catalogue of the Louvre, in 1803, after recounting the various transmigrations of the Apollo Belvidere [*sic*] in the last two thousand years (vain warnings of mutability!) observed, that it was at last placed in the Museum at Paris 'to remain there forever.' Alas! It has been gone these ten years."[28]

Its relocation to the Vatican is fitting, for it has been returned to the grand setting that was designed to house it; however, in later years the location has gradually worked against the statue, even diminishing it. The courtyard has become a setting that one goes through, rather than one goes to, as visitors stream their way down through interminable hallways hoping to get to the Michelangelo and Raphael frescoes. These visitors brush past almost all the exhibits on the way, including those sculptures in the Belvedere, which seem to be standing in cold isolation in a windswept outdoor courtyard. The *Apollo* stands forlorn in a crowded world, denied attention from the visiting public and the sharp-witted critics who have heaped the highest disregard on him: neglect.

Even after the merciless verbal attacks of the twentieth century and the abandonment by tourists and visitors to the Vatican, Apollo's image is not yet dead, only sleeping for perhaps a later reevaluation. Some still remember his fame, and cherish a notion that the *Apollo* will resurrect. His reversal of fortune does cast a shadow, however slight, over the reputation of great thinkers like Goethe, Michelangelo, Raphael, and Winckelmann. Could they have all been so wrong about a work that today we see so differently? Or can we be modest enough to admit that our tastes are not permanent, but another phase in an artwork's reputation?

In some places, the *Apollo* still lives, even if it has been reduced to kitsch. A huge copy is in Caesar's Palace Hotel and Casino in Las Vegas, but that pales in comparison to what's in a luxury hotel called the Mediterranean Palace Luxe in the Canary Islands. Here a plastic *Nike of Samothrace* watches over a miniature golf course, eight Venuses de Milo surround a tennis court, and no fewer than fourteen gigantic *Apollo Belvedere*s circumnavigate the outdoor pool.[29]

Currently, Apollo is poetically sponsoring the NASA program as the emblem of the Apollo XVII mission. The once placid and cool face has been transformed into an energized countenance, looking beyond the galaxies into the heavens. The use of Roman numerals further enhances the mythic context of the space program.

Perhaps there's hope for the *Apollo Belvedere*'s reputation after all, now that the image has indeed circled the globe. Maybe the sculpture is waiting for another revival of interest, one that will prove Goethe and Michelangelo right and twentieth-century theorists wrong. If Rome is ever conquered again by a Napoleon-like figure, we may find out if the *Apollo Belvedere* still remains worthy enough to be plundered and taken through the streets of a foreign city.

The *Apollo Belvedere* has circled the globe as an emblem for the NASA launching of Apollo XVII. *Shutterstock*

Nike of Samothrace

The Victory of the Staircase

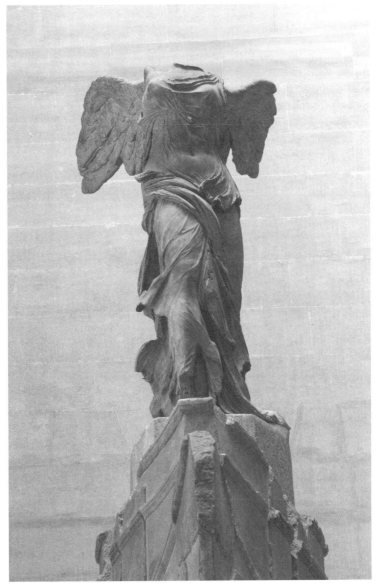

Nike of Samothrace. Toriru / Dreamstime

Location. Location. Location.

—Real estate advertisement in the *Chicago Tribune*, 1926

*O*n a chilly November afternoon in 1939 the employees of the Louvre Museum, sensing the worst, began gathering the greatest works of art in their collection for possible shipment to the far corners of France, and perhaps abroad as well. There was no confidence that this time the French were going to pull out a victory against the Germans. War had already been declared on September 1, but there was no action on the Western front; the belligerents were busy in Poland and had designs on Scandinavia. France, however, was high on the list of targets, and the Louvre with all its treasures was a likely objective.

The actual invasion of the country would wait until the following spring, May 10, 1940, to be exact. By that time the Louvre would be entirely empty of masterpieces. There was a very real fear among the French that if the Germans overwhelmed Paris they would seize all the great works of art in the Louvre and transport them to Germany. Ironically, many of the works in this museum had been seized by the French themselves in nineteenth-century wars. The French knew very well how conquerors work.

In one of the more herculean efforts, the great *Nike of Samothrace* was removed from the top of the monumental staircase in the Louvre with hoists, pulleys, and ropes, for an evacuation site in a Renaissance chateau in the Loire Valley. Undertaking the removal of the statue was a massive feat, considering that when the sculpture was discovered in 1863 it numbered no fewer than 118 pieces, with subsequent additions found later. All these are held together with metal joists and concrete patch. Seemingly sturdy, the sculpture is indeed quite fragile, especially since one of its wings had been assembled incorrectly. However, this sculpture had to be saved; it was a symbol of victory like no other.

Carefully, the marble sculpture was wrapped with protective matting and hoisted onto a wooden dolly. From there it was lowered down the great staircase on a series of wooden planks that were fitted like a ramp onto the stairs. Even so, this is an extremely steep incline, and the workmen had to stabilize the sculpture at every step. Once at the bottom of the stairs, it was passed through one of the doors and packed into a truck for exile.

Seemingly everything except the ancient Near Eastern lamassus, gigantic winged guardian figures, was moved. The heaviest pieces were covered by sandbags and left to their own devices. The Germans, as it turned out, never plundered these treasures, even though they suspected where they might be. Perhaps they decided that they had other things to do, like steal the paintings from Belgium, Holland, or Czechoslovakia. Eerily, the Germans reopened the Louvre in September 1940, although there was virtually nothing to see, just some plaster casts of famous works.

A month after the war in Europe was over, on June 15, 1945, the Nike was reinstalled with great ceremony as a symbol of the resurgence of the Louvre, and the French nation in general. It also served to remind everyone that Nikes are symbols of victory, and the return of this particular object symbolized the resilience of France.

The *Nike of Samothrace* is gingerly removed from her staircase perch to an awaiting van, so that she can be spirited away from German attack during World War II. © *Ministère de la Culture Médiathèque du Patrimoine, Dist. RMN-Grand Palais / Art Resource, NY*

This was not the first time the sculpture has made the journey away from Paris. In fact, plans for removal of great works of art were in place since World War I, when the Nike was also spirited out of town. While this Victory may have made her ironic journey to safety unimpeded, her image was being used as a symbol of military success everywhere. This Nike was the model for nearly five million Victory Medals issued to U.S. troops in World War I. French general Foch, during World War I, kept a bronze copy of the *Nike of Samothrace* on his desk at all times as a symbol of ultimate victory. As he fought the war, the real Nike was in hiding. At the time the sculpture was called "the greatest emblem of military success of ancient times."[1]

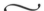

The world was not born to admire the *Nike of Samothrace*, nor archaeological finds in general, even in the nineteenth century when this sculpture was found. For example, there was no archaeology exhibit at the Great Exhibition of the Crystal Palace in London in 1851. Archaeology was still sleeping. However by the Paris Exhibition of 1867 the archaeology exhibition was front and center in the public's imagination. The hunt for antiquities was on.

Archaeologist-adventurers, as we can politely call them, roamed over the ancient cities of Greece, Turkey, Egypt, Iraq, and many other places. They dug up antiquities and shipped them out of their homelands to rest comfortably in European institutions.

Sir Austen Layard excavated ancient Near Eastern civilizations in the 1840s and 1850s, sending to the British Museum substantial finds from ancient Babylon and Nimrud. Sir Arthur Evans uncovered Minoan sites on the island of Crete in the 1900s.

One of the best known of these adventurers was Heinrich Schliemann, whose obsession with ancient Troy was so pervasive that two of his children were named Andromache and Agamemnon. His excavations—some say ransackings—of Troy and Mycenae caused a hysteria of interest, but not condemnation.

Who could resist? The lure of finding something big, beautiful, ancient—and expensive—just waiting to be unearthed was too great to ignore. Such was the scene in April 1863 in the lonely Aegean island of Samothrace when the French consul Charles Champoiseau set out to find traces of ancient Greece amid sprawling ruins.

Controlled by the Ottomans, Samothrace was a minor bauble in a bejeweled sea. By now the Ottoman Empire was openly called the Sick Man of Europe, and was besieged on all sides by enemies: the British in the south, the Russians in the east, the Greeks in the west, and the Bulgarians in the north. What happened on a small island with crumbling and overgrown ruins was of little consequence, especially since it did not represent the Turkish past.

Samothrace's antique features were already known: a smallish set of temples, altars, and miscellaneous architectural features had been uncovered, and then unceremoniously overgrown by nature. Unfortunately no significant sculptural find had been made—yet.

Champoiseau had not long to wait. Fragments of a gigantic sculpture of a woman began to emerge from the site, partly vandalized and partly eroded. Without pause, the sculpture appeared in Paris a year later in 1864, and an extensive effort was made to fit the largest pieces together with metal supports. By 1867, the year of the Paris Exhibition, the marble was ready for unveiling in the distinctly secondary Salle des Caryatides in the Louvre, a room more famous for Roman copies of Greek sculptures rather than the originals themselves. There it sat, friendless and unnoticed, perhaps thought unfinished because it lacked among other things a head and arms.

Part of the issue was the work itself, dating from the Hellenistic period, as do the famous *Laocoön* and *Venus de Milo*, but not from the golden classical age of Greece—the age of the Parthenon. The word "classical" itself connotes an eternal designation. Hellenistic art works were more known for their theatricality and were therefore sensational and, it was felt, lacked appropriate artistic decorum. As a result, Hellenistic works were doomed to distinctly secondary status in the nineteenth century. Connoisseurs saw classical Greece of the Parthenon period as the apogee of sculptural forms—with its restraint, proportion, balance, and contrapposto. When the great sculptor Antonio Canova was asked to restore the Elgin Marbles from the Parthenon itself, now removed to London, he claimed that no one should touch these masterpieces for fear of desecrating them. Lord Elgin wanted heads attached to all the sculptures to make them more marketable, and therefore have their prices go up.

Canova again refused. On the other hand, Hellenistic sculptures such as the *Laocoön* had already been restored in the Renaissance, and therefore had the authority of the great Renaissance masters behind them. The restorers at the Louvre then set about repairing Nike—but what should she look like? Other versions of Nike have her arms in an array of poses, depending on her mission.

Nike, the goddess of victory, was the center of a Greek cult that used her as a symbol of athletic competition. The Greek poet Pindar, who wrote four books of Victory Odes celebrating athletic prowess about 483 BC, indicated that Nike receives the victorious athletes into her waiting arms. He celebrated these achievements at the Panhellenic Festivals, including the ancient Olympic Games:

> The fortune that is born along with a man decides in every deed. And you, Euthymenes from Aegina, have twice fallen into the arms of Victory and attained embroidered hymns.[2]

Popular in sculpture and in pottery, Nike was invoked by struggling Greek city-states to ensure victory in military conquests. Some artists, perhaps at the orders of interested patrons, depicted Nike without wings so that she could never leave the cities she was created in.

By the time the *Nike of Samothrace* was carved, figures of Nike had been represented in a bewildering array of poses, whether running, flying, crowning, hovering, or alighting. She indulges in a number of missions: bringing messages, honoring trophies, leading bulls to sacrifices, and sometimes merely fixing her sandals.[3]

It is understandable that such an adaptive figure as Nike would be a natural choice for a large-scale monument, especially in an age in which warfare was so common.

So many Aegean wars have come and gone that it is difficult to ascribe the *Nike of Samothrace* to a particular event. Further complications arise when one considers that it could have been commissioned by a patron evoking a distinct historical event in the distant past that was perhaps paralleled by a modern event.

Scholars continue to debate the date of the monument as well as which long-since-forgotten battle it was meant to celebrate. It is likely, although not certain, that it was erected by the people from the island of Rhodes who defeated the forces of a certain Antiochus III, who tried to drive the Romans from Greece around 190 BC. A series of naval failures doomed Antiochus's efforts, and secured victory for the Rhodian admiral Eudamos, a native of Samothrace. It seems logical that Eudamos may have been the patron of a work that so celebrates a naval victory.

Such a large statue as this would have been placed most prominently in a central location on Samothrace. Successive excavations, mostly done in the hopes of finding some other ancillary goodies for the Louvre, have uncovered a piece of the boat that acted as a base, and parts of the right hand. Some scholarly detective work reunited fragments of fingers in a storage closet in the Kunsthistorisches Museum in Vienna with the right hand. These items are displayed in an adjacent case at the Louvre since it is still unknown what the original position of the arms would have been. The hand has caused a bit of an issue, though, because it is differently scaled from the body of the sculpture, and rationalizations abound as to the reasons why.

Few people realize that Greek sculptors often disproportionately size everything from heads to feet so that the artist could achieve an artistic statement. Perhaps the Nike's hand has been enlarged to emphasize a gesture or perhaps form a solid base for an upheld object.

Close examination of the original parts of the work reveal a sculpture of transcending sophistication and virtuoso handling of stone. One can see the masterful nature of the carving the sculptors used on the two different kinds of marble, their varying textures and densities. A white Paros marble was used for the statue and a grayer white-veined marble from Rhodes supports the base. This has led some art historians to feel that the base was carved elsewhere or at least by a different team of artists. These distinctions are hard to see today because a patina has formed over the whole surface, blending them together.

One way in which the high quality of the sculpture can be seen is in the drapery. The Nike is wearing two garments, although this is difficult to see because the swirling and twisting nature of the work makes the garments hard to read. The inner garment is a chiton, or tunic, which is held up by a hidden belt under the folds of the garments. The outer garment, called a himation, is usually worn as a cloak, but this has somehow slipped between her legs. It is this garment that sweeps behind the figure and flutters behind the statue. The himation is so sophisticated in its handling that as it waves, the inside of the cloth folds out, so in places we are seeing both the inside and the outside.[4]

The lower portion of the monument usually gets scant attention from the viewer, but there are objects of interest here. The base depicts the front end of a Greek war vessel and reflects the ingenious nature of ancient naval shipbuilding. At the rear there are designs indicating oarboxes, that is, wooden objects that rise above the deck of the ship for the placement of oars. Moreover, the side panels picture oar slots, which were used to balance heavy, long oars. These devices gave rowers more power and hence the craft more speed.

Another Greek shipbuilding innovation was the ram, placed just above the waterline that could be used to smash an enemy craft. Although missing from the sculpture group, restorers can reconstruct the appearance of the ram by studying one from the first half of the second century BC. This solid bronze ram was recently discovered off the coast of Israel, and is now housed in the National Maritime Museum in Haifa. It weighs a staggering 1,025 pounds.

The prow of the Nike's ship was discovered separately in 1879 and sent to join the sculpture in Paris. Curators refitted the sculptures together with the recently uncovered pedestal in a courtyard of the Louvre before the pieces were then reassembled indoors.

The foundations at the site on Samothrace reveal that the sculpture was not placed frontally toward the viewer but at a three-quarter angle so the object was meant to be admired in the round. This may account for the harder to see and rather unfinished right side where the carving is not as fine as the left.

As was the custom for much Greek sculpture, the statue was carved in parts and carefully fitted together on the site. The *Nike of Samothrace* was particularly delicately constructed, given the massiveness of the wings and the careful balancing act the structure had to achieve to remain viable. It weighs a staggering three tons.

When the fragments of the sculpture arrived in Paris the decision was made to restore it, although the largest piece, consisting of the legs and torso, was put on display by itself in 1866. Curators went to work reinforcing and reattaching the marble elements, some only a centimeter or two in size, as well as filling in missing, chipped, or damaged fragments of drapery or wings in order to complete the experience. So little of the right wing has come down to us that it was decided instead to cast a mirror image of the left wing and fashion it onto the back of the work. One of the breasts was found, and so the restorers crafted a second breast to match and placed them both over a reconstructed bodice. This was mounted onto the existing torso. The reconstruction was finished in 1884, the sculpture having been in and out of public view for eighteen years, no one really missing it when it was gone—the French newspapers are virtually silent on the sculpture.

Critical reaction was mixed at best in its unveiling. One French critic said it was the product of "*un époque assez basse,*" or a "fairly low time period."[5] English critics were equally tepid, recognizing the sculptor's talent but using disparaging words such as "sensational" to describe the fall of Greek civilization:

> There is a realistic vigour and dramatic force about the Victory of Samothrace which carry us away at the first impulse, but from it the eye turns with relief to rest on the simpler conception and execution of the 5th Century.[6]

Meanwhile the Louvre itself was being remodeled. Thoughts began to turn to a grand central staircase, now known as the Escalier Daru, to greet visitors as they make their way up to a temple of the arts. Grand staircases are part of the fabric of all major traditional museums from Philadelphia to Saint Petersburg, and the Louvre is no exception. During the remodeling in 1884, curators saw the possibility for a visual coup de théâtre by enshrining the Nike on its boat at the top of the stairs for all to admire. In a strange way, this arrangement evoked the magical placement the sculpture would have had in its original setting.

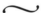

Enough of the original positioning is known so that a modest reconstruction can be attempted. It seems that Nike, alone, stood above the prow of a marble ship, before a series of rough-hewn rocks, evoking shallow and dangerous waters, which this Nike has to glide through to reach victory.

Ship monuments are common in the ancient world; this sculpted boat is one of about a dozen that have come down to us from the Aegean alone. The choice of a Nike figure dominating a boat to commemorate a naval victory is natural enough, but there are indications that this Nike was famous even in its own time. As pointed out by scholar Karl Lehmann, who has intimately studied this work and its site, numerous Roman imitations of this sculpture have been found, indicating that this Nike must have had a profound impact.

For example, in the first century BC an island in the Tiber River in Rome was sculpted into the prow of a boat, creating a scenic effect of a marble boat rushing into

actual running water. The prow was certainly crowned by a statue, perhaps of Nike herself, and like the circumstances in Samothrace, this monument commemorates a naval victory.[7] In any case, the *Nike of Samothrace* seems to have survived quite well for hundreds of years, even being commented on by an obscure Greek writer, Nikostratos, who claims to have seen a figure of a goddess rushing forward to protect a sanctuary.[8] But in the early sixth century a powerful earthquake toppled the sanctuary, and its ruins were left to rot until the appearance of the French in 1863.

As an added feature, the Nike was almost certainly the centerpiece of an active fountain playing enthusiastically around the figure.[9] The wet drapery look, the clinging clothes, the windswept garments, and the pinned-back wings all suggest the effect of wind and rain. The great twisting torso reflects the ocean's spray and seems to relish in it. The fountain likely had two levels with the statue and the boat on the upper tier surrounded by rushing water, and the lower tier filled with boulders and the play of fountains.

In order to create this fountain one presumes that Greek engineers had the ability to harness a constant water supply and direct the water onto this work. No small accomplishment, especially in an age when water was scarce and rarely wasted on ornamental projects such as civic fountains. The active playing of fountains symbolizes a society that is so blessed and powerful, that it could take its most life-sustaining resource and use it for decorative and commemorative purposes. Not just a few people ever since have wondered about the wisdom of sending missiles of water into the air in places as dry as Las Vegas, especially since most of it seems to evaporate before hitting the ground.

While the Louvre could not create this grand scenographic effect on its own, it could supplant one drama for another by mounting the group at the head of a monumental flight of stairs. Instantly the placement of the Nike caused a sensation. Visitors were mesmerized. Suddenly criticisms of its sensational nature melted away to be exchanged for outbursts of appreciation. In a real way the Nike boat has docked comfortably at the top of the grand staircase, moored for all to admire the way great ships are docked in ports around the world and are visited by legions of tourists. To make the effect even more pronounced, the statue was lifted off the boatlike pedestal and placed on a block fourteen inches high during a restoration in 1934. This has greatly increased the commanding view of the work when seen from below; however, the most recent restoration in 2014 has removed that block and will allow the sculpture's presence to speak for itself.

Any visitor to the Louvre, by default, cannot claim to have seen the museum unless he or she stands before the sculpture, preferably from the base of the staircase, and rises to meet her.

Schoolchildren everywhere instantly became familiar with her. At an exhibition of art materials for school classrooms held in Brooklyn, New York, in 1896, in the center of the room, mounted on a pedestal stood the great Winged Victory, singled out among the four hundred works of art suitable for elementary school display.[10] When the Worcester Museum of Art opened in Massachusetts in 1902 the local Woman's Club donated a plaster cast copy of the Winged Victory for the museum because no civilized museum could be without one![11] Copies of the Winged Victory could not be made fast enough to meet demand. No fewer than twenty small factories

in the New York area made reproductions of the sculpture, now called "one of the most beautiful and majestic of ancient statues."[12]

Immediately artists became fascinated with the piece and began seeing it, for good or for bad, as a representative of ancient beauty. Poet Gabriele D'Annunzio was so inspired by the work that he wrote a sonnet, in French, dedicated to it:

> I see your wings spread out suddenly.
> O Victory. I see your marble where the blood flows
> Take flight from its pedestal as the dawn
> Of a star spreads out in the breast of the firmament. . . .
> The soul sings the noble chorus of Euripides—
> Honored Nike, follow my life in its rapid journey!
> Crown it there at its end![13]

The *Nike of Samothrace* began to inspire victory monuments around the world. One of the largest is El Ángel de la Independencia, built in 1910 to commemorate the hundredth anniversary of Mexico's War of Independence. The twenty-two-foot statue by Enrique Alciati is gold on bronze. It features a mammoth version of the *Nike of Samothrace* atop a giant "victory column" placing a laurel crown over the head of Miguel Hidalgo, a key figure in the revolution.

One of the greatest works of American sculptor Augustus Saint-Gaudens is the Sherman Monument on Fifth Avenue in New York City. General Sherman, weary from war, but noble and victorious, marches behind a version of the *Nike of Samothrace*, who appears tired from exposure to innumerable battles. This 1903 monument is almost a direct quotation from the ancient work complete with the alighting of the feet on a firm surface.

After World War I the Nike was used as a benchmark for all victory monuments, usually glorifying war dead and a veteran's general ascension to heaven. The most typical of the genre is Winged Victory, a bronze monument in Vancouver, Canada, constructed in 1921 to commemorate veterans who worked for the Canadian Pacific Railway. The 1,100 employees are symbolized by a dead male figure in full uniform, being lifted by a Nike to heaven. The ambitiously named artist Coeur de Lion MacCarthy, son of the equally ambitiously named artist Hamilton Plantagenet MacCarthy, claims that the *Nike of Samothrace* formed the basis for his memorial. At seven feet tall and three hundred pounds it rivals the original in scale. The monument must have been popular, because immediately after it was finished a copy was erected in Winnipeg in 1922, followed by another copy in 1923 in Montreal.

Not every institution could raise the funds for a gigantic sculptural grouping so quickly. The state of Washington had to sell forest land to gather the $100,000 to commemorate their fallen citizens in the Great War. In 1927 Utah-born sculptor Alonzo Victor Lewis was commissioned to create a Winged Victory monument with a splendid Nike urging a sailor, a marine, and a soldier onto victory. A Red Cross nurse completes this grouping, bringing the total figures to five, and hence more complex than the other sculptures. It was installed in front of the state capitol in Olympia in 1938.

The copies seem to be everywhere for many a military monument: the First Division Memorial in Washington, D.C., by Daniel Chester French, Winged Victory on the Maryborough War Memorial in Queensland, Australia, and on the Victor Emmanuel Monument in Rome, Italy.

All these artistic renditions supply a new female head, arms with attributes, and delicate feet, but they copy the *Nike of Samothrace*'s soft contrapposto of the body, the sweeping effect of the drapery against the skin, the flying cloth behind the body, and the proudly outstretched wings.

The greater the fame, the more it was enshrined, the more modern artists revolted. The futurists, whose very creed celebrated the machine aesthetic and whose goals included the destruction of museums and art institutions of all kinds, proclaimed in their 1909 Manifesto:

> We declare that the splendor of the world has been enriched by a new beauty: the beauty of speed. A racing automobile with its bonnet adorned with great tubes like serpents with explosive breath . . . a roaring motor car which seems to run on machine-gun fire, is more beautiful than the Victory of Samothrace.[14]

As if to answer the antique in a modern voice, Umberto Boccioni interpreted a walking figure in full stride in a work called *Unique Forms of Continuity in Space*. This ambitious bronze, less than life-size, seized the effect of wind on a striding figure, but interprets the drapery in a hard-edged mechanical way. However, for all of Boccioni's efforts to create a new and thrilling sculpture that is a dynamic reinterpretation of the ancient masterpiece, this work suffers by comparison. The *Nike of Samothrace* is never compared to the Boccioni, but the Boccioni exists seemingly to be compared to the Nike. Most general art history books that feature the futurist sculpture cannot withhold the comparison to the ancient work.

After World War II the sculpture was no longer used for artistic inspiration—few modern artists have appropriated ancient symbols. However, it began to take on a life of its own through copies both in life-size versions (as in Caesar's Palace in Las Vegas or in the Hotel des Regions in Montpelier, France) and in small-scale works (like a Rolls Royce hood ornament). It was even used to symbolize victory in the original World Cup soccer games. The Golden Nike was designed by French sculptor Abel Lafleur, and used as the first trophy of the World Cup. Perhaps because the cup was over eight pounds of solid gold, it was stolen in 1983 and never recovered.

Architect Frank Lloyd Wright was particularly taken with the sculpture, incorporating it as a design element in several of his homes. The Little House, formerly in Minnesota but now at the Metropolitan Museum in New York, features a large table-top version cast of the sculpture. Even more impressive, a nine-foot, six-inch replica of the Nike was cast for the David Martin House in Buffalo, New York, where it not only dominates Wright's crisply designed conservatory, it absolutely overwhelms it.

In 1949 the French sent a plaster copy of the Nike to Boise, Idaho, as a gift from the people of France for the sacrifices made during and after World War II.

Perhaps little known now, the Merci Train, as it was called, had forty-nine boxcars, one for each state and one for the District of Columbia and the Territory of Hawaii, filled with presents. The boxcar for Idaho had a full-scale replica of the Nike, today enshrined in the state capitol building.

Even Hollywood, the epicenter of the banal, has featured the Winged Victory in movies. In the 1956 classic *Funny Face* Audrey Hepburn descends the Escalier Daru wearing a bright red dress and holding her shawl as if she were the sculpture itself. Life imitates art, as Oscar Wilde once said.

Hollywood may have been the first, but it certainly was not the last, to see the dramatic opportunities such a visually stunning setting could command. In 2007 American dancer and choreographer Bill T. Jones staged a fifty-five-minute interpretative dance called "Walking the Line" in which the works of Greek and Roman art form a backdrop to a modern dance performance.[15]

Fame has brought demands that the sculpture be returned to Samothrace. In a case of sending mixed messages, the Greek government gave the Louvre a newly found finger that belongs to the sculpture, but more recently the mayor of Samothrace has said that he wants the entire sculpture returned. The Louvre has refused. "The world would be awfully sad if all archaeological pieces had to be exhibited in their country of origin," spokesman Christophe Monin said in 1999.[16]

Through her copies, imitations, and reincarnations, the Nike remains a great symbol of Greek culture, and a broader symbol of victory. In any case, her position atop the Escalier Daru has permanently secured her fame, and except in times of war, one can expect her always to remain.

• 6 •

The Birth of Venus by Botticelli

Nothing Is Forever, Not Even Neglect

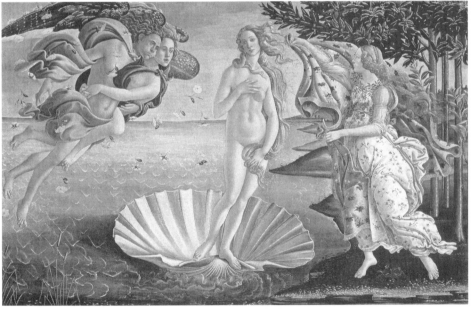

Birth of Venus by Botticelli. *Galleria degli Uffizi, Florence, Italy / Bridgeman Images*

As a companion piece to the Allegory of Spring . . . he added The Birth of
Venus, *now one of the greatest treasures of the Uffizi Gallery in Florence, and
the most important example of fifteenth century Italian painting ever shown
in this country.*

—*Bulletin of the Art Institute of Chicago*

*N*o artist has had his reputation come back from the grave more dramatically than
Sandro Botticelli, and no work of art has been rescued from obscurity and resurrected
more assuredly than *The Birth of Venus*. It is hard to imagine today that this painting, one
that has been on public view since 1815, has spent most of its life ignored or repudiated.

How did Botticelli's reputation collapse so completely? He was extremely popular
in his lifetime; how else could he have been given the commission to paint the walls
of the Sistine Chapel in Rome and the private quarters of Medici villas in Florence?

Like Leonardo da Vinci, Botticelli was trained in the workshop of Florentine
master Andrea del Verrocchio. In fact, art historians are quick to point out a painting
in which all three painters' hands can be seen: Verrocchio's masterpiece, *The Baptism
of Christ* in Florence's Uffizi Gallery. This painting features the two principal figures
by the master himself accompanied by two angels: the one on the lower left with a
turned body is by Leonardo, his companion is by Botticelli.

Such an auspicious beginning surrounded by great luminaries should assure
Botticelli's star stayed bright during his lifetime, but his reputation flickered out im-
mediately thereafter. As it turned out, Botticelli himself was in part responsible for
his declining popularity. In his late years he fell under the spell of the fiery preacher
Savonarola, and he may have renounced his earlier works as pagan and hedonistic. In
any case, at his death, his achievements were overshadowed by the great spirits of the
High Renaissance: Leonardo, Raphael, and Michelangelo, and he suddenly began to
sink by comparison, looking rather old fashioned.

True, Botticelli was the subject of one of Giorgio Vasari's biographies in his
*Lives of the Most Excellent Italian Painters, Sculptors, and Architects, from Cimabue to Our
Times*, but so were over 160 others, and there was little in his life story to make the
artist stand out. Others have amorous adventures, quirky habits, barside brawls, and
secret liaisons. Botticelli had none of this, little of his life being memorable. Vasari
does mention *The Birth of Venus*:

> For various houses in the city he painted round pictures, and female nudes of which
> there are still at Castello, a villa of Duke Cosimo's; one representing the birth of
> Venus with those Winds and Zephyrs that bring her to earth, with the Cupids; and
> likewise another Venus, whom the Graces are covering with flowers, as a symbol of
> spring; and all this he is seen to have expressed very gracefully.[1]

This is hardly a quotation for the ages, nor does it suggest that we are looking at
something special, by any means.

His work remained on public display in churches in Tuscany, but because there
was so little active interest, they garnered no serious attention. Even his frescoes on
the walls of the Sistine Chapel suffered the fate of being upstaged by the grand ac-
complishments of Michelangelo's ceiling and *Last Judgment*.

Botticelli himself signed only one painting in his life, *The Mystic Nativity*, done in 1500 and now in the National Gallery in London. This lack of documentary evidence has led to a host of misattributions. Critics have sometimes assumed they were looking at a Botticelli when they were looking at someone else's work. None of this has done the painter's reputation any good. His paintings were largely neglected or were greeted with disapproval, even scorn.

Sometimes references to Botticelli were downright contemptuous. Henry Fuseli, the great romantic artist, saw the works of Botticelli in the Vatican and said:

> Mediocrity, tinsel ostentation and tasteless diligence mark the greater number of that society of craftsmen whom Sixtus IV conscribed . . . to decorate or rather to disfigure the panels of the grand Chapel which took its name from him. . . . The superintendence of the whole the Pope, with the usual vanity and ignorance of princes, gave to Sandro (Botticelli), the least qualified of the group, whose barbarous taste and dry minuteness palsied, or assimilated to his own, the powers of his associates, and rendered the whole a monument of puerile ostentation, and conceits unworthy of its place.[2]

The Birth of Venus, all this time, was sleeping soundly in the Medici Villa at Castello. No one came to look at it, let alone even knew it was there to look at. When Napoleon ransacked the Italian collections, most Botticellis were left right where they were, and certainly *The Birth of Venus* was left untouched. These works were not even considered good enough to plunder.

In 1815 *The Birth of Venus* moved from the Pitti Palace to Florence's great museum, the Uffizi, and no one noticed or cared enough to mention it. When Charles Dickens traveled to Italy and took in the sights, he discussed Florence in great detail but never once mentioned Botticelli's name in his 1846 *Pictures from Italy*. Similarly, Mark Twain's 1869 *Innocents Abroad* made no mention of the artist, let alone this painting. Even Bayard Taylor's exhaustive 1846 *Views Afoot: Europe Seen with a Knapsack and Staff* discusses the Uffizi in great detail, pausing over the works of Guercino and Raphael, but Botticelli is missing.

Strangely, early fervent admirers did not include the painters whose style reflected quattrocento tastes, like the Nazarenes. These German artists set up camp in a neglected monastery in Rome to dig deeply into the Early Renaissance. They especially admired the works of Fra Angelico and Jan van Eyck. Botticelli's lack of name recognition probably caused those disposed to be friendly to his work to look elsewhere.

Slowly, however, critics began looking at the Botticelli paintings differently, seeing things that they thought had never been noticed before. The first person to intently study Botticelli was Alexis-François Rio, who wrote rapturously about him in a book that was popular in several languages, thereby helping to bring Botticelli to a general European awareness. Rio particularly enjoyed Botticelli's Sistine frescoes, the ones so offhandedly dismissed by Fuseli. Rio's writings triggered a flurry of activity, with critics beginning to see something of note, plus secretly harboring the thrill of exploring an artist that had hitherto escaped notice.

Rio's books were widely translated, and by 1854 they were available in English. John Ruskin, the famous English art historian, probably read the book in French

beforehand, not that he was terribly impressed by what Rio had to say. His first reaction to Botticelli's art was tepid at best, but he allowed himself to be convinced that Botticelli was more than what he originally thought. His assistant, Fairfax Murray, recommended that he purchase a *Madonna and Child* for £300 in 1877, but when Ruskin finally got an eyeful of the Botticelli, he wrote to Murray, exclaiming that it was "so ugly that I've dared not show it to a human soul. Your buying such an ugly thing has shaken my very trust in you."[3] This painting is now in the Ashmolean Museum in Oxford. Ruskin eventually did reverse his appraisal of the artist, but it took years. He later commented:

> Botticelli lived amidst the concourse of Florence, admiring all earthly beauty, himself untainted by it. He is in one the most learned theologian, the most perfect artist, and the most kind gentleman whom Florence produced. . . . As an artist he is incomparable.[4]

However, the Pre-Raphaelites, like Dante Gabriel Rossetti, enthusiastically endorsed Botticelli's style, admiring his "primitive" quality, enhanced by the expressive use of line.

Scholars were slow to follow Botticelli's popularity, that is until Walter Pater published an essay that solidified his reputation, at least in the English-speaking world. The book, called *The Renaissance*, was published in 1873 and begins its discussion by calling Botticelli a "comparatively unknown artist" and that his name was "little known in the last [eighteenth] Century" and "is quietly becoming important"[5] in the nineteenth.

Pater goes on to explain a number of Botticelli's works, but his pen rests longest on his *Birth of Venus*. This partial quotation captures Pater's mood:

> What is the strangest is that he carries this sentiment into classical subjects, its most complete expression being a picture in the *Uffizii* [sic], of Venus rising from the sea, in which the grotesque emblems of the middle age, and a landscape full of its peculiar feeling, and even its strange draperies, powdered all over in the Gothic manner with a quaint conceit of daisies, frame a figure that reminds you of the faultless nude studies of Ingres. At first, perhaps, you are attracted only by a quaintness of design, which seems to recall all at once whatever you have read of Florence in the fifteenth century; afterwards, you may think that this quaintness must be incongruous with the subject, and that the color is cadaverous or at least cold. And yet, the more you come to understand what imaginative coloring really is, that all color is no mere delightful quality of natural things, but a spirit upon them by which they become expressive to the spirit, the better you will like this peculiar quality of color, and you will find that quaint design of Botticelli's a more direct inlet into the Greek temper than the works of the Greeks themselves even of the finest period.[6]

The Victorian era with its veneer of respectability seems an odd time for the reawakening of so dynamic a nude. After all, this was the era in which the private parts of Michelangelo's *David* were covered up for genteel society.

However, Botticelli's nude is different from many others. It does not allure or entice like a Titian or a Giorgione. It is cold and averts our gaze. You may admire

her, but she does not take in that admiration. A Titian *Venus* stares directly at us and confronts our visage. The Botticelli is comparatively demure and mostly covers herself with her hands. Victorian society probably felt attracted to the beauty of the female form, but was happy that the form was idealized without resorting to promiscuity.

After the Pater essay, scholars began to take notice of *The Birth of Venus*, and pondered its seeming pendant, *Primavera*, with the same eye. Botticelli did both works while under the patronage of Lorenzo de'Medici—called "Il Magnifico." The two share a similar history, being housed in a country estate of Lorenzo and Giovanni di Pierfrancesco de'Medici. Whether the works were supposed to hang together, despite the differences in size, backing, and date, is still the subject of intense scholarly thinking. The paintings have been connected together nonetheless, and today they are exhibited in the same room.

The fact that *The Birth of Venus* was painted on canvas, a material that at the time was generally used for parade banners, suggests that this unusual choice may have originally dictated the function of the painting to be a processional banner. This is perhaps the reason that the painting has so few figures, so it can be seen from afar. There is documentary evidence that indicates Botticelli did paint works for this purpose, even though none can be identified. Recent critical theory suggests that the erotic tone, decorative character, and canvas support signal the fact that it may have been done to decorate wedding festivities.[7]

Part of the attraction of *The Birth of Venus* is the peculiar take it has on the peculiar Venus story. According to the myth, Kronos cut off Uranus's genitals and cast them into the sea, the foam of which symbolizes his semen. Aphrodite, or Venus, was born fully grown from that foam, as her name in Greek suggests ("she who came from the foam"). She rested on a shell until she drifted to shore, as some say, in Cyprus.

When she arrived, she was greeted by semidivinities who covered her up properly. However, artists have depicted her as both nude and clothed since ancient times. The Greek sculptor Praxiteles famously carved her as the *Aphrodite of Knidos*, for which a Roman copy now survives. The Knidians revered the cockleshell, because they believed Aphrodite grew inside of one. Perhaps this is the reason why Botticelli shows us the shell that her feet gently glide across.

The painting has its source in a poem by Poliziano, which encouraged Botticelli's imagination:

> You could swear that the goddess had emerged from the waves, pressing her hair with her right hand, covering with the other her sweet mound of flesh; and where the strand was imprinted by her sacred and divine step, it had clothed itself in flowers and grass; then with happy, more than mortal features, she was received in the bosom of the three nymphs and cloaked in a starry garment.[8]

We are so used to depictions of Venus that perhaps we don't see just how novel this painting really was. Mythological subjects were just starting to make a comeback in Renaissance Europe, and Botticelli was spearheading its development.

Unlike in northern Europe, where such subjects were still a generation away, Botticelli was leading the exploration of the female nude in the guise of re-creating a mythological scene. It has been advanced that the subject may also be a reference to religion, politics, and the Medici themselves. Certainly, it was the first monumental female nude of a pagan goddess since the ancient world, and for that reason alone it must have raised eyebrows.

Once rediscovered, the fame of the painting increased exponentially in the twentieth century. First, it was given a pride of place location at the Uffizi, so that admiring throngs could be accommodated. Then, the celebratory books were printed. Distinguished scholar Michael Levey tells us that between 1900 and 1920 more books were published on Botticelli than on any other great painter.[9]

After 1920 Italians began to exploit the painting's fame by sending it on grand tour after grand tour, making it even more famous. Hard to believe that Italians would want to let the painting go, considering its age, delicate condition, fame, and not to mention its status as the main attraction in the Uffizi, but away it went as a centerpiece of one great Italian exhibition after another.

In 1930 it was the focus of a show held at the Burlington House in London. *The Birth of Venus* was in august company: Mantegna's *Dead Christ*, and Giorgione's *The Tempest*, joined a host of Titians and Raphaels. Even three famous *David* sculptures by Donatello, Verrocchio, and Michelangelo were in the show. The raves from newspapers and the public were rapturous, although there were reservations on how the great paintings were displayed. One review proclaimed, "The raspberry-fool tint of the lincrusta [a type of thick embossed wallpaper] walls in the Large Gallery, for example, drains all the color from the pictures, and the delicate tints of Botticelli's 'Venus' with the gold lights on the hair and waves are completely destroyed."[10]

This was the first time that some of the works were seen outside Italy since Napoleon hauled them away at the end of the eighteenth century. It took the authority of Italian dictator Benito Mussolini to send these works abroad.

Mussolini understood that the paintings possessed a political power greater than any he could muster, and *The Birth of Venus*, given its fame and portability, possessed the greatest power of them all. And so, to gratify the request of the English foreign office, the paintings, some three hundred of them, were packaged off to Britain. As for *The Birth of Venus* itself, Mussolini cared nothing. Nor did he care about any of the paintings, some of which were far too fragile to be moved. When curators balked at letting their masterpieces go, Mussolini politely asked a second time, and could be counted on not being so polite a third time.

Mussolini was interested in enhancing his popularity in Britain, and saw this export of Italian works as a comfortable stage for Italian politics to stand on. Many Englishmen and Americans were positively disposed to Mussolini when he first arrived on the political scene. It is no exaggeration to say that the great English playwright George Bernard Shaw adored Mussolini, as did poet Ezra Pound, who lived in Italy during World War II, broadcasting anti-American sentiments over the radio. An impressive list of thinkers who embraced Benito Mussolini at first included no less than Thomas Edison, Sigmund Freud, and Winston Churchill.

Even critics of Mussolini were impressed by the art show. The critic for the *New Statesman* claimed, "However much we may growl about Fascism, this country is now permanently in debt to the Italian Government."[11] Not surprisingly, over half a million people saw the exhibition in London, a record by any yardstick. Most said they came to see *The Birth of Venus*.

Since the paintings were lent once, there was no problem lending them again. The second viewing was a short five years later, this time at the Great Italian Exhibition in Paris in 1935. This was a monumental display, one that garnered works from collections across Europe and the United States. With such company to compete with, the Italians had to pull out all the stops, and again *The Birth of Venus* was asked to be the headliner, the showstopper. Once again, it was in the company of greatness: Titian's *Venus of Urbino*, Michelangelo's *Holy Family*, and Leonardo da Vinci's *Annunciation* were all invited participants.

This time, Premier Mussolini helped select the works himself, contributing his "enthusiastic aid" to the process. This probably means that he strong-armed hitherto reluctant curators to lend paintings that they deemed too fragile or important to transport. He also waived shipping and insurance costs—nothing was too good to promote Italian prominence in the arts. Once again, despite the competition, *The Birth of Venus* outshone her sister paintings: The *New York Times* reported that "Botticelli's 'Birth of Venus' occupies a place of honor . . . and in view of its fame will doubtless attract as great attention as any picture in the exhibition."[12]

The *New York Times* reporter in Paris, like many others, could not contain his enthusiasm standing before the painting:

> Under a rain of flowerets, so fragile and refined a symbol of gracefulness is caressed by a very soft marine breeze. A greenish mist lingers. It is the image of spiritual daintiness, the map of lyrical slenderness; and its sharp calligraphy, heightened with gold threads, still surprises and enchants. All the compliments that Verlaine and a thousand other poets of all nationalities have poured upon this tenacious panel remain vivid. Its presence in Paris is said to have revived a certain coquetry and may upset the style of feminine hairdressing.[13]

The painting was a huge success in Paris, as it was in London, but there was every reason to believe that this was the last journey the painting was going to make. After all, the European political situation was tense at best in 1935.

However, in faraway San Francisco, the city fathers were quietly planning a World's Fair, one that was supposed to emphasize Pacific nations and their international commerce. Needless to say, things were every bit as tense in the Pacific as they were in the Atlantic, with Japan invading China and Korea, and spreading its wings throughout Asia.

Oddly, the Italian government had a presence at the fair, and once again sent a delegation of paintings for exhibition under the proviso that the Americans would pay for shipping and insurance. Once again there was competition. Diego Rivera painted a mural for the fair, and pre-Columbian works were on display. None of this mattered. The hit of the Golden Gate International Exhibition was the twenty-one Italian

paintings and seven sculptures lent by the Italian government. Although *The Birth of Venus* had heady competition again, including Titian's masterful portrait of *Paul III* and Raphael's *Madonna of the Chair*, it was the Botticelli that the public came to see. The fair was open from February 19 to October 29, 1939, and by the time the season was over, Germany had already invaded Poland and was well on its way to devastating Europe. Although the fair was to remain for the 1940 season, the Italian government summoned the works home, fearful that if America got drawn into the war, the paintings would remain prisoners in this country.

However, quick diplomatic work was afoot to have the works form a bit of a triumphal march through the heart of the United States before ultimate shipment to Italy. The first stop was a three-month-long exhibition at the Art Institute of Chicago, from November 1939 to January 1940, where once again *The Birth of Venus* was the big hit. Chicago newspapers had large-scale illustrations of the works, with accompanying stories that told tales of history, sources, patronage, context, and influences. And, oh by the way, there were also twenty-seven other works on display as well. The Art Institute published a discussion of the paintings in the exhibition in a special edition of their bulletin. In the opening remarks, Frederick A. Sweet proclaimed with amazement "that Sandro's Birth of Venus should be permitted to leave the walls of the Uffizi is virtually a miracle."[14] Perhaps Mr. Sweet was unaware that this miracle was occurring with incredible frequency.

The paintings were packed in zinc-lined cases and placed in air-conditioned express railroad cars, an unheard-of novelty in the 1930s. Each car had six armed guards and two members of the Italian government keeping watch.

More footwork was required to bring the paintings to a final exhibition space, this time in New York and for only two months, shortly before their shipment back to Italy. The paintings would be displayed in, of all places, the Museum of Modern Art. At this point a law was passed in Italy that these works could not leave the country again, so there was vast promotion of the event as being once in a lifetime.

Promotion was unnecessary, as it turned out. With great ceremony the Italian ambassador Prince Colonna made an address welcoming the paintings to New York in front of *The Birth of Venus*. "I see, in fact, a special significance in this exhibition, that, as an oasis of peace in this troubled world, shall bestow upon the great American public great and unforgettable emotions."[15]

Next to speak was Nelson Rockefeller, president of the Museum of Modern Art, and future vice president of the United States, who affirmed that the works were being received with "tremendous enthusiasm" because they "give us a clear understanding of your great Italian culture."[16]

Interest was indeed keen. Attendance records were smashed in the small museum, some 7,206 people viewing the paintings on the first day, 31,884 for the week, and ultimately 250,000 for the short stay in New York. As newspapers pointed out, one in every twenty-five people in the city saw the exhibition. Concurrently, the museum ran a parallel exhibit of modern artists, containing masterpieces by Cézanne, Degas, Derain, Eakins, Gauguin, Van Gogh, Homer, Matisse, Picasso, Renoir, Rousseau, Ryder, Seurat, and Whistler. They should not have bothered; it drew scant attention.

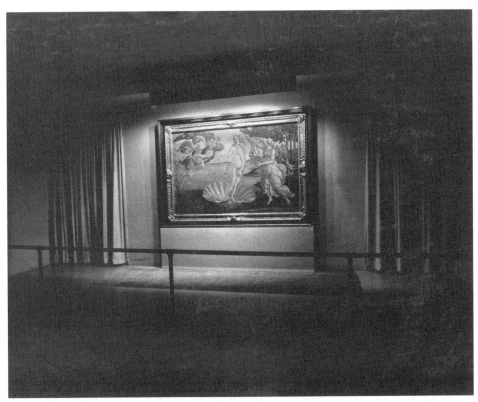

The Birth of Venus had a very theatrical installation at the 1940 *Italian Masters* exhibition at the Museum of Modern Art in New York City. *Digital Image © The Museum of Modern Art, Licensed by SCALA Art Resource, NY*

Museums have long learned that when a blockbuster comes to town, the price for admission can go up, and people will pay. In 1940 it cost twenty-five cents to enter the exhibition; the price was doubled to see the Italian works. There was no additional admission for the modern masters.

When the balloting took place to determine the most popular painting at the show, surprisingly *The Birth of Venus* came in third, behind Titian's *Portrait of Paul III* and Michelangelo's *Madonna and Child*. Writers at the time suggested that the Botticelli had "become too familiarized in too many cheap prints."[17]

All three exhibitions were immensely popular, and *The Birth of Venus* was the chief draw. But more than a few people began to murmur—and not quietly murmur—that the shows were nothing more than Fascist propaganda, and that Mussolini was using the treasures of Italian art for his own ends. *The Birth of Venus* could be made to lionize the Italian state—a state that needless to say did not exist in Botticelli's own lifetime.

Even if Italian curators were unable to prevent these old and fragile works from leaving their homeland, many of the recipients wondered aloud if it did these works any good to have them risk being transported by sea. When the ocean liner *Leonardo*

da Vinci carried the masterworks to London, it weathered a terrible storm, battling gales for the entire six-day journey. As soon as the boat arrived, the contents were unpacked and examined and a telegram was dispatched to Il Duce relieving him of any doubts about the safety of his artistic patrimony. Since Mussolini cared so little for these works, one wonders if he would not have minded collecting the insurance money on an estimated value of seventy million dollars.

The risks are worth taking, proclaimed art historian Roger Fry, who mused, "Pictures, then, may almost be said to need change of air and change of company. Immensely important as the material preservation of a picture is, its importance depends on the picture continuing to exercise its vital function as a source of spiritual life."[18] Then, in an interesting twist of logic, Fry added, "People who are as familiar with the Uffizi as with the National Gallery have had to admit that they have seen the *Birth of Venus* fully for the first time when they saw it in London."[19]

As it turned out, these trips to London, Paris, San Francisco, Chicago, and New York were not the last for *The Birth of Venus*. World War II ended all exhibitions but did not end trafficking in the art world.

Only two months after the closing of the New York exhibition on June 10, 1940, Italy had entered the international conflict, which plunged its artistic patrimony into chaos and destruction. No matter how brave a face the Fascists could put on their decision, things could not remain as they were, and all movable objects had to be relocated for their own safety—the Italian state not having the capability to protect them in situ. By November 1942, the Directorate of Fine Arts ordered that everything that could be moved, should be moved. Crisscrossing Italy in a webwork of transports, Italian works of fine art including the entire contents of the Uffizi Gallery were sent to a number of rural locations. Care was taken to mix an artist's work in different sites, so *The Birth of Venus* ended up hidden in the heavily fortified medieval Castle of Poppi, about fifty-three kilometers east of Florence. The *Primavera* was sent to the Castle of Montegufoni in the Val di Pesa, south of Florence.

It was hoped that in these hideaways the ravages of war would bypass the worst efforts of German confiscation and Allied bombing. When the Allies finally arrived at the Castle of Poppi, there was every expectation that they could find the gems of Florentine art intact. Unfortunately, retreating German soldiers had taken a sizable portion of the collection, except they left the most famous painting there: Botticelli's masterwork. They helped themselves to a number of northern European works, three Raphaels and a Titian, but the Botticelli was not taken.

It was likely that the Nazis felt that they were reclaiming their artistic heritage when they took German works. It was also true they probably felt that *The Birth of Venus* was too famous to be sold or fenced, its fame making it unsellable. Even though the operation was ordered by the German high command, it is unclear if the choice of objects was dictated from above. Certainly Italian authorities, such as they existed in 1944, had no knowledge of the transfer, which resembled more an act of plunder than of restitution.

The Americans in charge of maintaining the dignity of the Italian artistic heritage were dubbed by GIs as the Venus Fixers, named after the goddess of beauty Venus, the inspiration for Botticelli's work.

After World War II, the Uffizi was resurrected as a rather sad shadow of itself, much despoiled by marauding soldiers and generals with sticky fingers. When the Botticelli was reinstalled, however, and the gallery ultimately reopened in the summer of 1948, the Uffizi could then reproclaim itself as one of the artistic centers of the world.

It was the arrival of *The Birth of Venus* to its enshrinement at the center of the Uffizi's collection that declared the reawakening of Italian culture, after the disasters of World War II. Strange how fortunes change a work's life: noted at birth, forgotten for centuries, resurrected in the nineteenth century, and a symbol of a reconstructed Florence after World War II. Such are the vicissitudes of fame, that what was once forgotten can now symbolize a renaissance.

When Frederick Hartt, esteemed art historian and American GI who was a member of the Venus Fixers, saw that the *Venus* was not plundered by the Germans from the Castle of Poppi, he averred that this painting and the Michelangelo *Holy Family* was of greater worth than the truckload of masterpieces the Germans had stolen in 1944. Not a bad turn of fortune for the Sandro Botticelli that Henry Fuseli labeled as having "barbarous taste and dry minuteness."

Mona Lisa by Leonardo da Vinci

You Never Know What a Smile Can Do

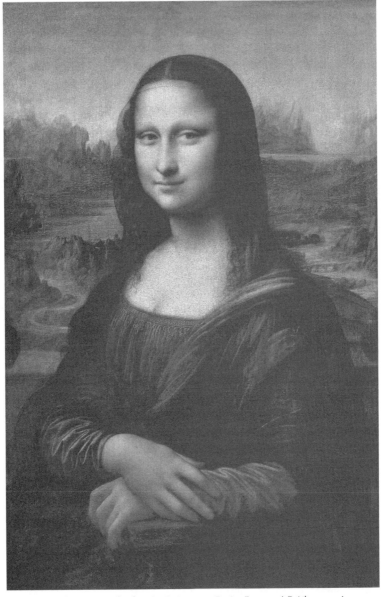

Mona Lisa by Leonardo da Vinci. *Louvre, Paris, France / Bridgeman Images*

The so-called mystery of the smile is . . . largely a nineteenth century invention of intellectuals—but in the second half of the twentieth century it has been the preoccupation of men of science rather than art historians.

—Donald Sassoon, "'Mona Lisa': The Best-Known
Girl in the Whole Wide World"

*T*he *Mona Lisa* proves that sometimes it only takes a smile to accomplish greatness, even if it might take hundreds of years to do so. The smile on the *Mona Lisa* has always been noted, but it did not get recognized as captivating and alluring, and hence world famous, until the middle of the nineteenth century. Today it is hard to look at this painting without being reminded about the smile, one that seems to have captured everyone's imagination, presumably because today we are ready to be captured.

The *Mona Lisa* has always been celebrated, but for most of its life it was famous because Leonardo da Vinci painted it, rather than being well known in its own right, and certainly not because it may have been a painting in which someone smiles. There are so many of these.

It was, however, well known soon after it was finished. One of the signs that this is so, is to look at the number of times it was professionally copied around the time it was painted. In fact, the *Mona Lisa* has been copied more often than any other masterpiece in history: there are literally dozens of old reproductions of the work in existence, maybe as many as sixty. Some have her with a nondescript background; some have pronounced columns on either side. Others make much ado about the chair she is sitting on; a few have just her face. The strangest of all are the nude copies, with Mona Lisa's breasts prominently displayed as she sits naturally in an open window.

There is a special copy in the Prado Museum in Madrid; more than just a version of an old master painting, it is claimed that it is a copy done by someone actually sitting next to Leonardo da Vinci while he was working on the original. The evidence for this comes from x-rays that reveal that the underdrawings are almost identical. This means that changes made in the copy are the same as changes made to the original, leading to the speculation that the copyist was working side by side with Leonardo while the master was making the original.[1]

It is such a good copy, that when the Louvre wanted to mount a Leonardo exhibition, they did not want to move the original, so they borrowed the Prado version as a stand-in for the real thing.

If this copy is to be believed, then it sheds new light on a masterpiece that is so familiar that we almost don't see it anymore. The Prado version has a bright, beautiful background. Mona Lisa is younger, more vibrant, and has eyebrows, now long since painted out of the original by restorers in days gone by.

The Louvre *Mona Lisa* is now buried under heavy layers of dried-up varnish and has taken on a green patina that makes her look like a Martian. She sits behind bulletproof glass that further removes her from view, obscuring her from the millions who come to pay homage.

The world's most famous painting is a simple portrait, a figure set apart on an outdoor loggia with the hint of columns on either side. She has a fantasy background behind her, with rivers, mountains, and forests as an appropriate backdrop. A faint

trace of activity is suggested by the presence of a road on the left and a bridge on the right. Otherwise, there is no other evidence of human activity.

Leonardo, who was known in life as being a big talker, had surprisingly little to say about Mona Lisa—in fact, nothing at all. In his thousands upon thousands of pages of notebooks that have survived in the collections of everyone from Queen Elizabeth II to Bill Gates, there is not a single mention of *Mona Lisa*, nor an early sketch for the work, nor even a contract for this painting.

Because of the lack of a paper trail, there have been more speculations than ever about its execution, its subject, and its true intended audience. Did this woman have a beguiling personality, or is this the gift of the artist to posterity? Despite efforts to reconstruct her life, we still know little about the encounter with Leonardo and how he came to paint the work.

Her name was Lisa Gherardini, born in 1479 in Florence, Italy. She married a man fourteen years older than herself, not a terribly unusual occurrence in the Renaissance. He was a Florentine nobleman, already widowed the year before, named Francesco di Bartolomeo di Zanobi del Giocondo. Lisa Gherardini became Lisa Giocondo. Today, at the Louvre, and in every language except English, the painting is known as *La Gioconda* (or *La Joconde*, in French). Mona is an incorrect spelling of "Monna," a shortened form of Madonna ("mia donna"), meaning "my lady."

Her family didn't have much; a modest dowry of about 170 florins was hobbled together, and then Francesco could graciously accept her hand. By the time she met Leonardo she was in her twenties and had already had three children, although one died very young.[2] She was later to produce two more.

Even though Leonardo mixed with the high and mighty of his time, he never painted any of them. His portraits are of what would then have been called the upwardly mobile middle class, not popes, cardinals, kings, patriarchs, or queens. The closest he came to any of these people was a drawing of the Marchesa of Mantua, Isabella d'Este. Even though she pursued Leonardo, indeed, haunted him, for a portrait, nothing ever materialized. She could not have been the only person to ask so distinguished an artist for a likeness, but Leonardo painted when he felt the urge, rather than for a living. In a complete catalog of his paintings, only about twenty works come down to us as being by the master.[3] This surely is not the yield of someone who derived his income exclusively from painting. In contrast, the Rembrandt Research Project has cataloged about 250 paintings by the Dutch master, a much more typical output for a professional artist. Leonardo's looks positively insignificant in comparison. Yet of that twenty, he produced the world's most famous religious painting, *The Last Supper*, and the world's most famous portrait.

The connection between Mr. Giocondo and Leonardo has been established only recently. After diving into the state archives for over twenty-five years, Giuseppe Pallanti, an economics teacher from Florence, has discovered records that indicate that Leonardo's father, a local notary named Ser Piero da Vinci, knew Francesco del Giocondo for many years, and indeed they lived "almost around the corner from each other."[4] The father was probably the connection that made the portrait happen. It may even have been commissioned by Leonardo's father as a gesture to his friend, something he had done at least one other time in the past.

It has often been remarked that the painter kept the portrait and never gave it to the sitter, which was unusual to say the least. One wonders what Mr. Giocondo had to say about not getting a portrait that he presumably had his wife pose for, only to have Leonardo give him assurances that he was working on it. Ser Francesco's will, which went into effect at his death in 1538, called his wife as his "beloved" and an "ingenuous wife," which meant that she was loyal, honest, and of noble spirit,[5] but makes no mention of a portrait by Leonardo da Vinci.

The great Renaissance biographer Giorgio Vasari, who almost certainly never saw the work, did describe it. His commentary, which is about all we know of the work from the sixteenth century, reads:

> Leonardo undertook to execute, for Francesco del Giocondo, the portrait of Monna Lisa, his wife; and after toiling over it for four years, he left it unfinished; and the work is now in the collection of King Francis of France, at Fontainebleau. In this head, whoever wished to see how closely art could imitate nature, was able to comprehend it with ease; for in it were counterfeited all the minutenesses that with subtlety are able to be painted, seeing that the eyes had that lustre and watery sheen which are always seen in life, and around them were all those rosy and pearly tints, as well as the lashes, which cannot be represented without the greatest subtlety. The eyebrows, though his having shown the manner in which the hairs spring from the flesh, here more close and here more scanty, and curve according to the pores of the skin, could not be more natural. The nose, with its beautiful nostrils, rosy and tender, appeared to be alive. The mouth, with its opening, and with its ends united by the red of the lips to the flesh tints of the face, seemed, in truth, to be not colors but flesh. In the pit of the throat, if one gazed upon it intently, could be seen the beating of the pulse. And, indeed, it may be said that it was painted in such a manner as to make every valiant craftsman, be he who he may, tremble and lose heart. He made use, also, of this device: Monna Lisa being very beautiful, he always employed, while he was painting her portrait, persons to play or sing, and jesters, who might make her remain merry, in order to take away that melancholy which painters are often wont to give to the portraits that they paint. And in this work of Leonardo's there was a smile so pleasing, that it was a thing more divine than human to behold; and it was held to be something marvellous, since the reality was not more alive.[6]

From such a heady description all kinds of rumors developed. Was Leonardo in love with Mona Lisa, and that's why he kept the portrait? It is not likely, since there are no records of Leonardo's romantic involvement with anyone. Besides, Leonardo's sexuality has been thoroughly investigated hundreds of years after his death by an army of politically correct critics who have determined, without much evidence, that he was a homosexual. True, there was a trial for sodomy, but he was acquitted, and also true, there were no important women in his life other than his mother. However, there are plenty of portraits of women, and compassionate paintings of the Madonna. He was not like Guido Reni, the seventeenth-century baroque artist who was afraid of the female nude and made sure to cover up his women completely in his paintings. When he had to paint them nude, he often misplaced breast nipples and other anatomical parts, almost as if he didn't know where they belonged.

Almost immediately after being painted it was being copied. Raphael, who almost certainly saw the painting, seems to be the first to adapt the composition in his 1504 sketch called *Young Woman in a Loggia* in the Louvre. It wasn't long before seemingly everyone wanted to be painted Mona Lisa–like in their portraits, Raphael being only the proverbial tip of the iceberg.

In the sixteenth century, however, it was unusual for a portrait to achieve this kind of recognition. There was a definite pecking order to paintings according to subjects, and everyone, literally everyone, believed it. The best paintings were religious, historical, or mythological. Then came portraits, followed by landscapes, scenes of everyday life (called genre paintings), and finally, as a last resort, still lives. The *Mona Lisa*, no matter how famous, was but a portrait.

What was really famous in Leonardo's time was his *Last Supper*. This was his key masterwork, ambitiously painted with a mixture of techniques that would not coalesce on a mural. Because of the doomed nature of the project, *The Last Supper* took on the effect of looking at the ruins of an ancient civilization, and filled the viewer with a mixture of awe and fascination of what it might have looked like. Nineteenth-century students on an artistic grand tour of Italy had to make a stop before *The Last Supper*, suffering as it does from the harmful effects of Leonardo's own untested concoction of paints. But that was part of the allure. Leonardo, the endless experimenter, a so-called man ahead of his time, produced a painting that was revolutionary and magnificent, yet simultaneously likely to crumble to death.

Here was not one portrait, but in a sense thirteen, all artfully arranged around a table, and all expressing a variety of extraordinary emotions. The ruined nature of the masterpiece fitted very well into the preconceived notions of Leonardo as unable to fulfill all the requirements of his wandering imagination.

Even though the *Mona Lisa* was eclipsed, it was by no means in the shadows. It was important enough to earn the attention of King Francis I, who invited the ailing Leonardo to Paris to crown his court with the greatest mind of his age.

The king probably took Leonardo's estate after he died, although that part of the story is largely unknown. There is a legend that he purchased the painting for the huge sum of four thousand gold crowns.[7] Kings did pay huge sums for paintings, but in this case it seems unlikely that Francis would have bothered paying for something that he could just take. By the mid-1550s it was in Fontainebleau, in the king's favorite chamber: the Appartement des Bains.

The *Mona Lisa* was in good company in the king's apartments. In this luxury suite, mostly devoted to recreation as well as bathing, *Mona Lisa* sat with works by Perugino, Raphael, Andrea del Sarto, and Giulio Romano—apparently to be a great artist meant you had to be Italian. In fact, the rooms themselves were decorated by the Italian mannerist painter Francesco Primaticcio.

These chambers were the galleries of their time, functioning as nescient art schools, where those with credentials could examine "old masters." It is here that nude versions of *Mona Lisa* begin to multiply; even distinguished artists copied it, like the Flemish painter Joos van Cleve, whose work is now in the National Gallery in Prague, Czech Republic.

Mona Lisa languished in the royal collection, thought of as an object not above being traded for other works. King Louis XIII was willing to deal the painting for Holbein's *Erasmus* and Titian's *Holy Family* to the art-hungry English Duke of Buckingham. Cassiano dal Pozzo, an Italian antiquarian and patron of such artists as Nicolas Poussin, remarked that it was only "by the entreaties of several persons who advanced the consideration that His Majesty was sending his most beautiful painting out of the kingdom."[8] Dal Pozzo had already noted in 1625 that the painting was a damaged vestige of itself: "The dress is black, or dark brown, but it has been treated with a varnish which has given it a dismal tone, so that one cannot make it out very well. The hands are extremely beautiful, and, in short, in spite of all the misfortunes that this picture has suffered, the face and the hands are so beautiful that whoever looks at it with admiration is bewitched."[9]

Leonardo's painting style was not highly praised at this time. Seventeenth-century art theorist Roger de Piles wrote a book in which he rated each artist on composition, drawing, color, and expression. While Leonardo got relatively high marks for composition (15 out of 20), drawing (16 out of 20), and expression (14 out of 20), his use of color earned him only a 4 out of 20. That probably reflects the damaged state of preservation the *Mona Lisa* was already in.

This didn't stop people from sending the painting here and there. In the 1650s it was moved to the Louvre; by 1695, according to an inventory, it was at Versailles. In 1706 it was in Paris in the palace of the Tuileries. In 1709 it was in Versailles again. Even though it was shuffled around, it must have found an interested audience, because Jean-Antoine Watteau, the finest exponent of the rococo style, used the background to the *Mona Lisa* as the setting of his epic work, *The Return from Cythera*.

In 1750 the best 110 items of the royal collection were exhibited to a highly select public; the *Mona Lisa* was not in attendance.[10] The painting began to be bandied about to various offices in Paris: by 1760 it was in the office of the Directeur des Bâtiments (the keeper of royal buildings). In 1797, during the French Revolution, the *Mona Lisa*, along with hundreds of other works, was now thought to belong to the French people and to a royal collection, and it was with great dispatch moved to the former palace of the Louvre.

France had finally realized that great nations had great collections of great pictures. Already the Vatican in Rome, the Uffizi in Florence, and the British Museum in London were open, and pressure was mounting on the French to respond by placing their great works on display. By 1801 the Louvre was finally made available to all, although the *Mona Lisa* was absent, taken by Emperor Napoleon as a little jewel fit for his royal apartments.

By the early nineteenth century the painting had developed a reputation as a great work of art, but by no means was it the cult object it was later to become. Of course, anything attached to the name of Leonardo da Vinci was going to be precious just on the face of it.

In comparison to *The Last Supper*, the *Mona Lisa* is comparatively hardy. True, it was probably cut down on two sides, and was subjected to the interferences of various restorers, but at least it is not peeling or chipped or damaged. We see the bases of two columns on the parapet behind her, acting as framing devices for the

figure, but at one point the columns were removed, perhaps to make her fit in an available frame. Waste not, want not.

In 1849 a committee was set up by the Louvre to put a price value on each painting in the collection. "Le Portrait de Mona Lisa connue sous le nom de *la Joconde*" was evaluated as being worth ninety thousand francs, much less than Leonardo's own *Virgin of the Rocks*, set at 150,000 francs.[11] All of this pales distantly behind the Louvre's collection of Raphaels. His "La Vierge, l'Enfant—Jésus et saint Jean; composition connue sous le nom de la *Belle Jardinière*" was evaluated at a whopping four hundred thousand francs, as well as a *Holy Family* estimated at an even more impressive six hundred thousand francs.[12]

The *Mona Lisa* was famous, but hardly embraced, treasured, or world renowned. When Amilcare Ponchielli debuted his 1876 opera *La Gioconda* at La Scala in Milan, there was no mention made of the connection between this title and the painting. In fact, the opera makes no reference to the painting at all, the title simply referring to the street singer who is the main character.

Up to this time the *Mona Lisa* was a painting seen only by the intellectually curious, not sought after by the general public. Part of the problem was the lack of available prints; it had to wait until 1820 to be engraved. One could argue that the *Mona Lisa* was not easy to engrave. All those subtle passages of color and shading that make the painting so precious fall flat with an engraver's sharp and incisive tool. Once it was engraved, the general public could now have greater access to the work.

This meant that more people would want to see the original, and see they did. The Marquis de Sade, a man who was not shy around women, saw in the *Mona Lisa* a "seduction and devoted tenderness" that was "the very essence of femininity."[13] She began to have characteristics different from what was seen before. Was she the wife of Francesco del Giocondo, or was she a femme fatale, a seductive woman whose charms lure lovers into an entrapment that ultimately leads to their downfall?

Literature is laden with such stereotyped women. Delilah tricks Samson and ushers him to his death; Helen of Troy dooms any number of men who find her attractive. But the Mona Lisa? A woman whose veil covers her hair and whose demure, dark outfit virtually engulfs her? A woman with no sex appeal, and who doesn't even wear jewelry to attract the eye? Thank romantic writer and art theorist Théophile Gautier, who turned her into a woman of mystery, a woman whose smile beguiles and ensnares.

Gautier's popularity as a poet and playwright made nineteenth-century Parisians sit up and take notice when he began discussing subjects outside his usual realm. In 1858 he published an article in a magazine called *L'Artiste in dieux de la peinture*. This article was the turning point in the appreciation of the *Mona Lisa*, because now everyone who looked at her, looked at her with different eyes.

> How can we explain otherwise the singular charm, almost magic, which the *Mona Lisa* exercises on even the least enthusiastic natures? Is it her beauty? Many faces by Raphael and other painters are more correct. She is no longer even young. . . . Her costume, because of the darkening of the pigments, has become almost that of a widow; a crêpe veil falls with the hair along her face; but the expression, wise, deep, velvety, full of promise, attracts you irresistibly and intoxicates you, while the sinuous, serpentine mouth, turned up at the corners, in the violet shadows, mocks you

with so much gentleness, grace and superiority, that you feel suddenly intimidated, like a schoolboy before a duchess. . . . One is moved, troubled, images *already seen* pass before one's eyes, voices whose note seems familiar whisper languorous secrets in one's ears; repressed desires, hopes that drive one to despair stir painfully in the shadow show with sunbeams and you discover that your melancholy arises from the fact that Mona Lisa three hundred years ago greeted your avowal of love with this same mocking smile which she retains even today on her lips.[14]

But is Gautier's premise correct? Could one fall in love with a picture? Could one be so enamored with a painting that one could reconstruct a whole history around her? Apparently, in the nineteenth century, this was not a problem. Art historian Charles Clément said that Leonardo himself was in love with her, or at the very least the image he created,[15] a theme repeated throughout the century until almost everyone believed it. After all, if Frenchmen didn't understand great art, who did? Artists from every corner of the Western world flocked to Paris. The French did very little flocking elsewhere. Individual French artists traveled, some extensively, but they rarely felt they had to settle someplace other than Paris. Many American painters, like James Whistler and Mary Cassatt, left the United States and settled in Paris just so they could command better prices back home because they were now at the center of the art world.

In Britain it was Walter Pater who brought the *Mona Lisa* to the general consciousness of the English-speaking public in 1873. His landmark descriptions of great paintings tell us more about Victorian attitudes toward pictures than they do about the pictures themselves. His description of the *Mona Lisa* has become a milestone in the history of purple prose. Try this sentence out:

> She is older than the rocks among which she sits; like the vampire, she has been dead many times, and learned the secrets of the grave; and has been a diver in deep seas, and keeps their fallen day about her; and trafficked for strange webs with Eastern merchants; and, as Leda was the mother of Helen of Troy, and as Saint Anne, the mother of Mary; and all this has been to her but as the sound of lyres and flutes, and lives only in the delicacy with which it has moulded the changing lineaments, and tinged the eyelids and the hands.[16]

The Frenchmen may have cornered the market on great art, but in the field of literature, the British were held to be superior. Pater came to represent the perfect match of English prose with an insightful presentation of the arts. This would become a British trademark from the nineteenth century down to the time of Kenneth Clark, whose *Civilisation* television series from the 1960s was very convincingly and artfully put, even if it had very little to say that was new.

Even rebellious writers like Oscar Wilde admired Pater and his writing—so much so that he considered the criticism superior to Leonardo's masterwork. In his 1890 artistic conversation called "The Critic as Artist," Wilde says:

> I always think, even as Literature is the greater art. Who, again, cares whether Mr. Pater has put into the portrait of Monna Lisa something that Lionardo [*sic*] never dreamed of? The painter may have been merely the slave of an archaic smile, as some have fancied, but whenever I pass into the cool galleries of the Palace of the Louvre,

and stand before that strange figure "set in its marble chair in that cirque of fantastic rocks, as in some faint light under sea," I murmur to myself, "She is older than the rocks among which she sits. . . ."

And it is for this very reason that the criticism which I have quoted is criticism of the highest kind. It treats the work of art simply as a starting-point for a new creation. It does not confine itself . . . to discovering the real intention of the artist and accepting that as final. And in this it is right, for the meaning of any beautiful created thing is, at least, as much in the soul of him who looks at it, as it was in his soul who wrought it. Nay, it is rather the beholder who lends to the beautiful thing its myriad meanings, and makes it marvellous for us.[17]

By the turn of the twentieth century the *Mona Lisa* had achieved great status as *the* great artwork of all time. The painting had all the tools for enormous popularity. It was possessed by royalty: King Francis I had to have both Leonardo and it, and Napoleon placed it in his bedroom. It was created by one of the great minds in history. Furthermore, it has been authorized and sanctioned by the greatest art theorists of the nineteenth century.

It now began to be the focus of attention at the Louvre, rising before all competition in a museum filled with one masterpiece after another. It wasn't long before the fame of the object began to encourage commentary ranging from the most erudite studies to the ramblings of those who could barely write. In fact, few great thinkers could now withstand the allure of the portrait. Sigmund Freud, the Austrian neurologist who became the founder of modern psychoanalysis, was unable to resist the bait that apparently the *Mona Lisa* had to offer. Freud devoted himself to creating a psychoanalytical portrait of Leonardo using his chimerical biography, his mysterious paintings, and his profuse writings as a basis for the study. In the middle of his discourse entitled *Leonardo Da Vinci: A Psychosexual Study of an Infantile Reminiscence*, Freud comes to this conclusion:

> It was quite possible that Leonardo was fascinated by the smile of Monna Lisa, because it had awakened something in him which had slumbered in his soul for a long time, in all probability an old memory. This memory was of sufficient importance to stick to him once it had been aroused; he was forced continually to provide it with new expression. The assurance of Pater that we can see an image like that of Monna Lisa defining itself from Leonardo's childhood on the fabric of his dreams, seems worthy of belief and deserves to be taken literally.[18]

Now that the *Mona Lisa* was officially ensconced as a great work, it could become a target of thieves. But stealing the *Mona Lisa* was a problem. Not that it was well protected: it was only affixed onto the wall with four iron pegs, hardly something that would make thieves recoil. It was the problem of reselling it. Thieves rarely work for the fun of it, but often seek to take things that can be fenced somewhere else. Who would buy a stolen painting that was so famous?

At the time Louvre authorities thought that vandalism, not theft, was a threat, and they placed some of their most famous objects behind a glass, an innovation at the time. This caused a firestorm of protest from purists who felt that the glass was a barrier to an appreciation of the object. It also made people think that the real *Mona*

Lisa was missing, and that a fake had been placed behind glass. The Louvre hired a handyman named Vincenzo Peruggia, among others, to fashion the glass that would protect the great objects from disfigurement.

The inner workings of the Louvre, such as they were, were well known to employees of the vast complex. On Monday, August 21, 1911, Vincenzo Peruggia walked into the Louvre and straight up to the *Mona Lisa*, detached it from its bolts, and took it into a janitorial closet. Once in the closet, he placed the painting in his smock that had been precut with an inside pocket, deep and wide enough to house the painting. He walked out the door of the museum, jettisoning the glass and the frame along the way.

No one noticed that the painting was missing until the next day. Guards had assumed that photography had the painting, or perhaps one of the curators took it for study. Gradually it began to dawn on the security forces in the Louvre that the *Mona Lisa* was nowhere to be found, and then all of a sudden the museum was shut down, an investigation was under way, and all visitors had to be searched. Not that there was any need for this, for Peruggia had already spirited the painting to his apartment where he placed it, securely one supposes, under his stove. The Louvre was closed for a week pending intensive investigations that turned up nothing more than a clear but unusable fingerprint, and the glass and frame.

Instantly the news became international. Borders to France were closed—ships were searched while at dock; trains were told to stop at the French border. Newspapers began calling for the heads of all the officials at the museum. The *Petit Parisien*, a hugely popular newspaper in Paris, had a headline that read, "La Joconde a disparu du Musée du Louvre" (Mona Lisa vanished from the Louvre Museum), with a subhead that sardonically read, "Il nous reste le cadre" (We still have the frame).[19]

Stealing the *Mona Lisa* was one thing, disposing of it another. Peruggia had a general idea that it was "stolen by Napoleon" and should be returned to Italy, but how and why he could make that return was unclear.

Finally, two years later, Peruggia felt confident enough to make his move. He contacted a Florentine antique dealer named Alfredo Geri and told him that he had the *Mona Lisa*. All he wanted was five hundred thousand lire and an agreement that the painting would stay in Italy.

Clearly, Peruggia did not think this through. A quick call to the police, and he was staked out in his hotel room. Alfredo Geri, along with Giovanni Poggi, the director of the Uffizi, came to Peruggia's hotel room. Geri recalls the painting being removed from a trunk that had in it, among other things, a pair of old shoes, a shirt, and woolen underwear:

> After taking out these not very appetizing objects [Vincenzo Peruggia] lifted up the false bottom of the trunk, under which we saw the picture. . . . As soon as it appeared we had an impression that it was indeed the authentic work of Leonardo da Vinci. The smile of Mona Lisa was again alive in Florence. We were filled with a strong emotion. Vincenzo looked at us with a kind of fixed stare, smiling complacently, as if he had painted it himself.[20]

Needless to say, Peruggia was arrested and sent to jail, and the painting had to be returned, eventually, to France. The Louvre was overjoyed at the news, if only to

stop the unappetizing spectacle of watching visitors go to the spot where the *Mona Lisa* used to hang, and stare at a blank wall.

Now that the painting was in Italy, a short tour through the country seemed like it would be in order. First stop was the Uffizi Gallery in Florence, then the *Mona* show traveled to Rome where it was featured at French properties including the Palazzo Farnese, and the Villa Medici. It also was displayed at the Galleria Borghese. Lastly, it had only two days, which newspapers described as hysterical, at the Brera Museum in Milan, where sixty thousand people pushed and shoved their way toward the painting.

Peruggia got off lightly. By the time his trial was over, he had served his sentence of seven and a half months in jail, and was set free. Geri collected the reward money of twenty-five thousand francs from an organization called the Friends of the Louvre. Newspapers throughout Europe were absolutely crestfallen that the painting was stolen by an amateur thief and not the head of an international crime syndicate.

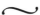

The theft had permanently enshrined the *Mona Lisa* as the most desirable and sought after painting in the world, one that every tourist would want to claim to have seen, and that every tour group would have to include on a journey through the Louvre.

But that meant a push back. In the early twentieth century it became fashionable for art critics to turn up their noses at the painting. Regular people, after all, liked it, and therefore it could not be of much value. Some of the most esteemed art critics, like Bernard Berenson, were downright nasty:

> Why indeed should this cultivated society of the future return to the "Mona Lisa"? There is nothing in her expression that is not far more satisfactorily rendered in Buddhist art. There is nothing in the landscape that is not even more evocative and more magical in . . . a score of other Chinese and Japanese painters.[21]

When Berenson learned that the *Mona Lisa* had been stolen, it was as if some pestering bully had moved out of town:

> One evening of a summer day in the high Alps the first rumour reached me of "Mona Lisa's" disappearance from the Louvre. It was so incredible that I thought it could only be a practical joke perpetrated by the satellites of a shrill wit who had expressed a whimsical animosity toward a new frame into which the picture had recently been put. To my own amazement I nevertheless found myself saying softly; "If only it were true!" and when the news was confirmed, I heaved a sigh of relief. I could not help it. The disappearance of such a masterpiece gave me no feelings of regret, but on the contrary a sense of long-desired emancipation. Then I realized that the efforts of many years to suppress my instinctive feelings about "Mona Lisa" had been vain. She had simply become an incubus, and I was glad to be rid of her.[22]

Berenson was far from being alone. He was joined by distinguished art historians like Roberto Longhi. But more measured approaches like those of Lionel Cust simply claimed, "Let it be conceded that this portrait had been invested with an aureole of exaggerated brilliance by certain distinguished literary characters of the 19th Century."[23]

Twentieth-century artists were not about to treat the icon with reverence, either. After all, modern art seeks to reject much of the tradition that has governed aesthetics for centuries. Fauvists loved the meaning of their movement: wild beasts. Futurists sought to destroy everything in the past, most especially museums, which represented to them the stagnation of civilization. Cubists rejected traditional methods of depicting the figure. Needless to say, each of these movements was more indebted to the past than they would have liked to confess.

Even opera, that most tradition bound of entertainment forms, experienced the debut of Max von Schillings's *Mona Lisa* in German, in 1915. The story is a complex mix of fictional elements, in the manner of any good opera plot, ending with Mona Lisa suffocating her husband in a shrine, of all things. It achieved a modest success in Germany and was exported to the Metropolitan Opera House for seven performances in 1923 and 1924.

After World War I when most conventional aspects of society were dismissed in view of the carnage and utter horror of warfare, the *Mona Lisa* became center stage in the struggle to reject the perceived decadence of the past. Marcel Duchamp, the Dadaist artist, used the painting as the subject of his witty retorts. He took a postcard reproduction of her and added a discreet mustache and a small goatee in pencil. He renamed the piece *L.H.O.O.Q.* The letters, seemingly meaningless, were placed at the bottom of the card. When the letters are individually pronounced they reveal an off-color statement: "Avoir chaud au cul," or "She has a hot ass." Maybe she did.

Duchamp's 1919 witticism was echoed many times for a public eager to throw darts at an acclaimed and popular masterpiece. Sometimes Duchamp repeated it on wood, other times in color, and even in the form of a playing card. By the mid-1920s Dada was dead as a movement; the joke became overplayed and tiresome.

During the two world wars Louvre personnel removed the *Mona Lisa* to points unknown, just so that it would be out of harm's way. The art-hungry Nazis would have liked this most precious prize in their collection, having looted just about everything that was both nailed and not nailed down. However, the whereabouts of this painting during this period has been shrouded in mystery.

It seems likely that Louvre officials made much of the distribution of their paintings to various chateaux and mines throughout the country in advance of Nazi conquest. This gave the Nazis the feeling that they had to search for what they wanted, but that they could eventually have anything they chose. To prevent the *Mona Lisa* from making the journey into Nazi hands, curators substituted a sixteenth-century copy of the painting and allowed the Germans to find it and take it, hoping that they would then lose interest in the real painting. Documents at the end of the war reveal that the *Mona Lisa* was returned from an Austrian salt mine in Altaussee, but actually it was only the copy that was repatriated. The original may have been in Paris the entire time, probably sleeping quietly away from view.[24]

The subterfuge on the part of Louvre officials is just one more ironic step in the journey this masterpiece has made from a portrait of a friend's wife to a femme fatale to a cult item. All kinds of rumors began to circulate about the painting. For example, it was believed that her eyes follow you around the room, as if such a thing could happen with a painting. Her smile, it was said, is inscrutable. "Vainly we question her; like the Sphinx her riddle eludes us still."[25]

Perhaps because of the fame surrounding the *Mona Lisa* it was decided by the French government that it should make a voyage to the United States. In a world filled with politics dominated by personalities, the American president and First Lady, John and Jacqueline Kennedy, were the reigning king and queen of a self-styled administration they called "Camelot." André Malraux, the French minister of cultural affairs, was approached during an official visit to Washington, D.C., by Jacqueline Kennedy, who asked if there was any possibility that the *Mona Lisa* could come to the United States on a state visit. Malraux didn't say no.

The world was fast becoming a place in which international diplomacy and goodwill was often dictated by gestures of sponsorship. Increasingly, corporations were advertising their cultural fundings of special art exhibitions, operatic productions, or symphonic concerts—high-visibility projects aimed at moneyed audiences. The age of international cultural exhibitions had arrived, in which works of art were being dragged around continents to suit a curatorial exhibition of one theme or another.

When news reached Paris that the *Mona Lisa* might go, Louvre officials were apoplectic, and not without reason. The image is not stable, painted on a piece of planed poplar wood, now slightly warped with a gentle convex shape. To remedy the warping, an oak frame was added in 1951, later reinforced with four horizontal crossbars in 1970. An eleven-centimeter crack in the back of the panel was prevented from widening with two dovetails to forestall the onset of woodworm.[26] This crack can be seen in the front of the painting, just above the head of the Mona Lisa to the right. This was not the kind of painting that could easily be moved and transported over the Atlantic—in those days only by sea. Some of the curators at the Louvre threatened to resign, and the French newspaper *Le Figaro* asked Americans to refuse the loan.

None of these concerns meant anything to the politicians who arranged the coup. Great preparations were made to make sure that the *Mona Lisa* would have an uneventful journey to the United States. It was booked a deluxe cabin on the SS *France*. The container case, both fireproof and waterproof, was affixed to a bed frame and it had, naturally, security guards and museum staff hovering over it for the entire journey.[27]

Two venues were planned in the United States: the National Gallery in Washington, where politicians could be seen gathering around the painting knowingly examining its virtues, and the Metropolitan Museum in New York, where those with money would have the opportunity of a lifetime to stand in line with the hoi polloi.

Although the SS *France* docked in New York, the first exhibition was to be in Washington, so the container with the *Mona Lisa* was loaded onto an ambulance with Secret Service agents and sent down the intentionally cleared highways of New Jersey and Maryland to its destination. In Washington, the reception was less than refined. After all, politicians were there to be seen *with* the *Mona Lisa*, not actually to see it. In attendance were the president, Mrs. Kennedy, and André Malraux, all of whom tried to address a crowd of two thousand of the elite and lofty by shouting over them, the public-address system having failed to operate. No one paid the slightest attention, but then again Washington crowds are stereotyped by their reliance on babble as a form of communication. The president and Mr. Malraux looked very angry, but there was nothing that could be done. Even the president's mother, Mrs. Rose Kennedy, could not squeeze through the unmoving crowd, and sat in a side gallery. Secretary of

State Dean Rusk tried to mitigate the circumstances by alleging, "Since the earliest days of our frontier, irreverence has been one of the signs of our affection."[28]

In contrast, the next day the gallery was open to visitors and the common man came through the doors of the museum in hushed silence to look at the painting—as long as he kept moving. On either side, the *Mona Lisa* was protected by armed, bayoneted guards who presumably were ready to pierce anyone who came too close to the painting.

New York, by contrast, only had its mayor, Robert Wagner, to present the painting to the public; a few short words were all that was deemed necessary to inaugurate the exhibition. The painting was placed in the great Medieval Hall, one of the largest rooms in the museum, so that the crush of visitors could be accommodated. Along the way, large explanatory panels kept the visitors busy, if they cared to read them, about the different aspects of the painting's technique, heritage, and execution. The museum had time to plan the exhibition, using Lorenzo di Credi's *Portrait of a Young Woman*, which is roughly the same size, as a stand-in to judge the appropriate placement of the work.

Everyone knew that the crowds were going to be enormous, because in 1963, how many people could travel to Europe to see this work? And now, here it is, coming to you! The largest day of attendance had 63,675 people enter the Great Hall, many of whom had never been inside the museum before.[29] In all, 1.6 million people had seen the *Mona Lisa* in the short time it spent in America.

After the *Mona Lisa* left, it was heralded in American newspapers as the beginning of a new era of diplomacy. And the French were listening. After the triumphant,

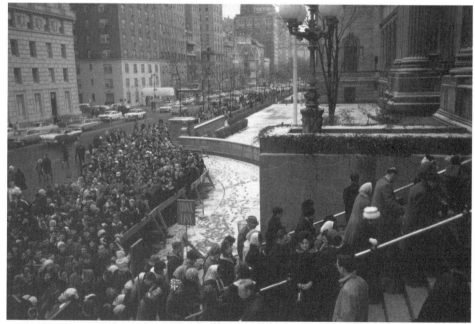

People queued up early to get a glimpse of the great lady when she appeared at the Metropolitan Museum in 1963. *Image copyright © The Metropolitan Museum of Art. Image source: Art Resource, NY*

and incident-free, trip to America, the French now thought the *Mona Lisa* could go even further afield.

This time the French sent the painting to Japan, by airplane, to what was then perceived as an opening market. The Japanese had discovered Europe, and were bringing fresh cash to an old continent. Their numbers may not have been as significant as other countries', but their Asian appearance was very new, and they stood out in the galleries of the Louvre. In 1964 Malraux had sent the *Venus de Milo* to Tokyo, where it was rather oddly greeted as a monument to French culture. The fact that it was returned chipped did not prevent future politicians from participating in the lending craze.

In 1974 French president Georges Pompidou approved of the loan of the *Mona Lisa* to Tokyo, where it stayed for two months, awaiting various hordes to pay homage. The Japanese, no strangers to crowd management, wanted to ban wheelchairs and crutches from the exhibition so that people could have their four seconds before the masterpiece unworried about the disabled slowing them down. In a society known for its longevity, and with a significant number of wounded people from World War II still around, this was greeted with outrage. The government relented after the protests mounted, bad public relations threatening to cloud the entire exhibition.

On the way back to Paris, a quick stop was arranged for the *Mona Lisa* to make its Russian debut at the Pushkin Museum in Moscow. Here it stood as a gesture of friendship during the height of the Cold War. In this three-month journey to two countries, the *Mona Lisa* entertained another two million people.

It is not that the *Mona Lisa* needed a world tour to become famous: it was already the most famous painting in the world. The world tour did, however, solidify its position in first place. Other great works of art have been around the world, but this one is the only one that went alone, not needing accompaniment. It was not part of an exhibit like *Great Masterpieces from the Louvre* to generate interest; it could generate a spectacular following all by itself, and it was the only one that could do so.

This has meant that almost everyone has had his or her say about the painting, putting a definitive mark on the subject. Art historian Kenneth Clark rather humorously remarked, "I cannot believe that she has ever aroused desire in anyone, although she has often aroused repulsion."[30] This is countered by Richard B. Carpenter, who had a PhD in art history from Harvard, who said, "One may ask whether she appears as mistress or mother, whether her face has the shrewd sweetness of a feminine love conspiring to unveil itself or whether the contemplative ascendancy of her knowing love seeks to possess while forbidding the equality of passion."[31]

By the dawn of the computer age, *Mona Lisa* began making headlines on an average of once a year. Artist Lillian F. Schwartz became famous when she grafted the *Mona Lisa* onto a Leonardo self-portrait, and claimed that the two matched perfectly, and therefore the *Mona Lisa* was a hidden self-portrait.[32]

It wasn't long before enthusiasts of all persuasions were going to have a go at Mona. The painting was examined by an eager team from the University of Amsterdam. They reported that through extensive computer analysis of the curvature of her lips and the crinkles around her eyes, Mona Lisa was 83 percent happy, 9 percent disgusted, 6 percent fearful, and 2 percent angry.[33]

But what about her teeth? Data have emerged in a field known as "dental archaeology" in which it has been determined that the Mona Lisa's smile hides her bad teeth.[34] And her skin? A doctor in Oakland, California, has determined that Bell's palsy, a common nerve disorder, is responsible for the Mona Lisa's smile. Dr. Kedar K. Adour tells his patients that their pain is also known as "Mona Lisa's disease," and according to him, when they hear this, they feel "200 percent better."[35] He told a meeting of medical professionals in Santa Fe, New Mexico, that the disease is the cause or reason why Mona Lisa's smile is higher on the left side of her face, and her left eye is narrower than her right.

But wait, she may have had high cholesterol, too. According to *Time* magazine, a Sicilian professor of pathological anatomy, Vito Franco, has determined that Mona Lisa suffered from xanthelasma, an accumulation of cholesterol under the skin, usually around the eyelids. He says he could find evidence of this condition around her left eye, as well as signs of lipoma, a fatty-tissue tumor on her right hand, just beneath the surface of the skin. One suspects that you don't need to ever go to the doctor, just send him or her a photograph of your face and wait for the lab results.[36]

No such intense diagnosis is necessary for other great portraits in history, only the *Mona Lisa*. She has the curious distinction of being subjected to the medical scrutiny hundreds of years after her execution, a medical scrutiny she could not have gotten while she was alive.

Looking carefully into her eyes with a microscope, an Italian researcher, Silvano Vinceti, says he has discovered Mona Lisa's true identity. Although not visible to the naked eye, somehow Leonardo managed to inscribe his initials, *LV*, into her right pupil. Her left pupil has the initials *B* or *S*, or possibly *CE*, a "vital clue" to identifying the model.[37]

Today her fame and her smile are used to sell everything. A copy of the painting has been imprinted with a McDonald's logo and the saying "I'm loving it." Dentists have used it to motivate clients to opt for cosmetic work, as is the case of a certain San Ramon, California, dentist, Dr. Mohammad Khandaqji, whose practice is called "Mona Lisa Smile Dental."

Her smile has been particularly used as a favorable trademark in any one of literally hundreds of restaurants around the world. Touristy sections of cities like San Francisco have several Mona Lisa eateries. A bistro in Wilmington, Delaware, sports an image of the famous painting with the saying that tells us "No passport required." A restaurant in "downtown" Manitou Springs, Colorado, takes a new twist on an old theme by using the image to promote the "Mona Lisa Fondue Restaurant."

Perhaps all of this is to be expected with an image as famous as this. On occasion, some groups have used the painting to pass along a simple ideal. Recently, billboards were put up across the United States by a group called Values.com with an enlarged image of the *Mona Lisa* and just the word "Smile" next to it. Underneath, in smaller print, was added "Pass It On." She certainly has.

Sistine Madonna by Raphael

The Most Perfect Picture in the World

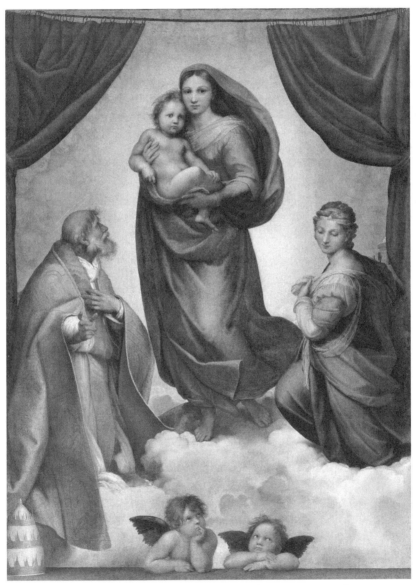

Sistine Madonna by Raphael. *Gemaeldegalerie Alte Meister, Dresden, Germany*
© *Staatliche Kunstsammlungen Dresden / Bridgeman Images*

In execution and design, this is probably the most perfect picture in the world.

—Mrs. Jameson, *Memoirs of the Early Italian Painters*

It comes as no surprise that this emphatic, if overly zealous, statement should be applied to Raphael's *Sistine Madonna*, for the painting has been the subject of pilgrimages by the literary and artistic community since the time it was created.

The painting's rise to fame crested in the nineteenth century, when literary figures took inspiration from scholarly judgment and declared their attachment to the work. English poet Edward FitzGerald wrote to his friend E. B. Cowell that he would never travel abroad again, "unless I go to see Raffaelle's Madonna at Dresden, which no other picture can represent but itself."[1] This statement seems to be a constant refrain throughout the painting's history: one has to *see* the *Sistine Madonna*—no reproduction will do—and one has to return again and again to experience it fully. What has made this painting so attractive to audiences past and present? Given the seemingly limitless representations of the Madonna and Child produced in the Renaissance (Raphael himself painted at least thirty), how does this masterpiece stand alone?

By studying the slightly earlier *Madonna of Foligno* painted by Raphael in 1511–1512 and now in the Vatican, some light can be shed on the *Sistine Madonna*. Here are paintings of comparable dimensions, composition, and coloring; they both share the lower placement of angels, and have an archivolt of putti (male winged children in art) surrounding the principal figures. In the *Foligno*, Mary tries to restrain a rather petulant and thoroughly childlike Jesus, who squirms at her side. This seems to set the general tone: the other figures look all too human, particularly the portrait of the donor, Sigismondo di' Conti, who is kneeling at right. This is a face of rare penetration: simple, honest, and direct. Saint Jerome embraces Sigismondo's head as he presents the donor to Mary, who smiles down beneficently. The candor of Sigismondo's expression is echoed with gentle resonance in the faces of the other figures in the painting, Saint John the Baptist and a kneeling Saint Francis of Assisi.

In some ways the *Sistine Madonna* is the fulfillment of the *Madonna of Foligno*. The composition in the later painting has been simplified, and the glow intensified. The multitude of putti faces has been subdued, all to make us concentrate more on the principal figures. To the left is Saint Sixtus II, and to the right is Saint Barbara shown with the fortress in which she was imprisoned behind her. Saint Francis in the *Foligno*, also a portrait of unblemished frankness, has a pose nearly identical to Sixtus. Saint Barbara mirrors the position of Saint John the Baptist in the earlier painting.

But the dramatic change—the one that essentially sets the *Sistine Madonna* apart from nearly every other religious painting—is the intensity of expression in the faces of Mary and Jesus. Here is Mary confronting the viewer, nervously perhaps, gently moving over the globe and clutching her child. Jesus's noble and puzzled expression betrays a wisdom beyond his few years. English poet Samuel Taylor Coleridge described the expression on Jesus's face this way: "The infant that Raffael's Madonna holds in her arms cannot be guessed of any particular age; it is Humanity in infancy."[2] F. A. Gruyer, a nineteenth-century French critic, called Christ's expression "enraged."[3] Arthur Schopenhauer, the great German philosopher, confessed he was "terror stricken"[4] by the strange young face.

Coleridge, Gruyer, and Schopenhauer are not alone in perceiving that something very special seems to be depicted here. Critics have noted the divine nature of the serious and pensive baby in Mary's arms, as well as the very human maternal instinct to embrace and protect the child she has given birth to. Moreover, Mary is divine, too, not merely in her youthful virginal state and in her graceful pose, but also in her position atop the earth surrounded by saints and miscellaneous angelic heads. Particularly attractive is the ethereal rendering of the forms, the soft, divine glow around the Madonna and Child. For centuries Mary's expression has struck the viewer as enigmatic and haunting. How protectively maternal she appears! The Christ Child, too, stares into the distance at what Mary is gazing at and pondering.

Where did Raphael find such a Madonna? A portrait in the Pitti Palace of an unknown woman painted by the artist a few years later in 1516 and now known as *La Donna Velata*, provides a clue. Mary in the *Sistine Madonna* and the figure in *La Donna Velata* look nearly identical, strongly suggesting that Raphael used the same model for both works. However, we are left with the same question: Who is this woman? History has both veiled her and her name from us, but undoubtedly Raphael must have seen in her the ideal vision of Mary. One legend claims she is Raphael's mistress, much like Fornarina, the name given to one of several of Raphael's known consorts.[5] However, Fornarina's image is known to us, and it does not match that of Mary in the *Sistine Madonna* or the figure in *La Donna Velata*.

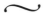

The painting has had a rather simple history. Painted between 1512 and 1513, it was meant expressly for the high altar of the Church of San Sisto in Piacenza, Italy, a church consecrated in 1514. It is this location that has given the painting its name. Pope Julius II Rovere had a special interest in this church, subsidizing its construction and granting the commission of this painting to one of the greatest talents in his artistic circle. Raphael approached the subject by combining the traditional Madonna and Child subject matter with two important saints whose relics are preserved in San Sisto. To deepen further the connection between patron and subject, the features of Julius II were used as the model for Saint Sixtus II. Details on Sixtus's cloak and tiara point to motifs on the Rovere coat of arms, and Sixtus himself was a patron of the Rovere family. Significantly, it is the pope who points toward the viewer, perhaps to ask us to behold the vision. After all, as supreme pontiff according to Catholic belief, Sixtus would have been a mediator between the sacred and the profane. However, whatever Sixtus's gesture may signify, the Madonna and Child stare fixedly out into space, looking beyond the pope and us into the future and the unknown.

The details of the pope's regalia are so strong that it is tempting to suggest that the *Sistine Madonna* was perhaps unveiled in Rome first, although no one knows for sure. Regardless of the location of its debut, the painting's impact was strongest among fellow artists, who journeyed to Piacenza to experience the Raphael. Central and northern Italian artists were particularly impressed: here was a genuine Raphael in their own backyard, no pilgrimage to Rome needed.

There were other reasons for the initial success of the work. By 1513 Raphael was already enthroned as the preferred painter of the pope, busy working on a project to decorate the papal apartments in the Vatican. Even Ariosto, in his famous *Orlando Furioso*, proclaimed Raphael, who was just over thirty years old, "already a legend."[6]

Art historians have been quick to find artistic descendants: Andrea del Sarto's *Madonna of the Harpies* painted in 1517 and now in the Uffizi, Florence, Titian's *Assumption of the Virgin*[7] painted in 1516–1518 and in situ in Santa Maria Gloriosa dei Frari in Venice, and Parmigianino's *Madonna and Child with Saint Jerome* painted in 1527 and now in the National Gallery, London, have all been mentioned as its offspring. Correggio, whose *Madonna and Child with Saint Sebastian*[8] painted in 1523–1524 and now in the Gemäldegalerie, Dresden, notably mirrors the composition of the Raphael very dramatically, is said to have cried before the *Sistine Madonna*: "And I, also, I am a painter."[9] In the baroque the impact was no less profound: Ludovico Carracci's *Madonna degli Scalzi* painted around 1590 and now in the Picture Gallery in Bologna, and Orazio Samacchini's *Christ in Glory* now in San Paolo in Bologna are two works that rely on the cosmic aura established by Raphael. Even that ardent anticlassicist, Caravaggio, has been accused of being influenced by this Raphael: his *Madonna dei Pellegrini* painted between 1603 and 1605 and in the Church of Sant'Agostino in Rome has been mentioned by critics[10] as the chief work to echo Raphael's composition.

Marooned in Piacenza, the *Sistine Madonna* was viewed only by artists and those connoisseurs interested enough to travel there. The Renaissance biographer Giorgio Vasari, who wrote the *Lives of the Painters*,[11] the first complete compendium of artists' biographies, dedicates only a single line to it; perhaps he never saw the original. Vasari worked in Florence and Rome where there was an abundance of works by Raphael to analyze; Vasari may have decided that he need not make the journey to Piacenza. Moreover, many of the accounts of the paintings Vasari chronicles were written with the guidance of others who acted as scouts for works he did not travel to see himself. This may account for his description of the painting simply as "rarissima e singular" with no further comment.[12]

In 1754 the cupidity of the priests of San Sisto succumbed to the entreaties of King Augustus III of Poland and elector of Saxony,[13] when they sold the Raphael for forty thousand scudi.[14] This sale of the painting has prompted critics to echo the sentiments of connoisseur Esther Singleton, who proclaimed, "That day the barbarians were not those the Italians think."[15] When it arrived in Dresden, where Augustus held court, the painting was greeted with great ceremony as it was brought into the reception room of the royal palace. The focal point of the room, Augustus's throne, was taken away and the painting was put in its place. The king is said to have uttered, awestruck, "Room for the great Raphael!"

The Madonna was subsequently moved to Augustus's picture gallery, now known as the Gemäldegalerie Alte Meister.[16] Back in Piacenza a copy made in 1728 by P. A. Avanzini was installed.[17] Other copies of the work were beginning to circulate throughout Europe, including a particularly fine example in San Severino in Naples, a seventeenth-century French copy for the Benedictine Abbey in Rouen,[18] and a copy in Saint Maurice, Switzerland. In 1827 the *Sistine Madonna* withstood its only recorded

restoration, by Pietro Palmaroli, who besides overcleaning the body of Jesus and therein removing some of the original paint, seems to have harmed little else.

Placing the painting in Dresden, however, meant that again it would be off the cultural radar screen, certainly removed from eighteenth-century tourists on the grand tour. But its isolation, ironically, was to prove a catalyst to the painting's fame. For only one year after the *Sistine Madonna* arrived in Dresden, so did the very beginnings of art history itself, in the person of Johann Winckelmann. More than anyone, Winckelmann is credited with the founding of art history as a discipline. He was the first person to organize systematically the history of art, drawing on his profound knowledge of ancient Greek literature, and on his intensive study of the limited number of antiquities available to him in the royal collection in Dresden. The precise contours of Greek vases and the idealized bodies of Greek sculpture formed the basis of Winckelmann's appreciation for Greek art, and his definition of great art in general. Winckelmann was less interested in chiaroscuro, mass, or color.[19]

The result of Winckelmann's exhaustive research was the publication in 1755 of his *On the Imitation of the Painting and Sculpture of the Greeks*, perhaps the first true art history book. In the midst of his discussion of the Hellenistic sculpture *The Laocoön and His Sons*, Winckelmann sums up what he considers to be the greatness of Greek art: "This noble simplicity and sedate grandeur is also the true characteristical mark of the best and maturest Greek writings, of the epoch and school of Socrates. Possessed of these qualities Raphael became eminently great, and he owed them to the ancients."[20] The *Sistine Madonna*, so newly arrived in Dresden, became the vehicle for Winckelmann's attraction to Raphael. For Winckelmann, it was the painting's very "Greekness" that makes the *Sistine Madonna* the masterpiece it is.

Winckelmann described the early popularity of the painting with references to Greek art: "It was the chief altar-piece in the cloister of St. Sixtus at Piacenza, which was crowded by connoisseurs, who came to see this Raphael, in the same manner as Thespiae was in the days of old, for the sake of the beautiful *Cupid* of Praxiteles."[21] Further Greek associations abound in his description of the painting, particularly stressing Mary's face, which he wrote contains a "silent awfulness which the ancients spread over their deities."[22] One can imagine how spellbound Winckelmann must have been as he stood before a painting he considered the rival of anything produced in the ancient world. Certainly having the Greeks in mind, Winckelmann rhapsodized "How grand, how noble is her contour!"[23] Here was the modern answer to the art of the ancients, and the historian convinced the artists in his circle of friends, like Anton Raphael Mengs, to revive antiquity as the key to success and immortality.

Winckelmann felt that the dramatic center of the *Sistine Madonna* is the baby, whom he described as "elevated above vulgar children, by a face darting the beams of divinity through every smiling feature of harmless childhood."[24] One could argue with conviction that not much smiling of any kind takes place in this painting, particularly not by Jesus, whose face seems to stare fixedly at something outside the painting in our

own space. But Winckelmann obviously saw differently, with an eye that interpreted Christ's expression in terms of his divinity.

In 1795, perhaps inspired by Winckelmann's effusive praise, the well-traveled Elizabeth Vigée-Lebrun, an eighteenth-century portraitist most known for her connection to the ill-fated court of Louis XVI and her portraits of Marie Antoinette, journeyed to Dresden just to see the Raphael. She reserved special praise for the painting in her memoirs:

> The very day after my arrival I visited the famous Dresden gallery, unexcelled in the world. . . . I will only observe that here, as everywhere else, one recognises how far Raphael stands above all other painters. I had inspected several rooms of the gallery, when I found myself before a picture which filled me with an admiration greater than anything else in the art of painting could have evoked. It represents the Virgin, standing on some clouds and holding the infant Jesus in her arms. This figure is of a beauty and a nobility worthy of the divine brush that traced it; the face of the child bears an expression at once innocent and heavenly; the draperies are most accurately drawn, and their coloring is exquisite. At the right of the Virgin is a saint done with admirable fidelity to life, his two hands being especially to be noted. At the left is a young saint, with head inclined, looking at two angels at the bottom of the picture. Her face is all loveliness, truth and modesty. The two little angels are leaning on their hands, their eyes raised to the persons above them, and their heads are done with an ingenuity and a delicacy not to be conveyed in words.[25]

As a painter who concentrated on creating flattering portraits of nobility, Vigée-Lebrun did not feel the same pull toward antiquity Winckelmann did. Her great idol was Peter Paul Rubens, the Flemish baroque master whose appeal comes mainly through color and emotion. Some of Vigée-Lebrun's self-portraits contain direct allusions to paintings by Rubens.[26] Ever since the influential seventeenth-century art critic Roger de Piles published his art-historical theories, Rubens and Raphael have been considered polar opposites: painters of equal talent who express themselves in a far different manner. For de Piles, Rubens's appeal is principally his use of color, rich dynamic color that continues to define his style in our imagination today. In Raphael, de Piles avowed that drawing and composition were his chief accomplishments, in a way that Winckelmann would have approved. Though Vigée-Lebrun was a confirmed Rubenist, and therefore less interested in Raphael's work, she was undeniably drawn toward the *Sistine Madonna*, noting that the angels' "coloring is exquisite." Perhaps fitting for a portraitist, she focused on the faces and hands, particularly taking note of their expressions. Echoing the classical taste of Winckelmann, she noted the "beauty and nobility" of Mary. Winckelmann, the classicist, and Vigée-Lebrun, the romantic, might be expected to have been at odds over this picture. In any event, they agreed that it is a universal masterpiece, each finding something in it to satisfy his or her own pleasure. The classical sense of form in the painting drew Winckelmann, while the emotion and color attracted Vigée-Lebrun. The painting evidently has the ability to transcend labels and ideological schools to supply a viewer of nearly any artistic conviction with a visually satisfying experience. Ultimately, this may be the chief source of the painting's fame.

The influences of the *Sistine Madonna* continued into the nineteenth century when Philip Otto Runge, a German romantic painter, copied Raphael's Mary, and the brilliant glow behind her, in his most famous work, *Morning*, painted in 1808 and now in the Kunsthalle, Hamburg. Jean-Auguste-Dominique Ingres, the greatest admirer of Raphael France ever produced, doubtless had the *Sistine Madonna* in mind in 1824 when he executed *The Vow of Louis XIII* for the Cathedral in Montauban, France.[27] Ingres's painting is an interesting paraphrase of Raphael's work. The parting curtains reveal a Madonna and Child afloat on clouds. A devoted kneeling Louis XIII offers the kingdom of France for the Virgin's protection, while two putti below hold an identifying tablet. The markedly clear and distinct depiction of Louis contrasts with the ethereal rendering of the heavenly figures. Even artists as different from Ingres as Henry Fuseli, a painter best known for his pictures of ghoulish nightmares, fell under the spell of Raphael. In Fuseli's written lectures, he declared, "We embrace Raphael" because his art is "more pressing on our hearts, the warm master of our sympathies."[28]

By 1800 the fame of Raphael's masterpiece had reached epic proportions through both artistic emulation and literary description. Winckelmann greeted it as the successor to the ancients; Vigée-Lebrun averred that Raphael's brush was guided by a "divine hand." Even among poets the *Sistine Madonna* was beginning to make an impression. A poem about the painting by Johann Gottfried Herder, the principal exponent of that most romantic of poetry movements, Sturm und Drang, sings in a kind of rhapsody:

> Did the image of the goddess appear to thee also,
> Raphael, as the sacred idea
> did it float before thine eyes in the inadequacy
> of the earthly fair? I see her image, it was she.[29]

Usually engravers and printmakers are eager to take great paintings such as the *Sistine Madonna* and have prints made so that middle-class people can have a copy of the masterpiece for themselves. However, church officials in Piacenza seemed to have declined any invitation to have the painting reproduced in this, or any, format. It is astonishing, therefore, that the popularity of this painting reached these heights without mass production of any kind. In any case, it took until its arrival in Dresden for the king to authorize engravings, with a particularly fine one by Frederic Müller in 1815 making the painting generally available to all.

The availability of the prints only meant that cognoscenti were even more curious to see the painting for themselves and began making their way to Dresden. It is true that some observers were indifferent, or even hostile. Some, like the Scottish essayist Thomas Carlyle, were antagonistic. Not even pausing before the masterpiece, Carlyle stormed off, serving up a curt remark as his only acknowledgment. On another occasion he turned to a friend to say, "I would rather have one real glimpse of the young

Jew face of Christ than to see all the Raffaele's in the world."[30] Carlyle's angry rejection of Raphael's painting only serves to demonstrate just how famous it had become; otherwise, it would not have been worth objecting to. Nevertheless, Carlyle's observation, and whatever unknown hostility to Raphael motivated it, was in the distinct minority. He may have echoed the feelings of British industrialist Josiah Tucker, who remarked, "A pin maker was a more useful and valuable member of society than Raffaele."[31] "Practical" people often have the strongest reaction against the fine arts, using the most popular artist of the time as grist for their mill.

Pioneering Renaissance historians J. A. Crowe and G. B. Cavalcaselle wrote, in 1885, an early appraisal of the *Sistine Madonna*, couched in the effusive language of the period: "But no one except Raphael could venture on such expedients, and of an effect so startling, as to stir the very innermost recesses of our hearts. There are sounds in music that strike us to the very core and bring tears of pleasure to our eyes."[32] Crowe and Cavalcaselle examine each part of the painting carefully, generously praising each figure. When their prose comes to rest upon Mary "erect in her blue mantle"[33] they characterize what others have seen in "this nobly shaped woman."[34] "Mary is but a mother, whose hands are grasping the frame of her child."[35] For Crowe and Cavalcaselle, Mary represents an ideal maternal figure. The child is aroused and concerned as if aware a danger of some kind must be nearby. The mother, too, is alert, holding her son defensively as she strides forward to face whatever it is that lies in store with "lofty dignity." Her contours are not graceful but "faultless"; her brow not beautiful but "perfect"; her nose and lips not shapely but "chiseled."[36] Her eyes

> reflect an eternity of unutterable fondness. There is a shade in those eyes so solemn and so grand, something so penetrating and profound, that we ask ourselves where the magic of them lies, and we look into them again and again, till a deep sense of mystery is left upon us, a mystery of which the source was known to Raphael, and Raphael alone.[37]

In short, this Madonna is a mother for all time.

The most renowned art critic of the nineteenth century in the English language was John Ruskin, whose mid-nineteenth-century commentaries on art history were widely read and discussed. In the preface to his second edition of *Modern Painters*, Ruskin admitted, "There are few works of man so perfect as to admit of no conception of their being excelled." In a footnote he clarified which works had this perfection:

> One or two fragments of Greek sculpture, the works of Michael Angelo, considered with reference to their general conception and power, and the Madonna di St. Sisto, are all that I should myself put into such a category; not that even these are without defect, but their defects are such as mortality could never hope to rectify.[38]

A contemporary of Ruskin, Anna Jameson, an Irish writer and art historian, published her widely read *Memoirs of the Early Italian Painters* in installments in the popular *Penny Magazine* between 1833 and 1845. Jameson (often referred to today as "Mrs. Jameson," just as Elizabeth Gaskell is known as "Mrs. Gaskell") summed up Raphael, declaring, "How can we treat, in a small compass, of him whose fame has filled the universe? On the history of Italian art he stands alone, like Shakespeare in the history of our literature."[39] Like Vigée-Lebrun, Mrs. Jameson was impressed by the nobility of the figure of Mary, saying that she is "standing in a majestic attitude; the infant Saviour *enthroned* in her arms; and around her head a glory of innumerable cherubs melting into light."[40] Finding laudatory phrases an inadequate expression of her feelings about the painting, she declared it a "*creation* rather than a picture."[41]

By 1870 the *Sistine Madonna* was being widely reproduced, not only in the traditional engraving format, but also now in photographs. Mrs. Jameson was the first critic to assess the verisimilitude and value of a work's reproductions. She acknowledged the primacy of Frederic Müller's engraving: "good impressions [prints] of which are worth twenty or thirty guineas."[42] She also recommended a "very beautiful and faithful lithograph by Hofstängol, which may be purchased for half as many shillings."[43] Raphael specialist Marielene Putscher counted over thirty different artists who engraved the *Sistine Madonna* in the nineteenth century alone.[44] Even more engravings were produced that focused on some details of the work such as the faces of the Madonna and Child, and perhaps as many as fifteen full-scale copies were painted.

Chromolithographs of the *Sistine Madonna* were particularly popular. In the United States one of the most famous companies that produced and sold chromolithographs (an early form of four-color printing) was Louis Prang and Company, which reproduced anything that would sell, from Civil War maps to prints of men dressed as carrots. The *Sistine Madonna*, in Prang's version, is a circular detail of the heads of Mary and Jesus on a frame 21⅞ inches square,[45] glued to a canvas, embossed to resemble brushwork, varnished, and placed in a gold frame.[46] The goal is nothing less than the allusion of re-creating the actual painting. All of this could be had for twelve dollars in 1891.[47] Mrs. Jameson was not impressed. She said she was "disturbed by feeble copies and prints,"[48] which undoubtedly took away from the experience of the real thing. To refresh her spirit and to recapture the Raphael painting completely, Mrs. Jameson made no fewer than six journeys to Dresden solely to see the *Sistine Madonna*.[49] Even the reproductions she herself endorsed not only left her feeling empty, but worse still, threatened to alter her memory of the original work:

> Six times have I visited the city made glorious by the possession of this treasure, and as often, when again at a distance, with recollection disturbed by feeble copies and prints, I have begun to think "Is it so indeed? Is she indeed so divine? or does the imagination encircle her with a halo of religion and poetry, and lend a grace which is not really there?" and as often, when returned, I have stood before it and confessed that there is more in that form and face than I have ever yet conceived.[50]

What seems to be lacking in the "feeble" copies as well as in her own memory is the sense that the artist has rendered the ineffable qualities of divinity that no one else, and no form of reproduction, can capture.

Among Victorian writers, it is perhaps not surprising that George Eliot would be the most profoundly taken with Raphael's masterwork. She was the only prominent writer of her day to set an entire novel, *Romola*, in Renaissance Florence, complete with a cast of characters taken directly out of art history.

In 1858 George Eliot and her friend George Henry Lewes embarked on a European trip, eventually making their way to Dresden by July. "It was a charming life—our six weeks in Dresden,"[51] George Eliot wrote in her journals. During her stay she studied paintings every Tuesday, Thursday, and Friday; she was particularly impressed with the Dutch school and with Holbein and Titian.

But what amazed her the most was the *Sistine Madonna*: "All other art seems only a preparation for feeling the superiority of the Madonna di San Sisto the more."[52] Eliot tells us that she sat opposite the painting for an instant, "but a sort of awe, as if I were suddenly in the living presence of some glorious being, made my heart swell too much for me to remain comfortably and we hurried out of the room."[53] Her companion Lewes, two days later, looked at the Raphael *Madonna* until he "felt quite hysterical."[54] Lewes writes in his journal of the

> never-to-be-forgotten divine babe we have at once the intensest realism of presentation, with the highest idealism of conception: the attitude is at once grand, easy, natural; . . . in those eyes and on that brow, there is an indefinable something which, greater than the expression of the angels, grander than that of pope or saint, is, to all who see it, a perfect *truth* we felt that humanity in its highest form is before us, and that to transcend such a form would be to lose sight of the *human* nature thus represented.[55]

George Eliot was to remain haunted by the painting for years. She had it in mind when she wrote her 1880 masterpiece *The Mill on the Floss*. Philip, one of the main characters, says, "The greatest of painters only once painted a mysteriously divine child—he couldn't have told us how he did it—and we can't tell why we feel it to be divine."[56] Henry James was inspired to refer to George Eliot's well-known fascination with the *Sistine Madonna*. In chapter 36 of his 1886 novel *The Bostonians*, the feminists have, in their Cape Cod cottage, "all George Eliot's writings, and two photographs of The Sistine Madonna."

In Russia, it came to represent "the quintessence of ideal beauty,"[57] and nearly every great Russian writer of the nineteenth century was sincerely moved by it. Dresden, perhaps for the *Sistine Madonna* alone, became a pilgrimage site for Russians making their version of the grand tour. Leo Tolstoy alluded to the painting's magical spell by using the face of the Christ Child as a touchstone for other paintings in *War and Peace*.[58] The Decembrist Mikhail Sergeevich Lunin cited the *Sistine Madonna* as the principal factor in his conversion to Roman Catholicism, a daring feat in nineteenth-century Russia.[59]

Of all the Russian writers, Fyodor Dostoyevsky was the most deeply inspired, if not provoked and shaken, by the painting. For most of his adult life, he kept on the wall above his desk an engraving of the Raphael; even today at the Dostoyevsky Museum in Moscow, this print still watches over his work. While in Dresden, Dostoyevsky caused a minor earthquake among museum guards when he climbed onto furniture for a closer look at the nearly nine-foot painting. Perhaps this closer look enabled him to describe Madame Resslich in *Crime and Punishment* as having a "face like Raphael's Madonna. You know, The Sistine Madonna's face has something fantastic in it, the face of mournful religious ecstasy. Haven't you noticed it?"[60]

Although themes surrounding the *Sistine Madonna* appear in much of Dostoyevsky's work, the most important illustration of his fascination with the painting comes in his monumental novel *The Possessed* (also known as *The Devils*). Stepan Trofimovich, a most intelligent and gifted—though highly flawed—man, attested that the painting contains "that very Queen of Queens, that ideal of humanity, The Sistine Madonna."[61] His wealthy and more worldly companion, Varvara Petrovna, retorts, "There is no one, absolutely no one, in ecstasies over the Madonna; no one wastes time over it except old men who are hopelessly out of date."[62] Was Dostoyevsky creating a self-indictment in Varvara Petrovna's claim that he was an old man out of date? Or perhaps this was his commentary on the nouveau riche that she represented? At the end of the novel when Mar'ia Shatova, the estranged wife of one of the characters, appears at her husband's house, Dostoyevsky gives the reader clear indication that she is in some sense the embodiment of Raphael's *Madonna*, describing her in a way that makes this clear:

> But when she looked at him with that harassed gaze he suddenly understood that this woman he loved so dearly was suffering. . . . He looked at her features with anguish: the first bloom of youth had long faded from this exhausted face. It's true that she was still good-looking—in his eyes a beauty, as she had always been. In reality she was a woman of twenty-five, rather strongly built, above the medium height . . . with abundant dark brown hair, a pale oval face, and large dark eyes now glittering with feverish brilliance. But the light-hearted, naïve, and good-natured energy he had known so well in the past was replaced now by . . . disillusionment . . . which weighed upon her.[63]

Dostoyevsky's modern Mary gives birth in poverty, the mystery of the Nativity briefly reenacted in a godless world by three poor villagers doomed to misery and death. For Dostoyevsky, the painting seemed to come to life. Haunted by the Raphael, indeed, making it the benevolent guardian of that critical generative place, his desk, he became mesmerized by the Madonna's expression to which he returns in his writings again and again.

In the nineteenth century, the fame of the painting began to spill over European borders into the United States. Travelers to Europe generally felt it was the height of their experience to see the painting, which, already crowned by European approval,

evoked similar responses among Americans. The peripatetic German American scholar Francis Lieber was not an easy person to impress. He first came to attention by formulating the idea that Americans should have their own encyclopedia, much in the German tradition. Indeed, he thought initially of simply translating an already existing German work, *The Brockhaus Konversations-Lexikon*, into English. Realizing how unfulfilling such a translation would be to the American market, he convinced a number of American intellectuals to contribute to a new work he called the *Encyclopedia Americana*. Lieber considered the fine arts among the highest forms of expression, and was particularly interested in writing about the great masters for the encyclopedia. With great excitement Lieber turned his pen to the *Sistine Madonna*. "The loftiness, dignity and sublimity," he wrote, "combined with a sweetness, grace and beauty, which reign in this picture, render it inimitable."[64]

About ten years after the publication of his encyclopedia, Lieber went on a European trip in 1844, in a way a homecoming to this German-born American. He had a chance to revisit Dresden and the Raphael painting, noting in his journal:

> I saw it again, that masterpiece, Madonna del Sisto, which more than 20 years ago, introduced me in the temple of the arts. I wept then; I wept again. It is now more beautiful, more holy, more exalted than ever. That which I call Raphaelism, that is elevation, consecration, simplicity, beauty in its highest degree. . . . God bless you Raphael. It overwhelms me and yet leaves my mind clear.[65]

Lieber distinguished, however, between his initial enthusiasm and his role as critic. In his journals he noted that Saint Barbara is "a little too selfsatisfied." In his encyclopedia entry he commented, "In foreshortening and in perspective, he [Raphael] was imperfect." In coloring "he never reached the excellence of Correggio or Titian, his colors always appearing too heavy and dull."[66] Lieber's words eventually found their way into volumes that had enormous cultural impact. In the nineteenth century, the *Encyclopedia Americana* was purchased for use in nearly every literate home in America that could afford it, including the White House. Lieber's pronouncements of "beauty in its highest degree" influenced generations of readers, especially those with the ability to travel to Europe to see for themselves.

With the official endorsement of the *Encyclopedia Americana*, the painting had now penetrated into the American psyche as the finest example of painting in existence. It had been tied strongly to concepts of motherhood, love, divinity, and beauty. References to the painting began to emerge in American literary works. In Angelina W. Grimké's 1916 play, *Rachel*, a work considered by many to be the first successful drama written, produced, and performed by African Americans,[67] Rachel, the protagonist, considers only two models of motherhood in her life: Mrs. Loving and the Blessed Virgin. Pictured on the wall of her living room is a reproduction of the *Sistine Madonna*. Lifting her eyes to this painting, Rachel sings "Mighty Lak a Rose." She then turns to the audience and exclaims, "I think the loveliest thing of all the lovely things in the world is just being a mother."[68] Clearly, Raphael's painting had found a central place in the popular consciousness as the personification of motherhood.

In fact, by the late nineteenth century, the image had become so popular in America that it appeared in everything from political cartoons to "trade cards." Trade

Raphael's angels have been parodied on everything: here on a poster from 1880, they are used to sell lard. *Library of Congress*

cards were the nineteenth-century version of business cards, often left in packages, placed in a bag of purchases, or mailed out to customers (perhaps the refrigerator magnets of their day). When a firm like N. K. Fairbank and Company in 1880 wanted to advertise lard refining, it chose the cherubs from the *Sistine Madonna* as a point of reference. Fairbank must have assumed that the average customer who saw the trade card would recognize the source. Instead of "Raphael's angels," which often is the caption for this detail from the painting, the trade card refers to "Fairbank's cherubs."

In the early twentieth century the critical interpretation of the painting began to change. Sigmund Freud, who was fascinated by many works of art, fell under the spell of the *Sistine Madonna*, as he did a number of other famous works: for example, Fuseli's *The Nightmare*, and Leonardo's *Mona Lisa*. In the case of Michelangelo's *Moses*, Freud wrote to a colleague that he stood "every day for three lonely weeks"[69] in front of the sculpture. "Under that implacable stare, Freud felt himself transformed into a guilty Israelite, caught cavorting round a golden calf."[70]

Works of art sometimes transfixed Freud's patients as well. In his *Interpretation of Dreams*, Freud recounted a dream by his patient, "Dora," which centered around a fascination she had with the *Sistine Madonna*.

> Another [male] cousin of hers, who was with them and knew Dresden, had wanted to act as a guide and take her round the gallery. *But she declined and went alone,* and stopped in front of the pictures that appealed to her. She remained *two hours* in front of The Sistine Madonna, rapt in silent admiration. When I asked her what had pleased her so much about the picture she could find no clear answer to make. At last she said: "The Madonna."[71]

Characteristically, Freud's interpretation of Dora's dream stresses her fascination with the Madonna's virginity. Dora's visit without male escort, her staring at the Madonna, her sense of "silent admiration," all lead to Freud's response that the Madonna is Dora herself. The *Sistine Madonna*, and then Dora herself, begin to represent to Freud innocence in motherhood, women who have children while children themselves, and girls who have felt "oppressed by imputations of sexual guilt."[72]

Freud's contribution to the fame of this painting rests not so much on his appreciation of the artistic merits of the work, but his emphasis on the psychological impact of the image. In this regard, Freud's broad impact on the visual arts serves as a bridge between the musings over the power of the image in the nineteenth century and the analysis of the meaning of the work in the twentieth century.

Other German scholars began to apply modern, analytic methods to the *Sistine Madonna*. In the 1920s one scholar after another published articles that claimed to be the definitive word on Raphael's painting, exchanging erudite broadsides across a sea of interpretation. Each scholar would defend his position and attempt to prove that his worthy opponent's viewpoints were not only without merit, but too inane to contemplate.[73]

Pressing questions began to arise, questions that, surprisingly enough, seemed never to have been asked before: Why did Raphael choose the uncommon technique of canvas instead of the more popular wooden backing? Was it really a painting; perhaps it was a processional standard!?[74] No, counters another expert,[75] it was meant to decorate the tomb of Pope Julius II: that's why the curtains are half-drawn!

Another critic mused: Doesn't Saint Barbara look suspiciously like Lucrezia della Rovere, the pope's niece?! No! yet another snapped. That's not Lucrezia della Rovere, it is Giulia Orsini, another niece of the pope! That alludes to the fact that it was used as a burial cloth for the Pope's funeral![76]

By 1971 the great Raphael scholar Luitpold Dussler had had enough, lamenting that "the work should not be obscured by a dead-weight of interpretation, as has often happened, for these lead one to misapprehend Raphael's genius and to overlook the mystery of the inspiration which he possessed."[77]

This remark did little to silence the academics, who continued to gnaw at the canvas well into the 1980s. The results seemed to yield a Raphael who was nothing more than the sum total of a series of influences, symbols, patrons, and assorted arcane iconographic features, devoid of an ounce of inspiration or artistic energy.

While scholars fought tirelessly over *the* meaning of the work, artists in the twentieth century still found the image compelling. Salon painters like William-Adolphe Bouguereau were inspired by the composition in works such as his *Virgin and Child* painted in 1900 and now in the Musée du Petit Palais, Paris. Dadaist Kurt Schwitters used the image as the basis for one of his "merz" collages.[78] There seems to be something for everyone: even Andy Warhol, the veritable king of pop art, chose the painting as a basis for a work that ended up on the program for his memorial mass.[79] When he died in 1987 a reproduction of the Raphael was found on the wall next to his bed.

Forces were at work, however, that were stronger than scholarly opinion and artistic emulation. Even though the painting has been crowned with critical blessings and has repeatedly been embraced by professional artists, it began to slowly but surely fade from the world's consciousness.

Twentieth-century art has not been known as the golden age of religious painting. Unlike previous centuries when great artists worked for the church and produced masterpieces inspired by faith, the church as patron began to diminish at a time when serious artists turned their attention to other forms of expression: abstraction, portraits, genre scenes, and so forth. Not surprisingly, interest in religious paintings from earlier periods began to wane. Once the most popular painting in the world, the *Sistine Madonna* does not even appear in general art history textbooks. Neither Janson, Gombrich, Gardner, nor Stokstad, authors of the four most popular college-level art textbooks, all of which have been issued in many editions, have included the painting, preferring less religious works like his portrait of *Baldassare Castiglione*, *The School of Athens*, or his pagan *Galatea*.[80]

General trends in America have led away from overt Christian symbols in many areas of popular culture: Christmas is less about Jesus Christ and more about Santa Claus, Easter is more about chocolate bunnies than about the resurrected Christ, and it has been years since anyone has seen the word "Saint" on a Valentine's Day card.

Angels, conversely, have never been more popular. They cross cultural and religious boundaries. Catholics and Protestants join Mormons, Jews, Muslims, Zoroastrians, Buddhists, and Hindus in their appreciation of angels.

Protestant theologian and religion media personality Billy Graham spearheaded the modern angel movement in America. His wildly successful 1975 book *Angels: God's Secret Agents* sold millions of copies, and was followed up by *Angels: Ringing Assurance That We Are Not Alone*, which sold three million more. Certainly his stature as a prominent religious figure lends authenticity and gravity to a movement many truly religious might feel inclined to dismiss. Plus, his renown as an evangelical Protestant, rather than perhaps a more naturally sympathetic Roman Catholic, made the acceptance of angels more palatable to the American public.

Publishing houses fed the rising American interest in angels by releasing one best seller after another, most prominently the 1990 appearance of Sophy Burnham's *A Book of Angels*, only recently out of print after laboring through over thirty printings. Television shows, such as *Touched by an Angel* and *Highway to Heaven* were successful, in part, because many in the audience participated in the belief of these spiritual beings. In December 1993 America's two foremost news magazines, *Time* and *Newsweek*, had cover stories on breaking news: angels.

Today antique-inspired angelic forms are common enough, but in the Renaissance they were an innovation. Donatello seems to have been the first artist to use them on a widespread basis, calling them "spiritelli" or sprites.[81] They appear on his Prato Pulpit and the Cantoria in the Museo dell'Opera del Duomo in Florence.

These sprites allude to childhood, of course, but have the overtones of the antique god Cupid. Moreover, they express joy without care, and a state of natural wonder devoid of adult concerns.

Raphael was later to render this form into exquisite perfection. However, it must be noted that his antique putti, as in the famous *Galatea* painted in 1513 for the Villa Farnesina in Rome, are not any different from his angels in the *Sistine Madonna* or its immediate predecessor, the *Madonna of Foligno*.

What did Raphael intend to demonstrate with the inclusion of these seemingly purposeless putti acting as a visual footnote at the bottom of the painting? Although no original drawings of the painting exist, a close examination of the canvas reveals that the angels are not part of the original composition, but painted over the cloud formations that encompass them; the clouds can be seen peeking through some of the lighter passages. A charming legend has emerged about the angels: One day Raphael came to his studio to find two boys staring at his monumental work. Struck by their poses, he asked the boys to remain a while so that he could sketch their images.[82] While the legend sounds more like a latter-day construct than an actual episode in the history of the painting, it does try to explain the position of the angels, which seem a little incongruous to the composition as a whole. They are placed on a ledge before the main figures, indeed, closest to our own space. Yet they are both looking straight up at the principal figures, who are actually behind them. So masterfully does Raphael accomplish this that the incongruity rarely causes the viewer concern.

The interest in angels today, combined with the popularity of Raphael's masterpiece, has led to a union that satisfies American sensibilities: these angels are neither male nor female, Christian nor pagan, religious nor nonreligious, and yet contain the feeling of childhood innocence. By the 1990s angel paraphernalia was flying off the shelves of American department stores. Angels came to represent American culture of the nineties in a way that psychedelic flowers did the America of the late 1960s. This has led to all sorts of curious manifestations. In 1994 a *New York Times* editorial calls Raphael "possibly the hottest new artist around," and grimly warns the unwary that the Metropolitan Museum cannot keep up with supply of angel reproductions.[83]

The serious art world has only been half a step behind. Exhibitions on angels have become more frequent. The 1998 exhibition *Angels from the Vatican* made the rounds at several American museums to the acclaim of the public and the gentle sneering of the art community. Even with its extensive collection of images this exhibition did not have the *Sistine Madonna* among its works.[84] Feeling the weight of this glaring omission, the exhibition catalog fills the gap by including the image of the angels (without the greater context of the painting), proclaiming that they are "the most famous angels of our own days."[85] Then, in what seems contradictory language for serious art historians, the image is summed up this way: "However banal, it is fitting they should at least be mentioned in our exhibition catalogue."[86] It seems that this detail is now so famous it is a requirement to reproduce the angels even if the act is blatantly gratuitous and adds nothing relevant to the current discussion. Perhaps as a reflection of modern taste the magic of the noble expression on the faces of the principal figures in the painting has slowly been pushed aside in favor of angelic cuteness.

While the angels have gone on to continue a life of their own, activity around the main painting has not remained stagnant. Andreas Prater published a study on the *Sistine Madonna* in 1991.[87] According to Prater, what Mary and the Christ Child are looking at is a crucifix, which would have commonly hung opposite main altarpieces in Renaissance churches. This explains, very conveniently, the "problem" of the expressions on the faces of Mary and Jesus, as well as the gesture of Pope Sixtus, who it is claimed, is pointing at it. It does not explain similar paintings that hang in the same circumstances, few of which have this feature. In only the way a modern scholar could profess, Prater proclaims that the expressions and gestures that have haunted centuries of viewers, like Crowe and Cavalcaselle or Dostoyevsky, can be easily accounted for by this new theory. Henceforth, we shall see this painting in a new light.

All of this deserves a resounding maybe. While this new theory may help to illuminate an aspect of the painting, it does not explain Raphael's genius, nor his innovation, nor his ability to transcend common Renaissance Madonna and Childs, even ones by Raphael himself, and turn the *Sistine Madonna* into an artistic milestone.

Ernst Gombrich, pioneer of the modern collegiate art history experience, has achieved a more complete synthesis of Raphael's approach as author of his widely read *Story of Art*. Sixteen editions after its 1950 debut, his assessment of Raphael has not changed—not a word—in the forty years his book has been and continues to be published. It remains the most concise expression of Raphael's achievement in the modern age:

> Raphael's greatest paintings seem so effortless that one does not usually connect them with the ideas of hard and relentless work. To many he is simply the painter of sweet Madonnas which have become so well known as hardly to be appreciated as paintings any more. . . . We see cheap reproductions of these works in humble rooms, and we are apt to conclude that paintings with such a general appeal must surely be a little "obvious." In fact their apparent simplicity is the fruit of deep thought, careful planning and immense artistic wisdom.[88]

It is this "artistic wisdom" that has allowed for such varied and complex interpretations of the *Sistine Madonna*. On the one hand it has been copied, photographed, engraved, and chromolithographed endlessly to satisfy the demands of the general public, a fickle public who has sometimes turned its back on the whole to express interest solely on a detail. On the other it compels those who have seen the original to return, the way George Eliot, Mrs. Jameson, Francis Lieber, and countless others have. It is this compulsion to return to the original, to fathom the complexities of what is so simply expressed, to illustrate divinity in human form, that has given the painting the popularity it deserves.

The Burial of Count Orgaz by El Greco

A Touch of Madness Goes a Long Way

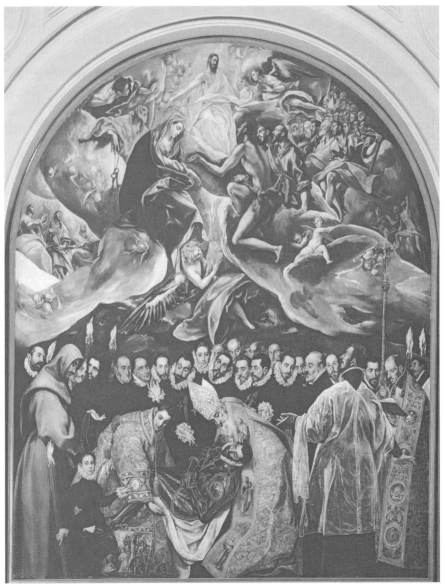

The Burial of Count Orgaz by El Greco. *Toledo, S. Tome, Spain / Bridgeman Images*

I paint because the spirits whisper madly inside my head.

—El Greco

\mathcal{E}l Greco's artistic output has been described in seemingly paradoxical terms that are at once contradictory and consistent. Few artists have had reputations die so instantaneously after their death, and few have had reputations resurrected from the dead so completely. He was simultaneously a mystic and a man of business, a modernist and a man deeply set in the mannerist tradition, a healthy individual and a man diagnosed as a lunatic and an astigmatic. He was a man with a lifelong female lover and a child, and a homosexual. Moreover, he was born on a Venetian-owned island and was Greek by birth. He was Italian trained but lived in a Greek community in Venice. Later he took up residency in Toledo, Spain, where he did his finest works. So was he Greek? Italian? Spanish? The name El Greco seems to indicate his Greek background, but it is in a polyglot form: if it were truly in Italian it would be Il Greco; if it were truly in Spanish it would be El Griego. Take your pick.

He called himself Δομήνικος Θεοτοκόπουλος or Doménikos Theotokópolous and signed his name in Greek on most of his major works, but he never returned to Greece, nor to Italy for that matter. El Greco seems to have established himself fairly profitably in Spain.

Spanish art historians today embrace him as one of their own, perhaps because before him there are no Spanish masters of international significance, and so he is often forced into a Spanish pantheon. Greeks have little international talent after the Byzantine age, mostly because their country was dominated by the Ottoman Turks, who had no use for Greek Orthodox painters. Italian art historians, on the other hand, often ignore El Greco's training in Italy—seven years in Rome alone—because the Renaissance is already overcrowded with great names. El Greco's works from his Italian period are a precious few; *The Miracle of Christ Healing the Blind* in the Metropolitan Museum is one, dating from 1570.

El Greco's indelicate remarks about Michelangelo's painting technique shortly after the great master's death alienated him from the Roman art establishment and probably contributed to a general feeling that he did not truly understand what great painting was all about. Giulio Mancini, private physician to Pope Urban VIII, is said to have overheard El Greco's remarks, in which he claimed he could repaint Michelangelo's *Last Judgment* "con honestà et decenza,"[1] apparently a remark that cast El Greco's fortunes adrift in the eyes of professional artists. At that time, however, the nudity in Michelangelo's frescoes was being painted over by order of the Council of Trent, and El Greco's comments may have been seen as an attempt to side with the prevailing wisdom. "He [El Greco] ventured to say that, should the entire work be destroyed, he would take it upon himself to do all of it over again with propriety and seemliness and to make it withal a piece of painting no less fine. His view . . . incensed all the painters and lovers of painting there."[2]

Some scholars believe that El Greco's remarks are apocryphal, because there are so many connections between individual elements in *Count Orgaz* and *The Last Judgment*, indicating that he must have been profoundly influenced. Italians may have dismissed El Greco as just the bragging and posturing of a foreign artist, which Italy had plenty of.

El Greco journeyed to Spain to seek the elusive patronage of King Philip II who in 1563 had begun construction of the enormous palace of the Escorial outside Madrid—a big, empty barn of a place needing paintings to make it feel like a royal residence. For whatever reason, El Greco did not win many princely commissions, and his sojourn to a foreign land in search of work was about to end in disappointment.

Onto the scene came a Spanish ecclesiastic, Luis de Castilla, who befriended El Greco. Luis's father, Diego, was overseeing the construction of a church in Toledo, a town fifty miles south of Madrid. Through this connection, El Greco secured the commission to execute a number of altarpieces, and hence established himself in that town for the rest of his career. This was a pivotal moment for El Greco—he was now middle aged and with an insubstantial resume. Settling in the prosperous town of Toledo meant a steady income and the generous support of local patrons. Thereafter he maintained a comfortable life, taking up with a female companion whom he never married, Jerónima de las Cuevas, and having one son, Jorge Manuel.

Perhaps it was too comfortable a life. He was known to be extravagant in his ways. Although he commanded high fees for his work, he spent it as fast as it came in:

> He earned many ducats, but spent them all in pompous living, and even kept paid musicians to play for him, that he might enjoy every pleasure when he ate. The *Inventory* of his worldly goods confirms these judgments. The furniture presents a contrast with the 24 fine rooms he occupied; and everything seems to speak of a rich establishment reduced and decayed.[3]

El Greco worked hard on his reputation, and drove a hard bargain in accepting commissions—*The Burial of Count Orgaz* being more complex than most. A certain Don Gonzalo, Lord of Orgaz, and benefactor of the Church of Santo Tomé, left in his will the terms of an endowment to his church, which was to be annually fulfilled by the townspeople of Orgaz.

The Church of Santo Tomé was originally built in the twelfth century and then completely reconstructed in the fourteenth, with lavish gifts from the count. Today it stands as an excellent example of Mudejar architecture—that is, architecture done by Muslims in Christian Spain. The location of the painting directly over the grave of Count Orgaz gives context to the work; removing the painting to a museum would destroy the effect of seeing the count actually being lowered into his tomb.

Perhaps figuring that the terms of the will had been fulfilled long enough, or that Orgaz's will was too demanding, the citizens declined to make payment, and by 1564 the parish took the town to court. A settlement was reached in 1569, ruling that the town indeed had to pay, and the church suddenly found itself enriched.

The details of Count Orgaz's life and the subsequent restoration of the endowment have been recorded in Latin in a plaque below the painting; thus, the ensemble has the effect of enabling the viewer to visualize the lowering of Count Orgaz into his tomb.

The plaque reads:

> Dedicated to the benefactor saints and to piety. Even if you are in haste, pause for a moment, traveler, and hear in a few words an old tale of our city. Don Gonzalo

Ruiz of Toledo, Lord of the township of Orgaz, Protonotary of Castille, among other tokens of his piety made it his concern that this church of the apostle Thomas, in which he desired to be buried, but which was formerly meager and impoverished, should be restored and enlarged at his expense; and he made many offerings, both in silver and in gold. When the priests were preparing to bury him—St. Stephen and St. Augustine descended from heaven and buried him here with their own hands. As it would take a long time to explain why these saints did this, enquire of the holy brothers of St. Augustine, if you have time. The way is short. He died in the year of Our Lord 1312. You have heard the gratitude of those who dwell in heaven. Now harken to the inconstancy of mortals. The said Gonzalo bequeathed to the parish priest and the ministers of this church and to the poor of the parish 2 sheep, 16 hens, 2 skins of wine, 2 wagon loads of wood and 800 coins which we called maravedis, all to fall due each year from the inhabitants of the domain of Orgaz. For two years they refused to pay this pious tribute, hoping that with the passage of time their obligation would be forgotten. It was enforced by order of the Chancellery of Valladolid in the year of Our Lord 1570,[4] the case having been energetically pleaded by Andrés Nunez of Madrid, priest of this church, and the steward, Pedro Ruiz Durón.[5]

Who could argue with a supernatural event? Andrés Nuñez, the patron of the work, had to get official approval from the bishop before such a reincarnation could be captured on canvas. The Council of Trent, the agency that invigorated the Catholic Church during the Counter-Reformation, set guidelines on the depictions of miracles. In a society that promoted Catholic miracles, as opposed to Protestants who played down such perceived extravagances, this one depicting saints and Count Orgaz was fairly routine.

Permission granted, the commission was pursued. Count Orgaz, not actually a count at all at the time of his death, was elevated in 1522 to that status by affectionately devoted followers who were impressed by the nobility of the Orgaz clan in general.

The painting was greeted enthusiastically upon its completion. A contemporary recorder of the events tells us, "The painting was made and it is one of the most excellent in all Spain and it cost 1,200 ducats, not including the framing. It is particularly admired by strangers who come to see it, while those of the city never tire of it, but always find new things to contemplate in the painting, because it has very life-like portraits of many famous nobles of our time. This was the work of the painter Domingo de Theotocapuli, a native of Greece."[6]

He designed the composition in two parts, the celestial and the earthbound, as in accordance with the stipulation of his contract. Up above, the heavenly host greets the arrival of the soul of Count Orgaz, pictured as a ghostly mummy in the arms of an angel. Down below, his death is mourned by the populace as a true loss for the people. Sober black dominates the bottom section of the painting; euphoric colors vibrate the top.

Fiery torches do little to illuminate the darkness of the earthly plane. The heavenly realm would seem to need no such artificial illumination to enlighten its brilliant atmosphere—it is aglow with radiant goodness. Besides Jesus and Mary an entire panoply of saints accompanies the soul to glory: Mary is to the left of Christ, Saint

John the Baptist on the right, both defenders of souls. Saint Peter with the keys unlocks the gates of heaven for those worthy enough to enter. King Philip II is in this heavenly crowd, appearing in yellow on the far right. Next to him, conspicuously, is Saint Thomas, whom this church is dedicated to. Mary Magdalene, Saint Sebastian, and Saint Paul are all in attendance as well as a bevy of miscellaneous faces revealing a conclave of holy figures.

On the bottom half, dozens of heads turn this way and that and are packed into this shallow space—one suspects that these sober Spanish men were grandees of the Toledo establishment, painted as if partaking in the miracle themselves. It was customary for dignitaries to gather at the death of a nobleman of the time, so their placement is fitting. El Greco himself stares straight out at us directly over the head of Saint Stephen. Augustinian, Dominican, and Franciscan monks silently attend the service.

The count, rather ashen faced since he has been dead for 274 years before his reinterment in this church, is in full regalia, armored in brilliant Toledo steel—Toledo possessing some of the finest armories in Europe at the time. Indeed, even today visitors to Toledo are sometimes aghast at the number of steel weapons that are for sale on the streets.

Singularly set apart at the lower left is a youngster traditionally identified as El Greco's son, Jorge Manuel. A small sheet of paper, or handkerchief, dangles from his pocket with the inscription containing the artist's signature and the date, 1578. Documentary evidence proves that this is certainly not the date of the painting, so art historians have presumed it is the date of the boy's birth. The boy ambiguously points to his left. Traditionally, scholars have thought that he is pointing to the body of Count Orgaz, which is plain enough to see without the help of the young Jorge. Some have theorized that he is pointing instead to the rosette on the sleeve of Saint Stephen. If so, the meaning remains obscure.

Anachronisms abound. The early Christian saints—Augustine and Stephen—have come to earth to bury a fourteenth-century count, surrounded by mourners from the sixteenth century wearing contemporary Spanish garb. The split between the heavenly and the earthly worlds is clearly marked by a serpentine black space. The connection between these two is effortlessly bridged with the cross at the far right as a symbolic and physical transitional element.

El Greco's tortuous mannerist style can be seen in the unusual figural positions with some seen from the back and many having disembodied hands, many set in just a sea of black. However, it was just these mannerist convoluted compositions and dissonant colors, and in particular El Greco's elongated figures and pointed chins, that doomed him to obscurity after his death.

Although El Greco, during his lifetime, had a following in Toledo, he was entirely forgotten after his death. Toledo was no longer a capital city, and El Greco was not directing the future of Spanish painting; his style look instantly dated at his death in 1614.

Truth to be told, the baroque was now in favor in Madrid, and this style came to be symbolized by artists who followed Caravaggio in Rome, who was then the rage in European painting. Some Spanish artists like Francisco de Zurbarán stayed within the Caravaggio orbit for most of their careers, while others like Diego Ve-

lázquez used Caravaggio as a starting point and moved into a world all their own. This left El Greco, and any artist daring enough to follow in his footsteps, looking distinctly archaic, stilted, and unnecessarily complex. In the eighteenth century the trend away from the baroque to the lighthearted and frivolous rococo made the manifestly un-lighthearted and unfrivolous El Greco sink even deeper into an abyss. Late eighteenth-century neoclassicism plummeted El Greco into deepest obscurity.

When, in 1633, only nineteen years after El Greco's death, biographer Vicente Carducho wrote *Diálogos de la pintura*, El Greco was conspicuously missing, already not even a footnote to the history of painting. If he wasn't being completely ignored, he was uniformly dismissed. Jusepe Martínez wrote a definitive account of Spanish art in 1673 with his *Discursos practicables del nobilísimo arte de la pintura*, and captured the feeling of the time about El Greco's art:

> At that time there came from Italy a painter called Dominico Greco; he was said to be a disciple of Titian. He settled in the famous and ancient city of Toledo. He introduced such an extravagant style that to this day nothing has been seen to equal its capriciousness; attempting to discuss it would bring confusion even to the soundest minds, his works being so dissimilar that they do not seem to be by the same hand.[7]

In the eighteenth century, El Greco fared no better. Antonio Palomino, a painter and a theorist, published a treatise on Spanish painting between 1715 and 1724 that enumerated the various virtues of many artists. Early in his career, Palomino felt, El Greco's style was acceptable because it imitated Titian, but later El Greco renounced Titian's style and "tried to change his manner, but with such extravagance, that his paintings came to be contemptible and ridiculous, as much for the disjointed drawing as for the unpleasant color." Palomino capped off his assessment with this pithy phrase, which unfortunately stuck: "What he did well, none did better. And what he did poorly, none did worse."[8]

When Juan Agustín Ceán Bermúdez, a friend of Goya's, wrote a biographical dictionary of the great painters of Spain in 1800, he sneered at El Greco. In describing his painting of *The Martyrdom of Saint Maurice* in the Escorial, Bermúdez caustically commented, "The picture is so hard, tasteless, extravagant. . . . They say he adopted this style to be distinguished from Titian, whom he resembled . . . but this is a lie of many that are told of this teacher." He even called his paintings "contemptible," "ridiculous," and "worthy of scorn."[9]

What made El Greco fall from grace so completely and yet have a rise to glory in the twentieth century? What did the people in the intervening time not see that seems so plain to us? *The Burial of Count Orgaz*, his acknowledged masterpiece, spent much of its existence ignored by the public and by professionals, barely worth mentioning in any art guide for hundreds of years, and yet, today, lines form outside the Church of Santo Tomé with the eager and the curious. It is the greatest single tourist attraction in Toledo, Spain.

El Greco's reputation took a while to rehabilitate, especially considering how long it was hibernating. The resurrection came not in Spain or Greece, but in Paris, when the Louvre decided to mount a show of Spanish masters in a newly constructed wing opened in 1838. King Louis-Philippe sent one of his cultural ministers to Spain

to gather paintings for the exhibition, and came back with no fewer than nine El Grecos, which may have gotten lost in the 450 canvases he eventually retained for the show. As mounted in this exhibition, El Greco was presented as a founder of the Spanish school, but considered a primitive, much in the way pre-Renaissance artists in Italy like Giotto or Duccio have often been hobbled with that label.

Still, El Greco was being seen, if only as the first step on the way to Velázquez or Goya. Collectors were still passing him by; few of his paintings were leaving Spain. *The Burial of Count Orgaz* was still sleeping soundly in Toledo; no connoisseur would make the trek to see what was considered an unconventional, even bizarre, work.

Romantics, who might have been expected to favor El Greco's work more than any other since his own time, labeled him as misunderstood, and then mad. Madness, in the romantic spirit, is not necessarily a bad thing. Romantics loved to delve into the underside of the human imagination, and the more a fellow artist was labeled as mad, the higher in popular estimation he rose. To them, El Greco became appealing because his madness drove his art to greater heights.

English poet and painter William Blake was considered a lunatic. He only once mounted an exhibition of his own work in 1809. Nothing sold, and only one review was published. He was labeled "an unfortunate lunatic" who had published "a farrago of nonsense, unintelligibleness and egregious vanity, the wild effusions of a distempered brain."[10] This did nothing to hurt his reputation—in fact, it has only made him seem misunderstood and the castaway of an uncaring and ignorant public.

William Stirling-Maxwell, author of the first comprehensive study of Spanish art in English, said El Greco had been "justly described as an artist who alternated between reason and delirium, and displayed his great genius only at lucid intervals."[11] It was this perceived mental illness that sparked an interest in El Greco. The artist's voice was thought to come from the depths of his mental fatigue through his hands and onto his sinuous figures.

What else could explain his extreme compositions and mannered style? Apparently, according to some,[12] astigmatism is the answer. Astigmatism is a common eye defect, the result of a misshapen cornea, which causes light entering the eye to be misaligned when it strikes the retina. Some say everyone has at least a slight astigmatism that is too minor to notice. The result is that the astigmatic only sees things in focus in one part of his or her vision. Today there are treatments for astigmatics, but there were no such advantages known to El Greco.

Not that he needed these cures, because he never had the problem. Astigmatism was used as a way of explaining El Greco's elongated figures. We know from El Greco's preliminary drawings that he sketched his figures with conventional proportions and then deliberately vertically stretched them when he painted them; he probably saw perfectly well and in all likelihood had no astigmatism.

In 1956 Dr. Gregorio Marañón said that El Greco used residents of a local insane asylum to model for the elongated look he so desired in his compositions. No one could look more haggard than lunatics, Dr. Marañón reasoned. These allegations, however, have been largely dismissed in view of the lack of documentary evidence.

Controversy over El Greco's technique raised his profile to a higher level, but the public by and large spent the nineteenth century ignoring him. Some French

critics saw much to admire in El Greco's modernist approach to the human figure and in his exaggerated compositions. However, by 1890 there still was no book about him, nor was there a demand for his paintings when they came on the open market. Foreign museums did not actively collect El Greco, neither did American millionaires who were busy buying up everything in Europe as if it were a Macy's one-day sale. Artists, however, were avidly collecting him; Manet, Delacroix, and Millet all owned El Grecos.

Professional admiration for El Greco slowly began to have its effect on critics, although some still held out. When the German scholar Carl Justi prepared a pioneering work on El Greco in 1908, he could not help himself from issuing a powerful broadside into the artist's reputation: "[El Greco] represents the most monumental example of artistic degeneration, an unequalled case in this history of art. This undoubtedly accounts for the astonishing admiration and even the reverence that he has inspired in our time."[13] This is from the author of a book on El Greco.

Art historians and museum curators must have been thinking seriously enough about El Greco, however, because the first one-man show dedicated to him was mounted in the Prado Museum in Madrid in 1902. Suddenly El Greco's convoluted stances seemed modernist, and his acid colors futuristic. The exhibit was followed in 1908 by the first book in Spanish about the artist penned by the art historian Manuel Bartolomé Cossio. City fathers in Toledo longed to create a permanent memorial to their favorite son, and so El Greco's house was saved in 1911 and turned into a museum. The Church of Santo Tomé suddenly woke as if from a deep slumber to discover they had a masterpiece in the rear of their church. It was later discovered that El Greco was a parishioner at Santo Tomé, perhaps determining the reason why he was employed to paint this large image of Count Orgaz's funeral and burial.

The National Gallery in London bought its first El Greco in 1882, now thought to be school of. The Metropolitan Museum in New York bought its first in 1905. Many latecomers to the game, like the Uffizi Museum in Florence, are still looking for their first El Grecos.

As he became more famous, he became more Spanish, and alternately depending on whom you listen to, more Greek. Italians sat on the sidelines. If he is a great Spanish painter, does it make him less Greek? And if he is a great Greek painter, does it negate his Spanish qualities? In a world filled with ethnic cheerleading, El Greco's status certainly matters.

The search is on. Greeks began investigating every panel from sixteenth-century Crete and looking to see if El Greco could have played a role in their execution. The Spanish have been on a similar hunt, examining every sixteenth-century painting that could have been painted in Toledo, equally hoping they will be El Greco's. Suddenly paintings have been elevated from obscurity to "copy after El Greco," then "school of El Greco," then "El Greco workshop," and ultimately to the work of the master himself.

Meanwhile, *The Burial of Count Orgaz* sits triumphantly enthroned in Santo Tomé welcoming visitors, art historians, hordes of schoolchildren, and busloads of the curious. El Greco's ersatz romantic soul has propelled him into the forefront of artists.

Still preserved: El Greco's studio in his home in Toledo, Spain. *Album / Art Resource, NY*

In 1912 German poet Rainer Maria Rilke went to Spain to see the El Grecos for himself. Some critics call it a turning point in the writer's life, especially when one considers his entire set of poems, "Himmelfahrt Mariae I.II," written in 1913, was based on El Greco's *Immaculate Conception.*

By the 1930s El Greco had been crowned as a great forerunner of modernism, and his artworks officially protected by the Spanish state, whatever that meant during the Spanish Civil War. On October 2, 1936, it was widely reported in the international press that *The Burial* was destroyed by Loyalist forces in heavy fighting around the city of Toledo. When the rebels entered the city they took an inventory of the works of art known to have been located in museums and churches in the city. They reported that the city was found "stripped bare" of all works of art, and those not taken were slashed beyond recognition.

Rumors that *The Burial of Count Orgaz* had been vandalized caused Harry Wehle, curator of European paintings at the Metropolitan Museum, to comment that "the loss of this masterpiece by El Greco would be irreparable."[14] That remark alone ensured that the reputation of the painter would be firmly established in the twentieth century and beyond.

Needless to say, the El Greco was not destroyed, nor was it moved. When in 1964 the Spanish government decided to send a famous painting to New York for the World's Fair, it briefly contemplated sending the El Greco. However, at the last minute Goyas were substituted, the Spanish government claiming the El Greco was in poor condition, the artist having mixed his primer paint with honey, which would make the transit of such a picture perilous because it would likely deteriorate with changes in air pressure.

The painting, and El Greco's reputation, was so restored that people began to fantasize about him, merging his life with elements of fiction to create a more dynamic story. Ernest Hemingway and W. Somerset Maugham, both of whom loved Spain, spent considerable time before El Greco's works and left very personal conclusions about his artistic output.

In Hemingway's book *Death in the Afternoon*, he considers the artist's oeuvre, in particular *Count Orgaz*, and comes to this conclusion:

> El Greco believed in the city of Toledo, its location and construction, in some of the people who lived in it, in blues, grays, greens and yellows, in reds, in the holy ghost, in the communion and fellowship of saints, in painting, in life after death and death after life and in fairies. If he was one he should redeem, for the tribe, the prissy exhibitionistic, aunt-like, withered old maid moral arrogance of a Gide [André Gide, an early twentieth-century French author]; the lazy, conceited debauchery of a Wilde who betrayed a generation; the nasty, sentimental pawing of humanity of a Whitman and all the mincing gentry. Viva El Greco El Rey de los Maricónes [Long live El Greco, king of the homosexuals—however, *maricónes* carries a more pejorative connotation than simply homosexual male].[15]

Hemingway's insistence on the homosexuality of El Greco as evidenced in *The Burial of Count Orgaz* might seem strange today, especially since there are so many

artists whose homosexuality is well known, and one doesn't need the imagination to fill in the details. However, Hemingway is insistent. In that same book, he says:

> One time in Paris I was talking to a girl who was writing a fictionalized life of El Greco and I said to her, "Do you make him to a maricón?"
> "No," she said, "Why should I?"
> "Did you ever look at the pictures?"
> "Yes, of course."
> "Did you ever see more classic examples anywhere than he painted? Do you think that was all accident or do you think all those citizens were queer? . . . Greco made them all that way. Look at the pictures. Don't take my word for it."
> "I hadn't thought of that."
> "Think it over," I said, "if you are writing a life of him."[16]

How Hemingway came to such a strange conclusion based on the visual evidence of *Count Orgaz* and El Greco's other works we'll never know. But to be fair, Hemingway was not alone. Somerset Maugham had similar observations expressed in a travelogue called *Don Fernando*, a 1935 account of his years in Spain:

> It cannot be denied that the homosexual has a narrower outlook on the world than the normal man. In certain respects the natural responses of the species are denied to him. Some at least of the broad and typical human emotions he can never experience. However subtly he sees life he cannot see it whole. . . . I cannot now help asking myself whether what I see in El Greco's work of tortured fantasy and sinister strangeness is not due to such a sexual abnormality as this.[17]

How much these remarks had to do with El Greco, and how much to do with Hemingway and Maugham is open to debate. However, this does illustrate how El Greco's art still seemed wildly perverse in the early twentieth century, and there must be some sort of psychological reason for this. While his genius is recognized, it is also tainted by the perceived reality that there is something not quite right about him.

The Burial of Count Orgaz, like many great paintings, has been the source of many artistic reincarnations. Modern sculptor and conceptual artist John Latham was most impressed by El Greco's ability to unite the spiritual and earthly worlds in one harmonious composition. In 1958 he created a mixed-media version on an old bagatelle board, that is, a board used for a game similar to pinball. The shape of the curve of the board suggested the shape of the original painting to Latham. The artist applied twenty-one books, a sponge, a spoon, a whiskey bottle, rags, a wire scrim, a fireguard, and a "flintstone for God," creating a work that is at once modern and a homage to the original.[18] The work today is in the Tate Collection in London.

Today *The Burial of Count Orgaz* is looked at in wonder; devotees of El Greco come to the small church to study and admire his great masterpiece. Of course, all of El Greco's real and presumed psychological baggage is now part of the experience

regardless of what art historians have had to say. The reports of madness, homosexuality, and astigmatism have become part of the El Greco mystique. In the end, if he were all of these things that history has placed on his head, how would it matter? The paradoxes that are El Greco have become part of his artistic experience, and *The Burial* has become the touchstone for all of it. El Greco's "madness" brought him back from oblivion. A touch of madness goes a long way.

Aristotle Contemplating a Bust of Homer by Rembrandt

Fame Available for a Price

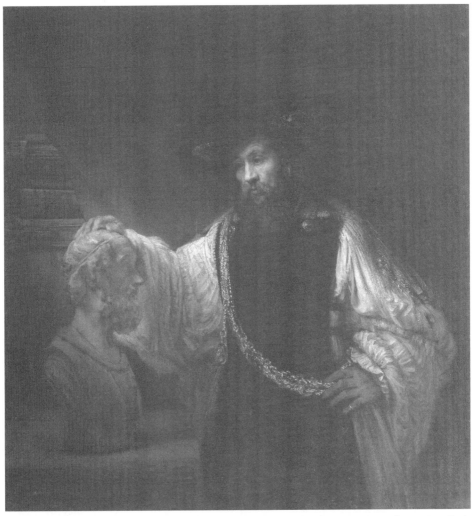

Aristotle Contemplating a Bust of Homer by Rembrandt. *Metropolitan Museum of Art, New York, USA / Bridgeman Images*

When a sum of that kind is involved in the expenditures of a public institution, one must inevitably be nagged by the question: could it have been better spent? Is it out of proportion? At what point does the price of any work of art, no matter how great, become unreasonable when it is thought of in terms of other human benefits that the same sum could bestow?

—New York Times editorial, 1961

The bidding for old masters in the aristocratic auction houses of the world is intense to the point of being nerve racking. On the evening of November 15, 1961, things were particularly apprehensive at the distinguished Parke-Bernet Galleries on Madison Avenue in New York City, for on this night the painting dubbed by the popular press as the "million-dollar Rembrandt" was to go on sale.

The story of this Rembrandt and its rise to fame has from the very beginning been about money. Rembrandt himself was paid an unusually handsome fee for the painting, some five hundred florins, which the patron, Antonio Ruffo of Messina, Italy, said in a later correspondence was four times greater than any painting he would have commissioned from a contemporary Italian artist.

However, on November 15, 1961, it was not florins, but dollars, and at least a million of them, that the crowd of some two thousand was expecting to gasp over. Every aspect of the art world seemed to be in attendance, including serious collectors, discriminating connoisseurs, fast-peddling dealers, and forlorn museum curators, the latter having ambitious lists and few funds.

High-stakes auctions are not something that museums usually want any part of. Museums generally count their blessings in the form of bequests, donations, and exchanges. Rarely do they enter a bidding war with other institutions, or heaven forbid, a wealthy individual. In fact, of the thirty or so Rembrandts in the Metropolitan Museum, the *Aristotle* is the only one that the Met actually purchased—all the others were donations. The same is true with the Rembrandts in the National Gallery in Washington and the Philadelphia Museum.

So attention was placed on private buyers who could drive up the cost of the "million-dollar Rembrandt"—drive it straight out of the reach of public eyes.

Auction rooms are very diplomatic; bidders often don't indicate whom they represent, at times acting as agents for their clients. Some man phones arranged in a bank at the side of the room so that bidders can be in contact with their prospective buyers, who cannot, or will not, be in the room when the auction commences.

The auctioneer places the object on prominent display, a few prefatory remarks are made, and the bidding begins. At Parke-Bernet acceptance of a bid is indicated by a gentle tap of two fingers placed at a coat lapel. All very discreet.

On this given day, twenty-three paintings were for sale, all from the estate of Mrs. Anna E. Erickson of New York City, a wealthy heiress married to Alfred W. Erickson of the McCann-Erickson advertising agency. The terms of her will particularly declared that her estate—pictures and all—should be sold and divided up equally into ninety parts and given out as legacies. The ninety recipients were family, business, and personal associates, all of whom concentrated their attention on the fortunes of the Rembrandt. With so many beneficiaries, it became obvious that the twenty-three

paintings and in particular this Rembrandt would have to command a substantial price for there to be enough to go successfully around.

What a choice collection of old masters the Ericksons had gathered! It featured a virtual who's who of European artists; in addition to the Rembrandt, there were works by Perugino, Fragonard, Cranach, Gainsborough, Holbein, Van Dyck, Hals, and Crivelli.

Few collections would ever go on sale again with such an array of artists; indeed, this was the auction of the decade. Anxiously, the museum world was waiting, board rooms humming with plans and schemes. Could donors be found who would fund such purchases? The director of the Metropolitan Museum, James J. Rorimer, was said to have mused, "Wouldn't it be nice if someone bought the Rembrandt for us."[1] No doubt other directors had the same feelings.

The Erickson Collection was known throughout the art community but was relatively quiet in the public eye. Most of their works were not lent out to museums. Therefore when the public learned of the Rembrandt's availability, it came as a bit of a surprise that there was still a masterpiece in private hands that could command such a high price.

The painting has had an unusually well-documented, and eventful, history.

It was commissioned by a Sicilian nobleman, Antonio Ruffo, who had an intense passion for paintings. At his death in 1678 he owned a vast collection of 364 works, a museum in its own right. Most were from contemporary artists of the Roman, Neapolitan, and Sicilian schools, but this collection also included great works by baroque masters such as Guercino, Van Dyck, Poussin, Rosa, and Reni. Older works by Dürer and Titian were also to be found, although the exact titles have mostly not been identified.

Ruffo had a keen eye for excellence, and through a Dutch intermediary ordered a Rembrandt painting of a philosopher for his collection. Surviving correspondence indicates that it was delivered in 1654, right on schedule. Ruffo—rather unusually—did not dictate the subject as Aristotle; most of what we see is of the artist's invention.

Ruffo must have been very pleased—he ordered two additional works from Rembrandt as well as a pendant figure by Guercino called *The Cosmographer* in 1660. One of the Rembrandts, a *Homer*, survives in fragmentary condition in the Mauritshuis Museum in The Hague, the other of *Alexander the Great* does not. The Guercino is also now lost; however, a sketch exists at the Princeton University Art Gallery.

Some one hundred paintings that formed the core of Ruffo's collection outlived him, and were handed down virtually intact from one generation to the next, including a fine Van Dyck, *Saint Rosalie Interceding for the Plague-Stricken of Palermo*, now also in the Metropolitan Museum. About seventy years after his death, his male heirs succumbed to the plague of 1743; the collection then passed to a minor branch of the family who thought little of the paintings except to show concern over how much money they would bring in. So with the thoughts of florins dancing in their heads, this Rembrandt, and indeed the entire collection, went on the block.

It was around this time that the painting was cut down, perhaps on all four sides. It is hard to make precise calculations because the standards of measurement varied so widely in Europe in the seventeenth century. One estimate is that we have the central portion of a canvas that was once twenty-four inches taller and at least seven inches wider. No one knows why the alteration was made. The Metropolitan maintains that the dimensions of the painting are close to the original, and what we have today is essentially what Rembrandt painted.[2] Perhaps parts of the painting were shaved off to fit a preexisting frame.

By 1815 the *Aristotle* was in England, where Sir Abraham Hume, an art lover and amateur painter, treated the painting royally, even making it available for its first public viewing at the British Institution in London. Hume set up a second family dynasty of ownership, passing the *Aristotle* to his grandson and then great-grandson. Once again, descendants did not have the same appreciation for the painting that the original owners did, and it was sold to an avid Parisian art collector, Rudolphe Kann.

Kann held on to the painting until his death in 1907, when his estate went up for sale, and the *Aristotle* was purchased by Mrs. Collis P. Huntington, a collector of unusually discriminating taste—an uncommonly astute connoisseur. The Huntington family gathered eight Kann works in total, and threw in for good measure his extensive collection of French furniture and objets d'art. Coincidentally, the Huntingtons were great supporters of the Metropolitan Museum, and there was every expectation that the Met could worm its way into the Huntingtons' hearts and have the painting bequeathed to them.

In fact, when Mrs. Huntington died in 1924, her son Archer gave the Metropolitan three paintings from his collection as a memorial to his father. This bequest involved no fewer than two Rembrandts (*Flora* and *Hendrickje Stoffels*) and a Frans Hals portrait of *Paulus Verschuur*. But no *Aristotle*. And there was no *Aristotle* to get. Archer wrote a letter to the Metropolitan Museum so that it would be clearly understood: "I will state I do not include the painting by Rembrandt known as Portrait of a Savant [the *Aristotle*] . . . as this I shall retain for my own home at a future date."[3]

Already the painting had a history of being bandied about with great enthusiasm, and the pace of exchange was about to quicken even more.

Archer Huntington sold the painting to the Duveen brothers, who were the most distinguished old master art dealers of the early twentieth century. Huntington used the proceeds for the construction of a pet project, the American Academy of Arts and Letters.[4] In a quick turnaround, Duveen unloaded the canvas for $750,000 to Alfred W. Erickson, the man with the fortune in advertising. Erickson was a great many things, but a philanthropist dedicated to public art, he was not. Hopes that the painting would be donated to an American institution began to flicker and fade as quickly as America's misfortunes in the Great Depression.

In 1930, two years after acquiring the work, Erickson's advertising business began to sink, and the painting was sent back to Duveen for a quick sale at $500,000. Overnight Erickson had lost $250,000 on his Rembrandt investment, but he could not quibble. When times are tough and money is needed, even the rich cannot complain about the price they get. Duveen held on to the painting for six years, probably un-

able to unload such a costly property in an age when everything was expensive, even to those with money.

Erickson never forgot his *Aristotle*, though, and by 1936 he repurchased the painting, this time paying $590,000 for the work. In all, Alfred Erickson paid $840,000 for the Rembrandt, which stayed in his family until after his death. Only his wife's will permitted the sale.

Parke-Bernet, a distinguished American firm that would later be bought out by the English company Sotheby's, was named as a suitable auction house to deal with this estate. Rembrandts were very hot in America, so there was little reason to assume that the painting would not remain in this country. As has oft been quoted, "Rembrandt had left behind him 600 paintings, 2000 of which are in America."[5]

Americans have always collected and treasured Dutch art for a number of reasons. Some American collectors, like the Vanderbilts, were of Dutch origin, and had a sense of pride in their ethnic background. This ethnic identification, no stranger to the art world, was felt particularly strongly in New York, at one time called New Amsterdam, the only part of the United States colonized by the Dutch.

Dutch artists also specialized in themes Americans liked in their paintings: landscapes, still lives, and portraits. For these reasons—and also because the Dutch weren't Catholic—Rembrandt became the preferred artist for the homes of the rich and famous. Peter Paul Rubens was thought to be popish, and too closely associated with idolatry and foreign tyrants.[6] The supposed rediscoverer of Vermeer, Etienne Joseph Théophile Thoré, alias Thoré-Bürger, said in 1860, "Rubens belongs with the defeated and slaves, Rembrandt with the victors and free."[7]

Rembrandts became the way a great financier could claim a first-rate American collection of bona fide masterpieces. Plus they are fairly plentiful; some say there are about 350 in the world today (the Rembrandt Research Foundation puts the number at a stingy 250), and numbered somewhere around seven hundred in 1900 when many "school of" canvases were considered autographs. Rembrandt paintings have the advantage of being portable rather than attached to a wall, and being painted in luminous oils rather than flat tempera. They are well suited to a parlor or a library rather than a chapel or a monastery. The rush to buy was on.

When the Metropolitan Museum opened in 1872, its prize possession was a grouping of 174 old master paintings, which were purchased as a lot for $100,000. The majority of the paintings were Dutch. The American writer Henry James saw the collection and claimed, "If it has no gems of the first magnitude, it has few specimens that are decidedly valueless."[8]

There were no Rembrandts—not at that price. Of the 174 paintings that the Metropolitan bought, 110 have been deaccessioned, the core of the Dutch collection still remaining. The only way to get a Rembrandt to America was to go to Europe and buy one. No one could count on an inheritance.

Economic misfortune—a stock market collapse here or a series of failed harvests there—ensured that eventually a Rembrandt would come on the market. Just such

an event triggered the sale of the first Rembrandt to America. Henry Marquand, a railroad financier, purchased *Portrait of a Man* in 1883 for $25,000. The canvas came from a British collection; the owners had fallen on hard times and some of the paintings had to go "owing to his estates in Ireland not paying."[9] Marquand bought the painting and seven years later in 1890 gave it to the Metropolitan as a public service. Now all Americans could see a Rembrandt, and now all rich Americans wanted one to have and one to give away.

The Marquand purchase was quickly followed by the Havemeyer acquisition of Rembrandt's portrait of *Herman Doomer* for the tidy sum of $80,000 in 1889, the highest price ever paid for a Dutch painting in the nineteenth century. The Morgans, the Gardners, the Fricks, the Huntingtons, and the Johnsons all bought Rembrandts, or what they thought were Rembrandts, in a rush to gobble up the remaining paintings that came on the market.

By the time the Metropolitan mounted its first great show, the *Hudson-Fulton* exhibition in 1909, there were thirty-seven "Rembrandts" to see including three owned by Benjamin Altman. The grabbing of Rembrandts wherever one could find them proceeded apace through the early twentieth century, until the *Aristotle* surfaced as if it were the last great painting by Rembrandt ever to come on the market.

It was at this point that the hype began to gather a life of its own. Museum boards met and declared, as only museum boards can, that this was the opportunity of a lifetime. In the 1960s there was a feeling that almost all the great works of art were already located in museums, and that there were few genuine masterpieces left in the world to buy. The great collections had already been amassed; all that was left was a refining and honing process.

In 1970, the Met revived this thinking when it again made headlines by purchasing Velázquez's *Juan de Pareja* for yet another record price, over five million dollars. No doubt the Met board felt that this opportunity would never come around again also.

Parke-Bernet moved the Erickson paintings to their headquarters and put them on public exhibition. This was a necessary part of the process, for prospective buyers needed to be sure that their millions were being well spent, and there was no way to really know unless one inspects the works firsthand. For three days the collection was open to the public. Soon after the entire collection was appraised at $3,000,000, and was then later insured for $5,000,000. Interest began driving up prices.

No doubt, curiosity was intense. Lines formed outside Parke-Bernet as twenty thousand people waited in November weather to see the great Rembrandt. Two thousand tickets were granted for admission to the sale itself, either to dealers, agents, collectors, or museum representatives from the United States and most artistic centers in Europe. When the painting was brought out for the process to begin, a spotlight shone on the warm colors of the figure of *Aristotle*, and the audience gasped, and then broke into applause.

No one has ever doubted the importance, or the greatness, of this Rembrandt painting. It shows the painter to greatest advantage with his warmest hues and deepest chiaroscuro. It also features a fittingly cerebral Aristotle, father of all philosophy, contemplating the most celebrated of Greek poets, Homer—figures representing

the very beginnings of Western thought. The introspective nature of Aristotle's gaze combined with the gentleness of his embrace of Homer's head draws us deeply into the composition.

Experts have paused over the smallest details in the painting to highlight their significance in relationship to the overall effect of the painting:

> The almost infinite variety of subtly changing tones in the painting draws attention to one of its most extraordinary elements: the contrast between the extreme restraint of the color scheme, limited almost entirely to browns and yellows, and the great richness of the variation to tone and hue within this narrow range. Hardly two strokes of the brush seem to repeat the same tone.[10]

The costuming, at once so baroque and so eternal, gives us a sense that these figures have been placed both in our own world and in an ideal world of philosophical thought—Aristotle looking down at the bust with particular penetration. The golden chain glistens with symbolism of worldly honor, stature, power, and wealth. The small medallion dangling from Aristotle's chain bears a portrait of his star pupil, Alexander the Great.

The bidding was expected to be record breaking. Prior to this the record for the world's most expensive painting was held by Raphael's great *Alba Madonna* now in the National Gallery in Washington. It was purchased by Andrew E. Mellon, who snagged it in a private sale directly from the cash-hungry Soviet government in 1931 for $1.1 million. Another high-priced painting was a portrait of *Count Duke Olivares* by Velázquez, purchased by Mrs. Huntington for the Hispanic Society of America for $600,000 in 1909. The previous record for a Rembrandt at auction was his portrait of *Titus in an Armchair*, which sold for $270,000 in 1927, although higher prices had been recorded at private sales. The highest auction price ever paid for a painting at that time was Rubens's *Adoration of the Magi*, which set a record when sold for $770,000 in 1959.

Auction prices are sometimes not a true reflection of the value of a painting. Two determined buyers can send the value of a mediocre work into the masterpiece category. It has happened that some auctions have been rigged. Some dealers have a vested interest in seeing that an artist they represent achieves a high price at auction, and will go so far as to buy paintings by their own artists to raise the price. While this is rare, it is a disturbing sidelight to the auction market. The general public is fearful of fine art pricing, in part because it seems so arbitrary.

When the bidding on the Rembrandt started at one million, the record set by the Rubens was already shattered. The auctioneer raised the price by a hundred thousand dollars at each level, making some of the participants fall away almost immediately. When the dust settled, the Metropolitan had purchased the painting, for a total of $2.3 million, triple the record price of the Rubens set only two years before. The entire process took a total of four minutes.

The Met cobbled together the money from a number of donors, and outbid its competitors, said to be the Cleveland Museum and Baron Henry von Thyssen, a Swiss collector with a museum at the time located in Lugano. The Cleveland Museum was said to have bid $2.2 million at the last call. No one knows how much the

Metropolitan was ready to spend to have it, but there was enough cash left over for the Met to buy a fifteenth-century painting by the Master of Saint Augustine for $110,000 for the Cloisters Collection.

Had they lived, the Ericksons would have seen a nice profit on their Rembrandt, and on their Saint Augustine as well, which they purchased in 1925 for $40,000. While the entire sale fell a little short of the five million eventually expected, the Erickson estate had little to be upset about. The heirs would have approximately $50,000 a piece. That is $50,000 in 1961 dollars.

At this point, the fame of the Rembrandt began to skyrocket. Capitalizing on the big price tag, the museum immediately brought the painting to its new home so that it could be on display just two days after the purchase. Even the moving van that carried the painting from 980 Madison Avenue to East Seventy-Eighth Street had extensive press coverage, reporters anxious to know how the movers felt about carrying such expensive cargo. Inside the main cab, an armed guard accompanied a curator and a driver, while the three moving men, a curatorial aide, and another armed guard rode inside with the painting.

Once at the museum, the staff had to work fast. The public wanted to see the painting now, and conveniently. They were not about to amble up the great staircase to find it hidden away in the Dutch collection of old masters. An old red velvet curtain was pressed into service to adorn the northwest wall of the Great Hall, only a few steps from the main entrance. The visiting throngs, overwhelmed by the presence of the painting, moved quietly, almost religiously before the work, some men removing their hats. Armed guards flanked the painting on both sides, and the area in front was roped off so that no one could get too close.

On November 18, 1961, forty-two thousand people came to visit. No one paid a cent—ironically, visiting the world's most expensive painting was free. This, however, was only the prelude. On November 19, a Sunday, an enormous throng of 82,679 people glutted the Great Hall, almost doubling the attendance record of the day before. This was especially notable because back in 1961, the Metropolitan Museum was only open for four hours on Sundays, from one to five. A similar pattern sustained the museum throughout the next few weeks.

A year after its purchase, the *Aristotle* was still popular, and still sitting in the lobby of the museum. Attendance at the Metropolitan increased a dramatic 41 percent that year, with a parallel increase in cleaning staff and security. Gradually, it was realized that the painting could not stay in the lobby, and a proper placement in the European galleries was contemplated. Before that was accomplished, the Metropolitan installed air-conditioning on its upper floor, so that visitors could appreciate the work in greater comfort. They then cleaned the *Aristotle*, perhaps for the first time, revealing more brilliant hues.

Today the painting draws some notice, but it would be unfair to suggest that it remains hugely popular. On a given weekday afternoon, the gallery that houses it, filled with miscellaneous Rembrandt portraits, has the idle visitor or two, but few who come just to see *Aristotle*. When they do come, they come with the knowledge that the fame of this painting was assured by the selling price, determined years ago, and still a daunting figure today.

**"That's The Way It Goes. Along Comes
Some Dame With A Smile —— "**

One icon supplants another. *A 1963 Herblock Cartoon © The Herb Block Foundation*

However, the record for the most expensive painting has been topped with such regularity, and the prices have gone up so precipitously, that the Rembrandt record, in contrast, looks quaint. The current record holder, which probably won't last all that long, is a version of Paul Cézanne's *The Card Players*, which was bought in a private sale in 2011 for an estimated $250 million. Cézanne painted five such scenes of cardplayers, but because four are now in public museums, interest in the fifth was especially keen.

Still, the jaw-dropping price staggers the imagination. No one was especially surprised to learn that the top bidder was from the tiny oil-rich nation of Qatar. Even though exact figures have never been released, gossip-driven unofficial estimates have murmured that the sale was indeed much higher; figures of $300 million have been proffered. The sale did not mean that Qatari bidders were left impoverished. On February 5, 2015, it was reported that a Gauguin sold for another $300 million to an undisclosed buyer from a Swiss private collection.

At auction, the highest price for a painting was reached on May 11, 2015, when Pablo Picasso's 1955 *Woman of Algiers* set a record at $179.3 million. Three years before, Munch's *The Scream* was also a record setter when it was purchased for the

handsome sum of $119.9 million on May 2, 2012. This was well over the initial auction estimate of $80 million.

The highest auction price for a Rembrandt was set on December 8, 2009. His 1658 *Portrait of a Man, Half-Length, with Arms Akimbo* went for $33.2 million at Christie's in London and was purchased by Stephen A. Wynn, the Vegas casino mogul.

The long-term effect of the sale of the *Aristotle* is not so much about the painting itself, as about the controversy it generated. An editorial in the *New York Times* declared that there was a "persistent feeling of discomfort, even of distaste, with the price."[11] People looking at the painting undoubtedly were aware of its price; in fact, it became impossible to look at the work without thinking of the cost.

The popularity of the *Aristotle* sparked an interest in the Metropolitan, and eventually museums throughout the country. Shortly after the spike in attendance, curators began speaking boldly of a renaissance in museum attendance in this country, indeed, also in the sheer number of museums nationwide. While the Metropolitan may have been the place to go for museum lovers in New York, local collections around America enjoyed a boon as well.

Morale at the Metropolitan soared after the purchase. Claus Virch, assistant curator of European paintings, said, "It gives me a lift every time I pass it." Still, the price of the painting dogged museum curators for a long time after the purchase. The director, James Rorimer, faced questions again and again about the acquisition, but never looked back: "I have never regretted the purchase," Mr. Rorimer contended. "A number of museum directors here and abroad have confessed to me that they had tried to raise funds to acquire the painting."[12]

One girl, age sixteen, looked at the painting and remarked, "You sort of feel like you're in the presence of greatness."[13] Another observer asked, "How can you put a price-tag on a thing like that?"[14] and indeed that has been the quandary for all great, famous, and expensive works of art before and since.

Washington Crossing the Delaware
by Emanuel Leutze

Or Perhaps, *Washington Crossing the Rhine*

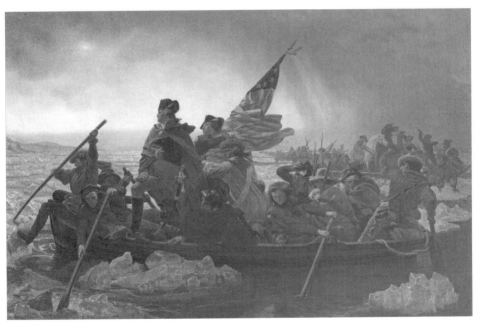

Washington Crossing the Delaware by Emanuel Leutze. *Metropolitan Museum of Art, New York, USA / Bridgeman Images*

We gaped responsive to every item, lost in the marvel of the wintry light, of the sharpness of the ice-blocks, of the sickness of the sick soldier, of the protrusion of the minor objects, that of the strands of the rope and the nails of the boots, that, I say, on the part of everything, of its determined purpose of standing out; but that, above all, of the profiled national hero's purpose, as might be said, of standing up, as much as possible, even indeed of doing it almost on one leg, in such difficulties, and successfully balancing.

—Henry James, *A Small Boy and Others*

*T*here are fewer images more well known in an American elementary school classroom than the iconic painting of *Washington Crossing the Delaware*. The work has become so familiar to so many students that it has come to exemplify the American Revolution, solidifying in visual format one of its most central moments.

The painting cannot fail to impress. It is gloriously mounted in a reproduction of its original frame in the main American painting gallery of the Metropolitan Museum in New York. This new frame, costing a reported $800,000, has the double task of providing a setting and a support for this cumbersome and extremely unwieldy canvas.

The painting is now ensconced in a refurbished gallery, and dominates, indeed overwhelms, everything else in the room. It would do so in any room in just about any museum. It is the largest canvas painting at the Metropolitan, containing twelve life-size figures sprawled over twenty-one feet of wall space.

The size of the work symbolizes the importance of this epic event, but size does not alone account for the picture's fame. For that we must look at the painting's history and the context in which it was created.

The year 1848 was a busy one in Europe. Revolutions flared up seemingly everywhere on the Continent from Sicily to Poland; the romantic spirit of freedom was in the air. Revolutionaries proclaimed death to tyrants. The will of the people will prevail! Revolutions were particularly widespread and intense in Germany, a country defined as an amalgam of small states with no central authority. This mix of tiny territories was run by dukes, princes, and assorted lower nobility who made the German intelligentsia of the time yearn for unification, and an end to petty local interests. If only there could be a way to cast off these self-serving and self-styled benevolent despots and create new world order.

Of course, there was a place where this had already happened; America was Germany's inspiration. The United States was a young republic running very well without a count or a duke to control everything from foreign policy to intellectual thought. Germans saw this as a political and social goal, a goal that was achievable even in the short term.

German artists of the early nineteenth century, however, were not free to express sympathy for a cause; either they conformed to the standard boilerplate image of German greatness, or fled to places like Rome—as the Nazarenes did—to develop their own style without the hindrance of dictatorial demands on their artwork. Some, like

Caspar Friedrich, were able to flourish—provided they worked as landscapists and did not try to make political statements.

It was in this milieu that Emanuel Leutze emerged as a painter in the early 1840s. Born in Germany but raised in Fredericksburg, Virginia, and Philadelphia, Pennsylvania, Leutze was trained by his artisan father at an early age to be a painter. As federal artists John Singleton Copley and Benjamin West both knew, the opportunities for accomplished artists were slim in this country, even if your specialty were portraits, the only thing that Americans would apparently buy. Leutze saw himself, instead, in the distinguished tradition of history painters, something hot in Europe and decidedly cold in America.

History painting is a broad term that covers a number of artistic subjects, including literary, religious, and mythological works. Creative history painters bring episodes from the past to life through the lens of modern interpretation, so that the final product does not re-create a desiccated ancient story, but rather revitalizes it in a context deeply resonating with the modern viewer. New interest in history painting was rekindled by Benjamin West whose *Death of General Wolfe* in 1770 broke new ground, because it raised a contemporary event to mythic status without resorting to dressing figures in antique robes. European artists capitalized on the current appetite for historical scenes by producing some of the most memorable paintings of the nineteenth century: Gros's *Napoleon in the Pesthouse of Jaffa*, Delacroix's *Death of Sardanapalus*, Goya's *Third of May 1808*, and Ingres's *Vow of Louis XIII*.

In the United States there was not much call for this. Maybe the government would want to commission a grand painting for the U.S. Capitol rotunda, or a state assembly for the adornment of its chambers, but few individuals had the space or the interest in decorating a large gallery with one painting.

If Leutze wanted to be a great history painter, he had to travel to Europe to do it, and so he arrived in 1841 in Düsseldorf, Germany, ready to re-create the past. His earlier efforts almost seem as if he is trying to catalog world history in paint: *The Mission of the Jews to King Ferdinand and Queen Isabella*, *The Return of Columbus in Chains to Cadiz*, and *The Court Life of Henry VIII*.

Leutze's themes were not random. He carefully chose historical episodes that would mirror a modern controversy: religious toleration, freedom of expression, freedom of assembly, and political opportunities. His choice of *Washington Crossing the Delaware* must be seen in this political light.

Painted seventy-five years after the actual event, and a continent away from the action, the painting is a fully realized dramatization of the story, given that so few reference texts were available to the artist, particularly at such a distance. Historians have felt the obligation to nitpick at details in the painting, perhaps unaware that what we have is an artistic rendering, not a documentary in oil. As the first president of the English Royal Academy, Joshua Reynolds, said, "A mere copier of nature can never produce anything great."[1]

The facts of the event itself are widely known, especially given the propensity of Americans to analyze, describe, and reenact every battle on the North American continent. On the evening of December 25, 1776, General Washington huddled his struggling troops together for a surprise assault on Hessian mercenaries encamped near

Trenton, New Jersey. Under cover of darkness, they plowed through the icy waters of the Delaware and marched nine miles to engage the enemy. Their perseverance paid off. Suddenly, out of the unsettled night, the Americans opened fire, and the Hessians were caught sleeping off a Christmas night's festivities. Like the Battle of Quebec, the subject of West's *Death of General Wolfe*, this battle was quick, only forty-five minutes. In that time one thousand Hessians were imprisoned and their commander killed.

The psychological effect of the victory was enormous. The colonists were given a much-needed morale boost; the Continental army showed it could fight and win. All this action may have seemed somewhat arcane in Germany, except for the fact that a scrub force of ordinary people could take on the agents of a royal army and win; this resonated with oppressed people in central Europe. Because of actions such as these, George Washington became the president of the United States and one of the most admired men in the world, and George III lost his thirteen most valuable colonies and was branded a lunatic.

It was also important that the troops Washington fought were not English, but Hessian mercenaries, who came from the provinces of Hesse-Cassel, Brunswick, and Hesse-Hanau in central Germany. These troops for hire were rented out by princes for a price, and were seen by the German population as one of the worst abuses of princely power.

All of this was not lost on German nationals of the nineteenth century, who were feeling the burden of persistent tyrannical occupation by successively repressive rulers. German philosophers like Georg Wilhelm Friedrich Hegel and Immanuel Kant had already argued for the progressive spirit in world history, and the gradual evolution away from European despotic states. Leutze saw himself as a German American responding sympathetically to these causes.[2]

The revolutions of 1848 brought republican feelings to the fore, and although the revolutions managed to grab headlines around the world, monarchial rulers in Germany crushed the opposition, casting aside freethinking ideas as just so much philosophical chatter. Germans responded by fleeing the country in record numbers. In 1852 alone, 250,000 Germans entered America, altering the ethnic makeup of this country, and making Germans the largest ethnic minority in the United States.

Leutze's intended audience, therefore, was a complex one. He wanted to appeal at once to the general American public, the German American public, and the German public at home. When he started the painting, he made sure that bulletins were sent out charting his progress. A report in the *Bulletin of the American Art-Union* in October 1849 said Leutze was about to paint *Washington Crossing the Delaware* and the figures were to be life size.[3] "He has already made a number of studies for this work," the report energetically proclaimed. In August 1850 a letter from the *Bulletin* reported that the canvas was "half underpainted," and another description appeared in October.[4]

Painter Worthington Whittredge recorded the proceedings in his autobiography:

> Leutze was in his prime when I came to Düsseldorf. I suppose there is no artist now living who is as familiar as I am with the assembling of his great picture of "Washington Crossing the Delaware." . . . A large canvas for it had been ordered

that day. When it came he set to work immediately drawing in the boat and fig-ures with charcoal, and without a model. All the figures were carefully corrected from models when he came to paint them. But he found great difficulty in finding American types of the heads and figures, all the German models being either too small or too closely set in their limbs for his purpose. He caught every American that came along and pressed him into service. Mr. John Groesbeck of Cincinnati, a man over six feet, called to see me at Leutze's studio and was taken for one of the figures almost before he had time to ask me how I was getting along. My own arrival and that of my friend were a god-send to him. This friend, a thick sickly-looking man—in fact all his life a half-invalid—was seized, a bandage was put around his head, a poor wounded fellow put in the boat with the rest, while I was seized and made to do service twice, once for the steersman with the oar in my hand and again for Washington himself. I stood two hours without moving, in order that the cloak of Washington could be painted at a single sitting, thus enabling Leutze to catch the folds of the cloak as they were first arranged. Clad in Washington's full uniform, heavy chapeau and all, spy-glass in one hand and the other on my knee, I was nearly dead when the operation was over. They poured champagne down my throat, and I lived through it. This was all because no German model could be found anywhere who could fill Washington's clothes, a perfect copy which Leutze . . . had procured from the Patent Office in Washington. The head of Washington in this picture was painted from Houdon's bust.[5]

Leutze's artistic license included changing night into day, because Washington crossed the Delaware at night to surprise the British. Diary accounts tell us that the troops suffered from the constant pelting of rain and sleet, none of which is visible in the glorious sunrise of this painting.

The boats Washington used were deep Durham boats, not the shallow row-boats that project the protagonists most artistically into the picture plane. Horses and cannons were ferried over later, and not at the same time as the soldiers. The Betsy Ross flag wasn't sewn at the time of the crossing; soldiers probably carried their regimental colors, at most their state banners. Washington's features were altered as well, from a robust forty-four-year-old military commander to a more stately fifty-year-old world leader.

For getting the effect of the water right, Leutze took himself down to the banks of the Rhine, where he spent many a day sketching and capturing its atmospheric ef-fects. A river is a river, Leutze must have mused.

Back in America, where he planned to show the painting on something of a grand tour, press announcements were constantly published, stimulating intense in-terest. Unfortunately, disaster struck when the painting was nearly completed. A fire broke out in the rooms directly below Leutze's studio, and the mad rush was on to save George. Despairing that all would be lost, his studio hands roughly tore the work from its frame and in the process rolled the brittle—and extremely heavy—canvas, ripping it in five places. Leutze dejectedly pronounced that it was beyond restoration, and that he must start again. At this point Leutze's insurance company arrived with a check for $1,800 and became the owner of the ruined masterpiece.

When the smoke settled, Leutze was able to reassess the remains of his painting, perhaps seeing an opportunity: if somehow the painting could be restored, and its

remains exhumed for suitable viewing! First his assistants began to meticulously sew the canvas back together, applying it to a firm backing. Then Leutze began reapplying paint to the damaged areas until the work was at least presentable. Harnessing the news flash that the ruined painting was raised from the dead, Leutze eagerly awaited for an exhibition. "There is no such thing as bad publicity," Dominic Behan once wryly pronounced. The emergence of this painting from the ashes was just the thing to stimulate interest.

The revitalized, although still somewhat damaged, painting was packaged off to the insurance company, which needless to say, had no real interest in holding on to such a work. They auctioned it off, eventually having it deposited in the Kunsthalle Museum in Bremen, via exhibitions in Cologne, Düsseldorf, and Berlin. It was greeted as if it were a Lazarus-like event, loaded with symbolic meaning of patriotic zeal and the overthrow of tyranny. Even the fact that Washington was aboard a rickety boat struck a chord with German emigrants who faced a perilous ocean voyage to America.

In the meantime Leutze began working on a replacement—the painting now in the Metropolitan Museum. Since so much of the composition, perspective, and coloring had been worked out in the first version, the second was a true copy with only minor details that had to be changed.

The effect of the first painting on the German public was electric. The American Revolution tapped into the deepest anxieties of the German people. For example, Germans were oppressed by cruel taxation; Americans had thrown out the idea that one could be taxed without being represented. Germans were afflicted by high land values; America had plentiful land—and empty land at that—at very low prices. In Germany, only a firstborn male could inherit property, making other siblings landless and looking for a home. All these people could come here. Even the thirteen colonies symbolized the patchwork of German states. After the revolutions of 1848 America called loud and clear. In 1851 when the painting debuted in Germany, it became famous well before it reached America, even if it depicted an event half a world away and seventy-five years old.

Having now oiled his publicity machine with the kind of advance notice that accompanies movie previews today, the painting was shipped to America. German reviews, which were predictably excited, ensured that connoisseurs would take the work seriously. It was no surprise, then, that when it arrived in New York, enthusiastic notices began to pour in.

WASHINGTON CROSSING THE DELAWARE.—This glorious picture is now exhibiting at the Stuyvesant Institute. Go by all means to see it. We will hereafter notice its beauties.[6]

LEUTZE'S WASHINGTON CROSSING THE DELAWARE.—This exciting picture, which is now all the talk, meets with great success. It is probably the greatest historical picture in the country. Our people will all like to see it, and we fear that the gallery of the Stuyvesant Institute will be too small.[7]

WASHINGTON CROSSING THE DELAWARE.—The Stuyvesant Institute was crowded last night, to see Mr. Leutze's magnificent picture. Thousands of children will no doubt visit it during the holidays.[8]

An ad in the *New York Daily Times* on December 26, 1851, proclaimed:

WASHINGTON CROSSING THE DELAWARE.—Over twenty thousand people have already visited LEUTZE's great national picture of WASHINGTON CROSSING THE DELAWARE, now exhibiting at STUYVESANT INSTITUTE, No. 659 Broadway. "The picture represents the moment when the great General, ahead of the mass of his army, is steering amidst the masses of floating ice to the opposite shore in a small boat, surrounded by Gen. Greene, Col. Munroe [*sic*], officers, soldiers and boatmen." Open every week day from 9 A.M. to 10 P.M. Admission 25 cents; children 12½ cents; season tickets 50 cents. Description of the picture 6 ¼ cents. A subscription book is now open for the print, which will be the most beautiful and largest line engraving ever published, measuring 38 × 22½ inches. Subscribers only are entitled to the inducements set forth in the prospectus.[9]

Not everyone was so pleased. A reporter for the *Richmond Whig*, sent to New York to review the show at the Stuyvesant Institute, commented that he did not appreciate the German and other "un-American visages" in the painting. He would have preferred they all be replaced by "some Maine lumberman." Later, when the painting's companion piece, *Washington Rallying His Troops at Monmouth*, was unveiled, General Washington was laughingly called "a fat German."[10]

~

In New York Leutze placed the painting in a setting entirely by itself, with no other works to accompany or detract from it. A solo showcase was nothing new in the nineteenth century. In fact, this was a way to maximize popularity and generate public interest. Such blockbusters like Vanderlyn's *Panorama of Versailles* (Metropolitan Museum, New York) had an entire building constructed so that the painting could be viewed to maximum advantage. Paintings of great size were housed in large galleries that charged admission so that the artist could recoup some of his expenses as well as generate significant buzz. If things really worked out well, he could sell souvenir copies in the form of engravings.

Leutze worked every angle to stir the patriotic soul: Brilliant visionary lighting accents the protagonists enduring winter hardship, the American flag is prominently placed to ensure civic pride and highlight the worthiness of the cause, and the struggling but brave troops ford the choppy river to capture the adversities facing the colonial army. The limitless expanse of sky symbolizes the drama of the event, setting the story so that Washington does not merely go to meet the Hessians but has a date with destiny or even eternity. These are precisely the things that later on made the painting fall from favor. But in 1851, in an America seething with unrest over the slavery question, there were few political figures from the past that could be looked upon with approval by the entire American public. Washington fit the bill.

Leutze's triumph inspired him to create a companion work in 1854, the aforementioned *Washington Rallying His Troops at Monmouth*. This equally mammoth painting depicts another military victory in New Jersey. In this engagement Washington literally saves the day, by charging onto the battlefield and rescuing the Continental army from what would have been a disorderly rout.

Much as this subject could have received equal adulation from the American and German public, there was a feeling that Leutze was now pandering to his audience and producing Revolutionary War images more because he could make a dollar from them than because he truly sympathized with the cause. When *Washington Rallying His Troops* went on display, it stimulated minor interest, but it subsequently faded from view, and faded quickly.

What was so successful in the first painting now looked tired and uninteresting in the second. The sunrise glow around Washington had been replaced by a showering of sloppy cannon fire, and the heroic nature of the deed is painted in a strangely stilted and cumbersome way. Leutze's deliberate appeal to the emotions that worked so well in the first painting became routine in the second. It was given to the art gallery in the University of California at Berkeley in 1882, where it sits unbefriended—few ever come to see it, mostly because no one has ever heard of it.

Leutze was not the only one interested in aggrandizing the American past. When fellow American artist George Caleb Bingham saw Leutze's work in New York in 1851, he immediately began envisioning his own version. He told his friend James Sidney Rollins in 1855 that he hoped to produce a picture of Washington "connected with some historical incident, in a manner that would rival the far famed picture by Leutze."[11] Bingham later met Leutze in his studio in Düsseldorf, where plans for his own version were no doubt strengthened, although a commission for such a work was still wanting. Hopes that the Missouri state legislature where Bingham had connections would purchase such a painting faded, and so did the artist's interests. Finally he was persuaded by his printmaker, John Sartain, to try his hand at the subject, and so the painting was fitfully worked on between 1856 and 1871.

Bingham's painting is considerably smaller than Leutze's and has suffered by contrast. If Leutze has populated his canvas with Germans, Bingham's seems to have envisioned Washington surrounded by Kentucky frontiersmen and Tennessee riflemen. While Leutze used the Rhine for inspiration, Bingham presents a distinctly Mississippi flavor to his version. Some of the uniforms may be colonial in the Bingham, but on the whole the painting has a backwoods quality.

Perhaps because it suffered by contrast, no one purchased Bingham's painting in his lifetime, and it was left to his estate at his death in 1879. Bingham's work has a clumsy composition, so unlike his other paintings, which are noted for their clarity and keenness of observation. Washington, for example, is mounted on his horse on a raft while crossing the Delaware, something that would have undoubtedly sent him instantly plunging into the river.

Both Leutze's and Bingham's paintings are marked by an aggressive patriotic tour de force that is sometimes too much for the modern viewer. Soon they began to slide from critical appraisal, even at times being removed from public view.

Leutze himself faced some bad luck later in his career. His masterpiece may have stirred the German soul, but figures in authority were ever watchful, and awaiting any political maneuvers the artist may have masterminded. It didn't take long. After fomenting unrest in Düsseldorf, he was officially branded as a rebel, and like his father, was exiled from Germany in 1859. Leutze long claimed to the German authorities that the painting of Washington was simply a way of expressing his American heri-

tage, but those in charge suspected otherwise. There is a long tradition of censorship in Europe, and all kinds of works were edited for their subversive content. However, the censors could not catch everything. In 1842 Giuseppe Verdi presented his first major opera at La Scala, called *Nabucco*, and the Italian public immediately understood that the show was not about the ancient Hebrews and their struggles against the Babylonians, but the cause of Italian unification against the Austrian occupiers. The opera caused an instant sensation, and the censors were embarrassed.

Leutze ultimately settled in Washington, D.C., where the fame of his great painting landed him a commission to execute for the Capitol rotunda *Westward the Course of Empire Takes Its Way*, which he finished in 1860. It was to be his last major work.

By the twentieth century Leutze was already a forgotten name in American art, and his painting looked upon as only suitable for elementary school classrooms. William Sloane Coffin, president of the Metropolitan Museum, said in 1932:

> There has been considerable discussion in the public press regarding the painting "Washington Crossing the Delaware," by Leutze, and the fact that it is temporarily not on display in the museum. In view of the impossibility of showing all of the paintings all of the time, it is customary to change the selection frequently, except in the case of great masterpieces. . . . "Washington Crossing the Delaware" cannot be classified as a masterpiece, nor is it an accurate historical record. Nevertheless, we believe that it is both fitting and desirable that this picture should be shown at the time of the Washington Bicentennial, and shown in the Metropolitan Museum of Art, because in spite of obvious defects it has great interest for many people in this country who were accustomed to seeing copies of this picture in their school books.[12]

These remarks must have been the feeling in professional circles for quite a while. When John S. Kennedy purchased the painting for the Metropolitan Museum, he paid $16,100. However the original owner, Marshall O. Roberts, paid at least $25,000 back in the 1850s for this work. The star had begun to set on the mighty enterprise.

It could be said that the Met was actually embarrassed by the work, having loaned it for a number of years to Washington Crossing State Park in New Jersey, where apparently they felt it belonged. Critical opinion continued to disparage it, as if to punish it for being too famous. An art critic for the *New York Times* called it "a corny 1851 painting by Emanuel Leutze"[13] as if to suggest that no serious art lover could ever pay it more than token appreciation.

In Germany, where the painting's reputation remained undiminished, fate struck again to the unhappy first version. The gallery in Bremen, Germany, where the painting was housed was firebombed by the American Air Force on September 5, 1942. Ironically, American planes ended up destroying the great painting that symbolized the struggle for independence. The Germans, as was their policy for most of their museums during World War II, never removed the painting from harm's way, the way the Louvre evacuated its contents.

The destruction of the German canvas now makes the Met version the only one. Still, in its profoundly dismissed state, the derided Met painting attracts fans of American history as well as people seeking to see in person what they learned about as a child. Even though the painting has been critically dismissed, it still has a popular appeal, based on the magic of the historical moment, and Leutze's not inconsiderable gifts at evoking it.

In 1936 an American lexicographer and cryptographer created a sonnet dedicated to the painting, which begins with the line "A hard, howling, tossing water scene." Most unusually, every line in the sonnet is an anagram composed of the letters in the title of the painting rearranged in a convincing way.

As a mark of the painting's continuous appeal, the U.S. Mint chose the image of Washington's crossing, ennobled by Leutze's painted version, for the reverse of the New Jersey state quarter. This was by far the first choice, beating out Washington on horseback, Thomas Edison's achievements, Barnegat Lighthouse, and such great New Jerseyans as Woodrow Wilson and Grover Cleveland.

The New Jersey quarter represents a recognition that the painted image, one conceived on the Rhine and using German models, has morphed into a full representation of an event suitable for framing in every American classroom.

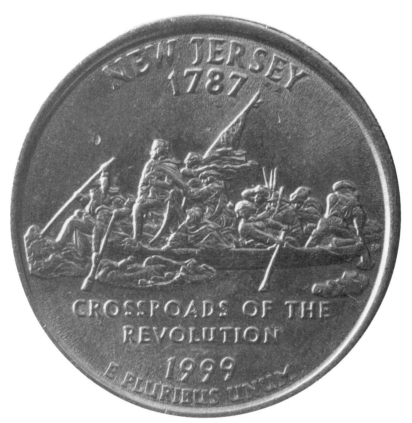

The reverse side of the New Jersey state quarter features Leutze's painting. *Pancaketom / Dreamstime*

Luncheon on the Grass by Édouard Manet

Success through Scandal

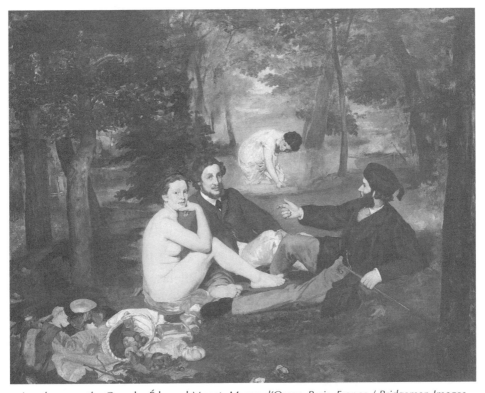

Luncheon on the Grass by Édouard Manet. *Musee d'Orsay, Paris, France / Bridgeman Images*

Manet plans to achieve celebrity by outraging the bourgeois. . . . His taste is corrupted by infatuation with the bizarre.

—Ernest Chesneau, *Manet* exhibition catalog

In 1999 a controversial exhibit opened at the Brooklyn Museum that caused such a stir that politicians vied for attention lashing out against it. The exhibition, called *Sensation: Young British Artists from the Saatchi Collection*, had a number of potentially offensive works, but the one that caused the most controversy was by Nigerian-born artist Chris Ofili called *The Holy Virgin Mary*.

This work depicts an open-mouthed Mary standing amid tiny cutouts of genitalia and buttocks from pornographic magazines. Shellacked onto the surface are clumps of elephant dung, which, according to the artist, symbolizes fertility. No one will really ever know if Ofili was doing this as an homage to Mary or to horrify his audience in order to garner his fifteen minutes of fame, but the effect was galvanizing. New York City mayor Rudolph Giuliani said, "The idea of having so-called works of art in which people are throwing elephant dung at a picture of the Virgin Mary is sick,"[1] and called the work insulting to Catholics, and no doubt many Catholics felt that way. New York senatorial candidate Hillary Clinton expressed the same view when she proclaimed, "I share the feeling that I know many New Yorkers have that there are parts of this exhibit that would be deeply offensive. . . . I would not go to see this exhibit."[2]

Supporters of Ofili were equally vociferous, especially the American Civil Liberties Union, which saw the case as a free speech issue, and the Brooklyn Museum who enjoyed the free publicity. Ofili added his thoughts to the controversy when he rather strangely declared, "Elephant dung in itself is quite a beautiful object."[3] The Brooklyn Museum, in an attempt to caution the public, mounted a warning on yellow traffic-sign stock saying, "The contents of this exhibition may cause shock, vomiting, confusion, panic, euphoria, and anxiety." More than one critic wondered aloud whether or not this was really a warning, or more likely a promise, a tease, or a suggestion.[4]

Ofili is now in all the survey books in art history as an example of attempted censorship in the arts. One suspects he could not have earned this kind of publicity any other way. The controversy over the reinterpretation of traditional images in a modern context is not limited to the modern world. Sometimes, as in the case of Ofili, controversy launches a career. History will witness whether or not Ofili is a lasting contribution to the arts, or if he will be just another someone who screamed louder just to get attention.

Not every artist thinks his work is going to cause controversy, even if they do. Such is the case of Édouard Manet, a man from a middle-class background, who defied his parents' wishes to become a lawyer and sought a career in the fine arts. No one wanted more acceptance than he from the official art world; in part, he wanted to prove to his parents that he made the right choice of occupation. All the same, no one was more ill prepared for the public rejection he was about to face.

Art in nineteenth-century Paris was a serious business. It was ruled by a discerning set of experts who had rather narrow notions of what art is and should be. These

critics dominated the powerful French Salon and had standards more defined by past achievements than by future experimentation. Paintings should have clean surfaces, with brushstrokes minimized. The finish was expected to be highly polished, and the forms softly modeled. Lofty subjects were encouraged, although portraits and land-scapes were acceptable, maybe even a genre painting once in a while could be submit-ted. Serious painting did not have subjects such as prostitutes, beggars, alcoholics, or clowns; even still lives were frowned upon. An artist was free to paint what he wanted, but the jury was free to decline any work it deemed inappropriate.

Just who was this jury and how did they get so powerful? The Salon itself was born, juryless, in 1667 during the reign of Louis XIV, and the name "Salon" came from the Salon d'Apollon in the Louvre where the show was held. At the time it was open only to the members of the Royal Academy. By 1737 the public was invited, and in 1748 a jury system was installed chiefly because the number of entrants became too large for the space allotted. The jury was composed of fourteen members, mostly government employees, since it was the sponsor of the show. The other members were medalists from prior exhibitions. Eventually the jury roster was compiled of a long and distinguished list of academic artists: Alexandre Cabanel, William-Adolphe Bouguereau, Jean-Léon Gérôme, and Jean-Louis-Ernest Meissonier, among others. These were not exactly the most liberal-thinking artists in history, holding on to a tradition that was drifting languidly out to sea. Perhaps the intended consequence of this jury was to promote academic-style painting indefinitely.

There was no doubt that despite the faults of the system, this was the place to be; the Salon was wildly popular. The 1855 Exposition Universelle des Beaux Arts attracted two thousand works by seven hundred artists. Almost a million people saw the show in the six months it was open. By 1880, seven thousand works were dis-played with half a million people crowding into the galleries in only two months. Fifty thousand people came through on Sundays, when entrance was free. For an artist, you simply had to be there; there was no place to succeed like Paris in the nineteenth century, and no place was more important than the Salon.

In that world, Manet had rather conventional ambitions. He wanted to be ac-cepted by the Salon, and win awards to ensure its blessings. He did not indulge in novel compositions, and saw his paintings as modern reworkings of old masters. This, he figured, would bring him recognition.

Hundreds of artists honed their craft and couldn't wait for official approval. In 1863 no fewer than five thousand paintings were submitted for acceptance to the Salon. The number was too huge to be accommodated in the space allotted, so the jury had the troubling task of winnowing out the poorer entrants. Besides, a dis-criminating jury should be allowed to eliminate some poorly executed works. When the dust settled, 2,783 works were rejected, and a considerable number of artistic reputations were bruised.

One of the results of the jury's decision was the huge number of enemies they created, many of whom vociferously appealed to Emperor Napoleon III to do some-thing about this perceived discrimination. The artistic honor of France was at stake!

Manet tried to influence the outcome ahead of time by having his first one-man show at a gallery owned by his friend Louis Martinet before the Salon jury was to

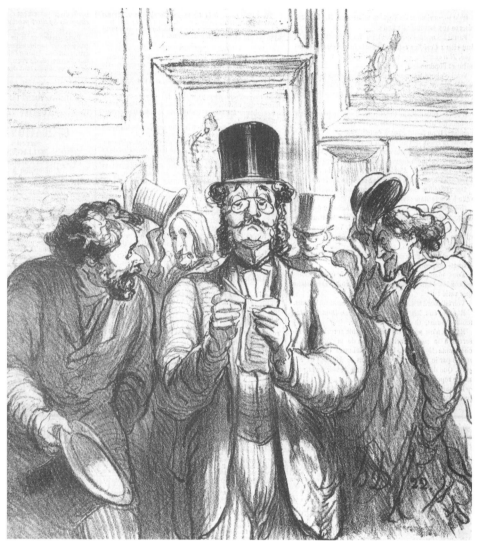

Honoré Daumier's print of *Art Experts* parodies the critics at the French Salon. *Image copyright © The Metropolitan Museum of Art. Image source Art Resource, NY*

meet. Encouraging reviews could stimulate interest in his work. Unfortunately, the plan was transparent and soon backfired; interest was tepid and reviews undistinguished. Perhaps for that reason, or maybe for reasons of its own, the jury declined Manet's three entrants to the Salon.

The three paintings in question were *Young Man in a Costume of a Majo*, now at the Metropolitan Museum in New York, *Mademoiselle V. . . in the Costume of an Espada*, also at the Metropolitan, and a painting at that time called *Le bain*. The latter became known as *Déjeuner sur l'herbe*, or in English *Luncheon on the Grass*, and was the center of one of the most electric moments in the history of Western art.

Napoleon III decided that the artists whose works were rejected could be given a second opportunity by having an alternate venue, in fact, across the hall from the official Salon, in a place nicknamed the Salon of the Rejected. Artists who wanted to contribute would be given their due before the public, even if the label of rejected seemed to hang over their works. If they withdrew their works, were they tacitly admitting that their paintings were indeed inferior? This was the only time in Salon history that an anti-Salon was sanctioned by the French government; attempts to revive the practice later met with dismissal.

Some twelve hundred artists exhibited at the Salon of the Rejected, including names we now see as pillars of nineteenth-century art: James Whistler, Paul Cézanne, Camille Pissarro, and of course Manet. Part of the problem with this arrangement was that since there was no jury selection, some of the works were indeed bad, in fact, very bad, and deserved to be banned. Many were incompetent, poorly executed, or just plain crude. Hanging your work amid this crowd was risky business; you ran the risk of guilt by association.

Official accounts in the newspapers ignored the Salon of the Rejected, whereas the government Salon garnered the attention, with long accounts of the winners' accomplishments. Meanwhile, Manet's three entrants stood among the crowd of hapless paintings, before huge crowds who came to mock. Seven thousand people showed up on the first day alone, with only a turnstile to separate the two venues. Manet's painting had to be hung high on the walls to prevent jeering onlookers from throwing things at it.

Luncheon on the Grass offers four figures. The seated woman is Manet's favorite model, Victorine Meurent; on the right is Eugène Manet, the artist's brother; and on the left Ferdinand Leenhoff, a sculptor, who was a friend of Manet's and later that year was to be his brother-in-law. Manet's marriage to Suzanne Leenhoff took place in October 1863. The figure in the distance was never properly identified.

The figures are gathered rather casually in a park, perhaps just finishing lunch and having some light conversation. The public found this topic shocking, not for its subject but because the figure of the woman in the foreground was nude surrounded by fully dressed gentlemen companions. There was no sense that this nudity had symbolic overtones and carried a higher meaning. If anything, with the contemporarily dressed men in the foreground there can be no doubt that this was not a myth and certainly not a religious painting.

Some sources allege that Napoleon III came to see for himself. He paused significantly before the *Luncheon* and then turned away, without expressing a word, but gesturing his disapproval. In his role as ruler of the French state, he had the duty to enforce morality in his empire, and this work was distinctly, according to him, amoral.

If the story is true, no one could have done more damage to Manet's career than the emperor himself. Such a dismissal meant that people could rely on the jury's opinion, that Manet's painting was indecent, at best, and that these progressive artists knew little about the true function of art in the modern world, whatever that was.

The only comfort Manet could take at this moment was the truth that many had grown very opposed to the Salon system of exhibiting new works of art. Already

alternative venues, for example, art galleries, were starting to pop up in various places around Europe. Here a client could be at one with a limited number of works and only a docent to guide and support him or her. Manet's world was the Salon, an artistic catch basin where everything is thrown onto walls in such a crowded way that the color of the wall is rendered unreadable, and the works vie for attention with one another. Manet experienced, in a cruel way, the sharp undertow of Salon criticism, which pulled down any experimental artist.

~

One of Manet's earliest supporters was the writer Emile Zola. Already a budding realist novelist, Zola had gathered attention in literary circles for his groundbreaking prose and his perceptive art criticism. On May 7, 1866, Zola wrote:

> I am so sure that Manet will be one of the masters of tomorrow that I should believe I had made a good bargain, had I the money in buying all his canvases today. In fifty years they will sell for fifteen or twenty times more, and then certain forty-thousand-franc paintings won't be worth forty francs. It is not even necessary to have very much intelligence to prophesy such things.[5]

But Zola was almost alone. Besides, he was a radical writer who composed novels about those sordid lower-class types. Of course, some reasoned, he would be sympathetic to Manet, who painted just the same types in *Luncheon on the Grass.*

The criticism was vicious. Even the artist Jean Charles Cazin, himself an exhibitor in the Salon of the Rejected, noted: "As at Madame Tussaud's in London, one passed into the Chamber of Horrors. People expected to have a good laugh, and laugh they did, as they got through the door. Manet, in the farthest hall, went right through the wall with his *Déjeuner sur l'herbe*."[6]

No one wants to be subject to such ridicule. One critic commented: "A common breda [low prostitute], stark naked at that, lounges brazenly between two warders properly draped and cravatted . . . these two seem like students on a holiday, misbehaving to prove themselves men; and I seek in vain for the meaning of this uncouth riddle."[7]

Perhaps the most hurtful remarks came from Théophile Thoré, who was the most sensitive critic of the period, and a personal friend of Charles Baudelaire, the great French writer:

> The *Bath* is very daring. . . . The nude hasn't a good figure, unfortunately, and one can't think of anything uglier than the man stretched out next to her, who hasn't even thought of taking off out of doors, his horrid padded cap. It is the contrast of a creature so inappropriate in a pastoral scene with this undraped bather that is shocking. I can't imagine what made an artist of intelligence and refinement select such an absurd composition, which elegant and charming characters might perhaps have justified. But there are qualities of color and light in the landscape, and even very convincing bits of modeling in the woman's body.[8]

In the highly politicized world of nineteenth-century French art, critics were everything. A good review in the right place was essential to the future of any artist.

Association with the wrong type of writers meant that you were cast in with that lot, the way Manet was cast in with the Salon of the Rejected.

It did Manet no good to maintain that his composition was based on an engraving by Marcantonio Raimondi, a follower of Raphael. Nor did it matter that a similar painting by the Venetian master Giorgione (or Titian) is in the Louvre. In this work, called the *Pastoral Concert*, there are two nude women contrasted with two clothed men. As in the *Luncheon* the clothed men in contemporary dress are looking at one another and not at the nude women. But even though the Louvre's collection was known to every educated Parisian, few seemed to care about the comparison, and instead, if they thought about the Giorgione at all, may have surmised that Manet was parodying him.

It also did no good to console Manet with the fact that many great artists had caused scandals with their paintings; Manet's problems, seen in that light, are almost routine. Caravaggio spent his entire career bucking one authority figure after another; several of his paintings were removed from their original settings and he was told to do them over again—usually with unfortunate results. Even Michelangelo faced withering criticism of some of his greatest works, including his *David* and the Sistine Chapel ceiling. The irascible Michelangelo withstood the critics' taunts. It is he we remember, and not what some critic may have said about his work.

No one is immune, but some handle it better than others. For Manet, criticism stung and hurt, and the situation was about to get worse. He was now considered a bohemian, a radical, and a revolutionary. Zola's attempts to paint him as an intellectual proved futile, as the artist struggled to find his own identity.

Manet's state of affairs collapsed two years later, when his *Olympia* was exhibited. Even though the painting was a quotation from Titian's *Venus of Urbino*, it was viciously criticized. Again he used his favorite model Victorine Meurent, but this time in a more exposed position: nearly frontally nude. Meurent was eighteen when Manet posed her in *Luncheon on the Grass* and only twenty when he used her again in the *Olympia*. Such a young girl exposed in such an open way to all society was sure to cause a scandal of huge proportions. Naming the composition *Olympia* only fanned the fire, because that name was associated with prostitutes, leaving no doubt what Manet was intending.

It is not that the French in the nineteenth century had no idea what prostitution was, or that Frenchmen of a certain class were expected to be interested in extramarital affairs. In contemporary literature, the courtesan or the lorette was given pride of place, even described in affectionate and sympathetic terms. Victor Hugo and Honoré de Balzac both wrote novels in which prominent figures were women prostitutes, and in almost all cases the writer draws on the reader's empathy to understand the conditions these women worked under, and how they came to be that way. Alexandre Dumas's *The Lady of the Camellias* charts the progress of a courtesan who sacrifices herself for her lover's welfare; the play was immortalized by Giuseppe Verdi in his 1853 opera *La traviata*.

However, it is one thing to read a play or see an opera about the life of a courtesan; it is another to look at a painted image of one. The book can be put down, and the opera is over in three hours, but the painting hangs on your wall constantly staring at

you. What Manet had painted was the physical representation of prominent figures in French literature and life, prominent figures who were socially unacceptable in polite society. Like many courtesans, Victorine Meurent is an unabashed and unashamed individual who looks out unflinching at the public. Could part of the shame of *Luncheon* be the fact that the courtesan has been removed from her private salon and is now on display in the open with young men, and that she is completely comfortable with her nudity? Is her lack of appropriate femininity stressed by her direct and confrontational stare? Is she offensive because such women should know their place?

Like most models in the nineteenth century, Victorine Meurent was poor and working class and had aspirations for a better life. The petite redhead hoped to become an artist herself, and knew that Manet could certainly help her advance her career—if he chose.

The two got along very well, provided Meurent knew that she was a model and did not try to reach for more than her station would allow. Manet, with aristocratic airs, understood the world in a different way than his models did, and objected to her rise as a lowly individual. It is not known if the two had an affair, but Manet was legendary for his liaisons, as any respectable Frenchman of his time would be. We do know that Manet died prematurely of syphilis at fifty-one, and Meurent lived to the ripe old age of eighty-three, so perhaps their relationship was purely professional.

Meurent did achieve success in her own right, and became an artist of unacknowledged accomplishment. Her *Self-Portrait* was accepted at the 1876 Salon, a Salon that Manet was again rejected from. Moreover, in 1879 her painting entitled *The Bourgeoisie of Nuremberg in the 16th Century* was accepted at a show in the Academy of Fine Arts, but so was a painting by Manet, and they both hung in the same room. This was too much for Manet, and they never spoke again.

Because Meurent had posed in paintings with no "higher meaning," she was never taken seriously by the public and her works were buried in apparent obscurity. Today it is hard to find many paintings firmly ascribed to her. In 2008 a museum in Colombes, France, purchased a Meurent painting, *Palm Sunday*, a dazzling work by a talented artist. Unfortunately her reputation held her hostage as the person who at eighteen posed for that notorious *Luncheon* painting by Manet.

In an attempt to gain some kind of popular acclaim, Manet arranged a temporary exhibition of his works in 1867. Featured again was *Luncheon on the Grass*, and again things did not work out well. The exhibition was not a popular success, and the critics were mixed at best. Visitors were few, and only came to gawk. You would have to be a most committed artist to have the energy to go on after this.

All was not so bleak, however. Manet did receive a medal at the Salon of 1881, but his life was nearly over by that point. When a posthumous exhibit was organized in 1884, it was to settle his considerable debts, not to honor a hitherto disregarded master. The Louvre purchased nothing. No museum was to accept a painting by him until after

his death, and even then it was in faraway New York, where the Metropolitan accepted the gift of *Boy with a Sword* and *Young Lady in 1866 (Woman with a Parrot)* six years after Manet's passing in 1889. Those Americans, what could they know? Erwin Davis, a New York collector, donated the paintings because he could not sell them.

As for *Luncheon on the Grass*, it remained in Manet's collection until 1878 when it was purchased by the opera singer Jules Faure for 2,600 francs. While that may have seemed like a good price at the time, it pales in comparison to the asking price, made back in 1871, when Manet wanted twenty-five thousand francs.

Photographs of *Luncheon on the Grass* began to circulate, and up-and-coming impressionist artists began to see the value of this work; moreover, they saw it as a groundbreaking moment in the history of art. Although at the beginning, impressionists were not taken seriously either, their day was shortly to come, and they began dragging Manet with them. His last few works, including his late masterpiece, *A Bar at the Folies-Bergère*, is a tour de force of the impressionist style.

Claude Monet, Paul Cézanne, and Paul Gauguin all did various homages to *Luncheon on the Grass* in their own way. Much later, in the 1950s and 1960s Pablo Picasso did 150 drawings, twenty-seven paintings, eighteen cardboard studies, and five concrete sculptures based on the work.[9]

Faure owned the painting for twenty years before releasing it to the dealer Durand-Ruel who bought it for twenty thousand francs. It was lent to the Exposition Universelle in 1900 where it was finally recognized as the great painting it is.

Etienne Moreau-Nélaton bought the work and donated it to the national collections of France, among a number of paintings by Camille Corot, Eugène Delacroix, Alfred Sisley, and Claude Monet. It was displayed at the Museum of Decorative Arts in 1907, and then entered the Louvre in 1934. It was transferred with the other realist paintings to the Jeu de Paume in 1947, and then into the Musée d'Orsay in 1986, when that building opened. Despite the fact that there have been a number of owners, the painting itself has only left Paris twice, for shows in London and New York.

The artistic community had rallied around the work and created buzz for it. However, the negative impact that the paintings first received has been used as a tool to prove that Manet was, as the saying goes, ahead of his time, or just as conventionally, a misunderstood genius.

Manet achieved what was called a *succes de scandale*. The greater the rejection, the more lionized he became among the avant-garde. Evenings in Paris could find Manet holding court in local cafes in the Batignolles district, the unofficial leader of a group of serious artists who became the who's who of impressionism: Pierre Auguste Renoir, Claude Monet, Edgar Degas, Alfred Sisley, and Paul Cézanne.

As purveyors of a new groundbreaking movement in art history, one that was rejected unceremoniously by the public and the Salon, the impressionists saw Manet as their spiritual father, one who faced public humiliation again and again.

The impressionist attempts to martyr Manet for their cause worked so well that what was begun as Manet's public disfavor and ridicule became a blackballing condemnation. Actually, there were some positive critics in Manet's lifetime, certainly enough to give the artist comfort and reason to go on; otherwise, why would he continue to try to gain acceptance at the Salon?

By 1910 the attack on established art criticism was in high gear; by this time the fauves and the cubists had already shocked the art world in a way that Manet could not envision. Still, his friend Théodore Duret, writing well after Manet's death, had begun to lionize the painter's art from the safety of historical perspective. In his landmark book *Manet and the Impressionists* he solidified Manet's accomplishments at the expense of art critics of the time, who are depicted as having imaginations dipped in formaldehyde and statically archived. Duret perhaps forgot that he was critical of Manet when the Salon of the Rejected was new:

> This painting, moreover, provided an unceasing source of amusement. It became in its way the most celebrated picture of the two Salons. It gave the artist an extraordinary notoriety. Manet became suddenly the painter who was most talked of in Paris. He had believed that this canvas would bring him fame, in that it had succeeded, even more than he had dared to hope; his name was in everybody's mouth. But the kind of reputation which he had won was not exactly that which he had wished. . . . What he achieved was the reputation of a rebel and an eccentric. He was considered to be beyond the pale.
>
> Thus was established between himself and the public a complete alienation, an unending feud, which was to be continued throughout the whole of his life.[10]

Duret perhaps did not know it, but he was helping to cement the image that everyone reviled Manet and that he stood alone in a vast storm of protest. Even if we now can soften this depiction, it has to be recognized that *Luncheon on the Grass* did form Manet's reputation, and did move modern art away from the academic tradition and create a new artistic world order.

And his fellow artists never forgot his achievements. Cézanne, in particular, resented the treatment Manet received at the hands of the Salon, and looked up to him as a symbol of liberation.[11] Later in life, he mused triumphantly over Manet's "kick in the arse . . . given to the Institute." Certainly this is a sign that Manet had freed painting of the rules and regulations of a bygone era, and made it possible for artists like himself to thrive. Zola noted that the reaction at the Salon was galvanizing to Cézanne: "The warlike atmosphere put new life into . . . [Cézanne] and roused him to such anger that he listened to the swelling laughter of the crowd with a look on his face as defiant as if he were listening to the whistle of bullets."[12]

Later artists who sought to present their challenging works and were confronted with official sneers and public rebuke had only to look at Manet's *Luncheon on the Grass* to understand how difficult the road to success could be, and how great the rewards. Still, scandal can be an assured way to make one's way in an art world that is susceptible to shock, perhaps even encourages it. When the famous *Armory Show* of 1913 opened in New York City, the American public confronted cubist painting for the first time, and the effect was electrifying. The prime feature was Marcel Duchamp's *Nude Descending a Staircase No. 2*, a painting that was savaged in the New York press, but has turned out to be a landmark in modern art.

Sometimes, as we have seen, the rebuke becomes a reason to celebrate, and the work passes from experiment into legend. As for Ofili, and his *The Holy Virgin Mary*, the jury is still out.

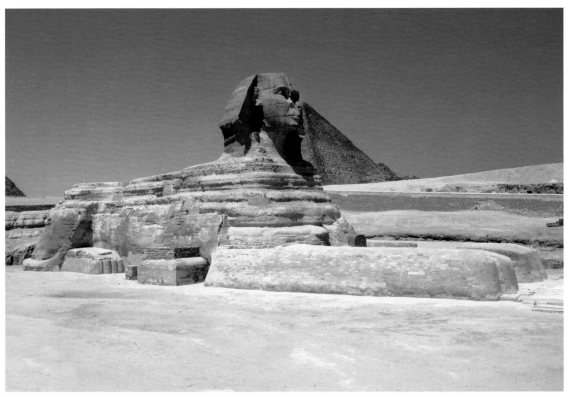

The Great Sphinx. *Pavle Marjanovic / Dreamstime*

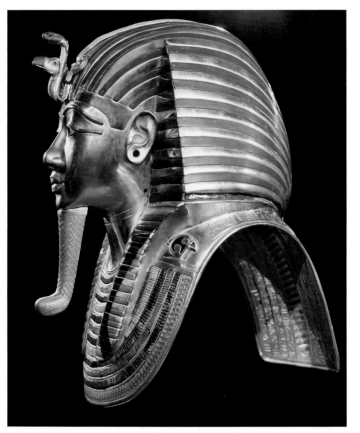

The golden mask of King Tutankhamun.
Neil Harrison / Dreamstime

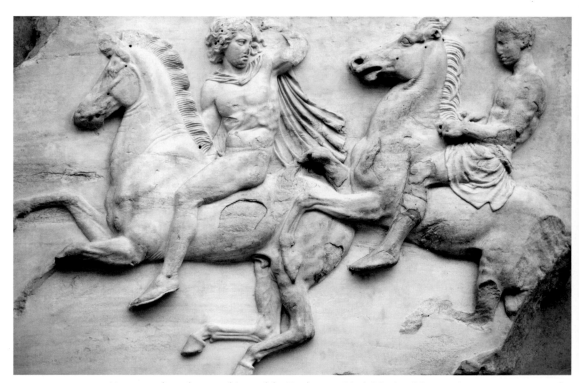

Horsemen from the west frieze of the Parthenon. *Mark Higgins / Dreamstime*

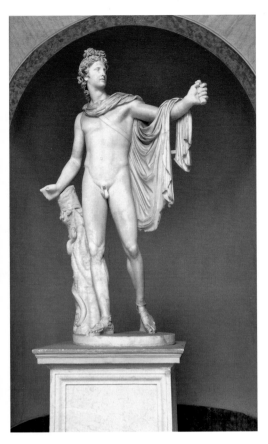

Apollo Belvedere. Valentyna Merzhyievska / Dreamstime

Nike of Samothrace. Toriru / Dreamstime

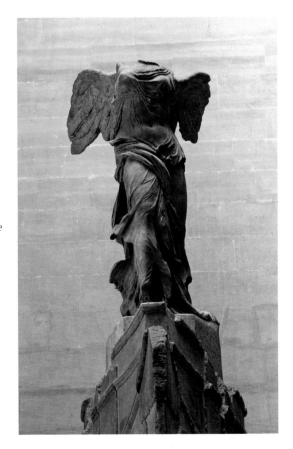

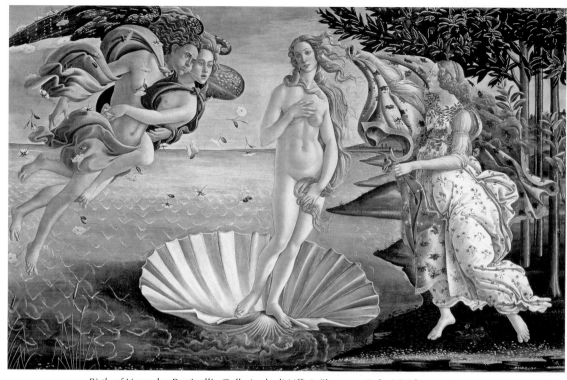

Birth of Venus by Botticelli. *Galleria degli Uffizi, Florence, Italy / Bridgeman Images*

Mona Lisa by Leonardo da Vinci. *Louvre, Paris, France / Bridgeman Images*

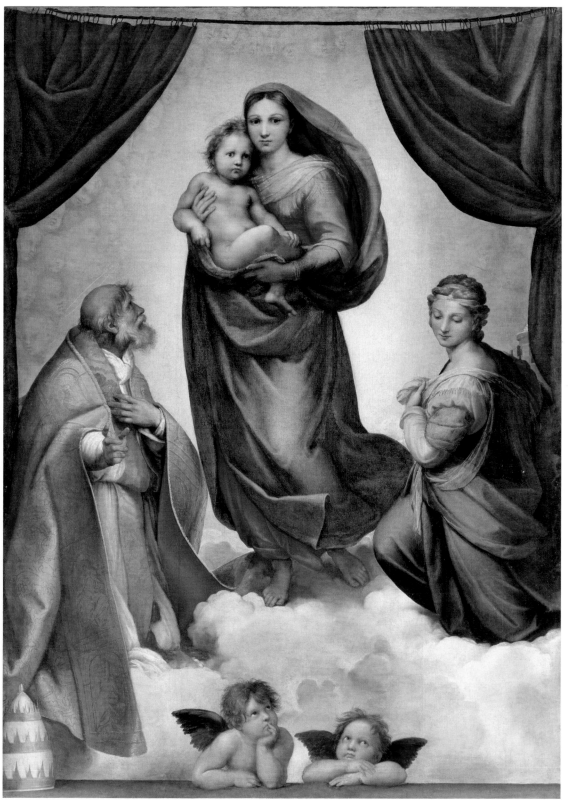

Sistine Madonna by Raphael. *Gemaeldegalerie Alte Meister, Dresden, Germany © Staatliche Kunstsammlungen Dresden / Bridgeman Images*

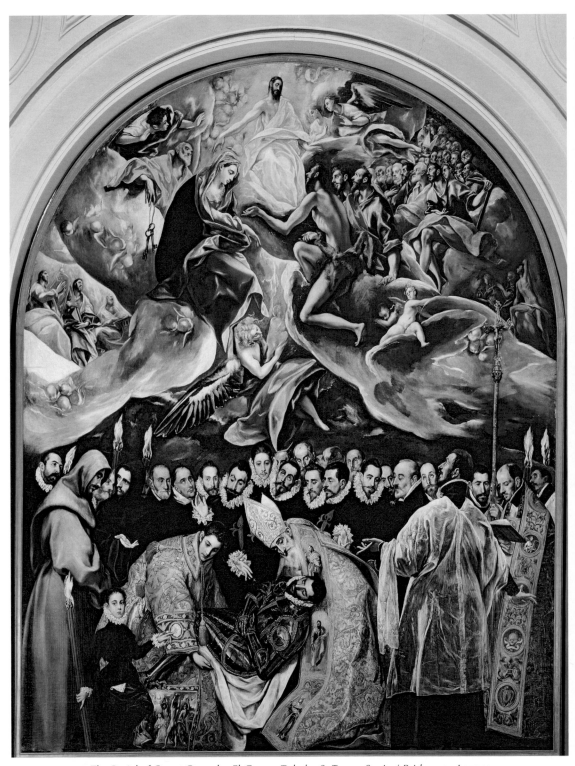

The Burial of Count Orgaz by El Greco. *Toledo, S. Tome, Spain / Bridgeman Images*

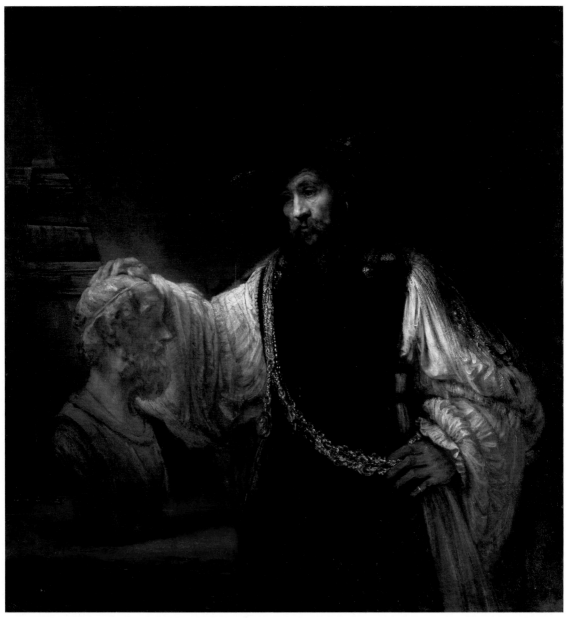

Aristotle Contemplating a Bust of Homer by Rembrandt. *Metropolitan Museum of Art, New York, USA / Bridgeman Images*

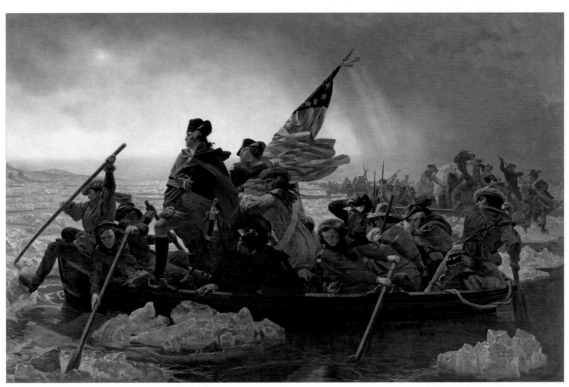

Washington Crossing the Delaware by Emanuel Leutze. *Metropolitan Museum of Art, New York, USA / Bridgeman Images*

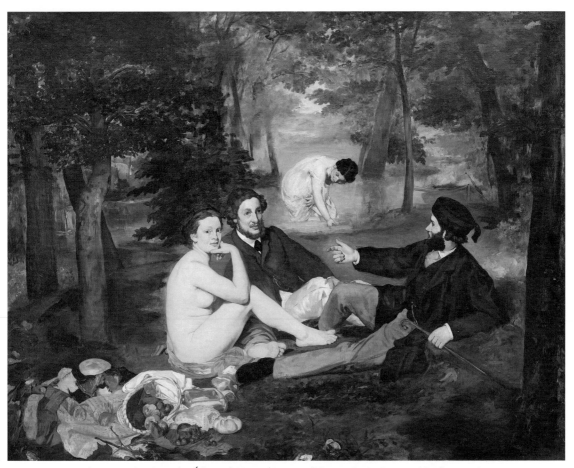

Luncheon on the Grass by Édouard Manet. *Musee d'Orsay, Paris, France / Bridgeman Images*

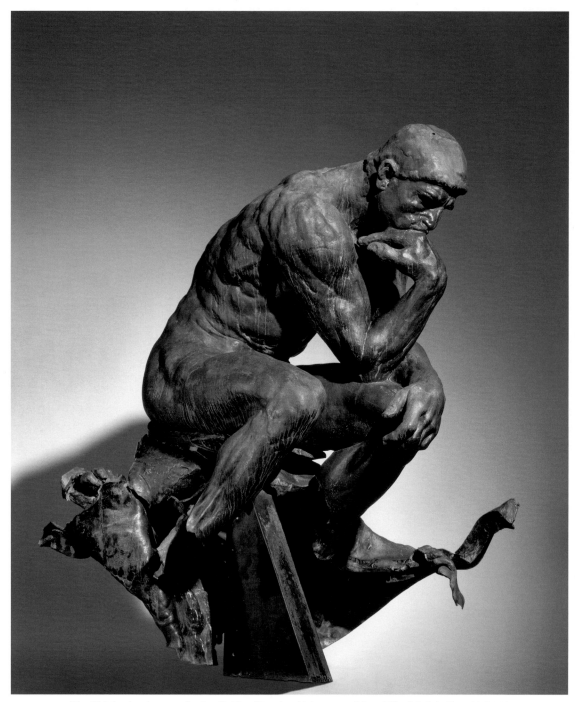

The Thinker by Auguste Rodin. © *The Cleveland Museum of Art. Gift of Ralph King 1917.42*

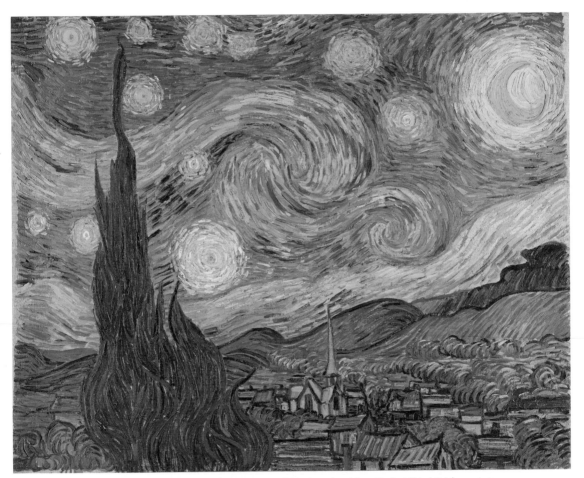

Starry Night by Vincent van Gogh. *Museum of Modern Art, New York, USA / Bridgeman Images*

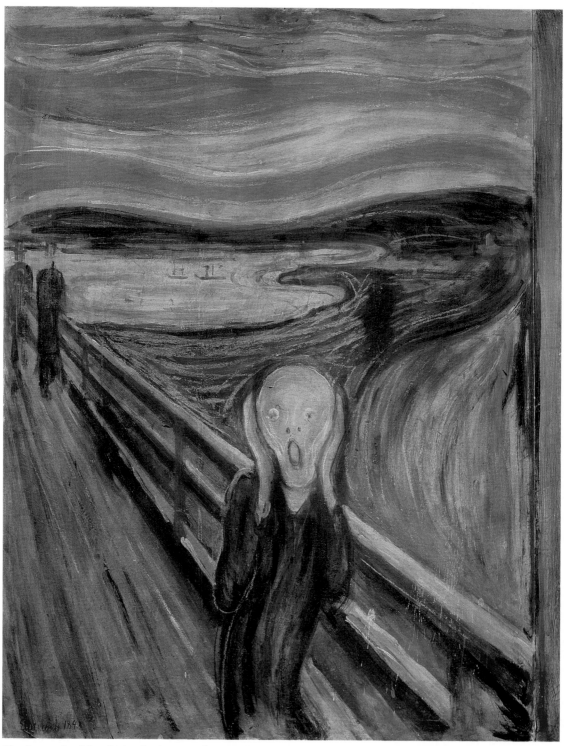

The Scream by Edvard Munch. © 2014 The Munch Museum / The Munch-Ellingsen Group / Artists Rights Society (ARS), NY; Nasjonalgalleriet, Oslo, Norway / Bridgeman Images

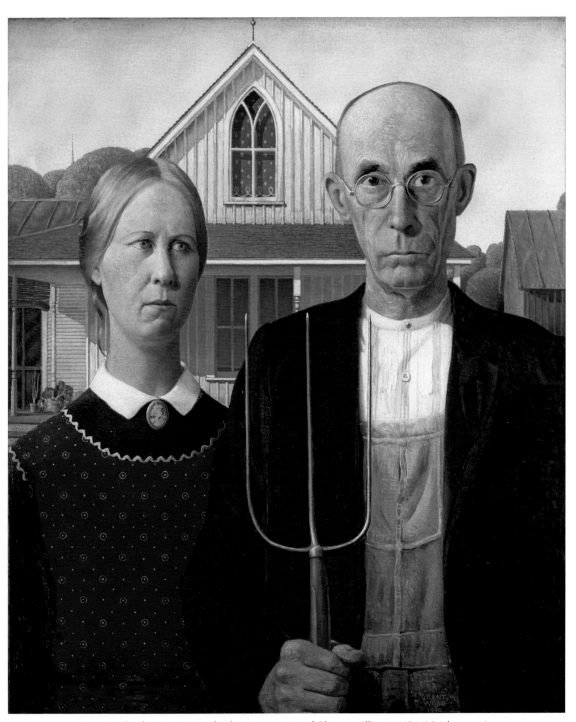

American Gothic by Grant Wood. *The Art Institute of Chicago, Illinois, USA / Bridgeman Images*

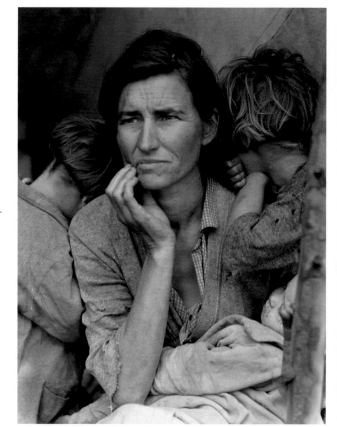

Migrant Mother by Dorothea Lange.
Library of Congress

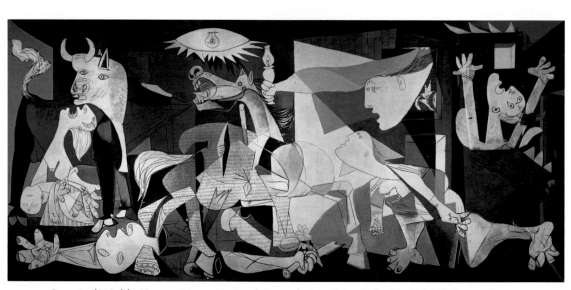

Guernica by Pablo Picasso. *Museo Nacional Cento de Arte Reina Sofia, Madrid / Bridgeman Images*

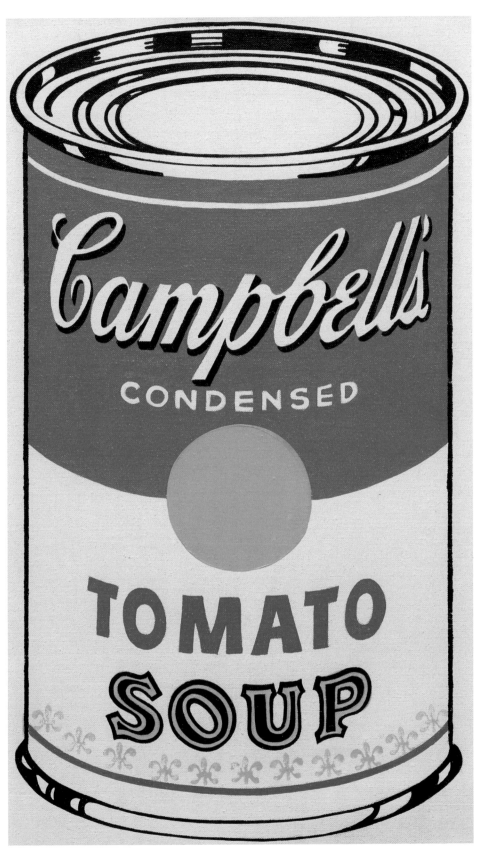

Campbell's Soup by Andy Warhol. © 2014 The Andy Warhol Foundation for the Visual Arts, Inc. / Artists Rights Society (ARS), New York; Private Collection Photo © Christie's / Bridgeman Images

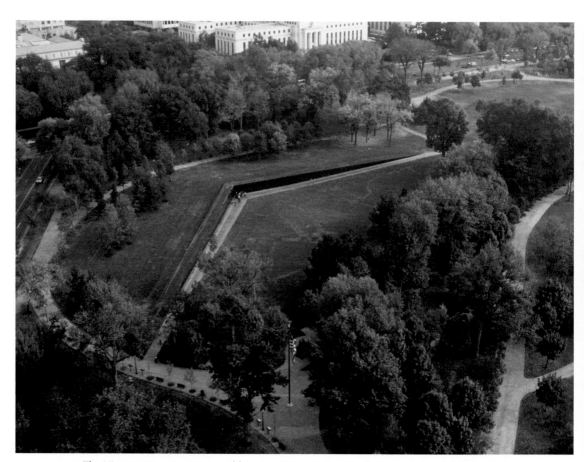
The Vietnam Veterans Memorial by Maya Lin. © *Maya Lin Studio, courtesy Pace Gallery*

The Thinker by Auguste Rodin

Fame Has Its Consequences

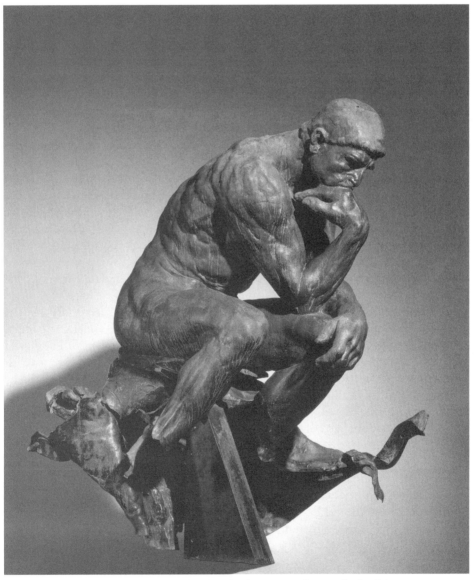

The Thinker by Auguste Rodin. © *The Cleveland Museum of Art. Gift of Ralph King 1917.42*

You are familiar with Rodin's statue of "The Thinker," the muscular chap sitting on a rock with his chin in his hand and his elbow on his knee thinking. Last week somebody planted a lead pipe bomb under that statue and toppled it over on the museum's steps. There had been half a dozen bigger blasts in the preceding 12 days, but the utter senselessness of this one was most significant and the fact that they bombed "The Thinker" most symbolic.

—Paul Harvey

*I*n 1991 a deranged man entered the Accademia Museum in Florence with a concealed hammer and attacked Michelangelo's great *David*, knocking off one of his toes, before being subdued. He later claimed that the spirit of Veronese's model, Nani, told him to do it.

In 1972 a Hungarian geologist entered Saint Peter's in Rome with a hammer, intent on destroying Michelangelo's *Pietà*. With a few well-placed strokes he knocked off the Virgin's arm and smashed her face. He screamed, "I am Jesus Christ—risen from the dead!"

Rembrandt's *Night Watch* has been repeatedly attacked, most famously in 1975 by an unemployed Dutch schoolteacher who slashed the painting twelve times with a bread knife stolen from a local hotel room. He called out during the massacre, "I have been sent by the Lord! I have been forced to do this by forces out of this Earth!"

It comes as no surprise, then, that *The Thinker* has also been a target. The more famous the work of art, the greater the need to protect it from those who would use its celebrity to make themselves famous. This time it was a political organization, the Weather Underground, who set their sights on Cleveland's most famous outdoor sculpture, one from the very workshop of Rodin himself, and the pride and joy of civic leaders who ensconced the bronze before the Cleveland Museum entrance. The weapon was dynamite; the goal was its obliteration.

Why would one want to attack *The Thinker*? What was it about *The Thinker* that they so deeply despised? Did they see it as a symbol of the American cultural establishment? What associations has the work gathered independent of its original placement and meaning? The Weather Underground, the poster child for anarchist organizations of the 1960s, must have thought that their cause would be advanced by blowing up a famous sculpture. Even so, Rodin made so many versions of *The Thinker* that destroying this *Thinker* would not erase the image for posterity.

Perhaps the casual viewer in Cleveland could be forgiven for presuming that this *Thinker* was *The Thinker* if he or she didn't know that Rodin created multiple originals of his works. But can the Cleveland Museum, as well as its sister institutions in Russia, Germany, Denmark, France, Japan, and Sweden all possess the original? And what of the versions that exist in places like the middle of the Plaza del Congreso in Buenos Aires or inside the lobby of the Columbia Savings and Loan in Denver? Are they originals? The answer is an unequivocal yes and no at the same time.

The Thinker has its origins deep inside the great intellectuals of human history: chief among them the medieval poet Dante. It was his *Divine Comedy* that inspired so many

nineteenth-century artists like Eugène Delacroix or Dante Gabriel Rossetti to achieve their greatest work. Painters were fascinated by the short but intense episodes from the *Inferno* that illustrated human failings so personally and so passionately.

The turmoil of Dante's poetic vision haunted artists principally because its tightly written episodes can be captured in a single painting or sculpture. Unlike Shakespeare, whose sprawling dramas span oceans of time and great distances, Dante's characters are deftly drawn in only a few lines of immortal poetry, making them fertile ground for the graphic arts.

Rodin also fell under the spell of another great genius of Italian thought, Michelangelo, during a trip to Italy in 1875. From him he acquired a taste for heroic nude bodies in oversized proportions. He also saw Michelangelo's figures as possessing great emotional drama, even if they do so with a quiet, but passionate, intensity. Michelangelo produced thinking figures as well who intensely struggle with their thoughts, like the sculpture of Lorenzo de'Medici in the Church of San Lorenzo in Florence or the figure of Jeremiah on the Sistine Chapel ceiling.

Rodin's Italian sojourn prepared him for the monumental commissions he was about to receive. The turning point came in 1880 when he was asked to erect a set of doors to decorate the entrance to a newly contemplated Museum of Decorative Arts in Paris. Hitherto Rodin was a relatively unknown artist employed mostly by sculptors who fashioned ornaments rather than created large-scale sculptures. Most recently, he had been involved in a particularly difficult partnership with a Belgian sculptor named Van Rasburgh, in which he was forced to have his name withheld from any work he produced in his colleague's atelier.[1] By 1880 Rodin achieved only modest publicity for his *Age of Bronze*, which was reviled by the press, and then dismissed. This made the choice of Rodin for the Museum of Decorative Arts particularly unusual, and perhaps was a testament to how powerful Rodin's friends were. He proved his supporters right: after he completed *The Gates of Hell* and *The Thinker*, Rodin would become a household name and the most influential sculptor of his time.

The project had huge historical associations for Rodin, because doors have been plum assignments for artists throughout history. In the ancient world doors were ornamented with huge flanking sculptures of mythological beasts to guard chambers against evil spirits. In the Middle Ages, stone sculptures were placed in doorjambs and above entrance portals to remind the religious of their sacred obligations. In the Renaissance doors were carved in bronze in prominent civic locations to announce the largesse of guilds or dukes.

No doubt the first work to spring to Rodin's mind was the most famous set of bronze doors ever carved: Lorenzo Ghiberti's *Gates of Paradise* located on the baptistery of Florence Cathedral. These doors took twenty years for Ghiberti to complete as he carefully orchestrated some of the most famous scenes from the Old Testament into a coherent artistic program.

Ghiberti organized a series of episodes firmly bordered by rectangular spaces giving order to figures standing in a world dominated by the rules of linear perspective and foreshortening. His accomplishment was so amazing that Michelangelo would later say that Ghiberti's doors "are so beautiful that they would do well for the gates of Paradise."[2]

Rodin's gates could not be more different, transforming the Renaissance doors into a broiling modern setting that suggests a world turned upside down by emotional turmoil. Instead of the *Gates of Paradise*, Rodin conceived a set of doors turbulently introducing the viewer to Dante's gates of hell. While Rodin had not literally translated the *Inferno* onto his doors, he had been inspired by the inscription Dante placed over hell, which reads, "Abandon all hope, you who enter here."

It has been suggested that Rodin was influenced by the political fallout caused by France's defeat at the hands of the Germans in the Franco-Prussian War in 1871. The French tried to put a good face on it, but there was no denying its unsettling impact on the national consciousness, especially since it only took only six weeks for the Prussians to capture Napoleon III and the entire French army. Later, Rodin's *Burghers of Calais* would make reference to this contemporary event even though the work itself was set in the Middle Ages. Thus, with political turmoil as a historical context, with Michelangelo for inspiration, with Dante as the text, and with Ghiberti as the precedent, Rodin began work on his doors.

No Renaissance-inspired fixed geometric structure could encapsulate the emotions of Rodin's work. He turned his doors into a swirling composition of free-flowing figures gliding up through the door frames and seemingly reaching out into our own space. Rodin remained fixated on the work for the rest of his life, even when it became clear that the Museum of Decorative Arts was never going to be built, and the doors would lead nowhere.

Inside this maelstrom, Rodin felt the work needed focus and direction, something unifying the swirling tour de force. The twisting shapes and patterns may soar through the spaces of the doors, but they do not leave the eyes to settle on just one spot. Thus, Rodin placed above the doors in the center of the lintel one figure, looking down on the tumult. It is *The Thinker*, perhaps Dante himself, contemplating the mess humans have routinely gotten themselves into.

Of course *The Thinker* does not look like Dante, that is, if we accept the traditional view of Dante's image handed down from Giotto. A generic Dante visage usually features a man in his sixties, with a great hooked nose, jutting chin, and huge skull, certainly not the image on *The Thinker*. Even if Dante did look like this sculpture, certainly he did not compose the *Divine Comedy* in the nude, nor did he sit over his work in naked contemplation. The nudity comes from Michelangelo and contains historical associations with greatness and profundity, associations that even maverick nineteenth-century artists could not deny.

When Dante died he was not buried in the Italian Church of Santa Croce in Florence, the way most great cultural icons of Italy were, like the composer Gioacchino Rossini and the astronomer Galileo. Instead, he rests in a restrained tomb on a side street in Ravenna, Italy, deliberately outcast from Florence, the city that once cast him out. Nevertheless, Santa Croce does boast a large seated sculpture of Dante in a thinking pose placed over a tomb-like monument. If Dante could not be there, at least his cenotaph could. The sculptor, Stefano Ricci, conceived of Dante as nude from the waist up, elbow upon a book, and wrapped in thought. His scowl indicates a mind dominated by unsettling thoughts as he peers down menacingly at the observers below. Set high over a sarcophagus and flanked by an allegorical sculptural grouping,

this version of Dante expresses the awesome power of his mind and his immense influence beyond his time and place. In this regard this sculpture certainly had a general influence on Rodin, even though it was done in 1830 in the neoclassical tradition, and is very conservative in execution.

In addition to the Ricci sculpture, there is no shortage of thinkers in Western art that Rodin could draw upon. Characteristically, the thinking person rests one hand in a thoughtful pose under the chin and lowers his or her eyes. In America there are a number of meditative figures wrapped in a thoughtful moment. The most famous is the Adams Memorial by Augustus Saint-Gaudens, dating from 1891. This lonely female figure, clad in antique robes, ponders the meaning of life and death with solemn dignity. How fitting that it is a grave marker for a woman who committed suicide.

When Rodin first exhibited *The Thinker* as an independent work, he called it *The Poet*, which of course implies Dante. However, in broadest terms, any emotional thinker of creative spirit is a poet. Certainly, a poetic self-portrait is implied in this figure, a figure chosen by Rodin as a monument for his own tomb.

Meanwhile *The Gates of Hell* were still wrestling around Rodin's consciousness, unable to yield a final expression, and left unfinished in his lifetime. In a sense, the spin-off figures from this work, including *The Thinker*, are the final by-products of his imagination. When *The Thinker* was exhibited on its own in 1889, it was at once part of a full composition and an autonomous work, not needing its original inspiration to function. Indeed, most people who view the sculpture today are unaware of its contemplated placement. The original work formed the inspiration, but the individual pieces could be exhibited independently.

Rodin understood that this brooding hulk, possessed of so much inner turmoil, was emblematic of the modern world. The huge rocklike outcropping that he sits on symbolizes the eternity of his quest. His great muscled back reflects sculptures of the classical age, like the *Belvedere Torso* in the Vatican.

Rodin touched on the dilemmas people face in life, across time and political boundaries, and he seems to bring that contemplation to the fore with this eternal gesture, made more complex and more intriguing by the fact that the figure's right arm rests on his left leg, in a twisted pose that creates a lively dynamic filling the composition with negative space. That space makes *The Thinker* more suitable for large-scale compositions, in which its silhouette is strikingly presented against an open sky.

Rodin had conceived a work that would look good just about anywhere: a courthouse, a government building, a university, a cemetery, or a library. Its symbolism is immediately obvious and can be applied to any situation. Its heroic nudity—although the genitalia is tastefully hidden from view—allows a placement in any grand setting. Its size makes it suitable for the center of large plazas, or placement at tops of staircases, or as a central focus in a rotunda. The universality of *The Thinker* ensured its popularity.

Nineteenth-century sculptors understood that people would want copies of famous works, and they were quick to oblige. Rodin had a massive operation, sometimes employing as many as forty assistants, who made reproductions of his works in plaster,

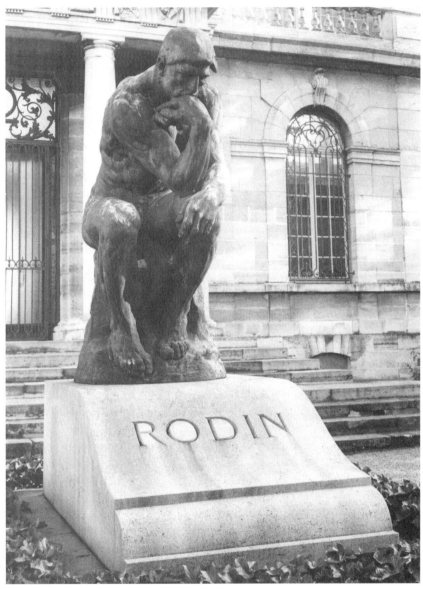

Rodin's grave with the "original" *Thinker* placed on top. *Bridgeman-Giraudon Art Resource, NY*

wax, bronze, marble, actually any medium you might like. He authorized over three hundred copies of his *Kiss* by 1917,[3] and the firm of Alexis Rudier made hundreds more both in his lifetime and well after. There are so many copies of Rodin's work that it is impossible to tell whether a given cast or marble comes from Rodin's own lifetime or after his death. In fact, there are still copies being made today, under more stringent regulation, and limited to twelve per casting. With so many Rodins authorized by the artist, let alone those done later, his images were sent everywhere, and everyone could

have one. However, familiarity and fame have its drawbacks. The more *Thinker*s produced, the less original each one seems.

Who would not want *The Thinker*? Its symbolism is easy to understand, it translates well into many media, and is equally effective as everything from a paperweight to a monumental sculpture.

In fact, when Leo Carey, an American GI stationed in France in World War II, returned home, he had a souvenir of *The Thinker*, a mere fourteen inches high, which he purchased in Paris. Not thinking anything of the statue, he used it as a doorstop in his house for twenty-five years. When he died, his heirs took the sculpture to an appraiser, who then sent it for examination to the Cleveland Museum, where it was determined to be by the artist himself, and to be worth $16,500.[4]

Once *The Thinker* became famous, Rodin began to see himself in that role. He was often photographed thinking and even rested his chin pensively on his hand and posed as if he were pondering the mysteries of the universe. Most famously, Rodin was photographed in 1902 with *The Thinker* by Edward Steichen, the great American photographer. In this famous photograph, the artist and his creation are placed facing one another in mirror poses. By this time Rodin and *The Thinker* had become one.

The public initially took to the work, and after its first exhibition a petition circulated in Paris to have it purchased and enthroned in front of the Panthéon. Removed from its original context and installed before one of Paris's greatest monuments, the sculpture took on the association of official art, because the Panthéon is the burial place of choice for France's intellectual elite. Voltaire is here, as well as Pierre and Marie Curie, and Jean-Jacques Rousseau—seemingly everyone who has contributed to French intellectual life is entombed between these walls from Louis Braille to Victor Hugo. What better work than *The Thinker* to introduce this accomplished assembly? Indeed, today *The Thinker* has been placed in city halls and corporate offices to symbolize the same thing. Thinking has universal appeal.

However, thinking turns out not to be so simple, nor so easily defined. Rodin's *The Thinker* became enmeshed in some of the most heated national debates of the time, simply by being placed where it was. It began in 1890 when the Société des Gens des Lettres decided it was time to erect a monument to one of its founders, Honoré de Balzac, one of France's greatest playwrights and novelists. It was already forty years since Balzac had died, but his influence on French culture had been enormous, compared frequently to Charles Dickens and his influence on English society. The first choice for the monument was a certain Henri Chapu, who achieved some recognition for a bust he executed of Alexandre Dumas, the author of *The Three Musketeers* and *The Count of Monte Cristo*. Chapu had died suddenly of the flu in 1891 and the commission was passed to Rodin through the influence of the president of that society, Émile Zola, who pretended to have a committee select the winner.[5]

Rodin always had a taste for the grand in his work, and he relished the thought of capturing Balzac's spirit in bronze. He struggled with the composition for a number of years, and it was not until 1898 that a model was at last produced and exhibited to the Société. The monument polarized the arts committee with those opposing the work raining abuse down on Rodin for his singular creation. The *Balzac* was not so politely rejected, and indeed was never cast in Rodin's lifetime; today it is thought to be one of his supreme masterpieces.[6]

Rodin's supporters were not about to remain quiet. Cultural matters in France are taken very seriously, because they are viewed as a part of France's identity as a nation. It is not surprising that over a hundred articles appeared in French periodicals between May and July 1898 over the fate of the sculpture.[7] While the controversy was bubbling over the *Balzac*, Rodin became more broadly entwined with another great controversy today known as the Dreyfus affair.

Alfred Dreyfus, a young French military officer, was accused of selling secrets to the Germans in November 1894, in what was to become one of the most famous scandals in the history of jurisprudence. It was later proved that he was framed by French military officers for a host of reasons, one of which was the fact that he was Jewish. Part of the scandal involved French feelings in the aftermath of the Franco-Prussian War, no doubt very sensitive to anything German.

Somehow, in the ensuing argument over Dreyfus's innocence, his defenders became Rodin's defenders in the *Balzac* cause. Perhaps as only the French could, *Balzac*'s legitimacy as a work of art and Dreyfus's innocence melded together in an explosive amalgam that characterizes French politics. For his part, Rodin did not see how his sculpture should be intertwined with Dreyfus, and in fact was openly hostile to the increasingly complex situation involving his sculpture. When pressed to take a stand, Rodin refused to sign a petition to support Dreyfus, not because the two situations had become one, but because he was privately an anti-Semite, and therefore anti-Dreyfus.[8]

When he eventually flatly and openly refused to support Dreyfus, it meant that he had to break with longtime friend Émile Zola, who had been his most staunch protector. "To many of the Dreyfusards who rallied to the support of this newest cause célèbre, Rodin's political indifference was a source of great disappointment."[9]

Even though a new military trial condemned Dreyfus in 1899, the president of France pardoned him in September of that year, and he returned to Paris after banishment at the notorious prison on Devil's Island. By 1904, when *The Thinker* was to be cast in bronze for the Panthéon, people were tired of arguing over Dreyfus, and the situation had calmed down. Even so, Dreyfus had to wait until 1906 for official recognition that he was exonerated, indeed reinstated in the army with back pay and a promotion.

By now, the subscription campaign to mount the bronze casting of *The Thinker* had support from both the Dreyfusards and the anti-Dreyfusards, each seeing things in the monument that suited their taste. *The Thinker* became a rallying point for both sides of the issue who had frankly had enough of the divisiveness that the Dreyfus affair had caused, but could not bring themselves to embrace the other side openly. Thus *The Thinker* gave Rodin the aura of peacemaker as was noted in the newspaper *La Liberté* in June 1904: "Today Rodin is an excellent worker for national reconciliation."[10]

When Zola died in 1908, his funeral cortege wound around *The Thinker* on the way into the Panthéon where a place of honor was reserved for the great writer. One of the mourners was Alfred Dreyfus, who in a bizarre turn of events was nearly assassinated, proving that the deep divisions in France were not entirely healed by the placement of a statue.

In the meantime the Panthéon *Thinker* began to take on socialist overtones, in a country known for its political parties more characterized by mini-factions than by solidarity. No sooner did socialist parties get established in France than they began to splinter and radicalize. Demonstrations and general strikes were the rule in the early twentieth century, when workers' rights were in their most nascent stage. The growing threat of militarism in World War I made for angry rallies in the university quarters in Paris. Later the fallout from the war and the excessive extravagance of the Roaring Twenties made socialism an attractive alternative to capitalism for the have-nots.

The Thinker, with its central placement at the forefront of French intellectual achievement, became a rallying point for opposition members of the government, who thought that right-minded thinkers would agree with them. In the contentious world of French politics, in which things are seen more in extremes of black and white rather than in shades of gray, *The Thinker* became a symbol for various causes and protests. Suddenly the government felt it had to be removed, pointing out, rather ironically, that its placement obscured public events from taking place.

Because Rodin's reputation had grown so formidable, his house in downtown Paris was converted to a museum two years after his death in 1917. In 1922 the Panthéon *Thinker* was delivered to the Musée Rodin where it has remained ever since.

With all the *Thinker*s around the world, it is rather strange that so many of them have traveled to distant places. The fame of this sculpture, however, is so overwhelming that many museums cannot see themselves without one, even if it is a loan, and even if a full-size version weighs one ton. In 2009 a copy from the Rodin Museum in Paris was sent to the newly opened Rodin Museum in the Palacete das Artes in Salvador de Bahia, Brazil, as part of Brazil's "Year of France" salute.[11] Stanford University sent its *Thinker* on a tour of Australia and Singapore in 2002 as a special exhibition.[12] Philadelphia has an entire museum dedicated to Rodin, with a requisite *Thinker* enshrined as a crown jewel.

In 1917 the Cleveland Museum acquired one of the original casts of *The Thinker* made by Rodin himself. Generous attention was lavished on the work, especially since the museum was only a year old when the cast was donated. At first it was displayed inside the rotunda, but the dull lighting caused the curators to rethink its placement, and shortly thereafter it was reinstalled on a pedestal near the south entrance.

Lively arguments took place about the preservation of the sculpture, now placed outdoors and subject to the intense lake-effect winters Cleveland is famous for. A few burnishings were administered from time to time to ensure some protection, but no effective measures were advanced to permanently care for the sculpture.

However, its placement before a major cultural institution in one of the country's foremost cities meant that it would attract notice. Unlike Paris, where the sculpture was removed to prevent rallies from circling around it, in Cleveland it was allowed to remain outdoors, perhaps unaware of the danger that loomed.

In the contentious atmosphere of the 1960s, radical groups formed throughout the United States, some of which declared that their object was to destroy American culture, violently if necessary. The Weather Underground, a particularly virulent strain of radicalism, proclaimed that the forceful overthrow of the American government was their ultimate goal. Institutions such as police headquarters, corporate offices, and public museums became targets.

No one used the word "terrorism" back then, but the random armed attacks on government institutions had all the markings of a modern terrorist organization. Prior to the explosion in Cleveland, there were thirty-two bombings in Seattle, and more than a hundred bombings or threats in San Francisco. An ROTC building in Albuquerque was demolished; the home of a district court judge in Denver was blown up; anything that looked like it expressed the establishment became a target. The country was on edge, which was the point of this radical ideology.

On the morning of March 24, 1970, three large sticks of dynamite were placed between the legs of the Cleveland *Thinker*; the resulting explosion was heard two miles away. The sculpture was thrown from its pedestal; pieces of the legs were found as far away as the roof of the museum. Even the bronze doors of the museum itself were dented by debris from the blast. People were horrified. One Ohio newspaper called the act "a symbol of sickness in our society." The *Cleveland Press* called it "a symbol of something wrong in our society today, violence and destruction without a purpose."[13] No arrests were ever made, and the members of the group who participated in the sabotage later relocated to New York City where they blew themselves up preparing bombs for another attack.

Cleveland was left with its *Thinker* in pieces. The museum studied treatment options, none of which fully satisfied anyone. First, they contemplated taking molds from another original *Thinker* and recasting the sculpture, thereby putting a new *Thinker* in place of the damaged work. This created an authenticity issue, because the Cleveland *Thinker* was created under Rodin's supervision, and a replacement might not have the same quality as the original.

Next, the museum considered using the molds to create casts of the damaged areas, replacing only those and mounting them onto the existing work.[14] This was even more of a challenge, because there was no guarantee that the missing pieces when recast would fit on the existing sculpture, especially since the bottom of the sculpture had been blown out. Moreover, the recasts from copies might not have the technical merits of the original. Complicating the issue was that bronze sculptures are known to shrink 5 to 10 percent over their lifetime, so refitting new pieces might be problematic.

Restorations brought up a question of color: What color should the new pieces be? Is it ethical to have the same color for the work without indicating what part of it is a restoration? Should the natural outdoor stains be preserved and be imitated on the patches? Should they create patches that are a different color than the original to indicate where the restored areas are? How would Rodin have reacted to a two-toned *Thinker*?

Even more complicating is that Rodin is known to have accepted "happy accidents" in the creation of his sculptures.[15] However, it is not known how Rodin would have reacted to an act of vandalism on one of his works.

Ultimately, the Cleveland Museum stabilized the sculpture and reerected it on its pedestal, but never fully restored it. Legless, it now stands as mute testimony to the arrogance of radicals, who believe that statements can be made by attacking inanimate, defenseless objects. No doubt the Taliban felt the same way when they blew up the gigantic one-thousand-year-old sculptures of Buddha in Afghanistan in 2001, simply because they could. Here too another irony, for Buddha is one of the most peaceful figures in history—someone who deplored violence. Nonetheless, the Buddhas are now gone, the Taliban out of power, and for that matter the Weather Underground is no more.

Then in 2007 in the Netherlands, a group of Dutch thieves, attracted by the high price of bronze on the open market, used a vehicle to smash the garden gate of the Singer Laren Museum near Amsterdam where seven Rodins are displayed, including *The Thinker*. They carried them off in the middle of the night in a crime so daring that no one noticed until morning that anything was amiss. Police asked smelters and foundries "to keep their ears and eyes open."[16] The police were right, because the fame of *The Thinker* was too high to fence on the black market, and it would probably be melted down and sold as raw material.

Fortunately the sculpture was recovered in only two days. However, it was so seriously mangled and twisted that the owners were faced with the problem the Cleveland Museum faced. The same questions as to the ethics of restoring this work were made, weighed, and considered. This time the decision was different. Under the guidance of the University of Amsterdam's Department of Conservation and Restoration in the Ateliergebouw (the Rijksmuseum's new conservation studio) in the Dutch capital, an extensive two-year restoration was completed. This restoration was dubbed "reversible" so that if art historians decide, years later, that improper techniques were used to restore the sculpture, they could be removed without harming what was left. In 2011 *The Thinker* was proudly reinstalled indoors, where one hopes it will be safer.

After these *Thinker*s were attacked, the museum community around the world began to question the wisdom of placing important sculptures outdoors. If *The Thinker* isn't safe, what great works are? Should all public sculpture be removed from their placements and directed indoors?

The other great thinker in world art, Michelangelo's *David*, was removed from the public square in Florence and into the Accademia Museum in 1873 to protect it from radicals as well as the weather. In 1527 rioters in the building behind the sculpture, the Palazzo Vecchio, threw furniture out the window and knocked the *David*'s left arm off. Although restored with the original pieces, the arm never looked the same

again. Placing the sculpture indoors has enhanced its security, but has not prevented a hammer-wielding attacker from damaging it.

There is now danger to the *David* even from below. A new high-speed rail link is being planned for Florence, and the seismic vibrations from the drilling are threatening to unbalance the great statue and topple it to the ground.[17] The Italian government must now find a way to keep the *David* safe and yet have a modern city.

Works of art have always been targeted by individuals waiting for their fifteen minutes of fame; otherwise, museums would not need guards. In 1987 a man entered the National Gallery of Art in London with a sawed-off shotgun and walked up to Leonardo da Vinci's *The Virgin and Child with Saint Anne and Saint John the Baptist.* From a distance of about seven feet he shot the delicate drawing just once, causing the protective glass to splinter into a huge six-inch gash and damage the artwork. The perpetrator told police that he wanted to express his outrage over "political, social and economic conditions in Britain."[18] This is just another statistic in the long history of violence directed at great works of art.

Fame has its consequences.

The Starry Night by Vincent van Gogh

Lost in a Starry Night

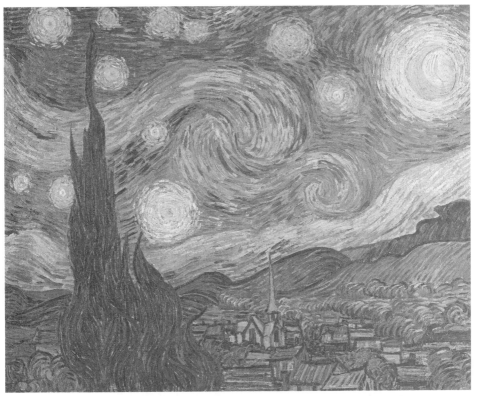

Starry Night by Vincent van Gogh. *Museum of Modern Art, New York, USA / Bridgeman Images*

At present I absolutely want to paint a starry sky. It often seems to me that night is still more richly coloured than the day; having hues of the most intense violets, blues and greens. If only you pay attention to it you will see that certain stars are lemon-yellow, others pink or a green, blue and forget-me-not brilliance.

—Vincent van Gogh, *Letter to Wilhelmina van Gogh*, 1888

*W*ounded, rejected, and hurt by the contemporary art establishment, realist painter Han van Meegeren had much to do to prove himself in an art world filled with cubist and abstract ideals. In 1932, he conceived a plot to create, or forge, old master Dutch paintings, and to burn those critics who said he could not paint.

He carefully studied the kinds of brushes and canvases the Dutch masters used and set about creating new versions of paintings they were likely to have executed. He hand-mixed his paints himself, using seventeenth-century ingredients. He ultimately produced forgeries that were a rousing success, fooling the Dutch art establishment with "newly found" Vermeers and Hals.

Van Meegeren was eventually unmasked, however, but not because his forgeries were detected in 1945. He was accused of selling the Dutch artistic patrimony to—of all people—Hermann Goering, commander in chief of the Luftwaffe. In order to escape prosecution, Van Meegeren had to admit that his Vermeers were not Vermeers, and so therefore he sold Goering fakes. Suddenly the Dutch-Nazi collaborator was transformed into a cultural hero. Thus was undone one of the most clever forgers in history.

Vermeer did so few works in his lifetime that only a limited number of forgeries could be manufactured; otherwise, the art market would get suspicious. Therefore his forgeries commanded high prices, enough for Van Meegeren to live very comfortably in one of his fifty-two houses or fifteen country homes. Not so with other great painters like Van Gogh, whose oeuvre was enormous, especially when one considers that he died at the age of thirty-seven.

One of the best ways to trace Van Gogh's rocket to fame is to chart the number of forgeries that were made after his death. Unlike Vermeer, Van Gogh's paints are easily available today and his compositions simple to reproduce.

Plus, Van Gogh executed paintings on the average of one a day, a furious output that left thousands of works in his artistic legacy. This meant that forgers could create just another Van Gogh, particularly in his fertile and highly desirable Saint-Rémy period.

In 1901, a scant eleven years after his death, two paintings of dubious authorship were removed from an exhibition at the Bernheim-Jeune Gallery in Paris, even though they came from the collection of renowned art critic Théodore Duret.

Forgeries quickly became rampant. Théodore Duret's 1916 monograph on Van Gogh had a jacket cover that boasted a drawing by Van Gogh—which turned out not to be by Van Gogh. The 1919 reworking of the text revealed that the cover and nine of the forty-four illustrations had to be changed because they were forgeries.

Worse was coming; fakes were everywhere. Jacob Baart de la Faille's 1927 catalogue raisonné of Van Gogh's works had an errata sheet appended to the text a year later that indicated three dozen of the entries might be forgeries—all of them passed

through the hands of one Otto Wacker, a German art dealer who had turned up the heat on the Van Gogh forgery business,[1] producing no fewer than thirty-three by himself. This was not all: Van Gogh forgeries were easily popping up because Van Gogh himself did not keep accurate records of his paintings, often making duplicates or simply giving away works to friends. In fact, Van Gogh forgeries still have the museum and curatorial world listing out to sea. When Jan Hulsker compiled the massive 1996 catalogue raisonné called *The New Complete Van Gogh* he admitted in the introduction that "this does not mean that all the works reproduced here should be considered authentic."[2] Van Gogh's fame has made him one of the most forged artists in history.

The ubiquity of forgeries symbolizes the craving audiences have for Van Gogh works. Museums realize what a hot property he is, and compete for exhibitions. The Museum of Modern Art in New York City held a vast Van Gogh retrospective in 1935–1936, which turned into a bona fide megahit, a hit that helped to put the newborn 1929 museum on the map.

Van Gogh must have struck a chord with the Depression-weary world of the 1930s. His struggle for survival found considerable echoes in the efforts of everyman during that era. Contemporary reports indicate that this blockbuster show traveled to ten cities and was seen by nine hundred thousand people.[3]

How did Van Gogh go from obscurity to ubiquity in such a short time? And how did *The Starry Night*, a painting unknown to the public until 1941, become his most famous work? It has come to represent not only Van Gogh's life, but his philosophy of life, his artistic output, and his relationship with others. *The Starry Night* has been asked to fill a tall order.

Scholars have used the painting as a sounding board for their themes, finding Van Gogh's philosophy of life expressed in just one canvas. One scholar alleges that the composition represents Van Gogh's loss of faith in traditional religion, a modern version of Jesus's agony in the garden.[4] Another asserts that the cypress tree traditionally has been associated with graveyards and that this painting represents Van Gogh's concept of death.[5] A third sees symbolism in "the swirling sky, the sun-bright moon, the milky way turned to comets, the exploding stars—the unique and overwhelming vision of a mystic, a man in ecstatic communion with heavenly forces."[6]

Why does this Van Gogh above all others, even his self-portraits, seem to express the artist's struggles more than any other? Part of it has to do with his early rejection as a serious painter by the art community. He has the reputation of the quintessential misunderstood artist; his inner turbulence has been seen principally through his paintings. Evidence for this interpretation has been centered on his hundreds of personal letters that have been published, criticized, examined, and dissected the way great literary works have undergone intense scrutiny. We will never know if Van Gogh would have approved of this disclosure, nor can we ever be sure that he might accept the general appellations placed on his head that he was a "madman," or a "social outcast." Many have resorted to the cliché that he was "an artist ahead of his time."

The aura of a struggling artist whom society rejects did not originate with Van Gogh, nor did Van Gogh necessarily seek this platform. This stereotype assumes that the artist eagerly looks for society's affirmation and acknowledgment, and the general public, in its ignorance, spurns him or her.

Paul Cézanne fled from the crowded Parisian art scene and cultivated a crude persona, in part because this rejection of society made his art more palatable to the elite, who may have felt the same way but could not act on their principles. Eugène Delacroix lived in Paris his whole life but saw himself as an outsider, often painting scenes like *Tasso in the Madhouse* and *Ovid among the Scythians* as a way of projecting the image of a misunderstood genius. Even his painting of *Michelangelo in His Studio* has the great Renaissance master in a moody pose with his throat wrapped by a heavy scarf—one that Michelangelo would have found strange, but that Delacroix used to protect himself against frequent throat ailments.

These societal rejections made Delacroix and Cézanne even more popular. Van Gogh had to wait for his death for his reputation to be resurrected. After he died his letters did the talking for him, providing physicians, psychiatrists, museum curators, and art historians with a wealth of interpretation. All those notations, awaiting decoding under the helpful eye of a deconstructionist, are ripe for the various critical philosophies of the twentieth and twenty-first century.

Episodes of his youth were projected onto his canvases, and later his paintings were made to sit on the proverbial psychiatric couch so that experts could delve into his personality without the subject's awareness, let alone approval.

Delve they do. Psychiatrists and novelists have labeled him as having "an eccentric personality and unstable moods"[7] or as a proverbial martyr for his art. So far no fewer than eighteen novels and short stories have been written about Van Gogh, all based on his correspondences. The most famous literary interpretation of his life is the docudrama *Lust for Life* by Irving Stone. This 1934 novel claims to be a biographically accurate account of Van Gogh's years as an artist. *Lust for Life*'s success gave birth to thirty-nine translations and spawned a 1956 movie with Kirk Douglas as the protagonist.

This was not the first movie; a 1948 French documentary called *Van Gogh* set the standard for a psychiatric interpretation of his life. That has been followed by films in Italian, English, Dutch, Czech, German, Japanese, Danish, Finnish, and even an animation in Serbian. In all, the Van Gogh 1990 Foundation has discovered an astonishing eighty-five films based on his life. More has followed: interpretative modern dance ("Vincent: An Encounter with the Artist in Music and Dance," the National Ballet of the Netherlands, 1988), opera (*Letters to Theo*, a 1986 Irish opera by James Wilson), and modern classical music ("Impressions of Vincent van Gogh" by Chris Peck, played on the vibraphone, bass flute, alto flute, and flute, 1987). Talented artists like Nicolas Poussin, John Constable, Thomas Gainsborough, or Giotto di Bondone lived fairly conventional artists' lives for their time—no great theatrical works are likely to be spun off their biographies.

Moreover, Van Gogh was committed to various asylums, which does not hurt the narrative flow. If you play it up enough, a writer can make the cutting of his ear the climax of self-torture. Perhaps that's the reason why biographies vary so widely on this episode: in some it's the whole ear, sometimes just the lobe, sometimes a slit. The ear, or parts thereof, was said to be delivered to a local call girl named Rachel. Even more drama: self-mutilation, misdirected love, prostitution.

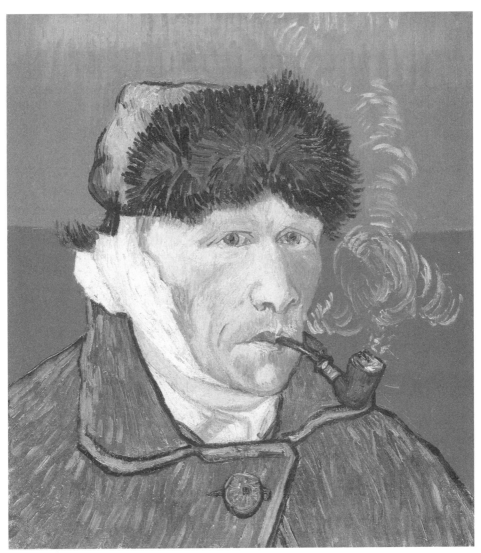

Van Gogh's self-portrait with a cut-off ear and bandage: fodder for psychoanalytical studies of the painter. *Private Collection / Bridgeman Images*

Then there are the medical problems. Take your pick from the experts: schizophrenia, chronic sunstroke, Ménière's disease, glaucoma, digitalis intoxication, brain tumors, and temporal lobe epilepsy. In the hands of a talented writer, he could have all these things at once, all affecting his mental state and, needless to say, his paintings.

Van Gogh has all the necessary ingredients for a biography filled with drama, with suicide as the defining moment. Or perhaps not, after all. A new biography by Steven Naifeh and Gregory White Smith maintains that there is a distinct possibility he was murdered instead. The authors point to the lack of a gun at the death scene and no suicide note.[8] The bullet was said to enter his body from an unusual angle for

a suicide. Still, this remains a theory, however fascinating, and one that has added intrigue to a life already filled with intrigue.

Scholars have not only re-created his life, making it into what the modern world calls edutainment, they have explored each item in his paintings searching for symbols. For example, his cypress trees, the kind that flame up in *The Starry Night*, have been described as

> nature contorted by madness. Strange, feverish works full of power, tension and violent expression. The realism of a neurotic, a desperate genius, often great, sometimes grotesque, but always pathological.[9]

Or:

> The torches burning in the wind, the zig-zagging circles of light and the feverish brushwork are clearly indicative of chronic sunstroke: the struggle between the conscious creative force of genius and the unconscious creative power of the sun.[10]

> The crackling lyrical cypresses are the expression of an anxious neuroasthenic patient [i.e., a patient suffering from chronic fatigue and weakness].[11]

> The spectral black cypresses shriek their haunting anguish. A storm of madness, the flame symbolizing his consuming creative passion and expressing his inner upheaval.[12]

> What we see here is epilepsy. This would explain the impulsive, irascible and mystical quality of the cypresses.[13]

And finally . . .

> In *The Starry Night* the contrast between the soaring verticals and oppressive horizontals as symbols of the conflicting effects of fate can be compared with epileptic bipolar movements.[14]

Rare is the art historian who does not consider Van Gogh's lifestyle and medical issues when he or she confronts a canvas:

> The jumpy undulating touches and the low undulating lines are a clear expression of the epileptic psychosis diagnosed by Dr. Peyron. In everything he painted during the Saint-Rémy period the symptoms of his psychosis are evident.[15]

Van Gogh makes frequent mention of cypresses in his letters, although not the ones specifically attached to *The Starry Night*. In a letter to French critic Albert Aurier he discusses his view of cypresses:

> If you will do me the pleasure of accepting it, I shall include a study of cypresses. . . . The cypress is so characteristic of the Provence landscape. You will feel it, and say, "Even the colour black." Until now, I have not been able to do them as I feel them; the emotions that come over me in the face of nature can be so intense that I lose consciousness, and the result is a fortnight during which I cannot do any work.

However, before leaving here, I mean to have one more try at tackling the cypresses. The study I intend for you represents a group of them in the corner of a wheat field during the mistral on a summer's day. It is thus a kind of black note in the shifting blue of the flowing wide sky, with the vermilion of the poppies contrasting with the note of black. You will see that it forms something like the combination of tones found in those agreeable Scottish tartans of green, blue, red, yellow and black, which seemed so charming to you and to me at the time, and which, alas, we hardly see any more these days.[16]

His hyperbolic description of losing consciousness when working on a project has made Van Gogh such a tempting target for the context-driven scholar, as well as the army of interpreters from various other philosophies.

Van Gogh's emotional response to his work dominates his correspondence, including this letter dated April 9, 1888, in which he remarked, "I must also have a starry night with cypresses, or perhaps above all, a field of ripe corn; there are some wonderful nights here. I am in a continual fever of work."[17]

If discussing Van Gogh's works as if they were patients rather than canvases seems a bit odd, remember that the world today seeks for no famous person to be granted a privilege of privacy, especially if there are deep secrets and psychological issues. While we have no formal published works by Van Gogh we do have his aforementioned 819 letters, as well as ninety-three more sent to him from his brother Theo or famous figures like Paul Gauguin. The definitive edition of his letters was only published in 2009, but before this, enough of them were available so that we could see he was a deeply serious person about his art—not a madman as tradition suggests. Persistent rumors advocate that he slashed canvases wildly in his act of creation. None of this is true.

His letters also reveal a passionate individual who was moody, eccentric, and extremely needy. When Van Gogh died and his reckless personality no longer mattered, his artwork achieved fame in part because the artist himself was no longer an obstructing factor. His mixed messages, contrary statements, and conflicting ideals often caused buyers to look the other way; in a sense he was his own worst enemy.

Art historian Carol M. Zemel has graphed the ascension of Van Gogh's reputation, and according to her research widespread appreciation for the artist began shortly after his death. Van Gogh's sister-in-law, Johanna van Gogh, returned to the Netherlands after Vincent's death, to tend to her very ill husband, Theo, in late 1890. She began organizing exhibitions of Van Gogh's work, an easy task because she owned the lion's share of his output.

Van Gogh was an artist who was almost totally unknown to critics, and whose works were seen by only a few. He was known to have sold only one, maybe two paintings in his lifetime, and his works were only exhibited in group shows, where they suffered from lack of name recognition. Ironically, by 1920 he was an acknowledged master of modernism, and his paintings—and forgeries—were commanding high prices.

The Dutch art climate of the time explains some of the ascent; it was a climate that was busy rejecting impressionism and stressing an artist's self-awareness. A movement called the *Tachtig*, or the "Eighties," saw naturalism in literature and art as faulty and denying the imaginative spirit of the artist. According to these critics, an artist should be relying on his or her feelings to fully capture an aesthetic experience. Any artist who works with documentary fidelity for creation, according to them, negates the artistic impulse. Such a philosophy was tailor made for Van Gogh. His works were seen as a culmination of the artist who summed up his life by his imagination.

Concurrently another Dutch movement called the *Negentig*, or the "Nineties," asked critics to think of the humanitarianism of an artist, and to look favorably on social artists, who thought of the world at large and their impact on society. Once again, Van Gogh was seen as the example of social alienation at its best. Misunderstood, they kept saying; look what society had done to him!

At the end of the century art movements began to stress the symbolic overtones in the formal elements of art: line, patternings, brushwork, and color could all be interpreted allegorically. Contemporary artists in France and England, like Gauguin and Beardsley, had long maintained that symbolism was a solid aesthetic interpretation. This made Van Gogh's work all the more appealing. He was called alternatively "child-like" and "feverish" by critics who used these words in the most glowing terms.[18]

All these fin de siècle movements crowned Van Gogh as their forerunner and gave brilliant reviews to his exhibitions. An 1892 exhibit in The Hague had eighty-nine works, and was extended an extra week to accommodate crowds. By 1900 there were annual exhibitions of his work in northern Europe, satisfying the need to see as much Van Gogh as possible.

The largest of these exhibits was the mammoth 474-work show held at the new Stedelijk Museum in Amsterdam in 1905. In the same year paintings were on view in Dresden and Berlin where the fauve group called Die Brüke (The Bridge) could admire them.

Johanna van Gogh understood the art market enough to know that the time was right to publish, and by 1914 a complete edition of the letters from the brothers—in three volumes—was printed, along with a biography that seemed more like a series of reminiscences. This biography set in stone the image of a tormented individual of singular genius who had profound issues both with himself and society.

A major shift came after 1914, when he was seen as a national hero, one whose image was idealized under the banner of self-sacrifice for a higher cause.[19] With World War I self-sacrifice became a mantra, and Van Gogh became a cultural hero. The neutral Dutch lionized him, and the French adopted him as one of their own. Sales of Van Gogh paintings, and there are many of them, were brisk—enough so that the painter himself would have been dumbfounded by the enthusiasm.

~

The Starry Night was executed near the end of Van Gogh's short life, in June 1889, after he entered the hospital at Saint-Rémy, France. He remained in the hospital for several weeks, painting from his cell window or in the garden on its grounds. The view

from his window is nearly identical to the view of the mountains in this painting, with perhaps the steepness of the mountains being exaggerated. Certainly the vertical rising of the mountains from left to right is easily seen from his room. The view of the town was probably sketched just outside the gates of the hospital, where the village rolled downhill before him, much as it appears in the painting.

Like most Van Gogh paintings, *The Starry Night* became the possession of his brother Theo shortly after it was painted. When Theo died a few months after his brother, his widow held on to the canvas for nine years. It was sold to Julien Leclercq, a French poet and art critic who had an abiding interest in Van Gogh, so abiding that Leclercq wrote the artist's obituary for a French journal when he died. This was practically the only official notice of Van Gogh's death since he died in such obscurity. It was also Leclercq who assembled the first major retrospective of Van Gogh's work. For reasons unknown, however, Leclercq exchanged the work with another dealer, who then exchanged it again for a different painting with Theo's widow. Consequently, the widow ended up with the painting from 1901 to 1906 when she sold it to Mrs. Georgette P. van Stolk. Because the painting was housed in a private collection since 1906, and prior to that by Van Gogh's family, it was almost unknown when it surfaced.

After the Van Stolk estate was dissolved in 1938, the painting was purchased by the Paul Rosenberg Gallery in New York, where undoubtedly it was seen by the New York museum elite. The Museum of Modern Art acquired the work in 1941, with the funds available through the Lillie P. Bliss Bequest. At the time, it was the only Van Gogh in the museum. During World War II, however, many of the masterpieces in New York were removed to safer quarters out of town, and the public was kept at a distance from the important paintings. The Metropolitan Museum, for example, put their choicest works in a Pennsylvania coal mine, and mounted exhibits of plaster casts of antique marbles. Therefore, it wasn't until after World War II that the painting received any kind of publicity—let alone studied by anyone intensively.

Van Gogh himself left little in terms of a paper trail concerning *The Starry Night*. Brief mentions are made in his correspondences, but the lack of descriptive remarks by the artist has ironically made the painting fertile ground for interpretation. Scholar Ronald Pickvance has calculated that the literary sources of Van Gogh's work claimed by others stem from such diverse starting points as the books of Genesis and Revelation, Walt Whitman, Henry Wadsworth Longfellow, Emile Zola, Alphonse Daudet, Charles Dickens, and Thomas Carlyle.[20]

The lack of a firsthand account has made all these interpretations more speculative—but no less interesting. Scholarly arguments may have increased the fame of *The Starry Night* in the intellectual community, but rarely does heated intellectual swordplay contribute to public fame.

What does contribute to fame is a spicy author biography. Scholars determined that the work was conceived in a mental asylum, a far more catchy phrase than rest home or hospital. From his window in his room, or cell if you prefer, Van Gogh could

stare out into an open landscape dominated by the French Alpilles Mountains, which are in the background to *The Starry Night*. Curiously these mountains are intermixed with a Dutch village with a church spire. These details, coupled with the Mediterranean cypress trees, suggest that the painting is a composite based on random memories rather than a painting done in plein air, a favorite Van Gogh technique.

The painting contains much of the same energy as other Van Goghs, like his thorny-looking irises and his animated self-portraits. However, *The Starry Night* painting has a horizontal roll of tsunami-like thunder across an apocalyptic sky. Great waves of thick impasto brush across an intense landscape.

Van Gogh has rendered an unforgettable image, one he reworked in his thoughts by producing a reed brush drawing of even more spontaneity. This is unusual because Van Gogh was not known for copying his works, but for revising them. *The Starry Night*, however, has not been interpreted as an ordinary landscape painting, but an artistic statement—the way one views Velázquez's painting of *Las Meninas* not as an ordinary group portrait but as a summary of a career and a profound artistic philosophy.

Unlike other Van Gogh masterpieces, *The Starry Night* deals with themes of eternity and the cosmos—particularly as it concerns the afterlife, thoughts so much stressed in his letters. Other great works, like *The Night Café* or *The Potato Eaters*, as wonderful as they are, address none of these concerns.

These themes make *The Starry Night* a potent philosophical force. Add that to his characteristic use of bold colors, in this case brilliant blues with contrasting yellows, and you get a painting with so expressive a palette that it draws the viewer in. Early commentators were captivated by Van Gogh's thick impasto brushstrokes, which were variously called "wild, feverish, discordant, barbaric and child-like."[21]

Van Gogh's landscapes are a common feature in his oeuvre, but few of them look like this. The fame of the work rests on the dramatically rendered sky—a sky unlike any other in the history of art beforehand. Even among Van Gogh's works, there are but a few like this, the most impressive being his *The Starry Night over the Rhone* painted almost a year before.

Even astronomers have written articles about the exploding skyscape, proposing exact astrological phenomenon depicted in the painting. They have explained, or more properly rationalized, the phases of the moon on a given date and then assessed the relative position of the stars. One glance at *The Starry Night* with the swirling oceans of supernovas suggests more the realm of artistic license rather than meteorological accuracy. Simon Singh's 2004 best seller *The Big Bang: The Most Important Scientific Discovery of All Time and Why You Need to Know About It* says that the painting's swirls resemble a sketch of the Whirlpool Galaxy drawn by Lord Rosse forty-eight years before the painting. Whatever the truth, Van Gogh's wild sky has made the painting a favorite most especially with the counterculture of the 1960s, who saw it as a manifestation of a drug-induced dream state.

In 1971 singer-songwriter Don McLean wrote a popular song based on the painting, and indeed put a copy of the painting onstage and sang to it. While the soulful tune pays homage to the work, it also contains all those clichés about Van Gogh's life, how his critics ignored him and rather strangely are still doing so, and then even more strangely, will never appreciate him.

Popularity implanted the image of *The Starry Night* on all kinds of merchandise. Casual browsing on the Internet reveals that all of the following are available for sale with *The Starry Night*'s image: sleeveless dresses, handbags, men's pants, slippers, earrings, candles, cigarette lighters, mouse pads, pocket mirrors, and a Snoopy/Charlie Brown/Starry Night wristwatch. A 100 percent cotton washable *Starry Night* bib complete with a portrait of a German shorthair pointer can be yours for only $12. Order now! These are among the more tasteful products.

After this, there was no stopping the painting from achieving cult status. Like *The Scream*, but unlike *Washington Crossing the Delaware* or the *Sistine Madonna*, this painting morphed into the artist's life and made the two inseparable.

Since artists' lives have become fair game, and the interpretation of their images have become psychological fodder, Van Gogh's life has provided much for the popular imagination to dwell on. Fame has come to *The Starry Night* at a price; perhaps we are no longer able to see the painting divorced from its context or its fame.

As for Van Meegeren, he became a celebrity at home in Holland for having fooled the Nazis. After he died, his paintings became so popular that he in turn was forged by his son, Jacques, who used his real signature on fake works.

And indeed, Van Gogh forgeries are still rampant. By one count, there are still forty-five in famous museums and collections that are probably fakes. Van Gogh is one of the most forged artists in history. His fame has seen to that.

The Scream by Edvard Munch

Scream, Indeed

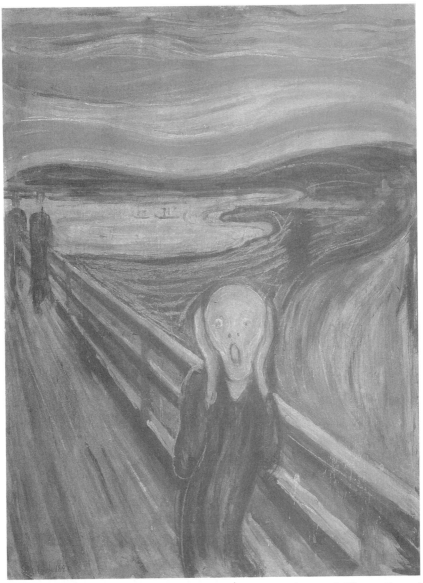

The Scream by Edvard Munch. © 2014 The Munch Museum / The Munch-Ellingsen Group / Artists Rights Society (ARS), NY; Nasjonalgalleriet, Oslo, Norway / Bridgeman Images

I was walking along the road with two of my friends. The sun set. The sky be-
came a bloody red. And I felt a touch of melancholy. I stood still, dead tired. Over
the blue-black fjord and city hung blood and tongues of fire. My friends walked
on. I stayed behind, trembling with fright. I felt the great scream in nature.

—Edvard Munch, on the frame of the pastel version of *The Scream*

One of the marks of a truly popular work of art is the number of times wild theories have been proposed to interpret it. For example, Michelangelo's *Creation of Adam* on the Sistine Chapel ceiling has been endlessly redefined: the billowing cloud behind God the Father is alleged to be a heart,[1] a uterus,[2] or a brain,[3] depending on who's doing the looking. The space between the fingers of God and Adam is said to illustrate the effects of electricity.[4]

Similarly, Munch's painting of *The Scream* has been variously interpreted by experts seeking to make the definitive analysis. For instance, the background, with its lurid blood red sky, has inspired one writer to see it as none other than the aftereffects of the volcanic explosion on the island of Krakatoa, east of Java, Indonesia. According to this theory, the cataclysmic blast of August 27, 1883, resulted in enormous quantities of dust spewing into the atmosphere, turning sunrises and sunsets into flaming spectacular celestial events half a world away. Munch allegedly witnessed this phenomenon and used it as a backdrop to his painting.

A century later, Petter Olsen, former owner of one of the versions of *The Scream*, said that "the image of *The Scream* could make more of us fathom the magnitude of the consequences of our continuing emissions of greenhouse gases."[5] Even more expansive is Los Angeles art critic Edward Goldman, who asserted that "'it seems to embody all the horror and prejudices of the 20th Century,' including two World Wars and the power of mass self-annihilation."[6]

Then there is the theory that the main figure in the painting was inspired by an Incan mummy housed in a museum in Florence. An Italian anthropologist has claimed that there is a striking resemblance between this mummy and *The Scream*. It even has its open hands placed against its cheeks, the way that the skeletal figure in the painting does. Munch did visit Italy in 1899, well after *The Scream* was painted, but theories abound that he could have made an earlier undocumented journey and seen the mummy. Moreover, there is not just one possible mummy theory: another effigy is in the Musée de l'Homme in Paris; Munch may have seen this one in an 1889 exhibition at the Trocadero.[7]

There is even much debate over the actual location that is depicted in the painting. Some allege it is a real place, the Oslo Fjord, viewed from Ekeberg Hill in modern-day Oslo (then called Kristiania). Others say it is no place in particular—the work is too expressionistic to depict an actual place.

Debates over the origin of details in the painting generally turn back to a biography of the artist himself, a man who had an enigmatic personality. Edvard Munch was not happy. Could a happy man have painted *The Scream*? His own words often spell out his unhappiness: "Disease and insanity were black angels on guard at my cradle."[8]

He had seen much misfortune in life: his mother died of tuberculosis after giving birth to his youngest sister in 1868. His father, a deranged doctor who oppressively

dominated his son, took the young Edvard on house calls so he could see the sick and the dying. He unremittingly indoctrinated his son with a fear of isolation. His favorite sister, Sophie, died in 1877, and his father was dead by 1889.

His early life makes his paintings understandable. Perhaps all this trauma contributed to the main figure in *The Scream*'s unearthly yell, and why passersby are indifferent and uncomprehending. Munch also had other internal devils. He was an unrelenting alcoholic, and suffered from agoraphobia. What is more, he was very quick tempered, known to get into fights for no reason.

As if things were not bad enough, Munch was pursued by Tulla Larsen, a woman possessed by the notion that she needed to marry Norway's most famous painter. She drove him crazy, following him throughout Europe, in a behavioral pattern that we would today call stalking. Things reached a climax when she shot off a joint in the third finger of his right hand—the marriage band finger in Norway. He later entered a sanitarium for a good long rest. Scream, indeed.

This episode led to his aversion to women and to hands. After the shooting Munch always wore gloves. "Nothing is more naked or more disgusting than fingers," he said.[9] Interestingly the central figure in *The Scream* has no fingers.

These facts may suggest that Munch was reclusive and hid his emotions from others, but actually he was constantly on the go, particularly when it came to socializing with the leading Scandinavian thinkers of his day, including famed playwright August Strindberg. Strindberg's plays, such as *Miss Julie*, are often characterized as groundbreaking in their efforts to expose conventional attitudes toward wealth, power, position, and sexuality. Munch's artistic temperament may have felt a comfortable parallel in Strindberg's works.

All of this sets the stage for *The Scream* itself. In the 1880s Munch began working on a series he euphemistically called *The Frieze of Life*. This series did not begin with a definite number of works in mind, nor set organization. It was conceived as a fluid arrangement, with additional panels being added when Munch felt so inspired. The nucleus of this series was a group of six paintings, which Munch exhibited in December 1893 and called *Studies for a Series "The Love."* Included in this series were *The Voice*, *The Kiss*, *The Vampire*, *The Madonna*, *Melancholy*, and *The Scream*.

Originally, *The Scream* was designed with just a sunset and no figure. That picture was sold to a Viennese collector, and Munch busily rethought the composition for a replacement. In the reworking, he interjected the screaming figure in the center, providing, no doubt, a dramatic conclusion to his *Love* series.[10]

Paintings done in a series were a common feature of the impressionist period, having been popularized by Claude Monet, whose *Haystacks* and *Poplar Trees* had already debuted in 1891, and *Rouen Cathedral* was to emerge in 1894. All this was preceded by Eadweard Muybridge's chronophotographs of humans and animals taken in the 1870s. In an effort to capture the fleeting moment, Muybridge set up a series of cameras, called a zoopraxiscope, which recorded the movements of people in action: some jumping over chairs, others hopping on one foot, still others doing somersaults.

It was the first time that actions were frozen on film, and it was a boon to artists, who hitherto relied on their own impressions of what a figure looked like in motion.

Munch must have known that whatever the merits of *The Frieze of Life*, no one collector would want all the paintings. Monet sold paintings in his series as buyers became available. Munch reasoned that this was solid business practice, and if buyers only wanted one work, he could paint a replica so the integrity of the exhibition could be maintained.

It is in this setting that *The Scream* was born. After his initial compositional experiments in earlier works, and a sketch done on cardboard, the first version of *The Scream* was painted in late 1893, the one that is now in the National Gallery in Oslo. This work is done on tempera and pastel on a board backing. After completion, he penciled on the top red stripe, "Only someone insane could paint this!"

It was unlike anything that had been painted before; true scenes of horror are rare in art history. Before this, the romantics were virtually alone in producing graphic images. Compared to *The Scream*, Henry Fuseli's 1781 *Nightmare* looks almost quaint, and certainly theatrical. Only the horrifying graphics and *Black Paintings* of the Spanish romantic painter Francisco de Goya could equal Munch's creation.

The Scream is also unlike many of Munch's own works. Up to this point, he painted emotional scenes of despair and death, but none as dramatic or tortured as this. This painting contains one of the most sexless male figures in art history. He is screaming out into the landscape, becoming one with his environment, which undulates alongside his emotional state. Because of the swirling and sinuous brushstrokes, the painting looks somewhat like the art nouveau style, which was coming into its own at this time. However, where the art nouveau artists used gracefully flowing lines to suggest artistic decadence, Munch uses the same lines but filled with dissonant color harmonies to indicate a troubled world overflowing with anxiety and apprehension.

So much about this painting was new. The skull-like head only suggests a figure rather than describes one. It is immediately apparent that the figure is in a deeply emotional state that transcends the feelings of a single event, or one misfortune.

In 1895 Munch began to experiment with printmaking; he wanted to mass produce *The Scream* by issuing a lithograph. In printmaking the print is usually a mirror image of what is created, the artist needing to think in reverse to create an image. Munch desired the print to have the same format as the painting, and so he created the print backward so that the descending line of the pier would arc in the same direction in both. Munch must have felt strongly enough about the representation of this emotional tailspin because the lines fall sinkingly into the viewer's space. The downhill diagonal lines contribute to the emotional depression of the whole work.

When the painting was exhibited in Stockholm in 1894 it was called *Skrig* for the first time; prior to this it was unlabeled. In 1895 it was shown in Berlin, and the title was translated as *Geschrei,* which means in English "shouting" or "yelling"; the title was never translated into English by the artist, although he did study the language in the 1870s. The painting has traveled by a number of names in English, including *The Cry* and *The Shriek.* In Norwegian, *Skrig* carries the connotation of prolonged, painful agony, as in an emotional outburst. There is no such single word for this in English.

Munch painted three other versions of *The Scream*, one going into private hands for an extended period of time. The final edition was done between 1910 and 1919, and is a reworking of the same theme for another showing of *The Frieze of Life*.

Not only was *The Scream* famous enough to warrant all these versions, Munch himself was also very famous in his lifetime. In 1892 he was invited to exhibit at the Verein Berliner Künstler, a special art venue in Berlin. His pictures ended up causing a scandal, and the exhibit was closed in a few days. Munch's style was out of sync with what contemporary German avant-garde art was producing. This caused considerable overreaction among critics, who were unused to his discordant color harmonies and expressionistic style.

Munch seemed to have liked the controversy, saying, "Never have I had such an amusing time—it's incredible that something as innocent as painting should have created such a stir."[11] However, Munch's brusque dismissal was at the very least a serious breach of etiquette: an invited artist brought his prized possessions to a European capital, only to have Germany's art establishment reject them. This gave him unprecedented publicity. He carefully exploited this notoriety by sending the paintings on tour throughout Germany. Thereafter everything he did had interest; people came prepared to be scandalized and shocked. The aristocratic patrons in Berlin showered him with sympathy and assured him that Germans weren't *really* like that. This *succes de scandale* propelled Munch into the European artistic limelight.

Munch knew that if he were going to achieve success, he would have to make a gallery showing in Paris, the undisputed headquarters of world art in the late nineteenth century. So in 1896 he exhibited a lithograph of *The Scream* along with a number of other works. The reviews were mixed, at best, the French more interested in some of his traditional paintings rather than his shocking sexual images. Strindberg, hardly an unbiased judge, wrote a favorable review for a publication called *La Revue Bianche*.[12]

Even if the Parisian public was noncommittal about *The Scream*, the image had begun to develop a life of its own mostly because of its hypnotic pull. It invites the viewer to look again and again, to stare and gasp in horror at the figure's outcry. Munch's repeated repaintings of the work attest to its interest. *The Frieze of Life* was in demand seemingly everywhere: Berlin 1902, Leipzig 1903, Kristiania 1904, and Prague 1905. A final reworking of the canvases was ordered for the 1927 retrospective in both Berlin and Oslo. Lucky for Munch that *The Scream* was a success, because his later paintings are seen as bland and uninteresting. After his complete mental breakdown, Munch left the sanitarium in 1908 and went back to painting—but everything had changed. He no longer had the visceral reactions to the world that made his earlier paintings so compelling. His late paintings, and there are many of them, became conventional, academic affairs of little interest even to Munch scholars.

If Berlin was the site of Munch's first rejection, it would also be the place where his artwork would achieve permanent fame through yet another rejection. In 1937 the Nazis began to sweep clean German museums, ridding the Reich of "degenerate art"

that could contaminate public virtue. (This presumes the Nazis held the gold standard in virtue, and therefore could instruct museums on what to show and what to take down.) Munch's paintings became a favorite target. This act alone helped to popularize Munch as a great artist that tyrants could not understand or tolerate.[13]

This upset Munch, because Germany was his artistic second home, the place where he achieved international success and lasting reputation. Nonetheless, over eighty of his paintings were removed from museums and unceremoniously shipped back to Norway, including *The Scream*. Things worsened with the German invasion of Norway in 1940, because he felt trapped in his own homeland, fearing that at any minute his life's work would be set fire to by the Nazis.

Munch had trouble parting with his paintings and often declined sales, particularly after his celebrity reached a point in which he did not need the money. It is not surprising that at his death in 1944 Munch bequeathed to the city of Oslo over one thousand paintings, 15,400 prints, and 4,500 drawings, all unsold. He even executed six relatively unknown sculptures, which became part of the bequest.

Norwegians began to celebrate the artist and the paintings. In a country that today still does not have five million people, the success of an international hero is widely promoted from within. Munch has joined Edvard Grieg and Henrik Ibsen in a Norwegian pantheon of cultural heroes. He has appeared on money and stamps, and his museum in Oslo is widely promoted as a place to visit by the local tourist bureau.

The commercialization of *The Scream* image has enhanced the standing of a hometown hero, one that makes Norwegians bask in reflected glory.

The surest measure of *The Scream*'s popularity came on May 2, 2012, when the last copy in a private collection was auctioned for a staggering and record-breaking price of $119.9 million. Protestors outside Sotheby's in New York condemned the unknown buyer for the extravagant amount of money lavished on one work, especially in view of the restrictive economic climate of the time. Little, however, could deter the bidders who were eager to own their very own cultural icon. It took only twelve minutes for the opening bid of $40 million to climb at one-million-dollar increments up to $100 million and beyond. The buyer of the work was represented only by an agent on a telephone; he or she is protected by confidentiality agreements signed by auction houses prior to the sale. At the final hammer, Tobias Meyer, who served as Sotheby's auctioneer for the event, said, "It's worth every penny that the collector paid."[14]

Little surprise, then, that the new owner(s?) of *The Scream* have been reluctant to reveal themselves, for it has been stolen, not once, but twice. During the opening ceremonies of the 1994 Winter Olympic Games in Lillehammer, Norwegians were stunned to learn that *The Scream* had been taken from the National Gallery in Oslo, most probably to embarrass the Norwegian government at a moment that was to set to galvanize national pride. The theft was extremely daring. Two men climbed a small ladder, smashed a museum window, and used wire cutters to remove the painting from the wall. The whole episode was filmed by security cameras and took a grand total of fifty seconds.[15] The thieves left behind a note that said, "Thanks for poor security,"[16] and later contacted authorities about a ransom, which was never paid.

The theft of Norway's most famous painting made the painting even more famous. It caused national soul searching, made government employees point fingers

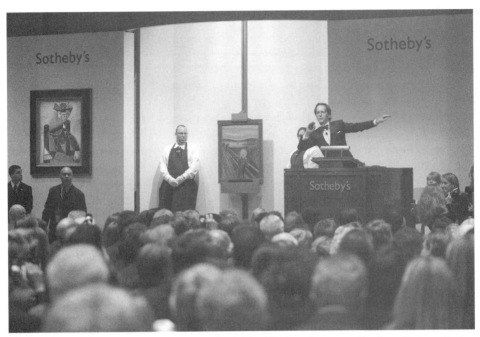

The Scream goes to auction in the spirited world of high-stakes art collecting. *Andrew Burton* © *Reuters*

at one another menacingly, and motivated the museum to make sure that this never happens again. At least never happen again, here.

The British police were called in to help the Norwegians set up a sting operation to snag the perpetrators and to recover the painting. Although the operation was entirely successful, and the paintings were found undamaged in a hotel in Asgardstrand, a small town south of Oslo, the importing of British detectives under fake identities doomed the prosecution's case in court, and the four arrested men were eventually released on a legal technicality. There was national rejoicing for the return of the painting. However, the fact that the perpetrators were now off the hook led to more finger pointing in every direction.

On August 22, 2004, the unthinkable happened again. In proverbial broad daylight, two men in ski masks entered the Munch Museum at midmorning, terrified the tourists by brandishing weapons, and yanked this version of the painting, along with a second work, down from the walls, and escaped into a black Audi A6. The frames were thrown from the car windows less than half a mile away.[17] More fame. More national soul searching. Even more finger pointing. Scream, indeed.

The second theft was relatively crude. The thieves were unprepared, not even knowing where the paintings were hanging, and had to ask a guard for directions. One thief put a gun to the head of a female museum guard, threatening her, but she was ultimately unharmed. It took about twenty seconds to steal the paintings; only thin wires held them onto the walls, and all one needed was a good yank to have them in one's hands.

Security was extremely lax. Even the Norwegian cultural minister, Valgerd Svarstad Haugland, described the theft as "dreadful and shocking." She added, "We have not protected our cultural treasures adequately. We must learn the lessons."[18]

This time it took two years to recover the paintings, and *The Scream* was damaged in some places beyond repair. Restoration took another two years to return the paintings back to something like they were before they were stolen. Now *The Scream* is mounted to a wall, attached with bolts and protected by Plexiglas. Metal detectors, x-ray scanners, and security gates greet visitors at the entrance to the museum, making the director's claim that the paintings were well protected before the theft sound rather hollow.

The thefts have made the painting's fame complete. Headlines and news articles emphasize that these paintings are among the most famous in the world. The sober *Financial Times* of London proclaimed, "One of the world's most famous paintings, 'The Scream' by Norwegian artist Edvard Munch, was stolen by armed thieves from a museum in Oslo yesterday."[19] The *Sunday Times of London* announced, "Norway's greatest painting is stolen; *The Scream* by Edvard Munch."[20]

Strangely, the men involved in the crime were easier to find than the paintings. Six went to trial with various charges relating to the theft, but only three were convicted. The judge sentenced Bjoern Hoen to seven years for planning the robbery, Petter Tharaldsen to eight years for driving the getaway car, and Petter Rosenvinge four years for supplying the vehicle.[21] The first two were required to pay £66.3 million as compensation to the City of Oslo for the value of the paintings. Although neither man could raise even a fraction of the cost, the law is the law, and the value of the paintings was placed on the backs of the thieves.

Eventually the paintings were recovered, albeit damaged and waterlogged. Paintings such as these are more liabilities than assets even to underworld figures who may covet such treasures. It is widely believed that the Caravaggio painting of *The Nativity with Saints Lawrence and Francis* that was in the oratory of San Lorenzo in Palermo, Sicily, was taken by the Mafia in 1969. It has never been found, if indeed it still exists. It may have been liquidated because its notoriety would cause problems on the art market.

Equally mysterious is the *Ghent Altarpiece* panel called the *Just Judges* by Jan van Eyck, which was stolen in 1934. Shortly after the theft, the bishop of Ghent received a ransom note for one million Belgian francs, which was never paid. A few months later, the thief was lying on his deathbed and refused to reveal the whereabouts of the painting—knowledge he took with him to the grave. Once again, the painting was probably destroyed because it was unsellable.

The reason for *The Scream*'s theft actually has little to do with art, little to do with the underworld, and still less with the stereotypical diabolical mastermind who wants great works of art so he can stare at his paintings in a basement where no one else can find them. The theft was tied to a spectacular armed robbery of the Norwegian Cash Services office in Stavanger, Norway, in April 2004. The crime seized headlines not only because of the value of the heist, but also because a senior police officer was brutally murdered with a machine gun. Linked to the crime was one David Toska who was eventually tried and jailed. Soon thereafter the police began to link the armed

robbery crime with the theft of *The Scream*, and it was Toska's lawyer who told police where the paintings could be found. The director of the Munch Museum and thirty policemen descended on an abandoned van and finally had the paintings in their possession. The police now believe that the theft was probably a ruse to distract the attention of the public from the serious crimes that the Norwegian underworld was guilty of.[22] In other words, the theft was designed to draw limited police resources away from the armed robbery, the painting then being rendered as valueless to the criminals.

Satirists were quick to pick up on the debacle. In the *Onion*, one of the best satirical newspapers in the United States, a headline proclaimed, "*The Scream* Poster Stolen from Area Dorm Room."[23] The painting has become one of the most parodied artworks in history; even its theft has been lampooned.

Capitalizing on the popularity of the parodies, the Art Gallery of Ontario snagged the Norwegian government's permission to present *The Scream* for an exhibition in 1997. However, instead of an in-depth exhaustive show dealing with Munch's oeuvre or artistic themes, the gallery put on a show that featured the painting surrounded by two hundred items of kitsch, and entitled the endeavor *Munch's* The Scream *and Popular Culture*. In order to save face, a hastily arranged show of Munch's prints was organized in a nearby setting.

The Scream was thus arranged in the opening gallery; then in subsequent rooms the knockoff images confronted the viewer. Everything from key chains to inflatable dolls was on display. Perhaps Dame Edna Everage, the camp character personified by Australian comic Barry Humphries, said it all best: "I always thought it was called The Munch. I thought it was someone about to take a bite out of something that's just out of view. Until I realized it's a painting of a woman at sunset who has lost her earrings."[24]

The gallery shop featured a great collection of *Scream* paraphernalia, including indispensable mouse pads (CAD$24.99), refrigerator magnets ($3.95), coffee mugs ($15.95), pillows ($35.95), and large blow-up dolls ($49.99). One wonders that if the original painting could talk, how it would express itself in view of all this merchandise.

Twenty-six thousand visitors saw this exhibition in just two weeks, proving how popular *The Scream* truly is. While it did not break records at the AGO, it was an extremely successful showing for an art exhibit that had very little art.

The crass commercialism of *The Scream* did not begin in the modern age; in fact, Munch's image had already been appropriated as far back as 1908, when it made its debut on the cover of a psychology book called *Psychopathology and Art* by Viennese hypnotherapist Heinrich Stadelmann. In a strange coincidence, the Art Gallery of Ontario owns a gruesome portrait of Stadelmann painted by the expressionist artist Otto Dix in 1922. Since Stadelmann's book *The Scream* has appeared on a legion of covers, including Ted Mico's 1995 best seller, *Life Stinks: A Wry Look at Hopelessness, Despair, & Disaster*, a book entirely devoted to whining.

Such good-natured fun was taken to the extreme by Masterfoods USA, which owns the company that makes M&M candies. After *The Scream* was stolen, M&Ms launched a campaign to sell dark chocolate using this admittedly very dark image as its foundation. They portrayed the M&M red candy playing hopscotch on the boardwalk behind the main figure in *The Scream*, providing a humorous counterpoint to this very

angst-ridden image. As if this were not enough, the unveiling of this candy campaign took place at the Guggenheim Museum in New York, one of the great modern art museums in the world. At this prestigious institution the new version of *The Scream* was unveiled as if it were a newly bought Cézanne or Picasso.

The irony has continued. Norwegians offered a two-million-dollar reward for the return of *The Scream*, but Masterfoods, instead of matching the bid, proposed the rather inane prize of two million dark chocolate M&Ms. Strangely, only days later, after a two-year absence, Norwegian police recovered the painting. Masterfoods quickly responded that they were going to honor their commitment and fulfill their obligation to donate this candy to the proper authorities, whoever they may be. Two million M&Ms is about forty thousand 1.69-ounce bags with a retail value of $22,000.[25] So now 2.2 tons of M&Ms are destined for Norway.

Scream, indeed.

American Gothic by Grant Wood

All-American Gothic

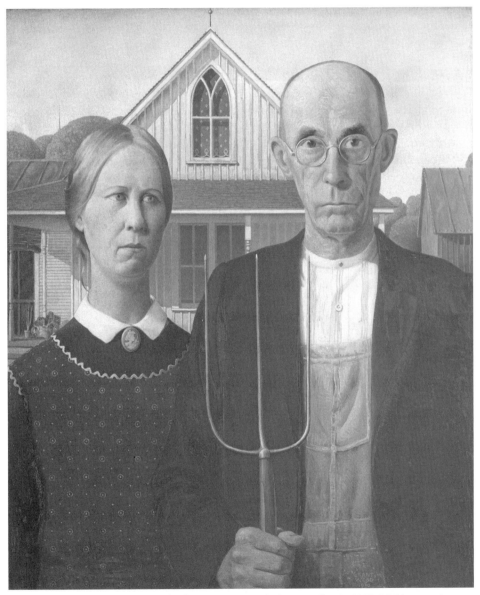

American Gothic by Grant Wood. *The Art Institute of Chicago, Illinois, USA / Bridgeman Images*

You can recycle the Mona Lisa *any way you like. Back to front, upside down, it remains instantly recognizable. That's the ultimate compliment, and it's been paid to Grant Wood's* American Gothic. *Somehow it seems to speak to the American psyche, though what it actually says isn't as simple as it might seem.*

—Sister Wendy Beckett

Certain works of art are instant successes from the very start, and their fame has never flagged. For example, Leonardo da Vinci's *Last Supper* was a resounding success when unveiled, and it has remained a sensation with art lovers, cultural historians, discerning critics, and the general public. Even in its shadowy condition, after suffering the onslaught of at least thirteen known restorations, the ghostly figures of Jesus and his apostles retain a firm grip on the popular imagination. Leonardo has rendered the world's most famous religious painting, in a world filled with religious paintings.

The list of works with instant and permanent success is not long—many wane from view after an initial dramatic splash. In the United States the best example of instant celebrity is Grant Wood's *American Gothic*. It debuted at the annual exhibition of contemporary art at the Art Institute of Chicago in 1930, where it was embraced by an eager public, each viewer seeing something different in these two majestic figures. Critics, always cautious that posterity will quote them, called *American Gothic* "one of the most distinctive paintings at the exhibit."[1] The public lavished enormous enthusiasm on the work, and Grant Wood had become the painter of the moment.

Surprisingly, *American Gothic* was not the top winner in the show, Wood earning the distinctly less significant Norman Wait Harris Medal and prize of $300. As is often the case in these contests, the actual winners have been unceremoniously discarded into the dustbin of history. Heinz Warneke's *Water Carrier*, which won the top prize, garnering $2,500, is virtually unknown today, as is the sculptor himself. Other prize medalists, such as Jacob Getlar Smith, Guy Pène du Bois, and Louis Rittman, hardly constitute a who's who of American art.

But if these other works won greater prizes, how did *American Gothic* capture the popular imagination? What did the public see that the critics did not?

For one thing, the figures in the painting are very odd. An old man, the artist's dentist, looks weary and lined with age, and peers sourly out at the unsuspecting viewer. He stares unflinchingly beyond his pitchfork—yes, pitchfork, of all things—to an urbane Chicago audience. And the woman—no bathing beauty, that's for sure—looks tentatively to her side. No voluptuous nude out of Titian or Rubens. No fetching soft-porn eroticism out of the rococo. Instead, she is dour, steadfast, resilient, and no-nonsense. Certainly this is no heartwarming couple, whose homespun values have produced a hospitable glow.

How could such a duo become the most iconic image in American painting right from the start?

The opening reviews focused on the public's fascination with the work, and subsequent notices concentrated not on its artistic merits, but on how its fame has remained undiminished. Public opinion has enshrined the image ever since. No art history survey text is without it—no overview of American painting can omit it. No advertising agency, needing an immediate reference point, can resist it. The parodies

heaped on the painting have only made it more famous. Indeed, when the painting travels to exhibitions in other museums, people line up to see it, much the way the *Mona Lisa* was treated on its trip to America in 1963.

The Des Moines Art Center reported record attendance to a new exhibition that featured the painting in 2009. So much have press accounts heralded the arrival of *American Gothic* that some news articles failed even to mention the name of the exhibition, or the intended purpose of bringing the painting to Iowa. What is mentioned, however, are anecdotes concerning public impressions about the painting. Take for example, one set of parents who felt it was imperative to expose their three-week-old child to great art:

> Among those coming to see it on Thursday were Emily Bahnsen and her newborn daughter, who slept through the experience. Bahnsen said that wasn't important. "It's great to expose art to kids at an early age," she said. "We're just starting at three weeks."[2]

Grant Wood began his artistic training at a young age, perhaps not so young as our friend quoted above. First traveling America and then Europe, Wood felt compelled to personally see the profoundly influential modernist trends current in Germany. He was particularly fascinated by a school called New Objectivity, a movement whose chief proponent, Max Beckmann, shares some parallels with Wood's own work. Wood enjoyed the direct German style of painting, with is sharp, angular folds and clearly detailed rendering of forms. New Objectivity artists rejected the innovations of cubism and abstract painting as cool and aloof, filled with theory but no relevance. Beckmann lambasted modern French movements, labeling them as detached from reality; he wanted a return to an objective way of looking at art and giving art a social purpose. "Let us hope that, from a mindless imitation of the visible, a feeble, backward-looking degeneration into empty decoration and a false, sentimental, inflated mysticism, we are now arriving at a transcendent objectivity arising from a deep love of nature and human beings."[3] Wood saw much to admire in the Beckmann style of painting, a style that would eventually be labeled as degenerate by the Nazis.

Wood was also deeply taken with paintings from the northern Renaissance, whose hard-edged realism and carefully manipulated compositions have an appropriate echo in Wood's paintings. He toured Belgium and the Netherlands particularly to see the works of Jan van Eyck and Rogier van der Weyden, the greatest proponents of that style from the fifteenth century.

American Gothic invites storytelling. Just who are these people? Do they represent us? Do they live in the house behind? Is this a married couple? If so, what is being said about marriage? About America?

Those who have studied the painting have been tempted to come to a conclusion, to definitely unravel the masterpiece, but to their own peril. The painting is more surrealist than the casual observer—or art historian—is willing to admit.

Wood may not have been impacted by the surrealist movement, which was at its apogee in 1930, but he was aware of it as a driving force in modern art. International reputations were already established for leading proponents of the style, and these artists were at the height of their greatest work.

Good surrealist paintings have titles that confound the viewer, adding another level of ambiguity to an already perplexing composition. One only has to refer to any of a number of paintings by Rene Magritte or Salvador Dalí to realize that painting titles like *This Is Not a Pipe* and *The Persistence of Memory* are not meant to clarify meaning.

The title of Wood's painting is *American Gothic*, not *Midwestern Gothic*, or *Iowan Gothic*. True, the painting shows an actual home in Eldon, Iowa, a house that has since been donated to the Iowa Historical Society and whose exterior is on view to the curious and interested. Little else in the painting rivets the work just to Iowa, as opposed to any other farming community virtually anywhere in the United States in 1930. As author Steven Biel argues, Iowans had become representative Americans by 1930 and these figures may have symbolized typical American citizens.[4] Indeed, the title does suggest that all Americans are somehow represented in these iconic visages.

The word "Gothic" also confounds the viewer. The pointed arch window in the center of the second floor of the house, said to have been purchased from a Sears catalog, is in an American style now called Carpenter Gothic. What else is Gothic? If we take the traditional art-historical definition, meaning a style of European art in the late Middle Ages, only a little. *American Gothic* shares a striking similarity to sculpture groups like the Royal Portals of Chartres in their stiffness, vertical thrust, and authoritative character. They even share the same elongation in their faces, drapery, and attributes.

The house in Eldon, Iowa, that Grant Wood used as a backdrop for *American Gothic* has become a tourist attraction in its own right. *Shutterstock*

If we take "Gothic" to mean macabre or gruesome, then a new level of satire has been layered onto the painting's meaning. Examining the pitchfork—the devil's attribute—in this context seems to have a gothic connotation, especially since it is echoed in the man's garments, as well as in the vertically tipped elements of the house behind. One could see a contrast between these pitchforked motifs and the gentle suggestion of crosses in the window frames.

These influences were brought to bear on Wood's mature work, which contains at once a photographic realism and at other times an almost surrealist atmosphere.

In some ways this painting has encapsulated Grant Wood's entire output. Most people cannot name a second painting by Wood, nor can they tell you where his paintings currently hang. Indeed, when Wood entered his painting *The Midnight Ride of Paul Revere* into the 1931 annual exhibition at the Art Institute of Chicago, one critic said it was "lively in pattern, but off in color," and then "its color shortcomings are demonstrated by the fact that the picture doesn't live up to the promise of its photograph."[5] Whatever that really means.

Certainly critics must have been waiting for another big splash in Chicago's artistic waters. What they got was an iconic theme, the midnight ride of Paul Revere, and it too was handled in an unexpected way, revealing a new twist on a familiar subject, and a strangely surrealist image of well-lighted, almost futuristic, eighteenth-century homes with manicured roads and lawns.

No one is suggesting that Grant Wood is a closet Salvador Dalí or Rene Magritte, no matter how guardedly the term "surrealist" is used. Nevertheless, the careful arrangement of clear-cut elements in this painting seems to owe much to the world of irony, a world that surrealists have certainly firmly occupied.

Those influences explain only part of the appeal of this work. Moreover, it is *American Gothic*'s use of irony that captivates its audience, and irony is an ingredient almost unknown in the northern Renaissance. However, New Objectivity painters did use irony, and it almost always tended to be overt and heavy handed. One wonders if *American Gothic* is a parody of American life or a celebration of American determination and survival. The artist does not provide an easy solution, and perhaps that's the reason why it produces such vehement denunciations and wild theories. Somehow, no matter what, it reminds the viewer of people he or she knows. "It brings back a lot of memories," says Thom Davis, a social studies teacher from Johnston, Iowa. "It's neat to think about how it captures the simplicity of the time. I think of my father, who was a farmer. He lived a simple life, yet he was a hard worker. My father died at 65. He could have passed for 80. You think of the stress of farming."[6]

The painting also has a surreal history of interpretation that is encouraged by the artist himself. While the two figures have been widely and solidly identified as the artist's dentist and the artist's sister, it has not been equally clear if it is meant to be a representation of a husband and wife or a father and his daughter. The models were age sixty-two and thirty, respectively, when painted, but the age of the woman has been dramatically, almost ambiguously, enhanced. Time has not been kind to this woman;

she has been weathered beyond her years; her severe hair and sloping shoulders imply a much greater age. Moreover, her chest seems nearly missing, her femininity suggested almost entirely by an old-fashioned cameo, said to belong to Wood's mother, hanging from an almost priest-like collar.

The issue is further complicated by Wood's search of a model for the woman, at first setting his sights on a local spinster in Cedar Rapids whom he could not bring himself to ask to pose.[7] Wood's sister was then asked to fill in. So is this a man and his spinster daughter, or could this still be a husband and wife regardless of the status of the models? When it was purchased by the Art Institute, it was clearly thought to be "a double portrait of an Iowa farmer and his wife."[8] Indeed, the ambiguity does add another level of irony, one that Wood enjoyed, no doubt, perhaps in the way readers of poetry find layers of contradictory meaning in a well-crafted sonnet.

When Iowa farmwives howled in protest over the painting, were they reacting to what they saw? Or what they chose to see? Wood did nothing to assuage the criticism by alleging, rather improbably, that the man in the painting might not even be a farmer.[9] How many other occupations have people holding pitchforks, even occasionally?

Some scholars see a deeper meaning behind the two faces. Art historian Sue Taylor observed that the woman is not just Grant Wood's sister as a model, but as a reflection of his sister's relationship with her husband, a domineering and intimidating mate. Furthermore, the sister then acts as a surrogate for their mother, Hattie Weaver Wood, who, like in the painting, is a farmer. Perhaps this is signaled in Wood's own testimony about the painting, in which he hinted that the figures were "tintypes from my own family album."[10]

On one level it's hard not to see this work as an expression of traditional values espoused by hardworking people. The simple house, with the tidy front porch filled with potted plants, the crisp, straightforward design of the curtains in the windows echoed in the print on the woman's dress, the single cameo adorning the neckline of the woman—all these attributes suggest a direct, sincere, and industrious couple whose modest achievements have been won with some struggle and a certain rigidity.

When a philanthropic group called the Friends of American Art first saw the painting, they insisted on buying it for the Art Institute of Chicago at the price of $300, and so it ended up in the museum almost immediately. Interestingly the *Bulletin* that announced its purchase claimed that

> the Friends of American Art have purchased the painting for their collection, because they believe that the artist has here portrayed an authentic bit of Americana in a thoroughly native way.[11]

However, it's those two great heads and that fierce pitchfork that lead us to feel that perhaps a satire is at work. Some declare it is a ridiculing of the narrow-mindedness of midwestern culture, representing an inflexibility that borders on repression. The crystal clarity of the painted surface and the hard-edged lines enhance that feeling.

Herein lies the birth of the picture's fame. The traditionalists immediately seized on the positive elements of the depiction. If hard work is a virtue, and a tough life has to be scratched out of an unforgiving Iowa landscape, then these people should be

justifiably proud of their survival and achievement. Wood imbued these sitters with a Victorian-era style of dress, and posed them as if they were as stiff as daguerreotype subjects standing attentively forward for fear they could blur the picture.

Satirists, on the other hand, see much to despise in these figures. Their icon-like stance has caused derision—people accusing them of possessing all the wrong qualities of the American lifestyle. Grant Wood reacted to the claim that this was a satire by stating in a 1941 letter that he "did not intend this painting as a satire. I endeavored to paint these people as they existed for me in the life I knew."[12]

Not everyone has been so quick to agree. When the *Boston Herald* critic first saw the work, he found the couple "caricatured so slightly that it is double cruel, and though we know nothing of the artist and his history, we cannot help believing that as a youth he suffered tortures from these people."[13] Art historian Matthew Baigell considered the couple savage, even exuding "a generalized, barely repressed animosity that borders on venom." He argued further that the painting satirizes "people who would live in a pretentious house with medieval ornamentation, as well as the narrow prejudices associated with life in the Bible Belt."[14]

The fame therefore comes not only from the enduring quality of the image, but what it has come to represent. It is the ambiguity of form and interpretation that has made the painting easy pickings for parodists. It has been decided that the figures are "funny looking" and can therefore be subject to ridicule, and the painting has been made into an endless series of jokes.

The painting also seems to invite comparisons with other works of art, showing couples in similar poses. One such group, *Arnolfini and His Bride* by Jan van Eyck, has a statically grouped couple in their bedroom—the man confronting the viewer directly and the woman averting her gaze. Recently this painting's traditional interpretation of being a wedding portrait has been called into question, creating a modern dilemma over the meaning—a dilemma one suspects exists only in the modern mind; everyone in the fifteenth century would probably have understood the meaning behind the gestures and expressions of this less than dynamic couple. If they are getting married, why is there no priest to preside? Why does this wedding take place in a bedroom? What does the dog represent? Or the one lighted candle in the chandelier? Such incongruities and multiple layers of meaning may have served as a general influence on the figures in *American Gothic*.

Like *Arnolfini*, *American Gothic* has a life in parody, outside the realm of the original painting. Visitors to Eldon can borrow a pitchfork or nearly any other large object from a nearby visitor's center and pose for their own version. In these playful photographic parodies the mixed realms of the real, the painted, and the surreal collide. Many artistic sites around the world have inspired similar antics. Those making the trek to Pisa to see the Leaning Tower will be treated to the sideshow of legions of tourists taking photographs of their friends leaning this way or that.

No one has been immune to the effects of *American Gothic*. Presidents, Hollywood stars, Barbie and Ken, even Kermit and Miss Piggy have been photomontaged onto the picture. The Broadway hit *Music Man* takes place "right here in River City," Iowa, and features a couple who suddenly form a tableau, frame and all, of the painting. This is surreal in its own way, since *Music Man* is said to take place in 1912,

eighteen years before the painting was painted! General Mills marketed New Country Corn Flakes, whose 1960s television commercial featured a tableau of the figures singing, "New Country Corn Flakes! Please buy our Corn Flakes! Oh they won't wilt when you pour on milk!" Fiction meets another form of fiction.

Not every parody is an inane capitalization on the fame of the original; in fact, *American Gothic* has been the foundation for a number of serious works in their own right. The most famous is by the African American photographer and filmmaker Gordon Parks, who, while visiting Washington, D.C., in 1942, happened upon Ella Watson, a cleaning woman in a government building:

> That was my first day in Washington, D.C., in 1942. I had experienced a kind of bigotry and discrimination here that I never expected to experience. And I photographed her after everyone had left the building. At first, I asked her about her life, what it was like, and so disastrous that I felt that I must photograph this woman in a way that would make me feel or make the public feel about what Washington, D.C. was in 1942. So I put her before the American flag with a broom in one hand and a mop in another. And I said, "American Gothic"—that's how I felt at the moment. I didn't care about what anybody else felt. That's what I felt about America and Ella Watson's position inside America.[15]

If Wood's painting is supposed to be a paean to an American past that perhaps never was, then the figure of Ella Watson is an ironic commentary on the inequality that past represents. If Wood's painting is a satire on what his sitters represent, then Parks's photograph layers another level of meaning on this satire.

Critical opinion of *American Gothic*, however, has been far from unanimous. It has been censured by many art historians for being intransigent and conservative. Midcentury critics believed that the only successful contemporary artists are the ones from the New York school; attempts at realism were branded as reactionary—holding little meaning to the modern viewer.

However, this is exactly the point of *American Gothic* and its fame. The painting looks back, nostalgically, on the past. The figures are dressed in nineteenth-century fashion before a traditional home in a rural setting. This is America as it exists not so much in reality, but in the collective conscience of its citizens.

Wood's membership in the art movement called regionalism also hampered efforts to promote his paintings outside the realist realm. Regionalism refers to a style of painting exemplified by midwestern artists of the early twentieth century, although one could argue any portion of the United States could be expressed as a region, and therefore regionalism could apply to them as well. Wood embraced the term and promoted his allegiance to the movement. This is ironic in some ways, because Wood's exposure to modern art was widespread and dynamic; as we have seen, he traveled to Europe four times to study the old masters as well as modern movements. While in Europe he painted the requisite number of nudes and fountains, but when he returned to the Midwest he discovered, to no one's real surprise, that these subjects were unwanted and unsellable. American painters in the early twentieth century generally turned out landscapes, genre paintings, or portraits for

their clients, not exactly the kind of material being generated in Parisian art galleries filled with cubist and surrealist creations.

Wood's paintings of rural America today are less interesting than his thematic paintings, like *American Gothic* and *The Midnight Ride of Paul Revere*, precisely because of the ambiguities that are in play.

After Wood's death, the critics were waiting. Already regionalism had been swept away by a torrent called abstract expressionism in the late 1940s. This left artists like Wood looking instantly aged, far older than their works would appear. How could *American Gothic* compete in an art world dominated by Pollock's action paintings, and De Kooning's women?

Abstract art, however, was happening a little too fast. The American public had not caught up with the latest artists and their creations, seeing the achievements of the New York school as the product of eastern sophisticates who had so immersed themselves in theory that they couldn't see with their own eyes. They viewed Pollocks and De Koonings as trite and simplistic and encapsulated their feelings with the phrase "I could do that."

But eastern critics would not be so easily dismissed. Among the first to blast *American Gothic* with critical disapproval was Mr. Institutional Art History himself, H. W. Janson, future author of the iconic *History of Art*—the text that was eventually to be the standard college art history survey reference in the 1960s and 1970s.

He despised the regionalists and did everything in his power to belittle them, saving special venom for *American Gothic* and Grant Wood. Janson paralleled the rise of regionalist painting with the worst abuses of artistic life under none other than Adolf Hitler. There is almost a fear of Wood's art in Janson's essays. He was particularly suspicious of Wood's broad appeal that stood, he claimed, as a warning for artists and critics to beware of the opinions of the general public. "Equally coincidental," Janson wrote, "but no less interesting, is the fact that many of the paintings officially approved by the Nazis recall the works of the regionalists in this country."[16] Perhaps Janson was unaware that Wood's chief inspiration, the New Objectivity artists, were condemned by the Nazis and driven from Germany.

Today some of the accusations Janson leveled at the regionalists seem curious. His insistence that these artists propounded a theory that "imagination in any form is frowned upon" seems wildly exaggerated. At the height of his fever the big guns were drawn up at *American Gothic*:

> *American Gothic*, his first popular success, had been intended as a satire on small-town American life, and it was only after the public in the "Eastern capitals of finance and politics" had refused to regard it as such, and Wood found himself acclaimed as the pictorial defender of the hinterland, that he began to adjust his point of view in accordance with the trend of the times.[17]

With such serious leaps of logic couched in deft prose Janson hoped to label *American Gothic* as a satire and its author an opportunist, almost as if to say no great artist in history has ever changed his or her mind about the meaning of a particular work. When Janson came to writing his *History of Art*, he left the painting out of the

first three editions—no regionalist was going to be found besmirching his text, nor was the reader going to get confused as to what *truly* is art. Apparently he must have felt that way about female painters and their works as well, since they were also uniformly banned from early editions.

It is unfair to suggest that Janson was the only critic to attack *American Gothic*, but he was one of the most virulent. Clement Greenberg, the esteemed troubadour of the avant-garde, satisfied himself with only a few sidelong, sneering glances:

> And when one has exposed oneself long enough to contemporary art, one begins to realize that the unsuccessful pictures of a good many abstract painters are more interesting than the most brilliantly successful pictures of such painters as Grant Wood.[18]

> What I do know is that Benton is and Wood was among the notable vulgarizers of our period: they offered us an inferior product under the guise of high art.[19]

In spite of and perhaps because of the ruminations of testy critics, the fame of the painting increased. Eventually *American Gothic* became the painting critics loved to hate; in fact, it is no exaggeration to call the painting critic-proof. The public will could not be denied, and slowly it began working its way into survey art texts, eventually appearing in Janson's own *History of Art*, albeit long after his death. Today the book is authored by six different writers, the one dealing with modern art seeing it as an essential edition to the canon. H. W. must be turning over in his grave.

One of the more troubling aspects *American Gothic* presents is the need to decide on the meaning. Instead of allowing the painting's multiple layers of interpretation to remain just that, there has been a critical push to definitively unravel the contents. Scholars beware! Scores of well-meaning dissertation writers have claimed to reveal the ultimate interpretation of such masterpieces as Velazquez's *Las Meninas*, Raphael's *Sistine Madonna*, and Giorgione's *The Tempest* only to have them critically shipwrecked by the succeeding generation of scholars.

American critic Robert Hughes understands the multiple layers of meaning, but perhaps misunderstands the author's intent:

> The answer in a sense is both: a mass audience was intrigued by the image because it couldn't quite decide either. Generally, the assumption that *American Gothic* was a satire tends to increase in direct proportion to one's distance eastward from Cedar Rapids.[20]

But isn't that a bit like saying that Robert Frost could not decide on the meaning of a poem, so he left it deliberately ambiguous? As the great poet said, "That's the way I write a poem . . . getting a small piece of it in my hands and pulling it out and not knowing whether it is a man or a woman. I never started a poem yet whose end I knew. Writing is discovering."[21] Let's give Grant Wood the same satisfaction.

Migrant Mother by Dorothea Lange

The Power of the Press

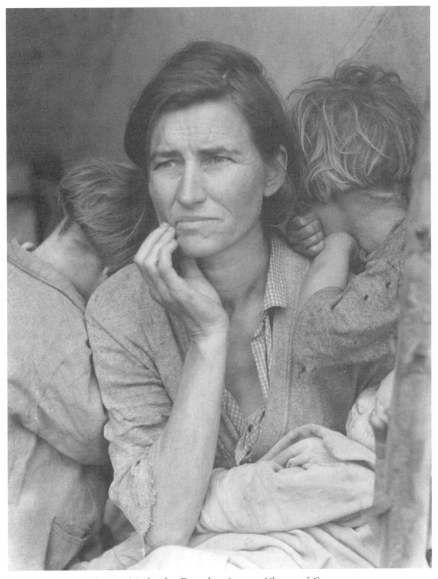

Migrant Mother by Dorothea Lange. *Library of Congress*

We were embarrassed by that picture.

—Katherine McIntosh, daughter of Florence Thompson,
quoted in a 2009 *San Francisco Chronicle* article

In a world filled with vivid 3-D and virtual reality images, it is amazing that some of the most famous pictures are black-and-white stills rather than colorful movie clips. Among the most famous photographs of the twentieth century is one of a sailor kissing a nurse in Times Square on V-J Day on August 14, 1945. This photograph was taken by photojournalist Alfred Eisenstaedt for *Life* magazine, and appeared in a twelve-page section entitled *Victory Celebrations* a week after being taken.

There is also a famous picture of men eating lunch on an I beam on the sixty-ninth floor of the RCA Building taken on September 29, 1932. This photo, which was not attributed at the time to any photographer, was later discovered to have been taken by Charles C. Ebbets. It was printed as *Men at Lunch* in the *New York Herald Tribune* Sunday supplement on October 2, 1932.

Perhaps the most famous war photograph depicts the U.S. Marines raising an American flag on the crest of Mount Suribachi, in Okinawa, taken by Joe Rosenthal and distributed by the Associated Press. It appeared in dozens of newspapers across the United States simultaneously.

The fame of these photographs all have in common the debt they owe to print media. Today newspapers and magazines have almost gone the way of the world, but their impact on the public consciousness in the first seven decades of the twentieth century is incalculable. Their technology, however, is outdated, first knocked down by the immediacy of television news, and then anesthetized by the general decline in reading and the advent of the Internet. Americans don't want to pay for news, especially news they have to read.

It is unlikely newspapers or magazines will ever again propel a great photograph onto the public consciousness, but at one time they were the only way a photographer could become famous. Art photographers like Alfred Stieglitz were people who supplemented their income by doing things like running galleries and selling paintings. It helped that Stieglitz was married to Georgia O'Keeffe, one of the finest American painters of the century. It also helped that he had money. None of Stieglitz's works, no matter how central to the development of the history of photography they are, have ever achieved the fame that Eisenstaedt, Ebbets, and Rosenthal have had with their pictures, because Stieglitz's work did not appear in newspapers. They were considered a cheap, impermanent venue for a sophisticated artist.

Photojournalists, on the other hand, were people who were never short of work, newspapers increasingly adding space for photographs as the news became more picture oriented. This is how *Migrant Mother* made its first impact, even though the photographer, Dorothea Lange, was not technically a photojournalist.

∽

Dorothea Lange knew hardship growing up, as much anyone. Born in New Jersey into a family that was never close, Dorothea struggled to grow up with a sense of love and belonging. Her father left the family when she was twelve and was never heard from

again. She lived with a grandmother who today would be diagnosed as bipolar. Her demanding screaming fits, for example, often sent people in the house running for cover.

At age seven, young Dorothea contracted polio, which severely crippled her in one leg, and left great psychological scars for the rest of her life. She was deeply ashamed of her limp, and even more ashamed that her parents were ashamed of her. For the rest of her life she wore very long dresses or pants to disguise the limp as much as possible. Later in life, she felt that the lameness in her leg was actually an asset when approaching people and asking for photographs. Many felt sympathy. Others felt companionship.

In the early twentieth century it was customary for young ladies who were interested in careers to enter either nursing or teaching; available options were not numerous. Lange's decision to become a photographer was sudden and determined, and certainly curious. She had enrolled in the New York Training School for Teachers, which was supposed to prepare young ladies for a genteel profession. She was very ill suited, suddenly showing the same kind of mood swings her grandmother evinced at home.

She took odd jobs working for various photographers in New York, and eventually broke the news to her family that she was not going to become a teacher. Photography, in the early twentieth century, was not an art, but a trade. Being a photographer meant taking portraits. No one was ready to hang landscape or still life photographs on a wall as if they were paintings.

Lange felt she had a natural proclivity for portrait photography, and she wanted to do it as far from home as possible. She and a close friend packed their bags and ended up in San Francisco, where, it was hoped, she could establish herself as a photographer to the rising middle class in this port city.

At this humble stage of life, Lange already showed the progress she was about to make as a future documentary photographer. She concentrated on the personalities of the sitters, making sure to reveal their expressions and their moods, not through props, dramatics, histrionics, or clothing, but through poses, attitudes, and lighting. There were no artificial drapes, no exaggerated posturing, no special effects. These photographs have a timeless quality, all characteristics of the Depression-era photographs taken later in life.

While Lange was very concerned with how to take the photograph, she was relatively uninterested in the mechanical developing process. Photographers like Ansel Adams spent as much time in the lab as in the field, seeking to achieve just the right optical effects. Lange, as often as not, just sent her photographs out to be developed. While she was working for the government in the 1930s, she developed very little; everything was sent to Washington.

Similarly Lange did not explore the possibilities of cutting-edge developments in photographic equipment, whether through her own disinterest or because such things cost more money than her resources could provide. For *Migrant Mother* she used a Graflex camera that produced negatives that were 4" by 5". The Graflex had the reputation among fine art photographers because it was capable of achieving special effects. Lange's camera had an extended bellows that could be used to achieve a sharp or soft focus on its subjects.

When the Depression hit San Francisco, and the unemployed roved listlessly around the city, Lange had the sense that there was something deeper that she could

accomplish. She took her camera and went down to an area where a philanthropic woman, nicknamed the White Angel, was distributing bread to the needy. She concentrated on a poor older man with a pathetic tin cup. He had turned away from the free bread and rested himself on a railing, perhaps waiting for the inevitable. At that moment, with her camera, Lange saw her future not as a portrait photographer in the conventional sense, but as someone who could use photographs to capture the soul of a nation. When people saw the photograph pinned to her studio wall, they looked at her and asked, "What are you going to do with this kind of thing?"[1] It was one thing to take such a picture, but another to make a living doing it.

The simple solution for a while was to continue doing portraits to fund her interest in documentary photography, but the truth was she had been doing portraits as a form of documentary photography all along.

Lange had a simple, yet extremely effective, way of working with people. She could walk up to the most destitute person and strike up a conversation, letting people know that they weren't merely subjects, but part of a larger narrative that she was trying to capture. She often wrote down the words people said, while she still remembered them. She was not terribly interested in names, however, perhaps feeling it was a little too personal. She said she had a "cloak of invisibility,"[2] perhaps gleaned from her experiences growing up and hiding her lameness from people's eyes.

When she eventually landed an on-again-off-again job for the Resettlement Administration of the federal government, it was her highly polished photographs that secured her placement as a staff photographer. Lange was different than other photographers of the time, however. She never tried to degrade her subjects or make them feel pitiable. She heavily criticized Margaret Bourke-White, whom she accused of sensationalizing the poverty of her subjects to gather attention to herself.

It was in this atmosphere that Lange decided to change course one day and follow her instincts to go down a dirt road to see migrants in a pea-pickers camp. She later recalled the events of the day:

> Having well convinced myself for 20 miles that I could continue on, I did the opposite. Almost without realizing what I was doing I made a U-turn on the empty highway. I went back those 20 miles and turned off the highway at that sign, PEA PICKERS CAMP.
>
> I was following instinct, not reason; I drove into that wet and soggy camp and parked my car like a homing pigeon.
>
> I saw and approached the hungry and desperate mother, as if drawn by a magnet. I do not remember how I explained my presence or my camera to her but I do remember she asked me no questions. I made five exposures, working closer and closer from the same direction. I did not ask her name or her history. She told me her age, that she was 32. She said that they had been living on frozen vegetables from the surrounding fields, and birds that the children killed. She had just sold the tires from her car to buy food. There she sat in that lean-to tent with her children huddled around her, and seemed to know that my pictures might help her, and so she helped me. There was a sort of equality about it.
>
> The pea crop at Nipomo had frozen and there was no work for anybody. But I did not approach the tents and shelters of other stranded pea-pickers. It was not necessary; I knew I had recorded the essence of my assignment.[3]

Lange took six, maybe seven pictures of the event; the exact number has never been firmly established, because occasionally other versions have turned up. Each photo in the series gets closer to the mother, Florence Thompson, and starts to eliminate some of the children. The teenager was taken out of the equation, because Lange felt that it would draw criticism against the mother, who may have had her when she was too young for society's sympathy. The other children proved rascally and fidgety and were tough to control. More importantly, Lange had very little experience working with children and did not know how to engage them effectively for the camera. A famous photo of her son handing her flowers on Mother's Day is all about an outstretched hand with flowers; the child is missing, as is the mother's response. One wonders how the child must have felt having picked flowers for his mother on Mother's Day, a mother he hadn't seen in months because he was placed in a foster home while she was on the road, to have her jump out of her car with a camera pointed at the flowers.

At one point she asked the two Thompson children to look away from the camera, so that now the back of their heads could act as a frame for the mother's face. Lange took a gamble. The mother certainly had better things to do than pose for photographs. The children could have wiggled their way into blurring the picture, and the sleeping child could have awakened. Lange suggested that Florence Thompson bring her right hand to her face and look away. This gesture brought the meaning of the photographic shoot to life in a very memorable, if highly posed, photograph.[4] The picture succeeds not only because of Florence Thompson's expression, but also because we see the back of the children's heads; we don't have a row of faces, but two backs framing Florence Thompson's countenance. While the photograph has the effect of looking like a candid, in reality the picture was very tightly composed, designed for maximum effect.

Lange may have had a burst of inspiration for the effect she achieved, but she also relied on her experience in the studio. Florence Thompson's pose was one she used over and over again for a variety of expressions: from lighthearted to ominous to thoughtful. She even used the pose in pictures of herself taken by other photographers.

Duly impressed with this session, Lange felt the urge to immediately develop her photos herself and see if they could be put to good use. She told the city editor of the *San Francisco News* that pea pickers in Nipomo were starving to death, and that something had to be done to rescue them. United Press put a story together that the federal government was sending twenty thousand pounds of food into the camp as a rescue mission. The paper printed two of Lange's photographs, although not the famous one, as an illustration of poverty. *Migrant Mother* had to wait until September when it was printed in a publication called *Survey Graphic* with a caption that said "Draggin'-Around People." Both Lange and the Resettlement Administration were given credit.

Survey Graphic was a journal that tackled important social issues of the day, including housing, labor, nutrition, and racism. The writers were all prominent social thinkers of the time, including Paul Taylor, Dorothea Lange's second husband. Once seen there, it was picked up by *U.S. Camera*, a publication that was a champion of New Deal photography, especially pictures taken by the Farm Security Administration, the succeeding organization to the Resettlement Administration. *U.S. Camera* was published by New York advertising executer Tom Maloney. Maloney's principal adviser

was the esteemed art photographer Edward Steichen, who often hand chose some of the works that would enter the annual publication. Both Maloney and Steichen asked viewers to examine the works aesthetically as well as for their social message—a new way of looking at these pictures. The bureaucrats at the Farm Security Administration had no such interest; there was an agenda to be met, and these photographs were key to getting the message out.[5]

Steichen made a pitch for what he called art photography, and in 1941 the photograph made its way into the collection of the Museum of Modern Art in New York. It was officially accepted.

Because it was a photograph, it could be reproduced, and everyone could have one. The Metropolitan Museum in New York has one, as does the Oakland Museum of California, and dozens and dozens of others. Because the original was owned by the Library of Congress, courtesy of the federal program called the Resettlement Administration, there were no known copyright restrictions about the work, so it could be reproduced literally everywhere. And was. It was used as a foundation for a number of causes from Latin America to Russia. It was even colorized, an effect that curiously minimizes the pain of the Great Depression.

Textbooks dealing with the 1930s feature this photograph for a variety of reasons independent of its quality. Publishers and authors did not have to pay a royalty fee for pictures owned by the Library of Congress and sponsored by the federal government. Who could resist free pictures of such high quality?

Lost in all this is the subject of the photograph, a woman with a great deal of patience, who humored Lange long enough to have her picture taken. Clearly, she had more pressing issues on her mind.

Florence Owens Thompson was born in 1903 on an Indian reservation in Oklahoma, "in a tepee,"[6] she once said. Although her father died when she was a teenager, her mother lived, it is said, to 108. Things were never good for Florence; she and her husband had already been on the road looking for work in California even before the Depression hit. "I left Oklahoma in 1925 and went to Oroville [California]. That's where them three girls' dad [Cleo] died . . . [in] 1931. And I was 28 years old, and I had five kids and that one [the baby in this photo, Norma] was on the road. She never even saw her daddy. She was born after he died. It was very hard."[7]

Life was indeed very hard. Florence worked in the fields, picking between 450 and five hundred pounds of cotton a day, just to feed the family. But she wasn't destitute. The way she tells the story: "Well, [in 1936] we started from L.A. to Watsonville. And the timing chain broke on my car. And I had a guy to pull into this pea camp in Nipomo. I started to cook dinner for my kids, and all the little kids around the camp came in. 'Can I have a bite? Can I have a bite?' And they was hungry, them people was. And I got my car fixed, and I was just getting ready to pull out when she [Dorothea Lange] come back and snapped my picture."[8]

Meanwhile, Florence Thompson had no idea that her pictures were going into newspapers. She said that Lange promised her that the photographs would never be

published, and was shocked to learn that they had. Her eldest son, Leroy, was staying with an uncle and worked the local paper route when he discovered, much to his surprise, that his mother made the paper. Thompson's grandson, Roger Sprague, tells the story that Leroy "ran all the way to his uncle's place to tell them his mother was dead. Why else would a poor person's picture be in the paper?"[9] To make the impact even greater, Leroy saw the published photo not as it was supposed to be represented, but with a printing press ink blot square in the middle of the head, making it look as if Thompson had been shot.

Needless to say, Thompson was far from dead, and far from comprehending the seismic impact the photograph was about to have on the Depression-era politics and the history of photography.

Thompson was not happy when she realized that the photograph was not only published, but had become a worldwide icon for suffering. She felt exploited. "I wish she hadn't taken my picture," she declared. "I can't get a penny out of it. [Lange] didn't ask my name. She said she wouldn't sell the pictures. She said she'd send me a copy. She never did."[10] Even if Lange could have sent the images, finding Thompson would have been no mean feat.

Lange did not make a dollar from the picture, not materially, anyway. The photograph did open up great opportunities for her, however, ones that would not have been available otherwise. Thompson, however, remained extremely bitter. She felt that others made money off her image, which she posed for, so why couldn't she? Ultimately she had ten children, and was very much in need; couldn't the Library of Congress send her some of the $120 a print that they charged for the image? The short answer, apparently, was no.

It took years for Florence Thompson to publicly admit that she was the subject in the famous photograph. On October 10, 1978, she finally spoke candidly to a reporter from the *Modesto Bee* about the picture and what it did for her, perhaps meaning to set the record straight. Lange did not get all the details of the image right: in particular the notion that she somehow was marooned because she sold her car tires for food, or that she was starving to death. She also didn't like the statement that the photograph saved her life, a notion that persists so strongly that it was repeated in a catalog accompanying a Lange exhibit at the San Francisco Museum of Modern Art in 2001. Florence Thompson's "life [was] likely saved by Lange's photo," curator Sandra Phillips said.[11]

Thompson's children groan at the contrast between the reality they knew and the legends that grew up around the photograph. "We were embarrassed by that picture," Katherine McIntosh, her daughter, the person on the left in the photo, said recently while relaxing at a park in Modesto, where she's lived most of her life. "We didn't want people to know we were poor. But we are proud of the story behind the picture."[12] "Our life was hard long after that photograph was taken," Ms. McIntosh added. "That photo never gave mother or us kids any relief."[13]

Misfortune struck again to Katherine McIntosh. A fire swept through her home in 2007, gutting the interior. Everything was lost, including a framed photo of her mother in the iconic photograph. Suddenly, at seventy-five, she was homeless again, as she had been as a child.[14]

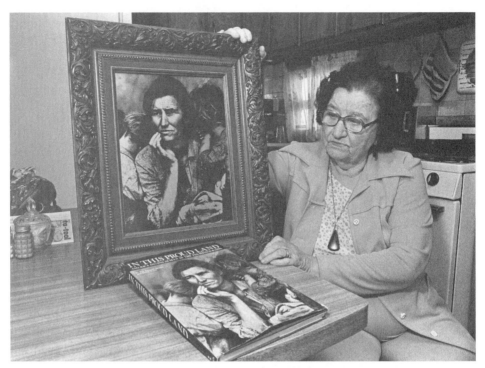

Florence Thompson is shown on October 10, 1978, during an interview with *Modesto Bee* reporter Emmett Corrigan. Acting on a tip, Corrigan found her at Modesto Mobile Village. She poses with copies of her famous photograph. © *Modesto Bee*

It is hard for us today to realize the impact a single photograph can have on the human consciousness, because we live in a world that is so glutted with images that we become desensitized to the impact one frame can have. So powerful was *Migrant Mother* that Lange was accused of hiring an actress to achieve maximum effect, because a poor person could never achieve such pathos, it was thought. Anti–New Deal Republicans accused her of staging photographs for a political agenda.[15]

The truth is that Lange did touch up her photographs when she felt they needed to be. A mysterious finger, probably a thumb, appears in the original at the bottom. Lange felt that the finger detracted from the overall effect of the picture. This thumb became what Lange called "a glaring defect" in the work, which went unnoticed at the time of the photo shoot but emerged significantly when the picture was developed. Perhaps Thompson stuck out her hand to steady her baby by holding on to the tent pole on the right. At any rate, Lange had the offensive digit removed. This caused a thunderstorm of protests. If one thing is altered, who is to say that the whole thing has not been rearranged in some way? The criticism hurt, but it did not affect the overall reception of the photograph.

The issue of whether or not to retouch, enlarge, or crop photographs has been around since photography was invented in 1839. Paul Strand, one of the pioneers

of modern photography, famously proclaimed that he was a purist, but later in life admitted, "It wasn't true even then." It turns out that even he cropped, enlarged, and retouched photographs routinely, "and had no great feeling of guilt" about it.[16]

The fame of *Migrant Mother* has remained undiminished. In 1998 it was issued on a U.S. postage stamp that was part of a series called "Celebrate the Century." The stamp featured the photograph with the caption "America Survives the Depression." That year, a retouched image of the photograph, with Lange's notes, were sold at Sotheby's for $244,000.

The photograph began to assume a life of its own, symbolizing an array of causes and activities. Most importantly, it has come to represent the whole documentary photography movement that was so important to capturing the spirit of the Depression. Lange did not like the term "documentary photography," but no one was able to come up with a suitable substitute.

More strikingly, the photograph has become the way we remember the Great Depression. More than John Steinbeck's *The Grapes of Wrath*, it has come to symbolize all that went wrong with the economic and agricultural policies of the 1920s that reduced people to ashes in the 1930s. It has also symbolized the strength of individuals who saw past the setbacks of today to create a world for tomorrow. Fittingly when Hollywood made a movie of *The Grapes of Wrath* in 1940 it was memorializing a Depression that was almost completely over, using the general influence of Lange's pictures in her and her husband's 1939 book *American Exodus* as a point of departure.[17]

In the late twentieth century revisionists were waiting, seeing the image as an example of extolling virtues of conservative stereotypes. Wendy Kozol, a cultural historian, has commented that the image was used not to stir up popular opinion over the plight of the poor, but to reassure the public that the traditional family was still a viable ideal in a world of crushing poverty.[18]

Today the image is freely labeled as an icon: an icon of the Great Depression, an icon of motherhood, an icon of poverty, an icon of victimization, and an icon of economic repression. Ultimately, it has been used as an icon for photojournalism itself.

Wherever the winds of interpretation blow, they did not blow around Florence Thompson, who spent most of her life struggling to make ends meet, no matter what others had to say. Ironically, when she contracted cancer and was faced with enormous health costs, her children used the photograph to raise money to offset the nursing home bills of $1,400 a week. Once again it was a newspaper, this time the *San Jose Mercury News*, that publicized the issue. A sum of $35,000 was raised for her hospice care, two thousand contributions coming in from across the United States. While Florence Thompson never earned a dollar from the photograph until the very end of her life, she rests in peace because of the indelible image made of her fifty years before. She is buried in Lakewood Memorial Park in Hughson, California. A plaque, flat against the ground, reads:

FLORENCE LEONA THOMPSON
MIGRANT MOTHER: A LEGEND OF THE
STRENGTH OF AMERICAN MOTHERHOOD

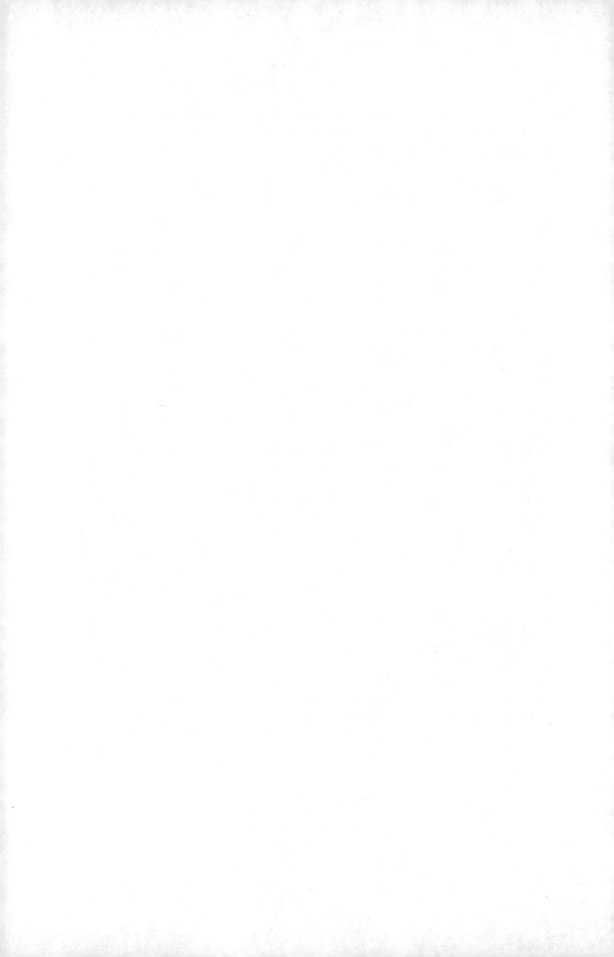

· *18* ·

Guernica by Pablo Picasso

Travels with *Guernica*

Guernica by Pablo Picasso. *Museo Nacional Cento de Arte Reina Sofia, Madrid / Bridgeman Images*

We call upon all men of good-will to protest this immense crime in the name of all that is sacred to human morality and human decency—and in the name of Almighty God.

—Times of London

Calling Pablo Picasso a great political artist is like calling Piet Mondrian the father of modern portraiture and Michelangelo the originator of pop art. In all of Picasso's output, and the *Guinness Book of World Records* says he is the most prolific painter in history, the number of political paintings he did are a precious few, fewer than five in fact.

All the more amazing that a cubist painter should come down to us as producing one of the greatest political paintings in history, and undisputedly the greatest of the twentieth century. What captivated Picasso so much that he was energized into creating this great manifesto? War atrocities came and went in Picasso's lifetime: in World War I he was in Paris maintaining his Spanish citizenship and declining to fight. In the Spanish Civil War he was again in Paris, this time as a Spanish citizen in exile, taking no part in Republican Spain's struggles. When war raged in his homeland, Picasso went on holiday to the South of France, as is the custom of every "Frenchman" in the month of August.

Later, when artists like Mondrian and Dalí saw World War II coming and fled to America, Picasso was still a Spanish citizen, and was content to remain in occupied Paris, surviving quite nicely. He even produced some of his now forgotten plays and cast some of his metal sculptures. Picasso was virtually surrounded by war and its aftereffects for most of his life. Even so, he was reluctant to entertain political subject matter in his artwork. This is not so unusual. Painters as famous as Thomas Gainsborough, Claude Monet, and Vincent van Gogh never committed themselves to political imagery, and no one today sees that as a problem.

Picasso, however, was beset by people who wanted a commitment; no doubt his celebrity could be a useful tool to enhance a cause. With this in mind, he was commissioned to paint a mural, on the subject of his choice, to hang in the lobby of the Spanish pavilion of the 1937 World's Fair in Paris.

The committee didn't give him much time. The invitation was extended in January and the fair was set to open May 24. Picasso had plenty of other work; he was by now not just an artist but an institution. He certainly was not waiting around for this large-scale commission from a besieged government. The artist mumbled a noncommittal response to the Spanish delegation, more as a way to get them out of his studio than to agree to the project. After all, he reasoned, those politicians seemed more concerned with the outcome of a pavilion in a World's Fair than with a bloody hotly contested civil war in Spain. Besides, the war was not going well for the Republicans who were sponsoring the Paris show. The mural was to be part of a propaganda-filled exhibition, to which other notable Spaniards like Julio Gonzalez had already agreed. Even American sculptor Alexander Calder had promised a work for the entrance lobby. For a painter who specialized in the cubic analysis of the human figure, politics was terra incognita.

In fact, the fair had already attracted a who's who of European artistic giants of the early modern era: Ferdinand Léger, Jean Metzinger, and Raoul Dufy committed themselves to various projects. Even the great architect Le Corbusier designed struc-

tures for the fair. Picasso was different, though—there was no denying that he was the most famous painter in the world. Whenever there was a Picasso exhibition, it was often advertised with the moniker "The World's Most Famous Painter."

But Picasso was not a political man. He refused invitations to social functions sponsored by the Spanish embassy in Paris and never took part in political rallies—up to that point. After the liberation of Paris in World War II he became a member of the Communist Party and stayed that way for the rest of his life, even though the Communists heavily criticized his work because it didn't have a socialist message.

In September 1936 he was asked to become an honorary director of the Prado Museum in Madrid, a flattering appointment even to Picasso. By November, when Nationalist troops were bombarding the city and the museum, he oversaw—safely from Paris—the transport of the museum's contents to Valencia. Sensing that even a greater war was approaching, the Prado's treasures were sent packing to Geneva. Picasso hoped that they could make it to the Paris World's Fair, but that was not to be. Tensions in Europe were far too great to risk the contents of the Prado on a daring train ride to a city that might be bombed.

Back in Paris, the Spanish World's Fair committee, who had no small part to play in giving the Prado post to Picasso, began to pressure him to come up with a subject for the exhibition space. Picasso may not have been interested in politics, but he certainly was a master politician when it came to dealing with clients.

When publisher George Macy commissioned Picasso in 1934 to design a set of prints for his limited edition of Aristophanes's *Lysistrata*, he discovered that the artist was quite the businessman:

> It required much cash, much manipulation, much pulling of strings, and a great deal of heartache and headache in getting the work out of him after he had agreed to do it. He is a charming person to talk with, a horrifyingly difficult person to do business with. . . . When I first got in touch with Picasso in Paris, he said he was willing to illustrate the book for a very stiff price. I paid the stiff price. I was in Paris again when Picasso had finished the plates, and sought to take them from his apartment. But he insisted on treating the transaction on a no-trust basis. He made me send to America for the money with which to pay him; he made me hand him the actual cash with my left hand while he handed me the plates with *his* left hand.[1]

In other words, Picasso's oblique response to the Spanish committee was typical of his business dealings. This does not mean, however, that he wasn't thinking about it. At first he lingered on the idea of an antipolitical mural, perhaps something like an artist in his studio with a nude. That never really got off the ground, and so Picasso ended up doing nothing for the time being.

Part of Picasso's reticence may have stemmed from the very public location of the commission, and the fact that he was seen as an artist in decline. Although every show he mounted was critically assessed, notices were not always favorable. Critics often looked at the vastness of his output and claimed that there was a certain formulaic approach to his art.

His personal behavior was a subject of concern as well. Picasso was noted for casting off lifelong friendships, not to mention marriages, and this did not endear

him to the public. His remark that women were either goddesses or doormats seems to sum up his female relationships.

Although personable and charming in public, Picasso could be neurotic in private. Odd behavior, such as saving locks of his hair and his nail clippings, made him seem like a suspicious character to many. He was also deeply beset by superstitions. Sometimes he painted as an act of obsession and believed his creativity came from magical powers.[2]

Picasso's foot-dragging over this commission turned out to be a proverbial blessing in disguise. Shortly after the last visit by the Spanish committee, the sleepy Spanish town of Guernica was pulverized in a devastating attack that propelled it onto the headlines of nearly every newspaper worldwide. The Spanish Civil War was making for daily press in Europe and in the United States, but this event catapulted the brutality of the conflict onto page 1, and became emblematic of the entire civil war struggle.

Up to this point, no one had even heard of Guernica, a town of about seven thousand people, which was declared an open city during the war. Like Pearl Harbor, the action on a particular day brought the world's attention into focus onto a hitherto unknown place.

The war in Spain began in July 1936 when a group of generals, called the Nationalists, commanded an only partially successful coup d'etat that spawned a desire to seize power from the left-of-center Republicans. Tensions were high because the Second Spanish Republic felt itself duly elected, and the Nationalists felt they had betrayed the interests of the country. The resulting conflict was marked by excessive cruelty to the civilian population on both sides.

By 1937 the Republican troops were in an orderly retreat in northern Spain, begrudgingly giving up one or two towns at a time to the Nationalists, who were pressing in from every side. The real object of the campaign in northern Spain was the important port of Bilbao, which held most of the Basque resistance forces. Airport photographic reconnaissance revealed that two important roads en route to Bilbao ran through the town of Guernica. These two roads were filled with retreating Basque soldiers, all headed over a small stone bridge, one that could easily be taken out by trained airmen.

This operation was not left to just anybody. Three squadrons of crack German fighters dropped a payload of one hundred thousand pounds of high-explosive and incendiary bombs on the town. Villagers trying to escape were cut down by machine-gun fire. The attack lasted from 4:30 to 7:45 on the afternoon of April 26, 1937. There was no ground resistance.

"We were hiding in the shelters and praying. I only thought of running away, I was so scared. I didn't think about my parents, mother, house, nothing. Just escape. Because during those three and one half hours, I thought I was going to die," said eyewitness Luis Aurtenetxea.[3]

The center of Guernica was completely destroyed; 71 percent of the town was leveled, including shelters that were struck by bombs entombing their inhabitants. It took three days to put out the fires, so all-consuming was the conflagration.

In all the slaughter and devastation, a single oak tree remained standing in the center of town. The symbolism of this standing tree was immediately felt by the Basques

of the village, because for centuries city fathers met under an oak tree to discuss community affairs; now this tree was a symbol of the Basque resistance and resurgence. The Guernica tree became an allegory for the ultimate triumph of the Basque people.

It is hard to say how many civilians died at Guernica, because the town was filled with refugees, so that its population was greater than it would ordinarily have been. Estimates range from two hundred to sixteen hundred. In all that destruction, the bridge that was the supposed target of the attack remained unhit and operational. The Germans who had attacked the town were sworn to secrecy, and the Nationalists who entered on foot were told that "Red elements" had destroyed the city before their arrival.

The destruction was immediate worldwide news; places big and small were reporting on the cataclysm. Headlines in newspapers like the *Murphysboro (Illinois) Independent* screamed: "Rebel Planes Kill 800 in 'Holy City.'"[4] The lead in the *Helena (Montana) Independent* read: "Guernica, Spain, April 27. — Hundreds of civilians were killed and this ancient city, once capital of the Basque country, was left a mass of blazing ruins today after a three and one half hour insurgent aerial bombardment."[5] The *New York Times* had the most succinct headline: "Mass Murder in Guernica."[6] The *London Times* was even more involved, printing eyewitness accounts from Basque citizens. The *Portsmouth (New Hampshire) Herald and Times* reported daily on the outcome of the bombing, even when most of the news was cold. Subsequent attacks in Spain were seen through the lens of the Guernica massacre: "Evacuation of All Women and Children from Balbao [*sic*] Planned: Authorities Fear City May Suffer Same Fate as Guernica Where 800 Civilians Were Killed in Insurgent Air Raid."[7]

Newspapers in France were more circumspect. Although the press wanted to report the incident, they downplayed German participation in the hopes of placating their neighbor's militancy. However, some intrepid French papers began printing photographs of the damage, and there was no hiding the truth.

Picasso was propelled to take swift action on his mural. He began drawing on May 1, concentrating on the human aspect of the bombing. The sketches contain no airplanes, no incendiary bombs, no burning buildings. Even so, there was plenty to shock: mangled and dead bodies, hurt animals crying out, fleeing figures. The visceral consequence of so many panicky images plays effectively upon the mind. Gradually Picasso began to structure the sketches into a permanent composition, placing figures across a wide spectrum. He had a photographer document each day's work, so his progress is fully recorded.

When Picasso's mural was finally installed in the Spanish pavilion, it caused a stir, not least because Picasso was so famous, but because it caught the essence of the civil war and its atrocities, and had capsulized in very broad strokes the horror of the moment. Moreover, the painting was in like-minded company. The exhibition featured a huge photomural of Federico Garcia Lorca, the great poet and playwright who was assassinated at the onset of the civil war by Nationalists. It also showcased grisly photos of murdered Spanish children. *Guernica* had remarkable companionship.

Unfortunately, after the first splash, the pavilion was ignored by the public. Rarely do spectators come to World's Fairs to be face-to-face with the horrors of a war-torn country, struggling for its very existence. The exhibit stressed the legiti-

macy of the Republican cause in Spain, and its track record of achievements in education and agriculture. These accomplishments were overwhelmed by the poster-size photographs of the horrors of war. Technology, the theme of the World's Fair, was largely overlooked.

Because the Spanish pavilion opened seven weeks late, the press was not there to cover detailed features of the exhibit. It was even too late to have the pavilion listed on official maps of the fair. Relatively few people ambled into the exhibition, which ironically had a choice location. Word had spread that it in fact was not a pleasant experience. It's not that the French were impassive to problems in Spain; the southern part of the country was being flooded by Spanish refugees trying everything to get out of harm's way. It's that the fair represented an escape from modern anxieties, and not a confrontation with them.

European art critics were ready to savage the work. The German fair guide, as might be expected, called *Guernica* "a hodgepodge of body parts that any four-year-old could have painted."[8] It dismissed the mural as the dream of a madman. More surprisingly, the Russians, who had provided invaluable support to the Nationalist cause, were also critical. Like the Nazis, or for that matter any totalitarian state, the Soviets favored an artistic style characterized by overt realism—something that propagandists could easily disseminate to the masses. Picasso's masterwork clearly did not fill this bill, and was therefore dismissed.

The Soviets spent the last fifteen years erasing and negating the achievements of abstract artists that once were the creative hallmark of a modern socialist state. After the Russian Revolution abstract artists brought a new awakening to the Soviet era, one that was very progressive, but not propagandistic. Eventually these artists were seen as not useful to the state, and therefore anti-Communist, and then degenerate.

Cubism, on the other hand, was already an old-fashioned idea by the time *Guernica* was painted, having debuted in 1907 with Picasso's other great work, *Les Demoiselles d'Avignon*, now in the Museum of Modern Art in New York. The avant-garde public had already absorbed the effects of cubism; indeed, younger artists had grown up with cubism as part of the art establishment.

Cubism, and many of its modern offshoots like futurism, De Stijl, and suprematism, was not a movement that stressed symbolism, the way that Renaissance painting did. However, it was obvious from the beginning that *Guernica* was a painting that went against the modern trend, and stressed symbolism. But what did the symbols mean?

As with his other great paintings, Picasso was deliberately evasive about the meaning of his work. He sometimes hinted at an interpretation; but more often than not, he would contradict one meaning with another. He created the kind of tension that ordinary viewers find maddening and art historians savor.

Despite what Picasso might or might not have alleged about his painting, there are some symbols that are easy to interpret. Bulls and horses, for example, are common themes in Picasso's art, as they are in other great Spanish masters, like Francisco de Goya. The famous *Bull's Head* that Picasso designed in 1943 is a restructuring of a bicycle seat and handlebars in an expressive way. The simplicity of the arrangement makes it all the more appealing.

In *Guernica* the bull can be an image of masculinity or a victim of suffering. It can also be an allegory for the country of Spain, the way an eagle represents the United States or the bear represents Russia. The grouping on the left-hand side is a modern take on the traditional pietà image of a woman grieving over a murdered child. The figure at the bottom seems to be a collapsed military monument with a broken sword and a head knocked off its mounting. Among the more perplexing images is the lightbulb encased in an eye.

The lack of consistent documentary evidence has led to a host of interpretations, both real and imagined. Many art historians, who say they have intensely studied the painting, have come up with additional symbols that are hard to see, even when pointed out to the viewer. For example:

- The entire center of the composition is said to be a bull's head
- A harlequin is crying a diamond-shaped tear
- A second harlequin appears when the painting is rotated on a ninety-degree angle
- There is a side view of a skull
- A concealed bull's head is underneath the horse

The list is nearly endless. Nearly everyone around Picasso wrote a book about him, and they all had anecdotes to share about *Guernica*. Françoise Gilot was Picasso's lover for ten years and the mother of two of his children, Paloma and Claude. Her interpretation of the painting differs from the art historians in that it is an insider's view:

> In *Guernica*, for example, the woman whose large head leans out of the window and whose hand holds a lamp, is clearly based on Marie-Thérèse [Marie-Thérèse Walter, Picasso's mistress from 1927 to 1935, and mother of their daughter Maya]. The rest of the painting, together with the preparatory sketches, is focused about the figure of a weeping woman. And Pablo often told me that for him Dora Maar [Picasso's lover from 1936 to 1943] was essentially "the weeping woman." . . . They were both very conscious, he told me, of the fact that they were assuring their own immortality by becoming an integral part of his painting. That feeling intensified the rivalry between them.[9]

Picasso never forgave Gilot for writing that memoir, and tried to take her to court to prevent it from being published. He was furious over the interpretations Gilot put on his paintings and his personal life. He was so enraged about the book that it caused a permanent rift between Claude, Paloma, and himself. They never spoke again.

Whatever Picasso's intent concerning *Guernica*, there is no denying that the combined set of images is thought provoking, indicating that a full understanding of the meaning is unnecessary to appreciate its grandeur.

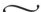

When the fair closed in November 1937, the painting was sent back to Picasso, even though the Spanish government had paid 150,000 francs for it. There was no way,

however, that the painting could make its way to Spain. If the great collection at the Prado wasn't safe, how long would *Guernica* last in the hands of Nationalist leader General Francisco Franco?

Picasso saw the chance to earn some publicity and raise awareness about Spain, and sent the painting on a tour to countries he considered safe. From January to April 1938 it was shown, along with the works of other artists, in an international set of venues in neutral Norway, Denmark, and Sweden. By October 1938 it was making a grand tour of England where proceeds were raised for Spanish relief. The distinguished London art gallery Whitechapel showcased the painting for two weeks, attracting fifteen thousand visitors. Admission to see the painting was the price of a pair of boots, so that Loyalist troops back home could be better equipped for the battles ahead.[10] While Picasso was generous enough to donate the proceeds that his painting earned to the Republican cause, he did not return his handsome fee to Spain.

The painting began to gather both critical acclaim and condemnation in a way that most modern art seems to. Anthony Blunt, distinguished art historian as well as Soviet spy, called the painting "not an act of public mourning, but the expression of a private brain storm which gives no evidence that Picasso has realized the political significance of Guernica."[11]

To Clement Greenberg, the premier American modern art critic, Picasso had lost his touch and was now a has-been.

> *Guernica* was obviously the last major turning point in Picasso's development. With its bulging and buckling, it looks not a little like a battle scene from a pediment that had been flattened out under a defective steam roller—in other words, as if conceived within an illusion of space deeper than that in which it was actually executed. And the preliminary studies for *Guernica* bear out this impression, being much more illusionistic in approach than the final result. . . . One gets a sense of the picture rectangle as something into which the picture is jammed, nearly or not as the case may be, but always with an excessive application of will.[12]

Other art critics rushed to Picasso's defense. Herbert Read said, "Not only *Guernica*, but Spain; not only Spain, but Europe, is symbolized in this allegory. It is a modern Calvary."[13]

It soon became clear to everyone that the painting was not safe in Europe, and by April 1939 it was on board the *Normandie* to New York. Ostensibly the painting was in America to raise awareness and funds for the Spanish cause, but realistically the Spanish Civil War was over, and Picasso's side had decidedly lost. There was no stopping the grand tour, however. After New York, it made its way to Picasso exhibits in Los Angeles, San Francisco, Chicago, and then back to New York for a huge Picasso retrospective at the Museum of Modern Art in November 1939 called *Picasso: Forty Years of His Art*. It was, as Picasso had hoped, the most discussed painting of its time. And the most ubiquitous.

For all his reticence about accepting large-scale commissions, Picasso knew how to turn a dollar when he had to. He understood that showmanship is part of the art game, and sending works of art on tour and having huge retrospectives are good for business.

Artists have learned that one blockbuster makes clients hungry for smaller and more available works. *Guernica* was the magnet, the bait, the work that drew people in so that the surrounding smaller works would sell. Nowhere were the profits better than in the United States. With the war approaching, this money would certainly come in handy.

Everywhere the painting went, it was greeted royally. Take the deferential treatment it received in California: "Picasso's 'Guernica' to Be Shown in S.F.," proclaimed the *Oakland Tribune*:

> The most important art announcement in many a day comes from the San Francisco Museum of Art which will exhibit Pablo Picasso's great mural "Guernica." The painting will be shown August 27–September 18.
>
> Guernica was the scene of much savage fighting during the Spanish War. Picasso's mural pictures the cruelty thereof.
>
> Concerning the mural, Dr. Grace L. McCann Morley, director of the San Francisco Museum of Art says, ". . . the importance of this enormous painting cannot be exaggerated. For the first time Picasso was spurred by an intense social conviction, and into this painting he has poured the result of the most fertile investigation in art in our time."[14]

The public was genuinely impressed, even if perplexed. Newspapers recorded various reactions: an elderly woman moaned this prayer aloud: "God. If I could only understand it." A younger woman said, "It is horrible," but she did not mean that the painting was horrible, but that it aroused an emotion of horror in her. Others saw in the canvas the "fourth dimension." One critic proclaimed, rather strangely, "To me it is a large painting in the extreme modern manner, rather badly done technically, but that is no sin in these days. In fact it takes an artist of skill or a child to put on paint badly and yet produce something worth seeing."[15]

The painting never seemed to tire of moving about. Its return to New York did not mean it was going into long-term parking. The horrifying war news from abroad, both in Europe and the Pacific, made the imagery even more palpable, and the painting more in demand. In January 1940 it was in the Art Institute of Chicago, in 1941 it was featured at the Columbus Gallery of Art in Ohio, and then in the fall of 1941 and summer of 1942 it was at the Fogg Museum at Harvard University, where it was described thus: "Picasso's atrocious 'Guernica' screams the agony of air bombardment, vibrates with the thin high notes of high speed engines; it is inhuman or, rather, it is our humanity itself, broken and tortured by a disaster which is outside it."[16]

Stateside Americans who saw newsreels of the horrors of World War II gathered quietly before Picasso's artistic interpretation, staring in hushed silence. Somehow the painting added a philosophical weight to the more visceral news footage.

All this travel did not do the painting any good. As careful as the movers were, it was so big—and incredibly heavy—that it was often taken off its backing and rolled onto a specially made canister to transport it.

After World War II, the Museum of Modern Art held on to the painting and waited for the Picasso clan to figure out what to do with it. No one was in a hurry,

because General Franco was firmly entrenched in Madrid, and there was no effort by the Spanish to have the painting returned, for the time being.

Even if Spain did not want to relive an embarrassing moment in its history, war-torn Europe did have a fascination for Picasso's masterwork. Already established as the most important painting of the twentieth century, it was headed on a number of tours to permanently cement its reputation. The Palazzo Reale in Milan held a large Picasso exhibit in October 1953, and *Guernica* was the hit of the show.

In December 1953 the painting was sent to the Museum of Modern Art in São Paolo, Brazil, so that a new audience could become familiar with Picasso's achievement. In 1955 and 1956 it went on a whirlwind tour of Paris, Munich, Cologne, Hamburg, Brussels, Amsterdam, and Stockholm. In 1957 it moved again to Chicago and onto Philadelphia before resting, somewhat, back in New York.

More than one critic was wondering why this painting had to be carted everywhere, even if it was enthusiastically received. By 1970 Picasso indicated that it could return to Spain when public liberties were restored, but he never defined exactly when that would happen, nor did he determine who would be the arbiter of Spain's public liberties.

General Franco began a deliberate campaign to have *Guernica* sent to Spain, claiming he had no interest in stifling consent. An incredulous Picasso emphatically said no to the moving of the painting as well as his own return to Spain. He had not been to Spain since 1934, and as it turned out, he never did go back. Picasso's death in 1973 complicated the fate of the painting, especially since he died intestate; hope of clearing up this mess died with him. Two years later, General Franco died, too. The legal battles began.

It's not that *Guernica* was entirely safe in New York during this time, either. On February 28, 1974, an artist named Tony Shafrazi sprayed red paint on the painting before an aghast grouping of high school students from Scarsdale, New York. His message "Kill Lies All" was meant as a reference to American involvement in Vietnam, in particular the My Lai massacre. "I'm an artist and I wanted to tell the truth," Mr. Shafrazi claimed. *Guernica* was undamaged due to a thick protective layer of varnish applied to the surface some years before. The painting was immediately cleaned with a chemical, xylene, which strips paint off a surface.

A radical faction called the Guerrilla Art Action Group argued that Shafrazi's actions actually completed the painting rather than vandalized it. Today he is a respected art dealer in New York and regrets his youthful impetuous actions. Seen in the context of the time, however, *Guernica* was a flashpoint for those who were horrified by American involvement in Vietnam. Some four hundred artists signed a petition in 1967 to Picasso asking him to remove the painting from New York in view of American military belligerence.

～

The popularity of *Guernica* motivated others to copy it in different media. The most famous copies were done in tapestry form, woven in Paris. Picasso admired the work

of René and Jacqueline de la Baume Bürrbach in 1951, and gave permission in 1954 for one of his works to be woven as a tapestry. The weavers had already created tapestries after works by Fernand Leger, Raymond Duchamp-Villon, and Robert Delaunay, three pioneers of French modernism. By 1955 they began work on the first of three versions of *Guernica*, coincidently on exhibit in Paris.

The Bürrbachs were significant artists in their own right, masters of the art of low warp weaving. It is said they studied *Guernica* with sketchbook in hand for three hours every morning before the museum opened. After creating a full-size drawing, Picasso himself made the necessary corrections and gave his consent for the weavers to start. The final product took six months to produce—far longer than the original, and was presented to Picasso at a museum in the South of France. Unlike the original, Picasso gave permission to use eleven colors, which created an entirely different effect. Another version was made for one of the greatest patrons of the arts in the twentieth century, Nelson Rockefeller, future vice president of the United States.

Rockefeller collected a wide range of material that suited his discriminating interests. It was he who amassed a huge collection of oceanic, African, and pre-Columbian art, which was at that time called primitive art. This collection was so comprehensive that he created the Museum of Primitive Art to house it and later donated the entire museum to the Metropolitan in 1979.

Beyond that, the Rockefellers were intensely interested in modern art, and formed a vast collection of contemporary works. As a child, he was raised in a Manhattan home surrounded by great medieval tapestries that his father purchased in Europe; they are now the *Unicorn Tapestries* at the Cloisters Museum. It was natural, then, that Rockefeller would want a tapestry version of a modern painting.

The Rockefeller version was done in shades of ochre and brown and has a warm effect that the black and white painting does not have. In 1985 the tapestry was loaned to the United Nations for display, feeling that an antiwar painting would harmonize with the mission of this organization. It was in this setting that the tapestry created a controversy of its own.

On February 5, 2003, Secretary of State Colin Powell addressed the press corps at the United Nations after making a speech at the Security Council, in which he proposed military action against Iraq. Because of the sensational press coverage, over two hundred TV cameramen alone, a large venue had to be hastily arranged; the hallway outside the Security Council that featured *Guernica* was chosen. The cameramen, however, insisted that the tapestry be covered over, because the cubist lines of the design contrasted wildly with the people before them; a neutral blue curtain was draped before the tapestry.

The cameramen were contented, and the Powell news conference went off without a hitch, but later it was realized that this great antiwar wall hanging was covered to provide a backdrop for a pro-war announcement, and the press had a field day. While the cover-up may have been unintentional, the symbolism was certainly clear and the embarrassment very palpable. Powell denied any attempt to mask *Guernica*, but the outcome was the same.

~

It took six years after the death of Picasso to sort out the details of the *Guernica*'s journey to Spain. Various relatives, including both legitimate and illegitimate children, all wanted their say. The French government grabbed 20 percent of Picasso's estate in artwork up front as an inheritance tax. That still left plenty to fight over.

In the meantime, in 1977, on the fortieth anniversary of the bombing, the city of Guernica erected a full-size replica of the painting downtown, where it was greeted with enthusiasm.

The Spanish accused the Museum of Modern Art of dragging its feet in the return of the painting, and petitioned the State Department to force the museum to adhere to Picasso's wishes. However, the legal barriers were more located in Paris, where a leftist lawyer, Roland Dumas, was executor of Picasso's estate, and it was his permission that was needed to send *Guernica* to Spain.

In 1977 Mr. Dumas took a position on the painting. *Guernica* may indeed go to Spain in the foreseeable future, "maybe in a couple of years."[17] He was unconvinced that the painting could hang securely in the Prado because of the number of right-wing extremists in Spain.

One by one the legal and political barriers were being removed, and in 1981 authorization was granted to have the painting sent to Spain, a place where, despite its extensive travels, it had never been. Even the packing of the painting created its own sort of drama. The Museum of Modern Art decided that with a work as large as this, it would be wisest to wrap it around an enormous plywood roll of about thirty inches in diameter. The painting took about six hours to remove from its backing. It was laid facedown on layers of dark brown craft paper and glassine, an acid-free paper. It was removed from its stretcher, itself placed in a box nearly twenty-six feet long.

The back of the painting showed the stresses of the constant movement it had endured. Restorers used a hair dryer to melt wax onto the back of the surface to smooth out the wrinkles that had creased the corners. The large roll was put in place over the back of the painting, and six men slowly curled the masterpiece around the tube. Finally the painting and the roll were shipped in a case, hanging very much like a roll of paper towel hangs under kitchen cabinets.[18] No greater care was ever taken for so large a painting. In fact, when the painting was ultimately mounted in Madrid, across town at the Museo de Arte Contemporáneo, a massive Picasso retrospective was under way to commemorate his achievements. In the center of the exhibit were the two crating boxes, one for the painting and one for the stretchers, revealed for all to marvel at, like some jewel-rich medieval reliquary without its relic.

Guernica was shipped in secret without insurance, in time for the hundredth anniversary of Picasso's birth on October 25, 1981. His daughter Paloma was the only Picasso to be at the unveiling, if unveiling you could call it. The painting was previewed to the press five meters behind bulletproof and bombproof glass and guarded by soldiers with machine guns. No one caught the irony of a military presence before a painting that condemned military action.

Spain was divided. Survivors of the civil war could still be seen throughout the country walking tenderly with their canes. The appearance of this painting did

On a roll: the Museum of Modern Art packs up *Guernica* for shipment to Spain. *Digital Image ©
The Museum of Modern Art / Licensed by SCALA / Art Resource, NY*

everything to reopen those wounds and make the Spaniards even more sensitive.
Most troubling of all, the painting reminded the victors of the unholy alliance the
Nationalists made with Hitler and one of the worst regimes in human history. In a
moment of national regret in 1999, the German parliament officially sent its con-
dolences in the form of a formal apology to the people of Guernica for the part it
played in the bombing. The Spanish government, ironically, still has not paid its
official respects for its considerable role in the conflict—a point all too clearly felt
in fiercely independent Basque territory.

 Guernica has been displayed at the Centro de Arte Reina Sofía since 1992, and
its travels seem to be over for a while. It's not likely the Spanish will let go too eagerly
what it took so long to get. Fortunately, it is no longer necessary to have a military
guard, although the bulletproof glass remains. The raw feelings that inspired the work
have slowly been assuaged, but its universal appeal is as strong as ever.

 Guernica now has the ability to conjure up new controversies of its own. The
Basques wanted it placed at the Frank Gehry designed Museo Guggenheim Bilbao
when it opened in 1997. The curators at the Reina Sofia claimed that the painting
was too fragile to travel, even for a temporary exhibit. The painting that has seemingly
logged more miles than any other now was too delicate to go anywhere, unless it was
between state-run museums in Madrid.

 All the political parties in Spain authorized a move for a 2006 exhibit to mark
the twenty-fifth anniversary of the arrival of *Guernica* in Spain, except for the ruling
Socialists who nixed the plan. The Basques have long wanted the painting to reside in
Bilbao, because for many the painting is more than capturing a moment in time, it is

an expression of the soul of a suffering people. It was considered an act of unity and subversion to hang a copy of *Guernica* in one's home during Franco's dictatorship.[19]

Picasso could not have known about the museum in Bilbao, and he specifically asked for the painting to hang in the Prado, a request that has not been honored. The Reina Sofía, an otherwise fairly routine modern gallery, would lose its crown jewel if *Guernica* left, and would return to its position as an uninteresting museum with miscellaneous paintings by a few big names.

Juan Ignacio Vidarte, Guggenheim Bilbao's former director, said, "This transcends technical considerations. To say it is too fragile is to insult our intelligence. We can provide a special frame, a special vehicle."[20] Apparently no one in Madrid is interested in this frame or vehicle.

Meanwhile the Rockefeller tapestry began to pick up the journeying where the main painting left off. The Whitechapel Gallery in London, where the painting was first exhibited in Britain, underwent a massive £13.5 million renovation in 2009 and wanted the *Guernica* back to mark the event. Knowing that the Spanish government could hardly say yes to Britain and no to the Basques, the gallery asked Rockefeller's wife, Margaretta "Happy" Rockefeller, if she could lend the tapestry to help salute the occasion. By coincidence, the United Nations itself was undergoing restoration, and that meant the tapestry had to go somewhere, and Whitechapel seemed like a wise choice. The London show was an instant success, the gallery being more than happy to have a Picasso-approved replica for display.

When the *Guernica* was returned to the Rockefellers, they took it to Kykuit, their estate in New York, and displayed it in their modern gallery in 2011. Soon afterward the tapestry flew off to Texas to charm another museum and another public. What the painting could not do, the tapestry could now do.

Ultimately, Picasso's reputation as a great artist did not need *Guernica*, but the creation of this masterwork and its subsequent fame cemented his standing as the most important and most famous artist of the twentieth century. The painting is quoted in every survey text on modern art, as well as every history text of the twentieth century.

The fame of the painting was certainly enhanced by the travels it endured in its over seventy-year history—travels that were meant to evoke the horrors and pointlessness of wars and those who create them.

It is not too much to say that Picasso became one of the most famous people of the entire century, and *Guernica* through its cubist expressionism—and its travels—guarantees that placement indefinitely.

Campbell's Soup by Andy Warhol

Mmm Mmm Good

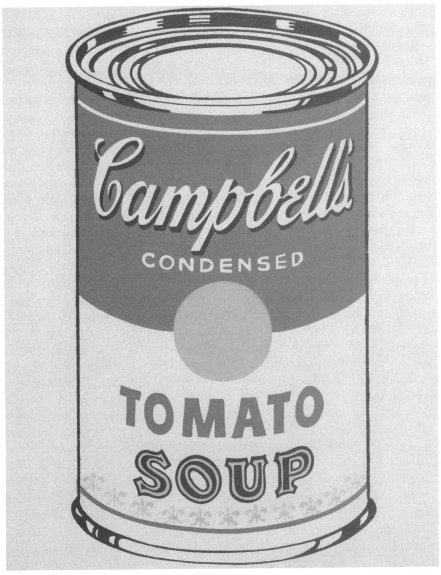

Campbell's Soup by Andy Warhol. *Private Collection Photo © Christie's / Bridgeman Images © 2014 The Andy Warhol Foundation for the Visual Arts, Inc. / Artists Rights Society (ARS), New York*

*The Campbell Soup Can painting was interesting enough, really autobiograph-
ical. He was always eating Campbell's Soup. He always had that for lunch.*

—Gerard Malanga, Warhol's painting assistant,
in *Warhol: Conversations about the Artist*

Crossover artists are common in the music industry, even if the result is met with mixed success. Opera stars have notoriously fared poorly when recording popular music, as soprano Kiri Te Kanawa did when she recorded Gershwin songs, or when tenor José Carreras sang Tony on an ill-fated recording of *West Side Story*. Similarly, Aretha Franklin's rendition, or perhaps better put, caterwauling, of Puccini's "Nessun dorma" from *Turandot* would have many opera lovers reaching for noise-canceling headphones.

In the fine arts it is really no different. Artists as popular as Norman Rockwell are labeled more as illustrators rather than fine artists, and that means that members of the art mafia can look down upon him with righteous indignation. Rockwell never sought to achieve a higher status in the art world, so some critics have placed him in a netherworld along with Thomas Kinkade and Currier and Ives. Truth be told, many artists, and musicians, have done work outside their fine art careers in order to make ends meet, especially in their early days. Andy Warhol, who came from a very poor background, understood the value of earning a dollar while pursuing a career in the arts. He came to New York as a commercial artist, designing shoe ads for newspapers, for example. At first he worked for prominent department stores like Bonwit Teller and provided illustrations for magazines like *Vogue*. Then he moved on to designing stationery for Bergdorf Goodman, greeting cards for Tiffany and Company, and album covers for RCA Records. One well-done job earned him an endorsement to do another.

For Warhol, money was the motivating factor. He quickly learned that the faster he worked, the more he made. Even so, he must have satisfied his clients because the content of his work was deemed excellent, and the speed with which he produced his material astonishing. There was a point in his career—even when he was extremely wealthy—in which it seemed as though he would never say no to any offer, no matter how mundane. His appearance on Pontiac and Diet Coke television commercials were cases in point. He designed an ice cream sundae for Schrafft's restaurants. He appeared on the two hundredth episode of the sitcom *The Love Boat*. A character in the show turns to him and says, "I just want to say how honored I am that you chose my wife to be the subject of your portrait." In a moment of full Warhol saturation in 1985, he endorsed Vidal Sasson Men's Hairspray, demonstrating how well it works, even if he was wearing a wig in the ad.

Material gain is one thing. Critical respect another. No art critic would review a shoe advertisement in a newspaper as if it were a Matisse or a Picasso, and Warhol knew it. In order to take his case to a respectable audience, he had to reach wider and deeper. He had to demonstrate that he was a true crossover artist, who could break through the barriers that separate illustrators from fine artists. Many painters lavished time and energy on new creations often waiting desperately for recognition, hoping a gallery would pick up their work. Warhol knew one needed a strong financial base before more daring adventures could be undertaken.

Andy Warhol's *Self-Portrait* from 1980. © *CNAC / MNAM / Dist. RMN-Grand Palais / Art Resource, NY / © 2014 The Andy Warhol Foundation for the Visual Arts, Inc. / Artists Rights Society (ARS), New York*

But where to turn? Warhol's style was not compatible with the most sought-after art form of the 1950s: abstract expressionism. This movement was born out of the chaos of World War II; abstract expressionists rejected the realism that epitomized Depression-era art a decade before. Instead they turned to European abstract artists and took them one step further. Jackson Pollock slammed the door on the art establishment of his time—including his mentor, regional artist Thomas Hart Benton—and foresaw that art needed to be free of the constraints of traditional training. Pollock splashed and splattered his way onto the American scene, at first achieving only modest success. Then publicity happened. *Life* magazine, at the time the most prominent American periodical, featured a spread on his art in the August 8, 1949, edition, asking the question in confrontational letters: "Is he the greatest living painter in the United States?" Everything changed. Suddenly Pollock was famous, idolized even, as the spokesman for the avant-garde.

He was quickly joined by Willem de Kooning, Franz Kline, and Robert Mother-well, composing a boy's club called the New York school. Even Pollock's talented wife, Lee Krasner, put her career on hold to nurture her husband's artistic output.

However, this grouping produced art that was self-important, even condescend-ing to other styles. The creators were alcoholics, manic depressives, heavy smokers, and not exactly politically correct. They uniformly hated homosexuals, and thought that women should know their place. They felt that African Americans were better off in jazz clubs than anywhere else. Into this atmosphere emerged pop art, and Andy Warhol, a man who was homosexual and who had African American friends includ-ing artist Jean-Michel Basquiat.

The contrast between the two artistic styles could not be more different. Pollock's bold and splashy compositions seem to have an accidental approach. Pollock, however, famously rejected this: "With experience it seems to be possible to control the flow of paint, to a great extent, and I don't use—I don't use the accident—'cause I deny the accident."[1] Warhol's *Campbell's Soup Cans*, on the other hand, are clear cut, hard edged, focused, and precise. Warhol had little sympathy for abstract expressionists, and the feeling was mutual.

When eventually the steam came out of the abstract expressionist movement in the mid-1960s, the New York school was left staring into the face of extremely suc-cessful members of the pop movement, artists who had touched a chord with ordinary people in a way that the abstract artists could not. Abstract expressionists had pro-duced objects that were individually unique, even if they were done in a uniform style. What Warhol had produced were objects that denied their uniqueness—they were all paintings of Campbell's soup cans—and enthroned a uniform style.

None of the abstract expressionists thought much of Warhol, but then again by the time pop art was born, abstract expressionism was an orthodox creed. Success meant splatter, drip, and smudge. No wonder when De Kooning saw the progress Warhol was making in the art market, he confronted him after a few drinks and declared, "You're a killer of art, you're a killer of beauty, and you're even a killer of laughter."[2] No matter how freethinking the avant-garde viewed itself, it did not tolerate dissent.

What is often forgotten is that even though today Warhol is the standard-bearer for pop art, he was actually one of the last artists to come into the movement. Robert Rauschenberg and Roy Lichtenstein had already gotten good press with their works, having one-man shows at important galleries in New York. A market had been cre-ated for pop art. Careful not to intrude upon the accomplishments of other artists, Warhol rejected the use of ephemeral materials that marked Rauschenberg's work, and the benday dots used by Lichtenstein to achieve a comic-book-like effect in his works. Instead, he took common objects that were found in supermarkets, like Camp-bell's soup cans, and wondered about the artistic value in labels such as these.

Warhol himself didn't know it yet, but the world of corporate logo design was about to radically change how art is viewed and conceived. Even without words, the shape of a Coca-Cola bottle tells us about what is inside, as do more current products like the logos for Microsoft and Nike sneakers.

One need not read the words "Campbell's Soup" to determine what is inside the can. Indeed, Warhol never, in any of his works, refers to the product. There are no depictions of actual soup, that it might be good for you, nutritious, or delicious. Warhol is after the marketing material, the standardization of the Campbell's product, the mass-produced product.

Before Joseph Campbell mass-produced soup, many everyday products were manufactured on assembly lines, like glass, steel, and metal. Food, however, has always resisted the marketing of mass production, because consumers do not want to feel as though they are eating something that is mechanically reproduced. They would rather think that the vegetables were delicately picked by discerning hands and carefully packed and shipped to a store near them. The slow-food movement in restaurants today picks up on this idea.

However, society's increased demand for quicker and faster food has spurred the development of mass production, like it or not. Entrepreneurs like Clarence Birdseye and Will Keith Kellogg understood the impact that speedily manufactured food would have on the American consciousness. Joseph Campbell has to be seen in this light—and Andy Warhol as well.

One afternoon, Warhol was wondering with some of his friends what his next project would be—something that could bring him into the respected fine art field. He asked his friends what he should paint. Muriel Latow, an art dealer and decorator, said he should paint money "or something people see every day, like a Campbell's Soup can."[3] One of his assistants was sent to the store the next day and was told to buy one can of each type of Campbell's, at that time numbering some thirty-two.

Once the subject of Campbell's soup was decided upon, then it was a matter of how to represent them on the canvas. Would a slavish copy be what was required? Should there be a take or a spin on the product?

He decided to use a magazine ad rather than the cans themselves, because the ads were already flat rather than three-dimensional; the actual cans were rounded and their surface therefore difficult to copy. Warhol projected the image from the ad onto a prestretched canvas mounted on a wall; he traced the outline and then slowly and mechanically painted in the color areas. He avoided any type of painterly brushstroke, which would indicate an artist's hand or influence.[4]

Moving deliberately and slowly, Warhol enhanced the flatness of the image by copying the script and typefaces meticulously, even if a few came off a little askew. However, when it came to the gold medallion on the center of the can, he declined to copy the fine engraving, instead substituting a plain gold disk. The medal would have announced a distinction that Warhol was declining, a distinction of being a unique product.

Despite efforts to make the painted surface look manufactured, the weave of the canvas backing lends a painterly contrast to the Campbell's logo. Therefore each of the paintings by Warhol is an individualized object, each representing a different type of soup. Warhol, the illustrator, had raised a mundane image into the world of fine art.

Questions arose everywhere. Was Warhol trying to sell Campbell's soup? Would people want to look at paintings of cans of soup on the walls of an art gallery, and then

presumably buy them and put them on the walls of their home? Is there a reason why we take commodities like Campbell's soup and put them in cupboards rather than on display in the house?

Painting the cans was one thing, having a gallery exhibit them quite another. After searching around, Warhol found a gallery in Los Angeles, the Ferus Gallery, that agreed to showcase his art. Off the paintings went to make the public debut of pop art on the West Coast. The show opened on July 9, 1962, with minimal fanfare. The paintings were arranged evenly along a wall, eye height, looking for all the world like shelves in a supermarket with products on display, which was the point.

This was not taken lightly by the Los Angeles art establishment, who saw this as a subject to ridicule. Some critics were simply quiet about the new works; others were openly hostile. A nearby gallery stocked cans of Campbell's soup in the window and advertised that the real thing was for sale, and for only thirty-three cents a can.

Warhol, a publicity genius of the first order, then took a photographer down to a supermarket and began signing cans of the soup, as if the soup were his invention. It became a sensation. Warhol's career was on its way, but not his soup cans.

If the measure of success is how well the paintings sold at the gallery, then this was a flop. Six people did buy the paintings, at $100 apiece, but not enough to make the gallery show a financial success. The low price was art collector Irving Blum's idea because he felt that this would generate interest during an "initial exposure."[5] Blum determined that the works really belonged together, having been conceived of as a set, and offered Warhol $1,000 for the collection of thirty-two—in one-hundred-dollar installments over the course of ten months.[6] Warhol readily agreed. In order to achieve the complete set, however, Blum had to buy back the paintings that had been previously purchased.

At the time Los Angeles was a cultural backwater. The Hollywood set was not interested in art; they fancied big cars and big houses. Art was thought of as something French, lightly painted, and goes with everything, not something that drips and splatters, or God forbid, looks like a can of soup. Nonetheless, there were early supporters of Andy Warhol like Dennis Hopper, the screen star, who built a substantial collection of his works, but he was unusual.

In any case, the short-lived show closed without fanfare on August 4, 1962, a day before Marilyn Monroe's death—which gave Warhol inspiration for his next series of works. Blum's collection grew in importance as Warhol's fame increased. Recognizing this as a milestone, the Museum of Modern Art in New York agreed to buy the series for their collection in 1996 for $15 million. The museum got a steal. If the set had been broken up and scattered to different buyers it would have earned much more. The museum of course knew this, and said that it was really more of donation than a purchase. In 2010 a six-foot-tall painting called *Big Campbell's Soup Can With Can Opener (Vegetable)* sold at Christie's for $23.8 million.

Warhol did not earn the critical respect he thought to gain from his first solo exhibition. Henry Hopkins, writing in the *Artforum*, said: "To those of us who grew up during the cream-colored thirties . . . this show has peculiar significance. . . . Warhol obviously doesn't want to give us much to cling to in the way of sweet handling, preferring instead the hard commercial surface of his philosophical cronies.

. . . However, based on formal arrangements, intellectual and emotional response, one finds favorites. Mine is *Onion*."[7]

Artist John Baldessari seemed to sum up the feelings of many when he said during an interview, "I remember they were all in a row and as I recall they were sitting on a very narrow shelf. I liked the matter-of-factness of it, that they were just like products in a supermarket, with all the cans lined up. . . . It did sort of resonate; what I liked about it was, Wow, I guess he thinks he can get away with this."[8]

A *Los Angeles Times* editorial cartoon had two art lovers, looking very disheveled, staring at the Ferus Gallery exhibit, hands on chins, and murmuring, "Frankly, the cream of asparagus does nothing for me, but the terrifying intensity of the chicken noodle gives me a real Zen feeling . . . besides, asparagus gives me indigestion!"

The critics seemed to have a sense of humor about the exhibition, even if it did not lead to critical approval. The *Los Angeles Times* assessed the show as the product of either a "soft-headed fool or a hard-headed charlatan."[9]

Although Warhol could talk up a storm when he felt so inclined, he said little about his own work. He once confessed, "If you want to know all about Andy Warhol just look at the surface of my paintings and films and me, and there I am. There is nothing behind it."[10]

Warhol was certainly not the first artist to appropriate imagery from consumer culture. Figures as famous as Pablo Picasso used elements from newspapers in their collages. Stuart Davis used Lucky Strike cigarettes as a starting point for his paintings as early as 1921. Dadaists like Marcel Duchamp became famous for taking simple things like a men's urinal, turning it upside down, and calling it "Fountain."

Warhol, who met Duchamp many times, was different. He didn't use preexisting items and remake them in a new way, like Jasper Johns did with his bronze Ballantine Ale cans. What he did learn from Johns was that he did not need to create original imagery, just appropriate what already exists into a new context. Warhol took an already successful mass-produced logo and made a hand-painted original from it. His career is based on celebrating the commonplace, raising it into an object worthy of contemplation.

Dutch still life artists of the seventeenth century sought to do the same thing with their *vanitas* paintings. These artfully arranged still lives display exotic and expensive products brought from around the world by Dutch commercial vessels. Sometimes the still lives show spoiled or half-eaten fruit, with tipped-over goblets and a prominently placed skull. Symbolically, these works stand for the inevitability of death, and the passing fancy of earthly achievements. By extension, it asks the viewer to think of his or her mortality and prepare for the next life.

Warhol's 1962 cans do none of these things. But in an odd turn of events, his next series of paintings involving Campbell's soup stressed a *vanitas* theme: the cans have ripped labels, crushed containers, or openers taking their lids off. These became very popular. When it became too difficult to keep up with the demand of painting Campbell's soup, Warhol turned to silk screen printing to mass-produce objects.

Silk-screening is a process that can be difficult to master, let alone perfect. The screens are often reused with the intention of producing alike images. However, many silk screens often have subtle differences, depending on the intention, or carelessness,

of the artist. Sometimes if the artist presses unevenly on the silk screen, blotches will appear in one area or empty spots on another. For Warhol, these differences were part of the final product. Oddly by mass-producing the objects, Warhol did not achieve the uniformity he expected—which he had with the hand-painted objects—but a variable product. Warhol had gone from illustrator, to individual crafter of fine art paintings, back to illustrator.

To make the connection clearer with mass production, he styled his studio as "the Factory" and repeated the phrase "I want to be a machine" to anyone who would listen.

Campbell's soup, of course, is produced in a factory, the company having achieved great success with their product, a marketing triumph. Condensed soup requires half the storage and shipping space than regular soup, so twice as much could be produced, dramatically undercutting the competition.

Originally the cans had a blue-and-orange label. According to corporate legend, Herberton L. Williams, future assistant general manager, attended a Cornell football game in which the players were wearing red-and-white uniforms. Williams so admired the colors that he changed the can design to reflect this influence.[11] The script used on the company label was said to be the handwriting of Joseph Campbell himself, one of the founders of the company. It was supposed to imitate the handwriting on homemade recipe cards. This was done to counteract the mass-produced image the soup otherwise has.

The only other significant alteration in the label came in 1900 when the company won a medal in the 1900 Paris Exposition. By the time Warhol painted his *Campbell's Soup Cans*, four out of five cans of soup sold in the United States were Campbell's; the age of the knockoff store brands had not yet begun. The soups have been criticized for their high sodium content, but basically their nutritional value is high, enough for Warhol to have eaten a can of it for lunch for twenty years with no side effects.

When Campbell's first discovered that their soup cans were being used as art, the company took a cautious attitude, preferring to see if the artwork was going to be greeted favorably by the public, or perhaps, thought of as a vicious satire. Later, when they saw that this was the start of a new artistic movement, they embraced the free publicity and even issued Andy Warhol–style cans on the fiftieth anniversary of the work's debut in 2012.

The marketing success that Campbell's had in selling soup was easily matched by Warhol's craving for publicity. Warhol had learned from Salvador Dalí that an artist is responsible for creating his own market. (Those artists who think that the public is going to enthusiastically greet their works by simply looking at their paintings are in for a terrible surprise.) Dalí had done strange things to generate publicity, including appearing on American television game shows like *What's My Line*, but he turned into an amateur compared with Warhol.

Warhol spent nearly every evening of his adult life at a party—not really to enjoy the party and the company of friends, but to be seen at the party. His person-

ality at a party varied from being introverted and morose to curious, animated, and a great gossip. He loved to stir up trouble. This produced uncomfortable results, with Warhol sometimes becoming an eerie presence that chilled the partygoers down to the bone.

At times he became "the" pop artist, by autographing books of S&H Green Stamps and labels of Campbell's soup. He liked all the things money could buy, so of course, he sought money at almost any turn. He was indiscriminate in choosing friends. He appeared at balls to hobnob with the powerful. He adored the Reagans and said that he celebrated "the return of style and elegance" to the White House.[12] He appeared, seemingly nonstop, at the Iranian embassy. One wonders how much art could be produced by an artist who spent most of his time away from art.

He fed into the American craze for celebrities, of which he had participated in as a child and then became the object of as an adult. As a youngster he lived on a daily diet of fan magazines and radio serials and then graduated to television when the invention became popular in the 1950s. He was so possessed by celebrity that he once said about his own death, "I'd like to disappear. People wouldn't say 'He died today,' they'd say 'He disappeared.' But I do like the idea of people turning into dust or sand, and it would be very glamorous to be reincarnated as a big ring on Elizabeth Taylor's finger."[13]

Warhol did understand the impermanence of life, especially the day he was shot by Valerie Solanas, a onetime writer and actress in one of Warhol's movies. She fired three times, hitting him once in the abdomen, in their Factory studio in Union Square in New York City. Solanas, perhaps thinking that Warhol was as good as dead, turned the gun on Mario Amaya, an art magazine editor. He was shot in the hip.[14]

No one knows exactly why Warhol was targeted since Solanas issued a number of random statements typical of murderers, but not addressing her particular crime. She said, "Warhol deserved what he got. He is a goddamned liar and a cheat. All that comes out his mouth is lies."[15]

Certainly Warhol did not like being shot, but he had no objection to the publicity attached to it. The next day Senator Robert Kennedy was murdered in California, and attention turned away from Warhol. Famed artist Chuck Close, who knew Warhol, summed it up most aptly: "Andy hated being upstaged by anyone. He was shot in 1969 about thirty-two hours before Robert Kennedy was shot. And he felt that he got knocked off the front page by having someone more famous than him shot near the same day!"[16]

Everything changed, except the partygoing. He wore a corset for the rest of his life. He became scared, greedy, avaricious. Anyone could get a portrait for $25,000. Art was always a business to Warhol, but now it became only a business. Critical response began to decline, and so did his health.

Time magazine art critic Robert Hughes, only briefly a fan of Warhol's art, was among the most scathing critics. He once said in a film, "I thought he was one of the stupidest people I ever met in my life."[17] In 1975 he assessed Warhol's output: "Ten years later . . . Warhol's can and Cokes and Marilyns look somehow stranded. Incessant exposure has dulled their impact, and what one sees is the brisk, elegant and

paper-thin sensibility for a commercial illustrator—designed-in rawness, hand-rubbed indifference."[18] By 1982, when Warhol's artistic reputation was in free fall, Hughes remarked, "It scarcely matters what Warhol paints; for his clientele, only the signature is fully visible. The factory runs, its stream of products is not interrupted. . . . What the clients want is *a* Warhol, a recognizable product bearing his stamp. . . . Warhol's sales pitch is to soothe the client by repetition while preserving the fiction of uniqueness. Style, considered as the authentic residue of experience, becomes its commercial-art cousin, styling."[19]

The truth is, critics did not matter, not even a little bit. Strangely, the more he was seen by the elite in cultural circles, the more lionized he became, living off his legacy as an avant-garde pop artist. Warhol perhaps didn't notice, but by the 1980s pop was dead, very dead, looking even more dated than the abstract expressionist paintings from a generation earlier. Of course, Warhol wouldn't be the only cultural figure who continued to remain in the public eye well after there was a reason to do so. Think of comedian Bob Hope who continued to demand celebrity in his late nineties by showing up on things like a Macy's float on the Thanksgiving Day Parade in New York City. Hope seemed to be unaware of his surroundings but was happy so long as people were there to applaud.

Warhol's health had never been solid, but it declined even more rapidly toward the end of his life. When a gastrointestinal attack caused by a gangrenous gallbladder became too much, he was rushed to New York Hospital on the assurances of his doctor that the operation was going to be routine. After all, this doctor had already performed this operation on clients as famous as the Shah of Iran. Warhol was not so reassured; he had premonitions of death; however, there was no choice but to operate.

The operation was hailed a success, the gallbladder was removed, and, for good measure, the doctor repaired a hernia that Warhol had endured for nineteen years. Warhol rested comfortably in his hospital bed that evening. In one of the great oddities of the situation, Warhol refused to have the surgery if his wig were removed. No one apparently ever saw him without his wig.

Although things initially went well, Warhol's condition worsened overnight, and in the middle of the night, he eventually turned blue. His night nurse called for help, but even with extensive teamwork to revive him, he died by sunrise. After an extensive investigation, it was determined that Warhol died as a result of "cardiac arrhythmia of underdetermined origin following surgical removal of the gall bladder and repair of an abdominal incisional hernia under general anesthesia . . . cardiopulmonary arrest occurred an indeterminate but significant time prior to notification of a 'cardiac code' and initiation of cardiopulmonary resuscitation."[20] He was fifty-eight.

Nothing could be more sensational than the death of a sensational artist, a person who was synonymous with the New York art scene. The number of friends he had was legion. The memorial service was held at Saint Patrick's Cathedral in Manhattan on March 1, 1987. It was a scene that Warhol himself would have been proud of. He could plan a funeral, but he could not determine who would show up. His artistic colleagues were well represented: Roy Lichtenstein, Claes Oldenburg, Richard Serra, Keith Haring, Leroy Neiman, Jean-Michel Basquiat, Jamie Wyeth, Robert Mapplethorpe, David Hockney, and Philip Johnson. Celebrities included Calvin Klein,

Liza Minnelli, Bianca Jagger, Tom Wolfe, Ultra Violet, George Plimpton, Don Johnson, Lou Reed, Raquel Welch, and Mary McFadden. Yoko Ono gave one of the eulogies. Could there have been anyone missing? No other twentieth-century artist, even Pablo Picasso, attracted such a glittering following at his or her funeral.

Whatever Warhol's *Campbell's Soup Cans* were worth while he was alive, the price skyrocketed after his death. That's not so unusual with any artist of reputation, but Warhol's was enormously spiked by his celebrity. He produced so much material that almost anyone could buy a piece of Andy Warhol. A set of completely worthless cookie jars that Warhol collected for the fun of it were auctioned at Sotheby's. A preauction estimate ranged from $75 to $250 each, just based on Warhol's name alone. The bidding was furious on these simple objects. As it turned out, most of the lots were bought by Gedalio Grinberg, who claimed he was a friend of Warhol's. The entire collection went for the staggering sum of $247,830.[21] This auction was dubbed the "Garage Sale of the Century" by *Time* magazine, which noted that forty-five thousand people came to look at Warhol's possessions in the first week of the show.[22]

This was only the proverbial tip of the iceberg. By December 2011 it was revealed that Warhol's works accounted for one in every six contemporary art sales.[23] Considering that his original *Soup Cans* were for sale for $100 each, and the whole lot resold to the Museum of Modern Art for $15 million, one can easily see how his stock has gone up.

Warhol became more famous in death than in life. One of the true marks of posthumous fame is surveying the number of people who visit a grave of a fallen idol. Julius Caesar's place of assassination in Rome is covered with fresh flowers every morning. James Dean's tombstone in Indiana is often marked with red lipstick kiss marks and Chesterfield cigarette boxes. In a poor neighborhood cemetery in Pittsburgh, Pennsylvania, the kind of place Andy Warhol sought his whole life to escape, a modest marker declares the spot where the pop art icon is buried. On any given day, the spot is enhanced by cans of Campbell's soup, which the faithful have brought to the site, as a remembrance of his achievement in the art world. Andy Warhol had turned cans of Campbell's soup from a commodity into an artistic statement. After his passing, Andy Warhol was hailed as a great fine artist, but in truth he was the ultimate crossover artist who went from illustrator, to fine artist, and back to illustrator again. As Campbell's often said in its commercials, "Mmm Mmm Good."

· 20 ·

The Vietnam Veterans Memorial by Maya Lin

The Triumph of Abstraction

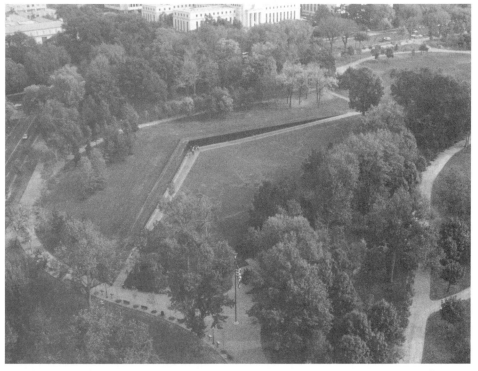

The Vietnam Veterans Memorial by Maya Lin. © *Maya Lin Studio, courtesy Pace Gallery*

We are young, they say. We have died. Remember us.

—Archibald MacLeish, "The Young Dead Soldiers Do Not Speak"

*C*an the public ever accept an abstract work as an example of great artistic expression?

A test case occurred in lower Manhattan in the 1980s when a new federal office building was planned for a large open space, and a minimalist artist was chosen to create a work that would enhance it. This opportunity was made possible by the United States General Services Administration, whose regulations say that 0.5 percent of the cost of all federal building projects must be allocated to the arts. The open plaza before the office building therefore was deemed an appropriate place to have a work set in a commanding space. New York City zoning laws require a builder to make available a proportion of open space that is relative to a structure's given height, and so a huge plaza was designed before the skyscraper to allow adequate pedestrian access. For the commission, the arts panel of the National Education Association recommended to the Arts in Architecture Program that Richard Serra, the minimalist artist, should be commissioned to construct a work suitable for this expansive space.

So in 1981 a huge curved steel wall was erected in Federal Plaza in New York City called *Tilted Arc*. At 120 feet long and twelve feet high, the arc bisected the plaza and made the viewer aware of his or her relationship to the given space, as well as the building before the viewer.

However, some office workers did not like that it restricted movement; in fact, the plaza was virtually cut in two. Judge Edward Re, a powerful New York City magistrate, began a letter-writing campaign to have it removed, and to possibly relocate it to another site. This was no small effort, because the original cost of the sculpture was $175,000, and another $35,000 would have to be spent on its removal, with some $50,000 more allocated to resurrecting it on another site if another site could be found. The artist, however, maintained that the work was site specific, and to remove it was to destroy it. In other words, the arc needed the Federal Building to complete its meaning.

Detractors alleged that the wall attracted graffiti, litter, and even rats. Some said that it could act as a cushion in a bomb blast that would direct firepower toward the building. However, all the arguments seemed to boil down to the fact that the arc caused an inconvenience to those who had to walk around it. If the arc did not cause this nuisance, there would have been no effort to remove it.

Although the art community was solidly behind Serra, and 122 people testified at a hearing in favor of the work, those who were inconvenienced, all fifty-eight of them, had their way before a jury of five, who voted four to one to have the work removed. The sculpture was sold for scrap metal and destroyed. Minimalist works have a limited fan base, especially when they impede traffic.[1]

The split between the progressive art community and the general public is nothing new, beginning perhaps a century ago with the advent of nonfigurative art. Before total abstraction, cubism, fauvism, and futurism challenged the status quo, defying

conventional ideas about pictorial form. Soon after, artists moved toward abstraction, and then by 1910 Wassily Kandinsky painted the first independent nonrepresentational works. Artists were fascinated. One by one, they took up the cause of abstraction, leading further and further away from subject matter, and closer to pure form. The list of twentieth-century experimenters is long: Malevich, Mondrian, Rothko, and Pollock, among many others.

Beginning in the 1950s and continuing through the 1980s a new spirit, called minimalism, dominated the abstract movement. Minimalists stripped a painting or a sculpture down to its most severe elements: simple tone values, rudimentary forms, and basic contours. Elements exist as a tension among one another by their juxtaposition. Paintings by Barnett Newman and sculptures by Donald Judd are typical minimalist works.

The general public, which resisted abstract art in the early twentieth century, rejected minimalism with renewed vigor. Vitriolic comments were thrown at these works, with the usual caustic remarks, "I could do that!" and "What's so special about that?"

Minimalists, however, do not seek general public approval, and understand that their work is controversial—that's part of the appeal. By 1980 it was a foregone conclusion that art would be one step ahead of public appreciation; in fact, it was expected to be this way. In the modern world most artists challenge the viewer; they are not viable members of the contemporary art scene if they don't. Connoisseurs in the nineteenth century would have found it hard to believe that the impressionists would today become hallmarks of bourgeois taste; perhaps one day minimalists will be as well.

That's why it came as a bit of a surprise when a jury of eight decided that they would select Maya Lin's abstract minimalist monument as something that could exemplify the Vietnam War. Two giant slabs of polished black granite, imported from India, stand at a 136-degree angle in the middle of the Mall in Washington, D.C., among the sacred American monuments dedicated to Jefferson, Lincoln, and Washington. Enemies of modern art could not contain their contempt.

The Vietnam Veterans Memorial is a monument unlike any other in Washington—a city hitherto known for its hyperrealistic sculptures that grace open plazas or expansive lawns. This monument however, is none of those things; it is long, low, and black, cut deeply into the National Mall—ironically full of meaning and seemingly empty at once. Simultaneously, it touches a chord in the American psyche, perhaps because of its simplicity, and yet carries with it the weight of that tragedy in the American experience.

The Vietnam War will always be a murky blot on the American consciousness. It was never a declared conflict, no act of Congress ever authorized invasion and military commitment, yet successive presidents became embroiled in the hostilities. Opposition at home was fierce and heated; riots swelled in American streets. It became fashionable to hate the military—a military who acted so heroically only a generation before in Europe, Japan, and Korea.

Times were different; this war was seen as unjust. Returning American soldiers were spat upon by a populace that was often openly hostile or indifferent at best. Suddenly service to one's country became anathema, and Americans who defied their government became cultural heroes.

In the throes of this horrific conflict, veterans had no place. Ignored by the public and the government alike, there was little to support them when they returned with the effects of Agent Orange, battle fatigue, and shock—not to mention the agony of dealing with missing limbs and tropical diseases.

The last Americans evacuated Saigon in 1975 when the Communists—who are still in power today—seized the city and made it their own, renaming it Ho Chi Minh City. The seeming waste of all those American lives in a battlefield far from home loomed large. Why did fifty-eight thousand Americans have to die in a cause that seemed unclear, and for a goal that was undefined and illusive?

It was in this milieu that a Vietnam veteran, Jan Scruggs, who served on the battle-field between 1969 and 1970, asked the government to erect a monument to memorialize the dead for an unpopular war. He wanted something hopelessly out of date—a monument dedicated to the military, one that showcased the sacrifice of thousands in a fruitless situation, and to have it done in a way that did not make a political statement. Scruggs conceived a master plan to build a monument on the National Mall, one that would be designed by competition and be a focus for American veterans.

Not an easy task. Many architectural firms, big-name firms with long, successful track records in Washington, stayed away from the competition precisely because military monuments were so obsolete. The last such monument was the Iwo Jima Memorial in Washington, D.C., an intensely realistic work based on an actual photograph of the raising of the American flag on that fiercely contested island in World War II. That memorial was dedicated in 1954, only a few years before the Vietnam War escalated. Even though the time between the Iwo Jima Monument and the Vietnam War was short, emotionally they were eons away from one another. The world had changed.

Interest was intense when the competition was announced. The debacle of Vietnam created a certain level of curiosity, and the memorial's prominent placement on the Mall in Washington, D.C., encouraged a huge number of submissions. Altogether 1,421 individuals and firms sent in entries, making it by far the largest artistic contest in American history.

The general requirements for the monument can be characterized by a few qualifications:

1. it had to be reflective and contemplative in character,
2. it had to harmonize with its surroundings (that is, the Lincoln Memorial and Washington Monument, which it sits between),
3. it had to list the names of the deceased or missing, and
4. it could make no political statements about the war.

Since there were very few restrictions, artists yielded a wide variety of approaches. Not since the 1922 *Chicago Tribune* competition did there seem to be such active interest in the creation of a work of architecture, and that competition attracted only about 260 submissions.

Like most contests, some entrants were filed right before the last day. As many as 150 proposals were received between 5:00 p.m. and midnight on the deadline, March 31, 1981. With five minutes to go, one woman was spotted in the parking lot filling out the necessary forms and return addresses on the various parts of her entry.

There were eight judges appointed to oversee the contest: two landscape architects, two structural architects, three sculptors, and an expert in urban development. They were older, and all male, perhaps not a group to accept a radical design, but all men well versed in architectural planning and design.

The prize for the winning design was a handsome check for $20,000 courtesy of the Vietnam Veterans Memorial Fund, a private association who sponsored the competition. Upon completion, the memorial was to be handed over to the National Park Service, who had donated the land in 1980. The fund selected the jurors and was allowed to use an airplane hangar at Andrews Air Force Base to house all the entrants. Through a process of elimination the 1,421 entrants became 232—still a staggering number—and then a final round of thirty-nine. All of the submissions were labeled with numbers so there was no way to know who the designer was until the decision had been reached.

Such intense scrutiny over such a contentious moment in American history meant that people would be watching. All kinds of groups were going to have their say after the judges had ruled: veterans, the Defense Department, the Interior Department, artists, architects, politicians, families of the deceased, antiwar protestors, draft dodgers—the gamut of the American experience. The jurors were mindful of the pressure but tried to stay above the cacophony and concentrate on the quality of the artistic renderings.

Tension began to grow. The press seemed unusually fascinated with the outcome of a contest concerning a war monument. No doubt the contentious atmosphere of the post-Vietnam era, with so many wounds still freshly exposed, fed the feverish interest in the outcome.

Scruggs marshaled support among famous people who would be willing to put their names on a document indicating that they supported the idea and were therefore sponsors. Former presidential candidates Barry Goldwater and George McGovern immediately signed on, which signaled a bipartisan approach, the two seen as polar opposites of the political spectrum. One by one senators began to approve the project, and the perennial wartime U.S. ambassador, Bob Hope, gave his permission to use his name on a fund-raising letter.

A National Sponsoring Committee was formed with all these participants as well as former president Gerald Ford, First Lady Rosalynn Carter, future First Lady Nancy Reagan, and General William Westmoreland. Also involved was Texas billionaire and future presidential candidate H. Ross Perot, who contributed generously in the early stages both with his money and his opinions.

The bumps and scrapes that the planning committee had endured during the early stages were nothing compared to the other memorials, both planned and built, that Washington is already littered with. The Thomas Jefferson Memorial Committee

was formed in 1902 to bring about a fitting dedication to the man who authored the Declaration of Independence. Construction did not begin until 1938, and it wasn't dedicated until 1943. A bronze statue of Jefferson was not installed until 1947—all this delay over an American political figure that nearly everyone could agree on. Imagine how the forces would line up before a memorial to a war that almost no one could agree on!

Like the Jefferson Memorial, which was hopelessly old fashioned when it was conceived and thus heavily criticized, the Vietnam Memorial would suffer a similar blitzkrieg of condemnation. At least the Vietnam Veterans Committee got permission for the memorial to be placed center stage on the National Mall. No such choice location had been given to any other organization before. With all the great wars the United States has been in, there had been no movement to create monuments up to that time for the sacrifices other veterans had made, and this was noted by the press. Even World War II, with its enormous concentration of manpower in two major theaters, had not raised the same commemoration as this until 2004. The Iwo Jima Memorial was just for the Marines, and that was set far away from downtown on a hilltop in Virginia someplace.

Besides, large, funerary monuments had gone out of style. Examples exist in the United States: Grant's Tomb on the Upper West Side of Manhattan for example, or Lincoln's mammoth tomb in Springfield, Illinois. However, by the twentieth century the public had moved away from grand mortuary statements. Indeed, when President Kennedy was interred at Arlington National Cemetery in 1963, a simple eternal flame was placed above the spot where he rests.

America has also moved away from military monuments. True, town squares throughout the United States, and throughout the world, often memorialize fallen heroes from local or worldwide conflicts. Heroic monuments have been a mainstay in traditional art history. Works as old as the *Narmer Palette* from ancient Egypt and the *Victory Stele of Naram-Sin* from the now forgotten Akkadian civilization, in what is today Iraq, show that military figures are more than willing to proclaim victory over their enemies. Such showy displays of military might are unfashionable today.

In that light it was most unusual that a progressive institution like Yale University would offer a course in funerary architecture. It was in this course that Maya Lin, an architecture student, would conceive the design that would change her life. Perhaps unknowingly, she created a monument that would link her with some of the oldest and most famous buildings in history: the Pyramids, the Taj Mahal, the Catacombs, and the Tomb of Shi Huangdi.

Students in this Yale class were encouraged to submit designs for the memorial, and their teacher led by example. Just before the deadline Maya Lin made the trek down to Washington to view the site, examine the location, and make some serious fine-tuning to her plans. Her plans were mailed off on the deadline date. Lin then sat back, not anticipating much more than a form letter expressing thanks and sincerest regrets.

The architecture class itself did not go well for her. Her professor gave her a B, rather a slap in the face to a student who had achieved almost nothing but As during her tenure at Yale. In any case, the design probably had left her mind af-

ter submission—there were so many entrants and the chances of winning were so limited. No one was more surprised than she when a delegation from the Vietnam Veterans Memorial Fund showed up to her dorm to discuss her submission and announce her prize.

The public was shocked to learn that the memorial was given to a complete unknown, rather than a prestigious firm or a career architect. Maya Lin, an American of Asian descent, a nineteen-year-old, an amateur, and not exactly a media darling, won the design competition. She was in no way prepared to face the onslaught of the Washington press corps and a myriad of veterans' groups.

Maya Lin in 2003. © *Maya Lin Studio, courtesy Pace Gallery; photograph by Walter Smith*

At first the abstraction of the design fascinated a number of art critics, particularly those who were tired of the column-and-dome type of monuments that cluttered Washington. Paul Goldberger, writing for the *New York Times*, was immediately enthusiastic: "The Vietnam Veterans Memorial, as it now nears completion, could be one of the most important works of contemporary architecture in official Washington—and perhaps the only one that will provide a contemplative space of the equal of any in the past."[2] The *Boston Globe* was more succinct: "It seems to me perfect," said critic Ward Just.[3]

The acceptance by the arts committee became an issue in its own right. Maybe, people thought, the work appealed only to the educated elite, members of the art mafia, born and bred in the New York school of abstraction. It was felt that the elite would have their way, perhaps looking down on everyone else who was too ignorant to understand. Particularly vitriolic was Tom Wolfe, the best-selling novelist whose works were selling in the millions. Wolfe is a talented purveyor of fiction in the guise of documentary, producing searing portrayals of modern celebrities and social norms that he takes displeasure to.

Wolfe saw modern art as anathema, dubbing the Vietnam Veterans jury as the "Mullahs of Modernism." He went on to call Scruggs a "prole," which in George Orwell's *1984* refers to working class—a term filled with sarcasm and sneers. He then blasted the wall as "a tribute to Jane Fonda,"[4] that 1960s actress and activist whom many suspect of treason because of her speech condemning the United States on a visit to North Vietnam.

All the naysayers managed to do was hype the fame of the Vietnam Memorial. Wolfe's deft prose made for good sound bites but contributed nothing to the discourse other than ratcheting up the volume of the dialogue.

The Veterans Committee was beset on all sides by various viewpoints. Many complained that with so many entrants, this was the best they could do? H. Ross Perot wanted to pay for a Gallup poll of veterans to determine whether this design was a fitting tribute to be placed on the Mall. Even though people like Henry Kissinger were now contributing to the fund, a crotchety secretary of the Interior, James Watt, seemed hard to please. And Watt had to be pleased, because the memorial was to be placed on Interior land.

Compromise seemed to have been reached when an idea was floated to have a traditional statue and flagpole placed near the memorial, so that both a representational and abstract work could commemorate the war.

Nothing could have appealed less to Maya Lin, but nothing could be done. In fact, the political agreement to have a sculpture near the wall meant that the controversy would heighten, and that a deliberate dialogue had now been set up between the two works. Frederick Hart, one of the artists who submitted a plan for the initial competition, was asked to design a work that would epitomize the struggle of the ordinary soldier. For this effort he was paid a staggering $330,000.

Politically there was no choice. The statue of three tentative young men looking everywhere at once was submitted to the committee, and they unanimously accepted it. The figures are called *The Three Servicemen* to make the distinction that they are representations of people who served in the war, and not just those who died there.

The names themselves raised issues that directly concerned—even haunted—every aspect of the memorial. For example, how many names are to be included on the wall? By honoring the dead, do we mean those who died in combat? Or died of tropical diseases while on duty? Or later died of Agent Orange when back home in the United States? Or missing in action and presumed dead? Or people killed outside the war zone but in support of direct combat missions? Or civilians working in the war zone for American companies? Decisions had to be made on each one of these criteria, and there was opposition to every decision. Originally a catalog of over fifty-eight thousand names was compiled, although the list has always been in flux, especially with so many considerations, and the inaccuracy of reporting under battlefield conditions.

More controversy: How should the names be arranged? Should they be in alphabetical order? Or should they be in the order they were killed? If they are in alphabetical order will it make it look more like a phone book? If they are in chronological order will they be hard to find? What date should be used if a soldier is missing in action? Ingeniously, Maya Lin insisted that the beginning and ending dates meet in the vortex. The first date appears at the convergence of the walls and fans out to one end, and then starts again on the tip of the other wall and extends to the middle. In this way, the beginning and the end meet in the middle: a kind of circular relationship that expresses an effective continuance.

Once the list had been compiled, other obstacles occurred that led to further questions: Since the names on the wall are etched in stone, there was the problem of corrections. What if a name is spelled incorrectly? What if the Department of Defense wants a formal name, and a family an informal one? More crucially, what if someone is placed on the wall, and then not found to be missing? Would erasing their names cause the wall to be marred? There are twelve such cases on the wall, and the decision has been to leave them as they are. What if names have been inadvertently omitted? Fortunately, there is room to expand, and there have been times when additions have been made, so there are now 58,300, the latest being added in 2014.

This is not the longest listing of names on a war memorial, not even close. In Thiepval, France, an enormous monument marks the deaths of 72,090 British and South African troops who died or were missing at the Battle of the Somme between July 1916 and March 1918. In all, over a million and half casualties were reported in successive battles on this site.

Yale has a much smaller, but impressive, wall honoring graduates who served in a number of American wars. Indeed, there is hardly a town in America in which a monument does not sit centrally in a public square dedicated to the fallen in one war or another. Maya Lin knew the great monument in France, and certainly passed by the wall plaques at Yale, but she was not a person deeply impressed by the political and historical sweep of these events. For her, the primary goal was to capture the human tragedy in a design concept.

Therefore, Lin conducted no interviews with veterans, consulted no history books on Vietnam and its conflict, and did not try to curry favor with those in charge. In the political maelstrom that is Washington, this could be fatal.

Part of the anxiety that existed in the early stages of this construction was the tension between Lin herself and the veterans. She believed it was her design, and they believed that it was their monument. Veterans claimed they wanted an inscription on the wall, one that expressed the meaning of the memorial and a dedicatory phrase to all veterans who served in Vietnam. Lin balked at the idea. Her memorial was for the dead. Period.

Things could have been smoothed over if Lin did a little healing of her own. She never asked veterans about their mission, their buddies, their emotions, the meaning of courage and sacrifice.[5] In the end, this crippled her insistence that there should be no inscription. The veterans had their way, and a small inscription, rather innocuous actually, was inscribed on the wall, beginning at the vortex and slowly descending into the earth on the east side: "In honor of the men and women of the armed forces of the United States who served in the Vietnam War. The names of those who gave their lives and of those who remain missing are inscribed in the order they were taken from us." On the flanking wall, rising from the ground, a companion inscription reads: "Our nation honors the courage, sacrifice and devotion to duty and country of its Vietnam veterans. This memorial was built with private contributions from the American people. November 11, 1982." Also added to the wall are the names of the Vietnam Veterans Memorial Fund as well as the name of the artist.

In one way Lin did win out. A movement to have the name of the monument and the United States printed somewhere on the wall was squashed by Robert Doubek, the project director, who exclaimed, "Does Washington's name appear on the Washington Monument?"[6]

Finally by Veterans Day 1982 the memorial was ready to be unveiled. It was completed at lightning speed, considering that it is located in Washington, D.C., and is something that involved politicians, veterans, the arts community, and private financing. Days before the official ceremony people were starting to gather in the capital, anxious for the grand opening. Soldiers, so long spat upon by the public, were at last coming home to a monument that was theirs. It was a chance for the general public to say thank you to those who had given so much, and received literally nothing in return. Preliminary ceremonies took place at the National Cathedral, where the entire litany of names was read aloud, slowly and majestically over the course of several days. Some came to hear one particular name; others stayed for the entire reading.

When the focus of the ceremonies turned to the Mall, the impressiveness of the monument soon became apparent. It digs deeply into the earth, creating, as one pundit called it, "a black gash of shame." The mirrored black walls echo back on the viewer with the eerie sense that one can see a reflection in the design, one's face appearing on the names so firmly etched in stone. The deepness of the trench makes the wall overwhelm the viewer, as the magnanimity of the loss—with the thousands of names inscribed—towers over the viewer.

People came with tracing paper and pencils, making crude rubbings of the surfaces so they could take the names home with them. They came in wheelchairs, with canes, or with others to hold them up. They brought small American flags and little groupings of flowers; they cried at the effect of seeing the names before them. They left photographs and mementos, small objects of hidden meaning or

obvious symbolism. One hundred fifty thousand people attended the dedication ceremony—the wall reached across all boundaries to unite Americans. A museum is now contemplated that would hold these mementos, all carefully gathered and stored by the National Park Service.

The deep gash etched into the earth healed, as Lin said it would. The effects of Vietnam will always leave a scar, but the remediation process had begun, and it is not too much to say that the monument was the first step toward healing a nation that desperately needed it. Americans learned at least one lesson; next time there was a war, this time in the Persian Gulf, there would be no spitting on veterans, no hatred of the military, no ambivalence about the men and women fighting. Question the politicians, but not the people who defend their country.

There was no agreement, however, on where Hart's sculpture should be placed. Should it be placed before the wall, so that it could seemingly be in contrast with it, and interact as if reality and metaphor were on the same plane? J. Carter Brown, director of the National Gallery in Washington and chair of the Fine Arts Commission, suggested that the statue and flagpole serve as an "entry point" to the memorial, and be placed to one side. The Interior Department agreed, and the statue was placed near but not in the monument,[7] at a respectful distance near one of the entrances. Paul Goldberger remarked, "The insertion of statues and a flagpole not only destroys the abstract beauty of that mystical inside-outside kind of space that Maya Yang Lin has created; it also tries to shift this memorial away from its focus on the dead, and toward a kind of literal interpretation of heroism and patriotism that ultimately treats the war dead in only the most simplistic of terms."[8]

Although Lin despised these two objects because she felt they intruded on her design, she achieved a minor triumph in that no one who visits the monument gives more than a passing glance at them. It is the wall that people come to see. Had the wall not been there, the flagpole and the statue would, no doubt, be just another nameless feature in a city filled with empty monuments. The Vietnam Veterans Memorial is a triumph of abstraction over realism. The solid black walls point on one end to the Washington Monument and the other to the Lincoln Memorial, and make a grand statement about the war's place in American history. Artistically, it also acts as a bridge between the hyperrealism of the sculpture of Abraham Lincoln in the Lincoln Memorial and the minimalist design of the Washington Monument.

The affection that the American public showed for the wall grew exponentially. So great was the interest that a replica was created, smaller in scale but just as powerful, which was sent on tour around the United States for those people who could not go to Washington to see the original. Wherever the small version went, it was greeted with the same enthusiasm of the real wall.

When it arrived in Saint Petersburg, Florida, the scene was the same as it would have been anywhere:

> You will see middle-aged men, in the remains of old uniforms standing around in numbness, and perhaps some women; some may be crying for the first time in 15 years. Other looking much like the guy next door will be on hand. Men and women who never may have been to a "vet meeting," never given much thought

to the war, but who now find that at this point in their lives they have no clear understanding as to why even though they have had a good life, something is missing. . . . There will be teenagers and other young folks looking for the name of a father they never knew. Women in their 30s and 40s will be saying goodbye to husbands who never grew old. Mothers and dads, sisters and brothers, friends and schoolmates sharing their loss.[9]

Fame, as it turns out, meted out a heavy price. The wall not only became a commemorative place, where people could reflect on the past, it also became a place of active political debate. Anti- and pro-Reagan demonstrators began using the site to protest, causing many in the Interior Department to fear for the safety of the structure, as well as to be concerned about the tranquility that the space was supposed to engender. Efforts to prohibit free speech were quickly met by threats of lawsuits from the ACLU. Compromise had to be reached; otherwise, the site would have been overwhelmed with blaring loudspeakers and littering leaflets.

Harold Bryant, a spokesman for the Vietnam Veterans of America, said, "We consider that memorial as sacred ground for us. There aren't demonstrations allowed in other veteran memorials, so why should ours be any different?"[10] What had become a controversial veteran monument with acrimonious language had morphed quickly into sacred ground that had to be respected with silence. Maya Lin had worked magic.

The general public did not connect to Richard Serra's *Tilted Arc*; it was seen as obstructionist and disconnected from society. Maya Lin's design, ironically, resonated because of its abstract nature. There are no traditional equestrian statues, or peace symbols or mourning angels. No quotations from the Bible, or Shakespeare or Dante. No indications of Medal of Honor winners or years of service. No listing of those who died in combat and those who didn't. The very lack of heroic themes, the simplicity of abstract design, one's engagement with the wall of names: these are the ideas that draw the public into the work. It's the wall that brings the viewer to a fuller realization of what Vietnam was all about, and does it in a way that no realistic work could.

Notes

FOREWORD

1. The variable and fairly complex terminology surrounding the word "masterpiece" itself is expertly documented and explained in Walter Cahn, *Masterpieces: Chapters on the History of an Idea* (Princeton, N.J.: Princeton University Press, 1979). See, too: Robert von Hallberg, ed., *Canons* (Chicago: University of Chicago Press, 1984).

2. John Michael Montias, *Vermeer and His Milieu: A Web of Social History* (Princeton, N.J.: Princeton University Press, 1989), 351, doc. 383.

3. For a discussion and reproduction of the celebrated canvas in its ruinous state, see Finbarr Barry Flood, "Between Cult and Culture: Bamiyan, Islamic Iconoclasm, and the Museum," *Art Bulletin* 84, no. 4 (December 2002): 653–54, fig. 9; Dario Gamboni, *The Destruction of Art: Iconoclasm and Vandalism Since the French Revolution* (London: Reaktion Books, 2007), 93–97, fig. 42; and, most recently, Tabitha Barber and Stacy Boldrick, eds., *Art under Attack: Histories of British Iconoclasm*, exhibition catalog (London: Tate Britain, 2013), 124–25. As remarkable as it would seem today, "Slasher Mary's" (as Richardson came to be known) attack prompted the closure of many of England's art galleries and museums to women and, in the case of the Royal Academy and the Tate Gallery in May 1914, to the entire public. The British Museum allowed female visitors, but only if accompanied by men who would be willing to accept responsibility for them. Unaccompanied women were only allowed in if they had a letter of recommendation from a gentleman who would vouch for their good conduct. Richardson had pinned her cleaver inside her sleeve on that fateful day in March 1914, and thus signs enforcing the rule of "No muffs, wrist-bags, or sticks" soon became common at places of historical interest.

4. Quoted in David Freedberg, *The Power of Images: Studies in the History and Theory of Response* (Chicago: University of Chicago Press, 1989), 409. Richardson was sentenced to six months in Holloway for the attack, but was released early on April 6, 1914, suffering from acute appendicitis.

INTRODUCTION

1. Peter Allen and Ian Sparks, "Woman in Hot Water After Attacking the Mona Lisa with a Mug of English Breakfast Tea," *Mail Online*, August 11, 2009, accessed July 17, 2011, www.dailymail.co.uk.

2. "Mona Lisa Attacked with Teacup," *New York Times*, August 11, 2009, accessed July 17, 2011, www.nytimes.com.

3. Mary Shelley, *Rambles in Germany and Italy* (London: Edward Moxon, 1844), 109.

4. Mark Twain, *Innocents Abroad* (Hartford, Conn.: American Publishing, 1892), 191.

5. George C. Williamson, *The Cities of Northern Italy* (New York: A. Wessels, 1901), accessed July 11, 2011, Archive.org.

6. Aubrey Stewart and George Long, trans., *Plutarch's Lives* (London: G. Bell & Sons, 1894), accessed July 10, 2011, Archive.org.

7. Bayard Taylor, *Views A-Foot: Europe Seen with a Knapsack and Staff* (New York: Putnam, 1887), 413.

8. Giorgio Vasari, *Lives of Seventy of the Most Eminent Painters, Sculptors and Architects*, ed. and annotated by E. H. Blashfield, E. W. Blashfield, and A. A. Hopkins (London: G. Bell & Sons, 1897), 4:59–60.

9. Maev Kennedy, "Largest Ever Hoard of Anglo-Saxon Gold Found in Staffordshire," *Guardian*, September 24, 2009, accessed July 10, 2011, Guardian.co.uk.

10. Walter Pater, *The Renaissance: Studies in Art and Poetry* (London: Library Edition, 1910), accessed June 20, 2011, http://www.gutenberg.org/cache/epub/4060/pg4060.html.

11. Karl Baedeker, *Northern Germany Handbook for Travelers* (Leipzig: Karl Baedeker, 1884), 364.

12. Taylor, *Views A-Foot*, 199.

13. Oscar Wilde, *The Picture of Dorian Gray* (Oxford: Oxford University Press, 1998), 21.

14. Richard Taruskin, "A Myth of the Twentieth Century: The Rite of Spring, the Tradition of the New, and 'The Music Itself,'" *Modernism/Modernity* 2, no. 1 (1995): 16.

CHAPTER 1. THE GREAT SPHINX: BEYOND HUMAN UNDERSTANDING

1. As quoted in C. de La Jonquière, *L'Expédition en Egypte, 1798–1801* (Paris, 1899–1907), 3:398–99. Trans. into English by Jean Christopher Herold, *Bonaparte in Egypt* (New York: Harper & Row, 1962), 239–40.

2. Elmer G. Suhr, "The Sphinx," *Folklore* 81, no. 2 (Summer 1970): 103.

3. Desmond Stewart, *The Pyramids and the Sphinx* (New York: Newsweek, 1971), 44.

4. Dario Camuffo, "Controlling the Aeolian Erosion of the Great Sphinx," *Studies in Conservation* 38, no. 3 (August 1993): 199.

5. The heads on Mount Rushmore are slightly larger, though not royal portraits, and the yet-to-be-completed figure of Crazy Horse in South Dakota is larger still.

6. Jacques Kinnaer, "Dream Stela—Translation," the Ancient Egypt Site, accessed May 5, 2011, http://www.ancient-egypt.org/index.html.

7. Betsy M. Bryan, *The Reign of Thutmose IV* (Baltimore: Johns Hopkins University Press, 1991), 348.

8. Evan Hadingham, "Uncovering Secrets of the Sphinx," *Smithsonian Magazine*, February 2010, accessed May 5, 2011, http://www.smithsonianmag.com/history/uncovering-secrets-of-the-sphinx-5053442/.

9. Stewart, *Pyramids and the Sphinx*, 142.

10. Christiane Zivie-Coche, *Sphinx History of a Monument* (Ithaca, N.Y.: Cornell University Press, 1997), 18.

11. *Oxford English Dictionary*, s.v. "Pyramid," accessed April 6, 2011, www.oed.com.

12. *Oxford English Dictionary*, s.v. "Obelisk," accessed April 6, 2011, www.oed.com.

13. Suhr, "Sphinx," 97.

14. Color made from iron ore

15. Pliny, *Natural History*, trans. D. E. Eichholz (Cambridge, Mass.: Harvard University Press, 1962), 10:59–61.

16. Pliny, *Natural History*, 10:60–61.

17. Robert Girardi, "Nose Job," *New Republic* 213, no. 20 (November 13, 1995): 14, accessed April 21, 2011, http://web.a.ebscohost.com.central.ezproxy.cuny.edu:2048/ehost/detail/detail?sid=3247b3ff-97b1-409b-b72b-49c89af21069%40sessionmgr4005&vid=0&hid=4107&bdata=JnNpdGU9ZWhvvc3QtbGl2ZQ%3d%3d#db=mth&AN=9512074326.

18. Peter A. Clayton, *The Rediscovery of Ancient Egypt* (New York: Portland House, 1990), 68.

19. Robert Girardi, "Sphinx's Nose," *Baltimore Sun*, November 9, 1995.

20. Emerson, *Notebooks*, 1859. As quoted in Ralph L. Rusk, *The Life of Ralph Waldo Emerson* (New York: Scribner, 1949), 313.

21. Herman Melville, *Moby-Dick* (New York: Bantam, 1981), 291.

22. George Bernard Shaw, *Caesar and Cleopatra*, act 1.

23. Ben Jonson, *Sejanus: His Fall*, 1605, act 3, line 65.

24. John Speed, *Historie of Great Britaine* (n.p., 1611), 9–11.

25. Charles Kingsley, *Two Years Ago*, ch. 27 (Cambridge, Mass.: Macmillan, 1857), accessed May 8, 2011, www.online-literature.com.

26. William Shakespeare, *Love's Labour's Lost*, 1598, act 4, scene 3, lines 318–21.

27. Alexandre Dumas, *Impressions of Travel, in Egypt and* Arabia, 1830, as quoted in Stewart, *Pyramids and the Sphinx*, 145.

28. Harriet Martineau, *Eastern Life, Present and Past*, 1846, as quoted in Stewart, *Pyramids and the Sphinx*, 148.

29. Hadingham, "Uncovering Secrets."

30. Hadingham, "Uncovering Secrets."

31. "Scholars Dispute Claim That Sphinx Is Much Older," *New York Times*, February 9 1992, 34.

32. William Edward Burghardt Du Bois, *Black Folk: Then and Now* (New York: Henry Holt, 1939), 25–26.

33. Sheldon Peck, "Sphinx May Really Be a Black African," *New York Times*, July 18, 1992.

34. Hadingham, "Uncovering Secrets."

35. Hadingham, "Uncovering Secrets."

CHAPTER 2. THE TOMB OF TUTANKHAMUN: POLITICS, ETHNIC PRIDE, HORNETS, A DEAD CANARY, AND A CURSE

1. Michael Hall, "Wonderful Things: Interview with the Countess of Carnarvon," *Apollo*, February 2009, 42.

2. Howard Carter, *The Tomb of Tutankhamun* (New York: Dutton, 1972), 32.

3. Lord Carnarvon's description, December 10, 1922, quoted in Nicholas Reeves and John H. Taylor, *Howard Carter before Tutankhamun* (London: British Museum, 1992), 141.

4. "Gem-Studded Relics in Egyptian Tomb Amaze Explorers," *New York Times*, December 1, 1922, 1.

5. "Tutankhamun Tomb Attracts Tourists," *New York Times*, December 31, 1922, 32.

6. "Tutankhamun the Magnificent, Last Pharaoh of Golden Age," *Atlanta Constitution*, March 4, 1923, F16.

7. "Tutankhamun Tomb Dazzles Egyptians," *New York Times*, January 18, 1923, 7.

8. Carter, *Tomb of Tutankhamun*, 63.

9. Carter, *Tomb of Tutankhamun*, 57.

10. "Royalty Inspects Pharaoh Treasures," *New York Times*, February 19, 1923, 1.

11. "Splendor of Tomb of Tut-Ankh-Hamen Astounds Experts," *New York Times*, February 20, 1923, 1.

12. "Find Priceless Treasures in Egyptian King's Tomb," *Philadelphia Evening Public Ledger*, December 28, 1922, Night Extra, 15.

13. "Greatest Art Discovery in World, Claim," *Ogden Standard-Examiner*, December 2, 1922, 1.

14. Brian Handwerk, "Curse of the Mummy," *National Geographic*, accessed July 20, 2011, http://science.nationalgeographic.com/science/archaeology/curse-of-the-mummy/.

15. Handwerk, "Curse of the Mummy."

16. "Death by Evil Spirit Possible, Says Doyle," *New York Times*, April 6, 1923, 3.

17. "Death by Evil Spirit Possible," 3.

18. "Carnarvon's Death Spreads Theories about Vengeance," *New York Times*, April 6, 1923, 1.

19. "Carter Goes to Luxor to Reopen the Tomb," *New York Times*, October 4, 1923, 25.

20. Carter, *Tomb of Tutankhamun*, 112.

21. Thomas Hoving, *Making the Mummies Dance: Inside the Metropolitan Museum of Art* (New York: Touchstone, 1993), 401–2.

22. Christopher Knight, "The Boy Shill: How King Tut Evolved from Cold War Cultural Ambassador to Today's Corporate Pitchman," *Los Angeles Times*, August 28, 2005, quoted in *Richard Nixon Foundation Blog*, "RN Was the Man behind 'The Treasures of Tutankhamun' in 1976," August 28, 2005, accessed August 22, 2011, http://blog.nixonfoundation.org/2005/08/rn-was-the-man-behind-the-treasures-of-tutankhamen-in-1976/.

23. Ruth Robinson, "The Tutankhamun Spirit Runs Riot in New Jewelry Everywhere," *New York Times*, September 12, 1977, 38.

24. Marilyn Chase, "Museum Show Inspires Tutmania," *New York Times*, March 8, 1978, C1.

25. Bryan Appleyard, "Treasure Linked to Tutankhamun Found," *Times of London*, March 7, 1988, accessed May 12, 2011, http://www.lexisnexis.com.central.ezproxy.cuny.edu:2048/hottopics/lnacademic/.

26. Appleyard, "Treasure Linked to Tutankhamun."

27. Knight, "The Boy Shill."

28. "King Tut's 'Comeback Tour' Begins," *MSNBC*, June 16, 2006, accessed July 19, 2011, http://www.nbcnews.com/id/8235766/ns/technology_and_science-science/t/king-tuts-comeback-tour-begins/#.VRQ7GPzF_To.

29. Maria Puente, "King Tut Reigns Again," *USA Today*, June 6, 2006, accessed July 19, 2011, http://usatoday30.usatoday.com/life/2005-06-06-tut-main_x.htm.

30. Puente, "King Tut Reigns Again."

31. Charlotte Higgins, "After a 35 Year Wait, Tutankhamun Makes a Golden, Glittering Return," *Guardian*, March 12, 2007, accessed July 20, 2011, http://www.theguardian.com/uk/2007/mar/13/topstories3.artnews.

32. Higgins, "A Golden, Glittering Return."

33. Albert Granberry, "Zahi Hawass: Man of Many Zingers at King Tut Exhibition," *Dallas Morning News*, October 1, 2008, accessed March 26, 2015, http://artsblog.dallasnews.com/2008/10/zahi-hawass-man-of-many-zinger.html/.

34. www.kingtut.org, accessed July 19, 2011.

35. http://www.Tutankhamunmanchester.com, accessed July 23, 2011.

36. Kate Deimling, "Mummies Are Beheaded and Museums Ransacked amid Egypt's Revolutionary Chaos," ArtInfo.com, January 31, 2011, accessed March 10, 2011, http://www
.blouinartinfo.com/news/story/36841/mummies-are-beheaded-and-museums-ransacked
-amid-egypts-revolutionary-chaos#.

CHAPTER 3. THE PARTHENON SCULPTURES:
LORD ELGIN AND HOW GREECE LOST ITS MARBLES

1. William St. Clair, *Lord Elgin and the Marbles* (London: Oxford University Press, 1967), 57.

2. St. Clair, *Lord Elgin*, 8–9.

3. John Merryman, "Thinking about the Elgin Marbles," *Michigan Law Review* 83, no. 8 (August 1985): 1898.

4. Lord Byron, *Childe Harold's Pilgrimage*, http://www.gutenberg.org/cache/epub/5131/
pg5131.txt.

5. Athena

6. Scotland

7. Sea; ocean

8. Scottish

9. Split; rip apart

10. A medieval plundering tribe

11. Rochelle Gurstein, "The Elgin Marbles, Romanticism & the Waning of 'Ideal Beauty,'" *Daedalus* 131, no. 4 (Fall 2002): 89.

12. Victor Ginsburgh and François Mairesse, "Issues in the International Market for Cultural Heritage" in *Handbook on the Economics of Cultural Heritage*, ed. Iide Rizzo and Anna Mignosa, 152 (Cheltenham, UK: Edward Elgar, 2013).

13. Antonio Canova, *Elgin Marbles* (London, 1816), 21–22.

14. Adolf Michaelis, *Ancient Marbles in Great Britain* (Cambridge: Cambridge University Press, 1882), 138.

15. St. Clair, *Lord Elgin*, 168–69.

16. St. Clair, *Lord Elgin*, 169.

17. *Report from the Select Committee of the House of Commons on the Earl of Elgin's Collection of Sculptured Marbles* (London: John Murray, 1816), 74.

18. *Report from the Select Committee*, 80.

19. *Report from the Select Committee*, 84–85.

20. John Keats, "On Seeing the Elgin Marbles," accessed March 26, 2015, http://www
.poetryfoundation.org/poem/183997.

21. British Museum, "History of the British Museum," accessed March 26, 2015, http://
www.britishmuseum.org/about_us/the_museums_story/general_history.aspx.

22. Lord Byron, *Childe Harold's Pilgrimage*, canto 2, st. 12, footnote.

23. Upper stories

24. Mark Twain, *The Innocents Abroad* (Hartford, Conn.: American Publishing, 1892), 347.

25. Elisabeth Kehoe, "Working Hard at Giving It Away: Lord Duveen, the British Museum and the Elgin Marbles," *Historical Research* 77, no. 198 (November 2004): 515.

26. Kehoe, "Elgin Marbles."

27. Christopher Hitchens, *Imperial Spoils: The Curious Case of the Elgin Marbles* (New York: Hill & Wang, 1987), 78.

28. "Greece Wants British to Return Elgin Marbles," *New York Times*, April 18, 1982, 10.

29. "Greece's Claim to the Elgin Marbles," *New York Times*, March 4, 1984, E9.

30. *San Francisco Chronicle*, May 26, 1983, 26. As quoted in Merryman, "Thinking about the Elgin Marbles," 1881.

31. "Greece Wants British to Return Elgin Marbles," 10.

32. "Heel 'May Hasten Marbles' Return,'" *BBC*, January 13, 2006, accessed July 10, 2011, http://news.bbc.co.uk/2/hi/europe/4610826.stm.

CHAPTER 4. *APOLLO BELVEDERE*: THE RISE AND FALL OF THE *APOLLO BELVEDERE*

1. Dorothy Mackay Quynn, "The Art Confiscations of the Napoleonic Wars," *American Historical Review* 50, no. 3 (April 1945): 438.

2. Le Musée Napoleon, Salle de L'Apollon, accessed March 26, 2015, http://napoleonic medals.org/coins/l-xxxi.htm.

3. David O'Brien, "Antoine-Jean Gros in Italy," *Burlington Magazine* 137, no. 1111 (October 1995): 660.

4. *Encyclopedia Americana*, s.v. "Apollo," Grolier Online, 2011, accessed May 18, 2011.

5. R. Weiss, *The Renaissance Discovery of Classical Antiquity* (Oxford: Blackwell, 1969), 103. Italian translation mine.

6. Deborah Brown, "The Apollo Belvedere and the Garden of Giuliano della Rovere at SS. Apostoli," *Journal of the Warburg and Courtauld Institutes* 49 (1986): 235.

7. Richard Jenkyns, *The Legacy of Rome: A New Appraisal* (Oxford: Oxford University Press, 1992), 303–4.

8. Wendy Stedman Sheard, "Renaissance Bronzes in Frankfurt," *Art Journal* 46, no. 2 (Summer 1987): 134.

9. Johann Winckelmann, *History of Ancient Art*, trans. G. Henry Lodge (Cambridge, Mass.: Harvard Divinity School, 1910), 312–13.

10. Joshua Reynolds, *Discourses on Art* (London: James Carpenter, 1797), 53.

11. Eudo G. Mason, *The Mind of Henry Fuseli* (London: Routledge & Kegan Paul, 1951), 206.

12. Johann Wolfgang von Goethe, *Italian Journey*, trans. W. H. Auden and Elizabeth Mayer (New York: Schocken Books, 1968), 123.

13. Von Goethe, *Italian Journey*, 135.

14. Alan McNairn, *Behold the Hero: General Wolfe and the Arts in the Eighteenth Century* (Montreal: McGill-Queen's University Press, 1997), 128.

15. Nathaniel Hawthorne, *The Marble Faun* (New York: Grosset & Dunlap, 1859), 317.

16. Lucy Morrison and Staci Stone, "Apollo Belvedere," in *A Mary Shelley Encyclopedia* (Westport, Conn.: Greenwood, 2003), 18, accessed May 18, 2011, via Gale Virtual Reference Library.

17. Robert Service, "Apollo Belvedere," accessed March 26, 2015, https://www.poeticous.com/poets/robert-w-service/poems/apollo-belvedere?locale=en.

18. Christopher Woodward, *In Ruins: A Journey through History, Art and Literature* (Westminster, Md.: Knopf, 2003), 156.

19. Anselm Feuerbach, *Der Vatiscanische Apollo eine reiche Archäeologisch-Ästhetiischer Betrachtungen*, 2nd ed. (Stuttgart: J. G. Cotta'Scher Verlag, 1855), 1.

20. A. D. Potts, "Greek Sculpture and Roman Copies I: Anton Raphael Mengs and the Eighteenth Century," *Journal of the Warburg and Courtauld Institutes* 43 (1980): 163.

21. William Hazlitt, *Notes on a Journey through France and Italy* (London: Hunt & Clarke, 1826), 260.

22. Hazlitt, *Notes on a Journey*, 148.

23. Rochelle Gurstein, "The Elgin Marbles, Romanticism & the Waning of 'Ideal Beauty,'" *Daedalus* 131, no. 4 (2002): 88ff, accessed May 18, 2011, via Academic OneFile.

24. George Stillman Hillard, *Six Months in Italy* (Cambridge, Mass.: Riverside Press, 1881), 150–51.

25. John Ruskin, *Modern Painters* (Project Gutenberg, 2009), 2:224, accessed May 5, 2011, http://www.gutenberg.org/ebooks/29907.

26. Kenneth Clark, *Civilisation* (New York: Harper & Row, 1969), 2.

27. Jenkyns, *The Legacy of Rome*, 9.

28. Hazlitt, *Notes on a Journey*, 113.

29. Orvar Lufgren, *On Holiday: A History of Vacationing* (Berkeley: University of California Press, 1999), 178.

CHAPTER 5. *NIKE OF SAMOTHRACE*: THE VICTORY OF THE STAIRCASE

1. Ferris Powell Merritt, "Victory Medals for Nearly Five Million Americans," *New York Times*, July 4, 1920, 37.

2. Pindar, *Nemean Ode 5: For Pytheas of Aegina Boys' Pancratium*, accessed March 26, 2015. http://www.perseus.tufts.edu/hopper/text?doc=Perseus%3Atext%3A1999.01.0162%3Abook%3DN.%3Apoem%3D5.

3. Karim W. Arafat, "Nike," in *The Oxford Companion to Classical Civilization*, ed. Simon Hornblower and Antony Spawforth (Oxford: Oxford University Press, 1998), accessed June 22, 2009, via Oxford Reference Online.

4. "A Closer Look at the Winged Victory of Samothrace," accessed July 15, 2011, http://musee.louvre.fr/oal/victoiredesamothrace/indexEN.html.

5. Olivier Rayet, "Victoire: Statue en marbre trouvée à Samothrace," in *Monuments de l'art antique* (Paris, 1881), 3.

6. Ernest Arthur Gardner, *A Handbook of Greek Sculpture*, 2 vols. (London: Macmillan, 1896–1897), 528.

7. Phyllis Williams Lehmann and Karl Lehmann, *Samothracian Reflections: Aspects of the Revival of the Antique* (Princeton, N.J.: Princeton University Press, 1973), 200.

8. Lehmann and Lehmann, *Samothracian Reflections*, 182.

9. Lehmann and Lehmann, *Samothracian Reflections*, 188.

10. "Ornamentation of Schoolrooms," *New York Times*, March 22, 1896, 24.

11. "New Art Museum," *New York Times*, July 6, 1902, 7.

12. "Large Market for Figurines," *New York Times*, November 23, 1902, 26.

13. Gabriele D'Annunzio, *Sonnets Cisalpins*, XII (1896). Translation courtesy of Jack Jarzavek.

14. F. T. Marinetti, *The Futurist Manifesto*, accessed March 26, 2015, http://www.goodreads.com/quotes/950614-we-declare-that-the-splendor-of-the-world-has-been.

15. Alan Riding, "Dancing across Frontiers at the Louvre," *International Herald Tribune*, November 23, 2007, accessed July 11, 2011.

16. Mike Toner, "Going Home: Some Artifacts That Have and Some That May; Coveting Thy Neighbor's Past," *Atlanta Journal-Constitution*, November 7, 1999, Q2.

CHAPTER 6. *THE BIRTH OF VENUS* BY BOTTICELLI: NOTHING IS FOREVER, NOT EVEN NEGLECT

1. Giorgio Vasari, *Lives of the Most Excellent Italian Painters, Sculptors, and Architects*, trans. Gaston du C. de Vere (London: Philip Lee Warner, 1912–1914), 248.

2. Eudo C. Mason, *The Mind of Henry Fuseli* (London: Routledge & Kegan Paul, 1951), 239.

3. Robert Hewison, *Ruskin, Turner and the Pre-Raphaelites* (London: Tate Gallery Publishing, 2000), 145.

4. John Ruskin, *The Complete Works of John Ruskin*, ed. E. T. Cook and Alexander Wedderburn (London: George Allen, 1906), 23:266.

5. Walter Pater, *The Renaissance* (1873; repr., New York: Boni and Liveright, 1919), 41.

6. Pater, *Renaissance*, 47–48.

7. Jane C. Long, "Botticelli's Birth of Venus as Wedding Painting," *Aurora, the Journal of the History of Art* 9 (Annual 2008).

8. David L. Quint, trans., *The Stanze of Angelo Poliziano* (University Park: Penn State University Press, 1979), 51–53.

9. Michael Levey, "Botticelli in Nineteenth-Century England," *Journal of the Warburg and Courtauld Institutes* 23, nos. 3–4 (June–December 1960): 291.

10. R. H. Wilenski, "The Great Italian Exhibition at Burlington House," *New York Times*, January 19, 1930, 117.

11. Quoted in Francis Haskell, "Botticelli, Fascism and Burlington House—The 'Italian Exhibition' of 1830," *Burlington Magazine* 141, no. 1157 (August 1999): 463.

12. "Italy's Finest Art on Exhibit in Paris," *New York Times*, May 17, 1935, 19.

13. Jacques Mauny, "Visiting the Great Italian Exhibition in Paris," *New York Times*, July 14, 1935, X8.

14. Frederick A. Sweet, "Masterpieces of Italian Painting," *Bulletin of the Art Institute of Chicago* 33, no. 7 (December 1939): 111.

15. "Art Masterpieces from Italy Shown," *New York Times*, January 26, 1940, 12.

16. "Art Masterpieces from Italy Shown," 12.

17. "Topics of the Times," *New York Times*, April 8, 1940, 14.

18. Roger Fry, "Notes on the Italian Exhibition at Burlington House—I," *Burlington Magazine for Connoisseurs* 56, no. 323 (February 1930): 72.

19. Fry, "Notes on the Italian Exhibition," 72.

CHAPTER 7. *MONA LISA* BY LEONARDO DA VINCI: YOU NEVER KNOW WHAT A SMILE CAN DO

1. Suzanne Daley, "Beneath that Beguiling Smile, Seeing What Leonardo Saw," *New York Times*, April 13, 2012, accessed October 13, 2014.

2. Donald Sassoon, *Mona Lisa: The History of the World's Most Famous Painting* (London: HarperCollins, 2001), 23.

3. Angela Ottino della Chiesa, *The Complete Paintings of Leonardo da Vinci* (New York: Abrams, 1967).

4. Bruce Johnston, "Riddle of Mona Lisa Is Finally Solved: She Was the Mother of Five," *Telegraph*, August 1, 2004, accessed October 21, 2014, http://www.telegraph.co.uk/news/worldnews/europe/italy/1468392/Riddle-of-Mona-Lisa-is-finally-solved-she-was-the-mother-of-five.html.

5. Johnston, "Riddle of Mona Lisa."

6. Giorgio Vasari, *Lives of the Artists*, trans. Gaston C. DeVere (London: Macmillan, 1912), accessed October 15, 2014, http://members.efn.org/~acd/vite/VasariLeo3.html.

7. Roy McMullen, *Mona Lisa: The Picture and the Myth* (New York: Da Capo, 1977), 147.

8. McMullen, *Mona Lisa*, 155.

9. McMullen, *Mona Lisa*, 146.

10. Sassoon, *Mona Lisa: The History of the World's Most Famous Painting*, 43.

11. Frédéric Villot, ed., *Notice des tableau expos'es dans les galleries du Musée Nationale du Louvre*, 1ére parties (Paris: Écoles d'Italie, Musée nationaux, 1849), 106, 108.

12. Villot, *Notice des tableau expos'es dans les galleries du Musée Nationale du Louvre*, 138–139.

13. McMullen, *Mona Lisa*, 168.

14. McMullen, *Mona Lisa*, 172–73.

15. George Boas, "The Mona Lisa in the History of Taste," *Journal of the History of Ideas* 1, no. 2 (April 1940): 216–17.

16. Walter Pater, *The Renaissance Studies in Art and Poetry* (Portland, Maine: Thomas B. Mosher, 1912), 164.

17. Oscar Wilde, "The Critic as Artist," Oscar Wilde Online, accessed October 21, 2014, http://www.wilde-online.info/the-critic-as-artist-page19.html. (Originally published 1881.)

18. Sigmund Freud, *Leonardo Da Vinci: A Psychosexual Study of an Infantile Reminiscence* (New York: Moffat, Yard & Co., 1916), accessed October 20, 2014, http://www.egs.edu/library/sigmund-freud/articles/leonardo-da-vinci-a-psychosexual-study-of-an-infantile-reminiscence/i/.

19. Sassoon, *Mona Lisa*, 176.

20. McMullen, *Mona Lisa*, 209.

21. Bernard Berenson, *The Study and Criticism of Italian Art: Third Series* (London: G. Bell & Sons, 1916), 36.

22. Berenson, *Study and Criticism of Italian Art*, 4.

23. Lionel Cust, "*Mona Lisa*," *Burlington Magazine for Connoisseurs* 28, no. 151 (October 1915): 29.

24. Noah Charney, "Did the Nazis Steal the Mona Lisa?" *Guardian*, November 12, 2013, accessed October 21, 2014, http://www.theguardian.com/artanddesign/2013/nov/12/nazis-steal-mona-lisa-louvre.

25. Quoted in George Boss, "The Mona Lisa in the History of Taste," *Journal of the History of Ideas* 1, no. 23 (April 1940): 219.

26. http://musee.louvre.fr/oal/joconde/indexEN.html, accessed October 22, 2014.

27. Aleksandr Gelfand, "Today in Met History, February 4," accessed October 24, 2014, http://www.metmuseum.org/about-the-museum/now-at-the-met/features/2013/today-in-met-history-february-4.

28. Marjorie Hunter, "'Mona Lisa' Debut Is a Noisy Affair," *New York Times*, January 10, 1963, 7.

29. Gelfand, "Today in Met History."

30. Kenneth Clark, "Mona Lisa," *Burlington Magazine* 115, no. 840 (March 1963): 148.

31. Richard B. Carpenter, "The Mythical Nature of Leonardo da Vinci's 'Mona Lisa,'" *Sewanee Review* 71, no. 3 (Summer 1963): 502.

32. Lillian F. Schwartz, "Art Analysis," Lillian.com, accessed October 22, 2014, http://lillian.com/art-analysis/.

33. "Mona Lisa 'Happy,' Computer Finds," *BBC News*, December 15, 2005, accessed September 21, 2014.

34. "Mona Lisa's Smile Hides the Hole Tooth," *Guardian*, April 4, 1999, accessed October 20, 2014, http://www.theguardian.com/uk/1999/apr/05/martinwainwright.

35. Associated Press, "Bell's Palsy Caused Mona Lisa's Smile, Doctor Theorizes," January 30, 1987, accessed October 20, 2014, http://www.apnewsarchive.com/1987/Bell-s-Palsy-Caused-Mona-Lisa-s-Smile-Doctor-Theorizes/id-acb087555dd91fa22ab09fd6b6789d25.

36. Jeff Israely, "Did Mona Lisa Suffer from High Cholesterol?" *Time*, January 9, 2010, accessed October 21, 2014, http://archives.mirroroftomorrow.org/blog/_archives/2010/2/12/4441079.html.

37. Tom Kington, "Mona Lisa's Eyes May Reveal Model's Identity, Expert Claims," *Guardian*, December 12, 2010, accessed October 31, 2014, http://www.theguardian.com/artanddesign/2010/dec/12/mona-lisa-eyes-model-identity.

CHAPTER 8. *SISTINE MADONNA* BY RAPHAEL: THE MOST PERFECT PICTURE IN THE WORLD

1. Alfred McKinley Terhune and Annabelle Burdick Terhune, eds., *The Letters of Edward FitzGerald II: 1851–1866* (Princeton, N.J.: Princeton University Press, 1980), 491.

2. Carl Woodring, ed., *The Collected Works of Samuel Taylor Coleridge* (Princeton, N.J.: Princeton University Press, 1990), 14:134–35.

3. Esther Singleton, *Great Pictures as Seen and Described by Famous Writers* (New York: Dodd, Mead, 1902), 48.

4. Rolf Toman, *The Art of the Italian Renaissance* (Cologne, Germany: Könemann Verlagsgesellschaft, 1995), 338.

5. J. I. Mombert, *Raphael's Sistine Madonna* (New York: Dutton, 1895), 30.

6. Ludovico Ariosto, *Orlando Furioso*, canto 33, st. 2.

7. John Shearman, *Only Connect. . . . Art and the Spectator in the Italian Renaissance* (Princeton, N.J.: Princeton University Press, 1992), 239.

8. Shearman, *Only Connect*, 105.

9. Singleton, *Great Pictures*, 57.

10. Marielene Putscher, *Raphaels Sixtinische Madonna: Das Werk und seine Wirkung* (Tübingen, Germany: Hopfer-Verlag, 1955), 187.

11. G. Milanesi, ed., *Le vite de' più eccellenti pittori, scultori, et architettori scritta da M. Giorgio Vasari* (Florence, 1878–1885), 4:365. "Fece a'monaci neri di San Sisto in Piacenza la tavola dello altar maggiore, dentrovi la Nostra Donna con San Sisto, et Santa Barbara, cosa veramente rarissima et singulare."

12. Giorgio Vasari, *Lives of the Most Excellent Italian Painters, Sculptors, and Architects*, trans. Gaston du C. de Vere (London: Philip Lee Warner, 1912–1914), 238.

13. Singleton, *Great Pictures*, 57.

14. There is some disagreement in the literature over the sale price, but uniform agreement is that Augustus got the better end of the deal.

15. Singleton, *Great Pictures*.

16. There it stayed until 1954 when it was removed to the Soviet Union for one year.

17. Luitpold Dussler, *Raphael: A Critical Catalogue of His Pictures, Wall-Paintings and Tapestries* (New York: Phaidon, 1971), 37.

18. The painting is now in the State Art Museum in Rouen.

19. David Irwin, ed., *Winckelmann Writings on Art* (New York: Phaidon, 1972), 22.

20. Irwin, *Winckelmann Writings on Art*, 73–74.

21. Irwin, *Winckelmann Writings on Art*, 75.

22. Irwin, *Winckelmann Writings on Art*, 75.

23. Irwin, *Winckelmann Writings on Art*, 75.

24. Irwin, *Winckelmann Writings on Art*, 75.

25. Lionel Strachey, trans., *Memoirs of Madame Vigée Lebrun* (New York: George Braziller, 1989), 81.

26. The most famous copy of a Rubens is Vigée-Lebrun's *Self-Portrait in a Straw Hat* painted in 1782 and now in the National Gallery, London. It is inspired by Rubens's *The Straw Hat*, 1625, also in the National Gallery in London.

27. Robert Rosenblum and H. W. Janson, *19th-Century Art* (New York: Abrams, 1984), 126.

28. John Knowles, ed., *The Life and Writings of Henry Fuseli* (London, 1831), 2:87–88.

29. Oskar Fischel, *Raphael*, trans. Bernard Rackham (London: Spring Books, 1964), 330.

30. Fischel, *Raphael*, 347.

31. John Barrell, *The Political Theory of Painting from Reynolds to Hazlitt* (New Haven, Conn.: Yale University Press, 1986), 54.

32. J. A. Crowe and G. B. Cavalcaselle, *Raphael: His Life and Works* (London: John Murray, Albemarle Street, 1885), 369.

33. Crowe and Cavalcaselle, *Raphael*, 370.

34. Crowe and Cavalcaselle, *Raphael*, 371.

35. Crowe and Cavalcaselle, *Raphael*, 371.

36. Crowe and Cavalcaselle, *Raphael*, 372.

37. Crowe and Cavalcaselle, *Raphael*, 372.

38. John Ruskin, *The Complete Works of John Ruskin*, ed. E. T. Cook and Alexander Wedderburn (London: George Allen, 1906), 7:13.

39. Mrs. [Anna] Jameson, *Memoirs of the Early Italian Painters* (Boston: Ticknor and Fields, 1859), 228.

40. Jameson, *Memoirs*, 269.

41. Jameson, *Memoirs*, 270.

42. Jameson, *Memoirs*, 270.

43. Jameson, *Memoirs*, 270.

44. Putscher, *Raphaels Sixtinische Madonna*, 268.

45. Larry Freeman, *Louis Prang: Color Lithographer Giant of a Man* (Watkins Glen, N.Y.: Century House, 1971), 187.

46. David Alan Brown, *Raphael and America* (Washington, D.C.: National Gallery, 1983), 27.

47. Freeman, *Louis Prang*.

48. Brown, *Raphael and America*, 27.

49. James P. Walker, *Book of Raphael's Madonnas* (New York: Leavitt & Allen Bros., 1874), 98.

50. Walker, *Book of Raphael's Madonnas*, 98–99.

51. Gordon S. Haight, *George Eliot: A Biography* (New York: Oxford University Press, 1968), 264.

52. Gordon S. Haight, ed., *George Eliot Letters Volume II: 1852–1858* (New Haven, Conn.: Yale University Press, 1954), 471.

53. Haight, *George Eliot Letters*, 471–72.

54. Haight, *George Eliot Letters*, 472.

55. Richard Stang, *The Theory of the Novel in England 1850–1870* (New York: Columbia University Press, 1959), 174.

56. George Eliot, *The Mill on the Floss* (Harmondsworth, UK: Penguin, 1985), 400.

57. James H. Billington, *The Icon and the Axe: An Interpretive History of Russian Culture* (New York: Knopf, 1966), 348.

58. Leo Tolstoy, *War and Peace*, book 3, part 2, ch. 26 (New York: New American Library, 1968), 937.

59. Billington, *Icon and the Axe*, 348.

60. Fyodor Dostoyevsky, *Crime and Punishment*, part 6, ch. 4, trans. Constance Garnett (Norwalk, Conn.: Heritage, 1938), 424.

61. Fyodor Dostoyevsky, *The Possessed*, part 2, ch. 5, trans. Constance Garnett (Norwalk, Conn.: Heritage, 1959), 289.

62. Dostoyevsky, *Possessed*, 288.

63. Dostoyevsky, *Possessed*, 490.

64. Charles R. Mack, "Beauty in Its Highest Degree: Francis Lieber and an 1844 Appreciation of Raphael," *SECAC Review* 14, no. 1 (2001): 19.

65. Mack, "Beauty in Its Highest Degree," 19.

66. Mack, "Beauty in Its Highest Degree," 19.

67. There is some discussion as to what the first successful African American play is. Interested readers might consult James V. Hatch and Ted Shine, eds., *Black Theatre, U.S.A.: Forty-Five Plays by Black Americans, 1847–1974* (New York: Free Press, 1974).

68. William Storm, "Reactions of a 'Highly-Strung Girl': Psychology and Dramatic Representation in Angelina W. Grimké's Rachel," *African American Review* 27, no. 3 (Autumn 1993): 464.

69. Sigmund Freud to Edoardo Weiss, April 12, 1933, in *Sigmund Freud as a Consultant* (New York: Intercontinental Medical Book Corp., 1970), as quoted in Peter Benson, "Freud and the Visual," *Representations*, no. 45 (Winter 1994): 101. Accessed March 27, 2015, http://www.pep-web.org/document.php?id=zbk.051.0416a.

70. Benson, "Freud and the Visual," 101.

71. James Strachey, ed., *Standard Edition of the Complete Psychological Works of Sigmund Freud* (London: Hogarth, 1953), 7:96.

72. Strachey, *Complete Psychological Works of Sigmund Freud*, 7:104.

73. Those interested might wish to consult:

Michael W. Alpatow, "Die Sixtinische Madonna van Raphael," in *Kunst und Literatur* (Berlin: Verlag Kultur und Fortschritt o.J., 1955), 692ff.

Wolfgang Schöne, "Raphaels Sixtinische Madonna und die Sixtuskirche in Piacenza," *Kunstgeschichtliche Gesellschaft zu Berlin, Sitzungsberichte*, 1955–1956.

Rudolf Berliner, "Raphaels Sixtinische Madonna als religiöses Kunstwerk," *Das Münster* 11 (1958): 85ff.

Josef Schewe, "Raphael's Sixtinische Madonna," *Das Münster* 12 (1959): 201.

Wolfgang Lotz, "Raffaels Sixtinische Madonna im Urteil der Kunstgeschichte," *Jahrbuch 1963 der Max Planck Gesellschaft zur Förderung der Wissenschaften.*

Herbert von Einem, "Raffaels Sixtinische Madonna," *Särtryck ur Konsthistorisk Tidskrift* 37 (1968): 97ff.

74. Karl von Rumohr, *Italienische Forschungen III* (Frankfurt: n.p., 1920).

75. Hubert Grimme, "Das Rätsel der Sixtinische Madonna," *Zeitschrift für bildende Kunste* 33 (1922): 41ff.

76. Francesco Filippini, "Raffaello a Bologna," *Cronache d'Arte* 72 (1928–1929): 201ff.

77. Dussler, *Raphael*, 37.

78. See Schwitters's *Wenzelkind*, 1921 in the Sprengel Museum in Hannover.

79. *Raphael I—$6.99*, 1985, Andy Warhol Estate.

80. All textbooks, however, at one time or another, have included various Madonnas by Raphael, for example, *The Madonna del Granduca* (1505, Pitti Palace, Florence), *La belle jardinière* (1507–1508, Louvre, Paris), and *The Madonna of the Meadows* (1505, Kunsthistorisches Museum, Vienna), among others.

81. Charles Dempsey, *Inventing the Renaissance Putto* (Chapel Hill: University of North Carolina Press, 2001), 13.

82. Mombert, *Raphael's Sistine Madonna*, 29.

83. *New York Times* editorial, September 4, 1994, section 4, p. 10.

84. As the exhibition title implies, only images in the Vatican collection were used.

85. Arnold Nesselrath, "Wrestling with Angels: The Invisible Made Visible," in *Angels from the Vatican*, exhibition catalog (Alexandria, Va.: Abrams, 1998), 60.

86. Nesselrath, "Wrestling with Angels."

87. Andreas Prater, "Jenseits und diesseits des Vorhangs, Bemerkungen zu Raffaels 'Sixtinischer Madonna' als religiöses Kunstwerk," *Münchner Jahrbuch der bildenden Kunst*, 3rd ser., 42 (1991): 117–36.

88. Ernst Gombrich, *The Story of Art*, 15th ed. (Englewood Cliffs, N.J.: Prentice Hall, 1989), 240.

CHAPTER 9. *THE BURIAL OF COUNT ORGAZ* BY EL GRECO: A TOUCH OF MADNESS GOES A LONG WAY

1. Allan Braham, "Two Notes on El Greco and Michelangelo," *Burlington Magazine* 108, no. 759 (June 1966): 307, accessed November 27, 2011.

2. George A. Rodetis, "El Greco's Statements on Michelangelo the Painter," *Journal of Aesthetic Education* 31, no. 3 (Autumn 1997): 25, accessed November 27, 2011.

3. Manuel B. Cassio, *El Greco* (Barcelona: C. Mallorca, 1908), 7.

4. The case was actually settled in 1569.

5. Francisco Calvo Serraller, *El Greco: The Burial of Count Orgaz* (London: Thames & Hudson, 1995), 7–8.

6. Serraller, *El Greco*, 9.

7. Serraller, *El Greco*, 30.

8. Jonathan Brown and Richard G. Mann, *Spanish Paintings of the Fifteenth through Nineteenth Centuries* (Cambridge: Cambridge University Press, ca. 1990), 19. Distributed for the National Gallery of Art, Washington, D.C.

9. Brown and Mann, 43.

10. John Lloyd and John Mitchinson, *The Book of the Dead* (New York: Crown, 2009), 382.

11. Brown and Mann, 20.

12. Stuart Anstis, "Was El Greco Astigmatic?" *Leonardo* 35, no. 2 (April 2002): 208.

13. Brown and Mann, 21.

14. "Toledo Art Gone, Rebel Chiefs Find," *New York Times*, October 3, 1936, 18.

15. Ernest Hemingway, *Death in the Afternoon* (New York: Scribner, 1932), 164.

16. Hemingway, *Death in the Afternoon*, 163.

17. W. Somerset Maugham, *Don Fernando* (1935, rev. 1950, repr., New York: Mandarin, 1990), 141.

18. John Latham's *Burial of Count Orgaz*, accessed May 15, 2011, http://www.tate.org.uk/art/artworks/latham-burial-of-count-orgaz-t02069/text-display-caption.

CHAPTER 10. *ARISTOTLE CONTEMPLATING A BUST OF HOMER* BY REMBRANDT: FAME AVAILABLE FOR A PRICE

1. *New York Times*, June 7, 1961, 21.

2. www.metmuseum.org, accessed May 10, 2011, http://www.metmuseum.org/collection/the-collection-online/search/437394?rpp=30&pg=1&ft=rembrandt%2Baristotle&pos=1&imgno=0&tabname=object-information.

3. Theodore Rousseau, "Aristotle Contemplating the Bust of Homer," *Metropolitan Museum of Art Bulletin* 20, no. 5 (January 1962): 156.

4. Rousseau, "Aristotle," 156.

5. Wilhelm Bode, "Bolshevism in Art Criticism," *New Republic* 1923, 218, as assessed in Catherine B. Scallen, *Rembrandt, Reputation, and the Practice of Connoisseurship* (Amsterdam: Amsterdam University Press, 2004), 18.

6. Walter Liedtke, "The Study of Dutch Art in America," *Artibus et Historiae* 21, no. 41 (2000): 213.

7. Liedtke, "Study of Dutch Art," 213.

8. Henry James, *The Painter's Eye: Notes and Essays on the Pictorial Arts*, ed. John L. Sweeney (Madison: University of Wisconsin Press, 1989), 52.

9. Esmée Quodbach, "The Age of Rembrandt: Dutch Paintings in the Metropolitan Museum of Art," *Metropolitan Museum of Art Bulletin*, n.s., 65, no. 1 (Summer 2007): 10.

10. Rousseau, "Aristotle," 150.

11. *New York Times*, November 18, 1961, 22.

12. Arthur Gelb, "Costliest Painting in the World Remains Popular after a Year," *New York Times*, November 16, 1962, 33.

13. McCandlish Phillips, "42,000 View $2,300,000 Rembrandt at Metropolitan," *New York Times*, November 19, 1961, 88.

14. Phillips, "$2,300,000 Rembrandt," 88.

CHAPTER 11. *WASHINGTON CROSSING THE DELAWARE* BY EMANUEL LEUTZE: OR PERHAPS, *WASHINGTON CROSSING THE RHINE*

1. Joshua Reynolds, *Seven Discourses on Art* (London: Cassel, 1901), accessed March 27, 2015, http://www.gutenberg.org/cache/epub/2176/pg2176.txt.

2. Jochen Wierich, "Struggling through History: Emanuel Leutze, Hegel, and Empire," *American Art* 15, no. 2 (Summer 2001): 53.

3. Natalie Spassky, *American Paintings in the Metropolitan Museum of Art Volume II* (New York: Metropolitan Museum of Art, 1985), 17.

4. Spassky, *American Paintings*, 17.

5. Worthington Whittredge, *The Autobiography of Worthington Whittredge, 1820–1910*, ed. John I. H. Baur (New York: Arno, 1969), 22.

6. *New York Daily Times*, October 29, 1851, 1.

7. *New York Daily Times*, November 3, 1851, 2.

8. *New York Daily Times*, December 24, 1851, 2.

9. *New York Daily Times*, December 26, 1851, 3.

10. Quoted in Wierich, "Struggling through History," 54.

11. *Washington Crossing the Delaware* in the Chrysler Museum of Art, accessed July 11, 2011, http://collection.chrysler.org/emuseum/view/objects/asitem/search$0040/4/title -asc?t:state:flow=3a448161-6d20-4e98-8846-cd5c8d3ec745.

12. *New York Times*, "Museum to Rehang Historic Painting," January 12, 1932, 25.

13. Grace Glueck, "Larry Rivers," *New York Times*, May 20, 2005, E32.

CHAPTER 12. *LUNCHEON ON THE GRASS* BY ÉDOUARD MANET: SUCCESS THROUGH SCANDAL

1. "Sensation Sparks New York Storm," *BBC News*, September 23, 1999, accessed March 27, 2015, http://news.bbc.co.uk/2/hi/entertainment/455902.stm.

2. "Hillary Weighs In on Art War," *CBS News*, September 23, 1999, accessed March 27, 2015, http://www.cbsnews.com/news/hillary-weighs-in-on-art-war/.

3. Hugh Davies and Ben Fenton, "Whiff of Sensation Hits New York," *Daily Telegraph*, October 2, 1999, accessed December 11, 2010, www.telegraph.co.uk.

4. Jeff McMahon, "The Script of Sensation," *New England Review* 21, no. 3 (Summer 2000): 68, accessed October 13, 2011, http://www.jstor.org.central.ezproxy.cuny.edu:2048/ stable/40244618.

5. George Heard Hamilton, *Manet and His Critics* (New York: Norton, 1969), 85.

6. *Manet*, exhibition catalog (New York: Metropolitan Museum and Harry N. Abrams, 1983), 165.

7. *Manet*, exhibition catalog, 166.

8. Hamilton, *Manet and His Critics*, 51.

9. Paul Hayes Tucker, "Making Sense of Edouard Manet's *Le Dejeuner sur l'herbe*," in *Manet's Le Dejeuner sur l'herbe*, ed. Paul Hayes Tucker (Cambridge: Cambridge University Press, 1998), 1.

10. Théodore Duret, *Manet and the French Impressionists*, trans. J. E. Crawford Flitch (London: Lippincott, 1910), 22.

11. Jack Lindsay, *Cezanne: His Life and Art* (New York: New York Graphic Society, 1969), 90.

12. Lindsay, *Cezanne*, 90.

CHAPTER 13. *THE THINKER* BY AUGUSTE RODIN: FAME HAS ITS CONSEQUENCES

1. Albert Alhadeff, "A Self-Portrait in the Gates of Hell," *Art Bulletin*, 48, nos. 3–4 (September–December 1966): 393.

2. Giorgio Vasari, *Lives of the Most Excellent Italian Painters, Sculptors, and Architects*, trans. Gaston du C. de Vere (London: Macmillan, 1912–1914), 159.

3. Catherine Lampert, "Rodin," Oxford Art Online, accessed March 27, 2015, http://www.oxfordartonline.com:80/subscriber/article/grove/art/T072591.

4. "Doorstop Statue Is $16,500 Thinker," *Lima (Ohio) News*, March 29, 1970, 5.

5. Naomi Schor, "Pensive Texts and Thinking Statues: Balzac with Rodin," *Critical Inquiry* 27, no. 2 (Winter 2001): 243.

6. Schor, "Pensive Texts," 243.

7. Norman L. Kleeblatt, "Introduction—The Dreyfus Affair: A Visual Record," in *The Dreyfus Affair: Art, Truth, and Justice* (Berkeley: University of California Press, 1987), 18.

8. Dominique Jarrassé, *Rodin: A Passion for Movement*, trans. Jean-Marie Clarke (Paris: Terrail, 1992), 165.

9. Kleeblatt, introduction, 19.

10. John L. Tancock, *The Sculpture of Auguste Rodin*, exhibition catalog (Philadelphia: David R Godine, 1976), 116; quoting "Notes parisiennes," *La Liberté*, June 1, 1904.

11. "Rodin's 'The Thinker' Visits Brazil," *Independent*, October 27, 2009, accessed May 10, 2011, http://www.independent.co.uk/arts-entertainment/art/news/rodins-the-thinker-visits -brazil-1810090.html.

12. Stanford News Service, "Rodin's The Thinker Returns to Stanford Campus after a Year Abroad," news release, October 1, 2002, accessed May 10, 2011, http://news.stanford.edu/pr/02/thinker102.html.

13. Quoted in "Statue: Symbol of Sickness," *Zanesville (Ohio) Times Recorder*, March 29, 1970, 25.

14. Bruce Christman, "Twenty-Five Years after the Bomb: Maintaining Cleveland's The Thinker," *Journal of the American Institute of Conservation* 37, no. 2 (1998): article 2, accessed May 10, 2011, http://www.jstor.org.central.ezproxy.cuny.edu:2048/stable/pdf/3179801 .pdf?acceptTC=true.

15. Christman, "Twenty-Five Years after the Bomb," article 2.

16. Martijn van der Starre, "Rodin's 'Thinker,' Statues Stolen from Dutch Museum," *Bloomberg*, January 18, 2007, accessed June 7, 2011, http://www.bloomberg.com/apps/news ?pid=newsarchive&sid=af35Ejin.a7w.

17. Nick Squires, "Michelangelo's 'David' Could Collapse due to High-Speed Train Building," *Telegraph*, March 4, 2011, accessed June 8, 2011, http://www.telegraph.co.uk/culture/art/art-news/8361779/Michelangelos-David-could-collapse-due-to-high-speed -train-building.html.

18. Sheila Rule, "Restoring a Leonardo Drawing That Was Hit by a Shotgun Blast," *New York Times*, November 8, 1988, C15.

CHAPTER 14. *THE STARRY NIGHT* BY VINCENT VAN GOGH: LOST IN A STARRY NIGHT

1. Roland Dorn and Walter Feilchenfeldt, "Genuine or Fake?—On the History and Problems of Van Gogh Connoisseurship," in *The Mythology of Vincent van Gogh*, ed. Kōdera Tsukasa (Tokyo: Asahi National Broadcasting Co., 1993), 263–305.

2. Jan Hulsker, *The New Complete Van Gogh* (Amsterdam: J. M. Meulenhoff, 1996), 6.

3. "Museum Acquires Its First Van Gogh," *New York Times*, September 30, 1941, 2.

4. Lauren Soth, "Van Gogh's Agony," *Art Bulletin* 68, no. 2 (June 1986): 301.

5. Joachim Pissarro, "The Starry Night," accessed April 6, 2011, http://www.moma.org/collection/object.php?object_id=79802.

6. "Van Gogh's 'Starry Night,'" *Bulletin of the Museum of Modern Art* 9, no. 2 (November 1941): 3, http://www.jstor.org/stable/4057833.

7. Dietrich Blumer, "The Illness of Vincent van Gogh," *American Journal of Psychiatry* 159, no. 4 (April 2002): 519, http://ajp.psychiatryonline.org/doi/full/10.1176/appi.ajp.159.4.519.

8. Steven Naifeh and Gregory White Smith, *Van Gogh: A Life* (New York: Random House, 2011), 851ff.

9. Gustav Friedrich Hartlaub, *Vincent van Gogh* (Leipzig, Germany: Klinkhardt & Biermann, 1922), 27–29. Translations and quotations of this quotation and the following five additional quotations from Elmyra van Dooren, "Van Gogh—Illness and Creativity," in *The Mythology of Vincent van Gogh*, ed. Kōdera Tsukasa (Tokyo: Asahi National Broadcasting Co., 1993), 331–36.

10. Roch Grey, *Vincent van Gogh* (Rome: Valori Plastici, 1924), 15.

11. Florent Fels, *Vincent van Gogh* (Paris: H. Floury, 1928), 170.

12. William F. Downes, *Vincent van Gogh* (Amsterdam: n.p., 1930), 92–93.

13. Louis Piérard, *La vie tragique de Vincent van Gogh* (Paris: Les Editions G. Grès & Cie, 1939), 210.

14. Kurt Badt, *Die Farbenlehre van Goghs* (Cologne, Germany: DuMont Schauberg, 1961), 164.

15. Frank Elgar, *Van Gogh* (Paris: F. Hazan,, 1949), 228.

16. Letter from Vincent van Gogh to Albert Aurier, February 10 or 11, 1890, Web Exhibits: Van Gogh's Letters: Unabridged and Annotated, accessed April 4, 2011, www.webexhibits.org/vangogh/letter/20/626a.htm.

17. Letter from Vincent van Gogh to Theo van Gogh, April 9, 1888, Web Exhibits: Van Gogh's Letters: Unabridged and Annotated, accessed April 4, 2011, http://www.webexhibits.org/vangogh/letter/18/474.htm.

18. Carol Zemel, *The Formation of a Legend: Van Gogh Criticism in 1890–1920* (Ann Arbor, Mich.: UMI Research Press, 1980), 3.

19. Zemel, *Formation of a Legend*, 153.

20. Ronald Pickvance, *Van Gogh in St Rémy and Auvers*, exhibition catalog (New York: Metropolitan Museum and Harry N. Abrams, 1986), 103.

21. Zemel, *Formation of a Legend*, 3.

CHAPTER 15. *THE SCREAM* BY EDVARD MUNCH: SCREAM, INDEED

1. Carlos DeJuana, "Michelangelo's Body of Work Seen in New Light," *Sydney Morning Herald*, June 18, 2005, accessed June 3, 2011, http://www.smh.com.au/news/World/Michelangelos-body-of-work-seen-in-new-light/2005/06/17/1118869095342.html.

2. Adrian Stokes, *Michelangelo: A Study in the Nature of Art* (New York: Philosophical Library, 1956), 89.

3. Frank Lynn Meshberger, "An Interpretation of Michelangelo's Creation of Adam Based on Neuroanatomy," *JAMA* 264, no. 14 (1990): 1837–41.

4. Tom Lubbock, "Buonarroti, Michelangelo: The Creation of Adam (1510)," *Independent*, January 5, 2007, accessed June 7, 2011, http://www.independent.co.uk/arts-entertainment/art/great-works/buonarroti-michelangelo-the-creation-of-adam-1510-744396.html.

5. Chris Michaud, "The Scream Sale Led to Record $330 Million Auction at Sotheby's," *Christian Science Monitor*, May 3, 2012, accessed May 3, 2012, http://www.csmonitor.com/The-Culture/Latest-News-Wires/2012/0503/The-Scream-sale-led-to-record-330-million-auction-at-Sotheby-s.

6. Gloria Goodale, "Iconic 'The Scream' to Be Sold at Auction. How Munch Will It Fetch?" *Christian Science Monitor*, May 2, 2012, accessed May 4, 2012, http://www.csmonitor.com/USA/2012/0502/Iconic-The-Scream-to-be-sold-at-auction.-How-Munch-will-it-fetch.

7. Rossella Lorenzi, "Italian Mummy Source of 'The Scream'?" *Discovery News*, September 7, 2004, accessed May 30, 2011, http://freerepublic.com/focus/f-chat/1209557/posts.

8. Vernon McCay and Marjie L. Baughman, "Art, Madness, and Human Interaction," *Art Journal* 31, no. 4 (Summer 1972): 415.

9. McCay and Baughman, "Art, Madness, and Human Interaction," 415.

10. Carla Lathe, "Edvard Munch's Dramatic Images 1892–1909," *Journal of the Warburg and Courtauld Institutes* 46 (1983): 197.

11. Arne Eggum, *Edvard Munch: Paintings, Sketches, and Studies* (New York: Potter, 1984), 91.

12. Alison W. Chang, "Chronology, 1889–99," *Philadelphia Museum of Art Bulletin* 93, nos. 393–94 (Summer 2005): 54.

13. "Stolen 'Scream' Back on Display," *CNN*, May 23, 2008, accessed June 6, 2011, http://globalgrind.com/2008/05/22/stolen-scream-back-on-display-cnncom/.

14. Chris Michaud, "Scream Sale."

15. "1994: Art Thieves Snatch Scream," *BBC*, accessed June 5, 2011, http://news.bbc.co.uk/onthisday/hi/dates/stories/february/12/newsid_3591000/3591994.stm.

16. "Scream Gallery Improves Security," *BBC News*, September 6, 2004, accessed March 28, 2015, http://news.bbc.co.uk/2/hi/entertainment/3631308.stm

17. David Montgomery, "Munch's 'Scream' Stolen in Brazen Raid," *Washington Post*, August 23, 2004, accessed June 5, 2011, http://www.washingtonpost.com/wp-dyn/articles/A23334-2004Aug22.html.

18. "Scream Stolen from Norway Museum," *BBC News*, August 22, 2004, accessed June 5, 2011, http://news.bbc.co.uk/2/hi/europe/3588282.stm.

19. Nicholas George, "Munch's 'Scream' Stolen by Armed Gang," *Financial Times*, August 23, 2004, 1.

20. John Davison, "Norway's Greatest Painting Is Stolen: The Scream by Edvard Munch," *Sunday Times of London*, February 13, 1994, 24.

21. "Three Guilty of Scream Theft," *BBC News*, May 2, 2006, accessed June 5, 2011, http://news.bbc.co.uk/2/hi/entertainment/4964872.stm.

22. Jonathan Jones, "The Bigger Picture," *Guardian*, February 17, 2007, accessed June 5, 2011, www.guardian.co.uk.

23. "*The Scream* Poster Stolen from Area Dorm Room," *Onion*, September 1, 2004, accessed June 5, 2011, http://www.theonion.com/articles/the-scream-poster-stolen-from-area-dorm-room,4751/.

24. John Bentley Mays, "Eeeeeeeeee!!! Popular Art/Edward Munch's The Scream Is Reproduced, Appropriated and Parodied More Than Almost Any Other Painting," *Globe and Mail*, February 22, 1997, C16.

25. "M&M'S to Honor Two Mil M&M Reward for 'The Scream,'" *Scoop*, September 5, 2006, accessed June 5, 2011, http://www.scoop.co.nz/stories/WO0609/S00066.htm.

CHAPTER 16. *AMERICAN GOTHIC* BY GRANT WOOD: ALL-AMERICAN GOTHIC

1. Eleanor Jewett, "American Paintings Exhibition Prizes Offer Some Surprises," *Chicago Daily Tribune*, October 31, 1930, 27.
2. "'American Gothic' Draws Crowd in Iowa: Grant Wood Painting on Display for 2 Months," *KCCI News 8*, January 29, 2009, accessed July 19, 2011, www.kcci.com.
3. Ursula Zeller, "Neue Sachlichkeit," *Grove Art Online*, *Oxford Art Online*, accessed March 28, 2015, http://www.oxfordartonline.com/subscriber/article/grove/art/T062031.
4. Steven Biel, *American Gothic: A Life of America's Most Famous Painting* (New York: Norton, 2005), 110–11.
5. C. J. Bulliet, "The Annual Exhibition at Chicago Art Institute," *New York Times*, November 8, 1931, XX12.
6. Bill Glauber, "Was Iowa Ever American Gothic?" *Christian Science Monitor*, February 20, 2009, accessed May 15, 2009, http://www.csmonitor.com/The-Culture/2009/0220/was-iowa-ever-american-gothic.
7. Nan Wood Graham, John Zug, and Julie Jensen, *My Brother* (Iowa City: Iowa State Historical Society, 1993), 74.
8. "The Cover," *Bulletin of the Art Institute of Chicago* 25, no. 2 (February 1931): 25.
9. John E. Seery, "Grant Wood's Political Gothic," *Theory and Events* 2, no. 1 (1998): 13.
10. Sue Taylor, "Grant Wood's Family Album," *American Art* 19, no. 2 (Summer 2005): 48–67, accessed July 17, 2011, http://www.jstor.org.central.ezproxy.cuny.edu:2048/stable/10.1086/444481.
11. "The Cover," 25.
12. Glauber, "Was Iowa Ever American Gothic?"
13. Taylor, "Grant Wood's Family Album," 54.
14. Wanda M. Corn, "The Birth of a National Icon: Grant Wood's 'American Gothic,'" *Art Institute of Chicago Museum Studies* 10, the Art Institute of Chicago Centennial Lectures 1983, 255.
15. "Half Past Autumn," *PBS NewsHour*, January 6, 1998, accessed March 28, 2015, http://www.pbs.org/newshour/bb/entertainment-jan-june98-gordon_1-6/.
16. H. W. Janson, "Benton and Wood, Champions of Regionalism," *Magazine of Art*, May 1946, 186.
17. Janson, "Benton and Wood," 184.
18. Clement Greenberg, "Review of Exhibition of Joan Miró, Fernand Léger, and Wassily Kandinsky," in *The Collected Essays and Criticism* (Chicago: University of Chicago Press, 1986), 1:65.
19. Clement Greenberg, Letter to *The Nation*, March 16, 1946, quoted in Clement Greenberg, *The Collected Essays and Criticism* (Chicago: University of Chicago Press, 1986), 2:64.
20. Robert Hughes, *American Visions: The Epic History of Art in America* (New York: Knopf, 1997), 442.
21. Harvey Breit, "In and Out of Books," *New York Times*, October 16, 1955, BR8.

CHAPTER 17. *MIGRANT MOTHER* BY DOROTHEA LANGE:
THE POWER OF THE PRESS

1. Milton Meltzer, *Dorothea Lange: A Photographer's Life* (New York: Farrar, Straus & Giroux, 1978), 71.

2. Meltzer, *Dorothea Lange*, 96.

3. Meltzer, *Dorothea Lange*, 132.

4. James C. Curtis, "Dorothea Lange, Migrant Mother, and the Culture of the Great Depression," *Winterthur Portfolio* 21, no. 1 (Spring 1986): 17.

5. Cara A. Finnegan, "Documentary as Art in 'U.S. Camera,'" *Rhetoric Society Quarterly* 31, no. 2 (Spring 2001): 38.

6. Interview with Florence Thompson (transcript), Ganzel Group, accessed September 3, 2014, http://www.ganzelgroup.com/movies/thompson.html#.

7. Interview with Florence Thompson.

8. Interview with Florence Thompson.

9. Jeff Jardine, "Woman in Iconic Photo Raised Family in Modesto," *Modesto Bee*, September 17, 2008, http://www.modbee.com/2008/09/17/432516/dust-bowl-part-iv-symbol-of-an.html.

10. "Who Was Dorothea Lange's Migrant Mother?" Public Domain Images Online, accessed September 3, 2014, http://imagespublicdomain.wordpress.com/2009/06/02/who-was-dorothea-langes-migrant-mother/.

11. Geoffrey Dunn, "Photographic License," *(San Luis Obispo, California) New Times Magazine*, 2002, accessed March 28, 2015, http://archive.newtimesslo.com/archive/2003-10-22/archives/cov_stories_2002/cov_01172002.html.

12. Carolyn Jones, "Daughter of 'Migrant Mother' Proud of Story," *SF Gate*, August 23, 2009, http://www.sfgate.com/news/article/Daughter-of-Migrant-Mother-proud-of-story-3221049.php.

13. Dunn, "Photographic License."

14. Tim Moran, "Depression Icon Homeless Again after Seven Decades," *Modesto Bee*, October 27, 2007, http://www.modbee.com/2007/10/27/104433/depression-icon-homeless-again.html##storylink=cpy.

15. Linda Gordon, *Dorothea Lange: A Life beyond Limits* (New York: Norton, 2009), 239.

16. Meltzer, *Dorothea Lange*, 200.

17. Paula Rabinowitz, *They Must Be Represented: The Politics of Documentary* (New York: Verso, 1994), 86.

18. Wendy Kozol, "Madonnas of the Fields: Photography, Gender, and 1930s Farm Relief," *Genders* 2 (July 1981): 1–23.

CHAPTER 18. *GUERNICA* BY PABLO PICASSO:
TRAVELS WITH *GUERNICA*

1. Aristophanes, *Lysistrata* (Norwalk, Conn.: Heritage, 1964). Quoted from the insert "Sandglass."

2. Melissa McQuillan, "Picasso, Pablo," *Oxford Art Online*, Oxford University Press, accessed March 28, 2015, http://www.oxfordartonline.com/subscriber/article/grove/art/T067316.

3. "Treasures of the World," PBS documentary, accessed June 17, 2011, http://www.pbs.org/treasuresoftheworld.

4. "Rebel Planes Kill 800 in 'Holy City,'" *Murphysboro (Illinois) Daily Independent*, April 29, 1937, 6.

5. "Brits Mean to Protect Own Ships," *Helena (Montana) Independent*, April 27, 1937, 1.

6. "Mass Murder in Guernica," *New York Times*, April 29, 1937, 20.

7. *Portsmouth (New Hampshire) Herald and Times*, April 28, 1937, 1.

8. "*Guernica*: Testimony of War," *PBS Treasures of the World*, accessed March 28, 2015, http://www.pbs.org/treasuresoftheworld/a_nav/guernica_nav/main_guerfrm.html.

9. Françoise Gilot and Carlton Lake, *Life with Picasso* (New York: McGraw-Hill, 1964), 241.

10. "Treasures of the World" documentary.

11. Anthony Blunt, "Picasso Unfrocked," *Spectator*, October 8, 1938, 504.

12. Clement Greenberg, *The Collected Essays and Criticism* (Chicago: University of Chicago Press, 1993), 4:32–33.

13. Herbert Read, "Picasso's *Guernica*," *London Bulletin*, October 1938, 6.

14. "Picasso's 'Guernica' to Be Shown in S.F.," *Oakland Tribune*, August 13, 1939, B7.

15. H. L. Dungan, "War Protest by Picasso Is Impressive," *Oakland Times*, September 3, 1939, B7.

16. Bob Considine, On the Line, *Lowell (Massachusetts) Sun*, August 7, 1942, 15.

17. Ellen Keerdoka and Sylvester Monroe, "Spanish Acquisition?" *Newsweek*, October 31, 1977, 13.

18. "Guernica Departs MoMA," *Museum of Modern Art*, no. 21 (Winter 1982): 3.

19. Elizabeth Nash, "'Guernica' Tussle Reignites Row between Madrid and Basques," *Independent (London)*, April 4, 2006, 17.

20. Nash, "'Guernica' Tussle," 17.

CHAPTER 19. *CAMPBELL'S SOUP* BY ANDY WARHOL: MMM MMM GOOD

1. Interview by William Wright, Summer 1950 (for broadcasting, but never used), as quoted in *Abstract Expressionism: Creators and Critics*, ed. Clifford Ross (New York: Abrahams, 1990), 144.

2. David Wallace-Wells, "Andy Warhol Is Soooo Overrated," *Newsweek*, March 13, 2010, accessed August 2, 2014, www.newsweek.com/andy-warhol-soooo-overrated-75779.

3. Gary Indiana, *Andy Warhol and the Can That Sold the World* (New York: Basic Books, 2010), 83.

4. George Frei, ed., *The Andy Warhol Catalogue Raisonné* (London: Phaidon, 2002), 45.

5. Postcard from Irving Blum to Andy Warhol dated June 26, 1962, as quoted in Mark Rosenthal, *Regarding Warhol: Sixty Artists, Fifty Years* (New York: Metropolitan Museum of Art, 2012), 250.

6. Christopher Palmeri, "Warhol's $100 Soup Earned Dealer $15 Million, Returns to L.A.," *Bloomberg*, August 11, 2011, accessed August 11, 2014, www.bloomberg.com/news/print/2011-08-11.

7. Henry Hopkins, "Reviews; Andy Warhol, Ferus Gallery," *Artforum* 1, no. 4 (September 1962): 15, as quoted in Rosenthal, *Regarding Warhol*, 250.

8. Philip Larratt-Smith, interview with John Baldessari, in *Andy Warhol: Mr. America* (Bogota, Colombia: Museo de Arte del Banco de la Republica, 2009), 266.

9. As quoted in Rosenthal, *Regarding Warhol*, 250.

10. Gretchen Berg, "Nothing to Lose: Interview with Andy Warhol," *Cashiers du Cinema in English*, May 1967, 40.

11. http://www.campbellsoupcompany.com/about-campbell/, accessed August 9, 2014.

12. Indiana, *Andy Warhol*, 133.

13. Paul Alexander, *Death and Disaster: The Rise of the Warhol Empire and the Race for Andy's Millions* (New York: Villard, 1994), 113.

14. Howard Smith, "The Shot That Shattered The Velvet Underground," *Village Voice* 13, no. 34 (June 6, 1968).

15. Frank Faso, "Court Orders Bellevue Test for Actress," *New York Daily News*, June 6, 1968, as quoted in David Bourdon, *Warhol* (New York: Abrams, 1989), 286.

16. Rosenthal, *Regarding Warhol*, 159.

17. Robert Hughes, *The Mona Lisa Curse*, 2009, BBC series produced by Oxford Film and Television.

18. Robert Hughes, "King of the Banal," *Time* 106, no. 5 (August 4, 1975), accessed August 22, 2014, via EbscoHost (0040781X).

19. Robert Hughes, "The Rise of Andy Warhol," *New York Review of Books*, February 18, 1982, accessed August 22, 2014, via EbscoHost.

20. Alexander, *Death and Disaster*, 86.

21. Alexander, *Death and Disaster*, 123.

22. Margo Hornblower, "Living; Garage Sale of the Century," *Time* 131, no. 19 (May 9, 1988): 90.

23. Bryan Appleyard, "A One-Man Market," *More Intelligent Life*, November/December 2011, accessed August 10, 2014.

CHAPTER 20. THE VIETNAM VETERANS MEMORIAL BY MAYA LIN: THE TRIUMPH OF ABSTRACTION

1. "Richard Serra's *Tilted Arc*," *PBS Culture Shock*, accessed June 22, 2011, http://www.pbs.org/wgbh/cultureshock/flashpoints/visualarts/tiltedarc_a.html.

2. Paul Goldberger, "Vietnam Memorial: Questions of Architecture," *New York Times*, October 7, 1982, C25.

3. Ward Just, "We Remember at Last," *Boston Globe*, November 13, 1982, 1.

4. Jan C. Scruggs and Joel L. Swerdlow, *To Heal a Nation: The Vietnam Veterans Memorial* (New York: HarperCollins, 1992), 85.

5. Marita Sturken, "The Wall, the Screen, and the Image: The Vietnam Veterans Memorial," *Representations*, Summer 1991, 124.

6. Henry Allen, "Epitaph for Vietnam; Monument to the Forgotten; Memorial Design Is Selected," *Washington Post*, May 7, 1981, F1.

7. Jean White, "Watt Okays a Memorial Plan," *Washington Post*, March 12, 1982, C1.

8. Goldberger, "Vietnam Memorial," C25.

9. M. Y. Keith, "Visit Replica of Vietnam Memorial," *St. Petersburg (Florida) Times*, July 8, 1988, 2.

10. Edward D. Sargent, "Park Service Proposes Curbing Demonstrations at Vietnam Memorial," *Washington Post*, April 5, 1984, C4.

Index

About the Author

John B. Nici has been teaching art history since 1976, both in high school and as an adjunct professor of art history at Queens College in Flushing, New York, specializing in courses in Italian art from the medieval, Renaissance, and baroque periods. He has worked for the College Board as a reader for advanced placement exams, as a writer for their curriculum guides, and as a consultant for their workshops. He has written articles and delivered scholarly lectures on fields as diverse as medieval crowns, Byzantine angels, Piero della Francesca, and Eugène Delacroix, as well as the *Barron's Guide to Advanced Placement Art History*. In 2004 he was granted the Queens College President's Award for Excellence in Teaching by Adjunct Faculty.